AESTHETICS OF EXCESS

ÆSTHE
OF

JILLIAN HERNANDEZ /

TICS
EXCESS

THE ART AND POLITICS OF BLACK AND LATINA EMBODIMENT

Duke University Press *Durham and London* 2020

Designed by Courtney Leigh Richardson and Aimee C. Harrison
Typeset in Arno Pro, San Marco, and Trade Gothic
by Copperline Book Services

Library of Congress Cataloging-in-Publication Data
Names: Hernandez, Jillian, [date] author.
Title: Aesthetics of excess : the art and politics of Black
and Latina embodiment / Jillian Hernandez.
Description: Durham : Duke University Press, 2020. |
Includes bibliographical references and index.
Identifiers: LCCN 2020015166 (print)
LCCN 2020015167 (ebook)
ISBN 9781478010050 (hardcover)
ISBN 9781478011101 (paperback)
ISBN 9781478012634 (ebook)
Subjects: LCSH: Body image—Social aspects. | Aesthetics. |
Human body in popular culture. | Art and race. | Body image
in art. | Body image in women. | Body image in girls. | African
American women in art. | Hispanic American women.
Classification: LCC HM636 .H476 2020 (print) |
LCC HM636 (ebook) | DDC 305.4/88—dc23
LC record available at https://lccn.loc.gov/2020015166
LC ebook record available at https://lccn.loc.gov/2020015167

COVER ART: *Just as a Reminder to Myself,* 2014. © CRYSTAL PEARL
MOLINARY. COURTESY OF THE ARTIST.

Duke University Press gratefully acknowledges the generous support
of the University of California, San Diego, Division of Social Sciences,
which provided funds toward the publication of this book.

CONTENTS

ACKNOWLEDGMENTS

I am writing these acknowledgments as the COVID-19 crisis unfolds here in the U.S. I am reminded of our bodily interconnectedness and vulnerability, and I am thinking of those I care for, and those who have cared for me.

I first want to thank the girls and young women who shared space with me in Women on the Rise! This book is in loving dialogue with their artistry, knowledge, and spirit. I send special thanks to Aurelie Anna-Florestal, Qualisa Thomas, Tamyra Benjamin, Bridget Jones, and Questella Bradshaw.

Women on the Rise! was the product of collaborative labor, and I want to thank the teaching artists, collaborators, funders, and Museum of Contemporary Art, North Miami, staff that I worked with: Guadalupe Figueras, Nereida García Ferráz, Monica Lopéz de Victoria, Dinorah de Jesús Rodríguez, Isabel Moros, Ali Prosch, Jen Stark, Susan Lee Chun, Kathleen Staples, Rosemarie Chiarlone, Naomi Fisher, Shara Banks, Shar Nims, Kristen Stoller, Vanessa Garcia, Ebony Rhodes, Shedia and Saliha Nelson, LaCriscia Fowlkes, Karla Stitt, Patricia Taboas, Alina Serrano, Fran Katz, Maritza Ejenbaum, Luigi Ferrer, Gabriel Garcia Vera, Vivian Marthell, Emmana Louis, Elyse Dermer, Juliette Graziano, Vivian Greer-Dogon, Adrienne von Lates, Bonnie Clearwater, Donna Fields, Esther Park, Valerie Ricordi, Kevin Arrow, Janice Angel, Willy Miranda, Carlos Prim, Karen Halpern, and Crystal Pearl Molinary. Crystal and I have been working to-

gether for almost fifteen years, and her artwork ignites my passion for writing. I am grateful to her for creating images that affirm my pride in Latina bodies. I am grateful to Anya Wallace for her creative vision, truth telling, and passion for Women on the Rise! Anya has been a partner in crime and critical interlocutor for me through years of WOTR praxis and crafting this book, and I cherish our friendship more than she can know.

This book grew out of my research in the Department of Women's, Gender, and Sexuality Studies at Rutgers University. In 2008, I enrolled in Louisa Schein's graduate seminar on feminism and popular culture, and it was a transformative experience. The texts on racialized sexuality and cultural production that we engaged there, and the critical questions she encouraged us to consider, forged a path for me to elaborate my own thinking. She has been an inspiration and steadfast support to me ever since. I could not have asked for a better adviser and intellectual provocateur. I am ever grateful to my dream team committee, Arlene Stein, Carlos Decena, Susan Sidlauskas, and Anne Anlin Cheng, for their deep engagement and guidance. Ferris Olin and Connie Tell provided a home for me as a graduate student at the Feminist Art Project and Institute for Women and Art at Rutgers, where I worked as a graduate assistant.

The University of California, San Diego's Ethnic Studies Department and Critical Gender Studies program provided a rich intellectual space for developing this book, and I thank the faculty for their support during my time there: Ross Frank, Kirstie Dorr, Sara Clarke Kaplan, Dayo Gore, Shelley Streeby, K. Wayne Yang, Patrick Anderson. Yen Lê Espiritu has been a committed mentor and friend, and I will never forget her care for me and my family. A special shout-out goes to Fatima El-Tayeb, Daphne Taylor-García, Roshanak Kheshti, and Curtis Márez for their feedback on various parts of the book. I deeply value Kalindi Vora's support over the years. I am also thankful for the critical engagement of the graduate students in K. Wayne Yang's spring 2017 proseminar in ethnic studies who read a draft of my manuscript and created an incredible zine based on it. I drew on many of their comments in revising the text. Dean Carol Padden provided a generous publication subvention that made it possible to print *Aesthetics of Excess* in full color. This book was written over many, many coffee dates with my UCSD writing crew, Gloria Chacón and Jessica Lynn Graham, whom I miss dearly.

I learned so much from my graduate and undergraduate students at UCSD. Yessica Garcia Hernandez's brilliance is a constant inspiration, and

many ideas in this book have been bettered through charlas with her. I am so glad our paths have crossed. Leslie Quintanilla's fierce artist-activist energy is intoxicating, and I am privileged to call her a homegirl. I also have so much love for Katherine Steelman, Patricia Zambrano, Mellissa Linton-Villafranco, David Sanchez Aguilera, Omar Padilla, Cynthia Vasquez, India Pierce, Samar Saif, Gracie Uriarte, Juliana Vega, JJ Soto, Gregory Valdivia, Chris Aviles, and Mely Quiroz. Beyond and through the confines of UCSD was a community of people who made me and my family feel at home in San Diego: Christina Carney, Candice Anderson, Jade Power Sotomayor, José Fusté, Lazaren Mendoza, Norell Martinez, and the whole Bomba Liberté crew. I am also grateful for my exchanges with Erica Cho and Ricardo Domínguez. Lilly and Danny Pino, Ali Prosch, Dave McFarland, Rachel Lachowicz, and Walter Meyer made Los Angeles home as well.

I am grateful for the sustaining relationships and community of scholars who make my work possible and pleasurable. Many of these women and queer of color scholars have taken serious risks to produce their groundbreaking work, and I could never adequately express my appreciation for the support they have given me in spite of the institutional demands on their brains and bodies. Juana María Rodríguez, Ruth Nicole Brown, Mireille Miller-Young—thank you, your work moves so many of us. Susan Richmond, Hoang Tan Nguyen, Melissa Hyde, Celine Parreñas Shimizu, Derek Conrad Murray, Mimi Thi Nguyen, Chamara Jewel Kwakye, Mekha McGuire, Uri McMillan, Nicole Fleetwood, Darius Bost, LaMonda Horton-Stallings, Deborah R. Vargas, Ramón H. Rivera-Servera, Mérida Rùa, Ana Y. Ramos-Zayas, Sarah Luna, Alexis Salas, Kristie Soares, Sandra Ruiz, Tyler Denmead, Derrais Carter, Jessica Pabón-Colón, Ernesto Renda, and the SOLHOT/We Levitate crew (Jessica Robinson, Porshé Garner, Blair Ebony Smith) are valued teachers, interlocutors, and friends.

I am convinced that spirit work brought me back to Florida to complete the revisions of this book, which is so grounded in its land and people. I am grateful to the faculty and staff at the Center for Gender, Sexualities, and Women's Studies Research at the University of Florida for their warm and enthusiastic welcome: Bonnie Moradi, Donna Tuckey, Alyssa Zucker, Manoucheka Celeste, K. L. Broad, Constance Shehan, Anita Anantharam, Maddy Coy, Elizabeth Garcia, Laura K. Guyer, Angel Kwolek-Folland. I extend special thanks to the members of my mentoring committee, Tanya Saunders, Trysh Travis, and Kenneth Kidd: their advice and encouragement has meant so much. I am lucky to have a vibrant network of colleagues

across the university that enrich my life at UF and in Gainesville: Barbara Mennel, Lisa Iglesias, Delia Steverson, Rachel Silveri, Porchia Moore, Nicholas Vargas, Carlos de la Torre, Christopher Busey, Cecelia E. Suarez, Della Mosley, Kaira Cabañas, Bianca Quinones, Tace Hedrick, and Efraín Barradas. I am grateful to Onyekwere Ozuzu and Anthony Kolenic for facilitating my collaborations with the College of the Arts.

Christine Bryant Cohen, writing coach and editor extraordinaire, was a steady guide in the difficult process of completing the book through relocations, pregnancy, and the other demands of life. I thank her for keeping me accountable, and for loving the book as much as I do.

Yessica Garcia Hernandez, Andreina Fernandez, Mellissa Linton-Villafranco, and Justine Veras were fabulous research assistants. I would not have been able to get the book through production without them.

Having this book published by Duke University Press is a dream come true, and I could not have asked for a better editor than Ken Wissoker. His enthusiasm for the project has sustained me over the years, and I am glad to have him as a friend. I am also grateful for the careful and dedicated work of Elizabeth Ault, Joshua Tranen, and Liz Smith at Duke University Press in guiding this text through peer review and production. I extend my heartfelt thanks to the readers for their time and labor in reviewing the book and providing me with generative and inspired feedback. The book has benefited so much from their critical insights and interventions. I am grateful to Ali Prosch for helping me design the initial mock-ups for the interludes, and to Courtney Leigh Richardson and Aimee C. Harrison for the gorgeous book design. Cathy Hannabach and the folks at Ideas on Fire created a wonderful index that led me to view the book's work in new and exciting ways.

I thank my mother, Zaida Milagros Machado, whom we lovingly call "Gram," for making hard sacrifices that allowed me to own an encyclopedia set and access a good education as a child. If I am a scholar, it is because of her. My paternal grandmother, Virginia Milagros Hernandez, provided a loving space that sparked my curiosity and aesthetic proclivities, and I learned about making the body into art from my maternal grandmother, Zaida "Madelyn" Santiago. I miss her every day. I am grateful to my aunt Leyda Hernandez for forging a path for me to follow as a Latina in the professional world.

I am blessed to share my life with a group of beautiful humans. My daughter, Masaya, and son, Teo, keep me present and often laughing. And Jorge Bernal, my boyfriend eternal, has taken care of all of us so that this book could be written. I am grateful for every day I get to spend with them.

The research in this book has been funded in part by a UCSD Frontiers of Innovation Grant, Hellman Fellowship, American Association of University Women Dissertation Fellowship, and National Women's Studies Association Graduate Scholarship.

Parts of the introduction and chapter 2 originally appeared in "'Miss, You Look Like a Bratz Doll': On Chonga Girls and Sexual-Aesthetic Excess," *National Women's Studies Association Journal* 21, no. 3 (2009): 63–91, and "'Chongas' in the Media: The Sexual Politics of Latina Girls' Hypervisibility," in *Girls' Sexuality in the Media*, edited by Kate Harper and Vera Lopez (New York: Peter Lang, 2013). Parts of chapter 5 appeared in "The Ambivalent Grotesque: Reading Black Women's Erotic Corporeality in Wangechi Mutu's Work," *Signs: Journal of Women in Culture and Society* 42, no. 2 (2017): 427–457.

In 2004, I founded the feminist community arts project Women on the Rise! (WOTR) at the Museum of Contemporary Art in North Miami, Florida. I developed WOTR in response to learning about the increasing number of girls committed to the juvenile justice system in Florida in the early 2000s. When I researched the kind of educational opportunities available to them while incarcerated, I found that none of their classes provided a space for creative release in the midst of what was a profoundly disorienting and distressing experience. I learned that the girls were regularly subject to various forms of dubiously effective, and at times violating, state-supported group and individual counseling. When not in those spaces, the girls were either in remedial education sessions in dismal classrooms or forced to entertain themselves in the cell block with random collections of old DVD movies and books.

 With that knowledge, I designed WOTR as an intergenerational feminist art praxis, rather than a form of art therapy, self-work, or carceral reform. The goal of this praxis was to generate a place for girls of color, both in detention and at other community sites, to engage in self-expression and critical dialogue, practices that they were either socially and institutionally excluded from (being artists) or were believed incapable of (being theorists).

Workshops for WOTR were conducted off-site from the museum in the spaces of collaborating nonprofit, government, and educational organizations that work with girls (ages ten to eighteen) and young women (ages eighteen to twenty-five). The project consisted of workshops that introduced participants to the work of feminist, antiracist, and queer artists. These workshops, which were free of charge, culminated in the production of artworks by participants in a range of media that were inspired by and responded to the particular practice of the featured artists. For example: girls created and documented silhouette forms they forged in nature with their bodies for the workshop on Ana Mendieta's *Silueta* pieces of the 1970s; they captured images in their schools and neighborhoods through gilded frames when they learned about Lorainne O'Grady's *Art Is . . .* (1983) project; and they composed performative instruction writings such as those found in Yoko Ono's book *Grapefruit* (1964). Bedazzled photo-collage self-portraits are made when WOTR covers Mickalene Thomas, and participants fashion elaborate headdresses for iconic women of color in the project based on Firelei Baez's work. These workshops were collaboratively led and developed by Miami artists Nereida Garcia-Ferraz, Guadalupe Figueras, Crystal Pearl Molinary, Isabel Moros, Ali Prosch, Dionorah de Jesús Rodríguez, Monica Lopez de Victoria, Anya Wallace, and myself.[1] Teaching artists also conducted workshops based on their own work, and WOTR organized trips for participants to visit artists' studios and exhibitions around Miami.

This pedagogy fostered creative intergenerational and transracial relationships and genealogies between young working-class Black and Latina women and the artists who teach and are taught in WOTR. By focusing on other artists, the project also allowed participants to potentially explore personal issues without having to make revelations that could make them vulnerable in a group context. This occurred, for example, in workshops based on the work of Yayoi Kusama, where we discussed how Kusama's method of "obliterating" objects by covering their surfaces with polka dots provides her with a feeling of control during the hallucinatory episodes she suffers. Artists teaching for WOTR prompted the girls to utilize polka dots and other repetitive patterns to create their own obliterations of objects in Kusama-inspired collages. The resultant abstract works of colorful patterns concealed the girls' feelings, leaving them to decide whether or not to discuss the meaning behind their work in a group setting. Several girls shared that they chose to obliterate a troubling fear, experience, or anxiety.

The relations and praxis of Women on the Rise!, situated within Miami's particular formations of gender, class, and race, form the lens through which

I view the spectacularly styled bodies of Black and Latina women and girls. In particular, a series of converging events that occurred in Miami in the spring and summer of 2007 led me to study how the discourse of aesthetic excess, and its attendant debates, significantly structure the boundaries around legitimate and deviant forms of gendered Blackness and Latinidad. These events set me on the path toward understanding how Black and Latina girls and women artfully trouble these binaries through their bodies and creative, aesthetic labor.

"Miss, You Look Like a Bratz Doll"

I was teaching a WOTR workshop at the Miami-Dade County Regional Juvenile Detention Center in the spring of 2007 with a group of girls along with the local Cuban American artists Crystal Pearl Molinary and Jessica Gispert. The artists discussed how Latina culture and body image inform their photographic practice, and they worked with the girls on a hands-on art project.

I remember how I was dressed. That day, I was wearing tight black leggings under a fitted olive green sweater dress with a V neckline. My shoes were vintage-style, bone-white peep-toe heels. Half of my hair was streaked with chunky blonde highlights, and it was flat-ironed straight. I had thick black eyeliner on and brick-red lipstick. At one point in the workshop, a participant told me, "Miss, you look like a Bratz doll."

Bratz: the multiracial, mass-marketed dolls for young girls, styled with plump lips, elaborately made-up bedroom eyes, platform heels, and miniskirts. My initial response to the comment was the same as everyone else in the room—laughter—and I enjoyed following the girls' jovial yet intense debate over whether this was an accurate description of me. The participant qualified her Bratz doll comparison by indicating my makeup, heels, formfitting clothes, and highlighted hair. It was casual and lighthearted.

Later that evening, however, I found myself reflecting on this characterization of me. As an art educator, I believed that my style reflected my studied eclectic taste. *Was it a joke? Do I really look like one of those tacky dolls? She must have been kidding...* At the time, I did not associate myself with the "type" of woman who would look like a Bratz doll. Why was I viewed this way? More importantly, why was this comparison so objectionable to me?

As the girl child of first-generation, working-class Cuban and Puerto Rican migrants raised in the Latinx enclaves of West New York, New Jersey, and Miami, Florida, I knew what Bratz-type women looked like. They didn't

look like me. I attended a private Catholic elementary school and was college educated. They, on the other hand, were girls who did not perform well in school, hung out on the street, and dressed in clothes that were cheap and too revealing.

When I ruminated on this exchange with the girls, my thoughts turned toward examining my unacknowledged biases toward the Latina women my mother trained me not to emulate and confronting the repressed shame I harbored toward my own working-class-ness. I began to understand that I drew upon my identity as educated to disavow my family's considerable financial precarity, as my educational access came at the tremendous sacrifices of my mother, who worked retail and factory jobs, and my stepfather, who was a self-employed handyman. Yet, even while living in a run-down, pest-infested building in West New York, New Jersey, when I was a young girl in Catholic school, we always identified ourselves as middle-class. Looking back now, I can see how acknowledging our working-class status would have meant denying ourselves dignity and accepting the discourse of failure attributed to racialized communities.

My initial rejection of the participant's characterization led me to realize my own social proximity to the aesthetic excess attributed to working-class Latinas via appearance. If the girls think I look like a Bratz doll, who is to say that others haven't viewed me in the same way—like the men who have sexually harassed me as I've walked along the streets of Miami, or the older Latinas who looked at me disdainfully when I was a pregnant nineteen-year-old? Other than perhaps my thick-rimmed glasses, as my body navigates social spaces, does anything separate me from these so-called low-class women?

Enter Chongas

Like I did every Thursday, I picked up a copy of the *Miami New Times*, Miami's free alternative weekly newspaper. The cover of the June 14, 2007, edition struck me. It was a close-up shot of two teenage Latina girls against a bright pink background. They had exaggerated, vaudeville-like facial expressions and wide-open eyes. Their hair was heavily gelled and slicked tight against their heads. Large silver hoop earrings dangled down their necks. They posed their hands performatively to display their long acrylic fingernails.

The *Miami New Times* cover text read simply, "CHONGAS!" in large, bold lettering across the bottom of the front page, framing the portrait of the two young women (figure I.1). "Chonga" is a colloquial term used by Latinx

June 14-20, 2007 Volume 22, Number 11
miaminewtimes.com FREE

MIAMI New Times

Chongas!

by Tamara Lush

FIGURE I.1. Chonga *Miami New Times* cover (22, no. 2, June 14–20, 2007), art directed and photographed by Ivylise Simones.

in Miami to describe so-called low-class, slutty, tough, and crass young women. The cover was articulating a characterization, the presentation of a type, through staging the girls' bodies against a solid-colored background and the corresponding, definitional term "chonga." The cover communicated, "This is what chonga girls are."

The girls in the photo were the creators of the widely viewed YouTube video "Chongalicious," a parody that mocks young Latina women who don tight clothing, heavy lip liner, and large hoop earrings. The performers, who do not self-identify as chongas, were the subjects of the *Miami New Times* cover story, featured in an interview about their "Chongalicious" video's unexpected and rapid rise to popularity.

I took careful notice of this visual impression, joined with what I already knew about the perception of chongas in Miami as "bad girls." The image spurred me to reflect not only upon my own girlhood experiences of navigating bodily self-presentation, but on those of the working-class Latina and Black girls I worked with as an educator through wotr. In that moment, viewing the *Miami New Times* cover image of these Latina girls, I felt that much was at stake in the chonga's dramatic coming into discourse.

The meaning making around class and gendered/racialized body aesthetics that appeared to me in these encounters animates the case studies on the art and politics of Black and Latina embodiment that make up this book, which span from 2007 to 2014. This was a time marked in the U.S. by economic recession, increasing urban gentrification and deportation of immigrants, and the murder of Trayvon Martin, a teenage African American boy, in Sanford, Florida, which sparked the Black Lives Matter movement. At this time, while Black and Latinx lives were being systematically devalued by violence and an economy failing in significant part due to predatory mortgage lending practices aimed at working-class and racialized populations, Black and Latina women and girls were achieving unprecedented success and visibility in various cultural sites. The young Latina girls who created the viral YouTube video "Chongalicious" became instant celebrities, appearing on internationally broadcast Spanish-language television networks. Nicki Minaj became one of the most financially successful mainstream hip-hop artists. And the work of Black women artists like Wangechi Mutu and Kara Walker became some of the most highly visible and valuable art in the contemporary art world.

Yet these moments of woman and girl of color cultural recognition and material achievement also occasioned cultural debates that marked Black and Latina bodies as fake, low-class, ugly, sexually deviant, and thus damag-

ing to the public image of their communities. The sociocultural boundary formation performed by the differential aesthetic valuing of Black and Latina bodies and their representation is what concerns me in this book. I analyze how these assessments are produced and negotiated in cultural production, the reception of body aesthetics in critical and popular discourses, and the creative and vernacular practices of Black and Latina girls and women. I ask why some gendered representations and embodiments of Blackness and Latinidad are celebrated and gain cultural and material value, while others are mocked, reviled, and considered dangerous. Throughout, I argue that the aesthetics of excess play a major part in defining what becomes legible as Blackness and Latinidad through varied processes of inscription, assumption, and disavowal.

Aesthetics of Excess centers on agitated responses (Garcia Hernandez 2017), such as my discomfort with being compared to a Bratz doll, as they illuminate the social and cultural stakes of Black and Latina embodiment and representation: the mockery and shaming of chonga girls; the harassment of masculine body–presenting young Black and Latina women; the vilification of superstar rapper Nicki Minaj's body as fake and plastic; and young women's reactions of repugnance and embarrassment at sexual images of women crafted by contemporary Black women artists.[2]

Continually subject to oppression and marginalization, women of color have, as Stuart Hall writes about Black people in the diaspora, "used the body—as if it was, and it often was, the only cultural capital we had. We have worked on ourselves as the canvases of representation" (1996, 473). Beyond tracing the politics and cultural effects of these often-hostile responses, this book also reveals the power and potential that the visual economy of aesthetic excess offers for contesting and reimagining formations of race, gender, class, and sexuality for Black and Latina women and girls as they make art with and about their bodies.[3]

Where Girls and Art Collide: WOTR as Performative Site

Feminist artists and art historians have attested to the unwieldy and radical ways that girls encounter and read art. Tracey Emin claims that those who best understand her deeply personal explorations of sexuality and relationships are working-class teenage girls, rather than art critics (Robinson 2006, 2). And Anna C. Chave has described how, when two teenage girls saw one of Donald Judd's 1968 floor box sculptures at the Museum of Modern Art in New York, they "strode over to this pristine work, kicked it, and laughed.

They then discovered its reflective surface and used it for a while to arrange their hair until, finally, they bent over to kiss their images on top of the box" (1990, 44). The multisited analyses in this book center on such encounters and pivot along the axis of my work with girls and young women through the WOTR feminist art collective.

Aesthetics of Excess draws on WOTR as a performative site, where the discrepant modes of cultural value in which aesthetics of excess are entrenched make themselves visible as girls and art collide. Art and theory are coproduced in spaces where they are not typically imagined, as WOTR takes art off the wall and activates it in social contexts that spark performative enactments by participants. Through these performances, they passionately debate the politics of gender, race, class, sexuality, and other vectors of difference. The girls who participate in the project often have agitated responses to the work displayed in WOTR workshops, due to elements such as the artist's nudity, the visibility of bodily processes and/or fluids, and content or aesthetics that they find unpalatable.

Rather than discipline the girls to appreciate these works in order to develop a form of cultured good taste, WOTR instructors utilize their agitation to probe what participants, instructors, and featured artists have at stake in the representations in question. What would compel an artist like Ana Mendieta, who was a young orphaned Cuban exile subjected to various forms of abuse and alienation in the U.S., to merge her nude body with the natural landscape and utilize animal blood as a medium? Might Wangechi Mutu's collages of deformed women be critiques of the racial ideals of the beauty industry? The girls' often highly performative and, to use Ruth Nicole Brown's (2014) phrase, "wrecklessly theatric" responses to such questions often reveal significant insights into the artists' works, and how participants theorize the aesthetic production and representations of gendered embodiment. I center these "dramatic, semi-confrontational, and passionately argued" (Brown 2014, 35) theatrics in crafting the arguments of this book, as I understand them as methods of theorizing, knowledge production, and self-fashioning innovated by the girls.

Through WOTR, I have gained a nuanced understanding of how notions of high and low culture are complicated when young women of color engage in cultural production, as well as how they challenge the disciplining of their bodies and sexualities through artistic authorship. Thus, the book chapters draw extensively from the insights of the Black and Latina young women I worked with, who are positioned in the text as artists and theorists of culture. I theorize in tandem with the girls, whom I also refer to as WOTR

artists, and my exchanges with them are also creatively evoked in the book through visual and textual interludes that feature their artwork, writing, and commentary, in addition to my creative responses.

I juxtapose the body practices of self-described gay and heterosexual WOTR artists in Miami with images produced by contemporary visual and pop culture artists whose works stage sexual bodies, such as Kara Walker and Nicki Minaj. These are figures who are taught in WOTR workshops or whose work is consumed by project participants. Rather than disaggregating girls' talk about themselves and their readings of cultural productions, I highlight how these narratives are enmeshed, illustrating the complex interplay between the sexual, racial, class, and gender discourses circulating in media and girls' aesthetic interpretations, transformations, negotiations, and incarnations of these meanings.

Ornamentalism and the Power of Sexual-Aesthetic Excess

There is nothing inherently excessive in the embodiments I discuss in this book, as to attribute excess would be to measure these styles against modernist European stylistic values, which were generated by influential white tastemakers, men who linked racial and gendered inferiority to so-called aesthetic indulgences.[4] For example, in "Ornament and Crime," the 1908 treatise on the role of style in modernism written by influential Viennese architect Adolf Loos, pleasure in elaborate aesthetic practices is framed as evidencing a deviant savagery. Loos states, "Primitive man had to differentiate themselves by various colours, modern man wears his clothes as a mask. . . . The lack of ornament is a sign of intellectual power" (1985, 103).

Similarly, Le Corbusier, a French architect, tastemaker, and contemporary of Loos, disavowed aesthetic excess by forging a connection between adornment and practices of girlhood consumption that were just emerging in the early twentieth century. As Rosalind Galt explains, "Le Corbusier also abhorred glitter, posing aesthetic purity against the fashionable patterns beloved of shopgirls" (2011, 66). Racialized and hypersexual femininity in particular has served as a denigrated prism through which the superiority of authentic, truthful, and natural/simple (white) styles have been asserted (Lichtenstein 1987). These aesthetic theories have traveled from Europe to the U.S. through the institutionalization of canonical histories of Western art and design, and they find contemporary life in the negative, racializing assessments of working-class Black and Latina women and girls—whose elaborate embodiments situate them as the antithesis of high

style and therefore as sexual others, according to both modernist and classical Western discourse.

L. H. Stallings (2015, 11) has observed how the Western construct of aesthetics has worked as an apparatus for making "art as valuable as science" through the mobilization of formalistic judgments fashioned after imperialistic logics of value that dehumanized colonial-racial subjects. I work from a conception of aesthetics that is inspired by Stallings's (12) framework of *transaesthetics*, which offers an understanding of art as intertwined with culture, rather than divorced from it. In discussing transaesthetics in relation to African American literatures, Stallings asserts that writers such as Zora Neale Hurston, who blur the boundaries between ethnography and literature, "would distance their forms and aesthetics away from singular and binary sensory expressions in which objects could be easily commodified into a collectible artifact to reflect an empire or an empire's wealth. Transaesthetics made possible the survival of a posthuman imaginary over knowledge-power, the representation of black bodies, and the improvisational nature necessary for building black creative traditions" (12). *Aesthetics of Excess* shares this understanding of the aesthetic, and I use the term to denote creative, diasporic iconographies and practices of bodily styling, art making, and cultural production enacted by WOTR artists and the cultural workers they engage with. Rather than attempting to normalize Black and Latina body aesthetics as tasteful or normal, I plumb the discourse of ornamental excess and the power of sexual aesthetics to probe the social and cultural disturbances they spark, and thus illuminate how class, race, gender, and sexual difference are formed via contemporary visual culture and embodiment. I attend to how Black and Latina women and girls tarry with these formations of difference and make art and pleasure out of them.

After all, the embodiments, iconographies, and objects created by racialized and colonized peoples are the canvases upon which Euro-American modernism articulated itself—via Picasso's abstracted masks inspired by his visits to ethnographic museums in Paris, Adolf Loos's infamous Josephine Baker house, and, later, Keith Haring's graffiti-inspired works that stemmed from his erotic attraction to poor and working-class Black and Latinx young men in New York City (Cheng 2011a; Foster 1985; Cruz-Malavé 2007). Aesthetics of excess are the miscegenated products of what happens when these appropriated innovators engage in the remix of crafting their own bodies and representations, which trouble, seduce, and sometimes capitulate with the desirous gazes of the Euro-American West.

To exceed is to trespass. Gazes invested in neoliberal racial, class, gender, and sexual normativity perceive excess as a negative, a social liability or deviancy, but I frame the excess engaged in this book as abundance, as possessing more than the essential, the alternative value that Puerto Rican artist Pepón Osorio describes as "the philosophy that more is better" (as quoted in Walker and Walker 2004, 28). Aesthetics of excess embrace abundance where the political order would impose austerity upon the racialized poor and working class, viewed as excessive as in unnecessary, unproductive (Vargas 2014). They flaunt the visuality of difference where the social order invests in the material erasure of Black and Latinx bodies through mass incarceration, detention, deportation, and other forms of social death. As Lisa Marie Cacho notes, "Under Neoliberalism, impoverished African American citizens' consumption patterns are under constant scrutiny. Poor African Americans are not only represented as unentitled to 'luxuries'; they are also denied the power to decide what constitutes a 'luxury' and the power to define what they need and what they can live without" (2012, 21). This is why artist Kehinde Wiley poses young working-class Black men against floral baroque patterns and ornate gilded frames, why performer Celia Cruz wore spectacular gowns and wigs, why the late Chicana singer Selena bedazzled her bras with sequins and rhinestones, and why my Puerto Rican grandmother wore impeccable makeup and hair to work as a seamstress in a north New Jersey sweatshop.

To present aesthetic excess is to make oneself hypervisible, but not necessarily in an effort to gain legibility or legitimacy. Embodying such styles often stems from one's racial, ethnic, and gendered culture, and the desire to utilize the body creatively, admire one's self-image, and potentially attract the gazes of others. Aesthetics of excess are the targets of commodification, appropriation, cultural dismissal, and erasure—but they tend to spectacularly survive and morph, slipping through such attempts at capture. It's how we dress in the undercommons (Harney and Moten 2013).

While aesthetics of excess declare dignity in the face of white supremacist state surveillance of Black and Latinx consumption, they encompass and perform much more than that. These aesthetics that become targets of scrutiny and attack stem from diasporic creative, cultural, and spiritual lineages that predate European colonization, though they have been undeniably altered by it. This book takes up the queering work performed by aesthetic excess in upsetting the dehumanizing formations of race, gender, class, and sexuality operative in the twenty-first-century United States as criminalized populations express their subjectivities and power through them.

I use the term "queer" to describe the destabilizing force of the nonnor-mative and the misfit. Recognizing the ways that, as Cathy J. Cohen (2013) has shown, some queer theorizing and activism have unwittingly reinforced the binaries between the heterosexual and the queer at the expense of in-tersectional understandings of how heteronormativity marginalizes some heterosexual people, Black and Latina single mothers on public assistance, for example, I embrace the "bi directional" orientation of the "quare studies" framework offered by E. Patrick Johnson, which moves between "theory and practice, the lettered and unlettered, ivory tower and front porch" (2013, 112).

Aesthetics of Excess enacts a disidentificatory use of the term "queer," working against the ways it has been deployed to exclude struggles of race and class but maintaining its utility as a signifier of sexual, gender, racial, and class difference. It is used throughout the text to describe both hetero-sexual and lesbian participants. For example, the WOTR artists I engage in chapter 3 self-identify as gay, and I use that term in addition to queer to de-scribe them, not in an effort to efface their self-definition and bring them in line with what is viewed as a more progressive sexual identification, but as a way of linking them to a wider collectivity of homegrown sub/working-class gender, race, and sexual radicals.

Queer also describes how others view the Black and Latina artists I cen-ter in the book as nonnormative, whether they are understood to be bisex-ual, straight, or lesbian. I claim queerness in a manner similar to how I reap-propriate the discourse of excess as a productive force for Black and Latina girls and women. In so doing I follow Cohen, who proposes that the radi-cal potential of queer politics can be "located in its ability to create a space in opposition to dominant norms, a space where transformational political work can begin" (2013, 75). The book focuses on how various manifestations of queerness (sexual, gender, classed, racial) are embroiled in the sociocul-tural power struggles mediated by aesthetics of excess.

Aesthetics of excess can describe a wide range of phenomena. The par-ticular mode of excess I take up in this study is what I term "sexual-aesthetic excess." I offer sexual-aesthetic excess as a concept for theorizing modes of dress and comportment that are often considered "too much": too sexy, too ethnic, too young, too cheap, too loud (Hernandez 2009). Sexual-aesthetic excess identifies a field of visual perceptions, embodied performances, cre-ative practices, sociocultural discourses, and their attendant values. Sexual-aesthetic excess is a racializing discourse that correlates stylistic deviancy with sexual impropriety, and vice versa.

Beyond indicating a hegemonic trope or normative gaze that mediates sociocultural value, sexual-aesthetic excess also signifies instances in which Black and Latina bodies, both in the flesh and in representation, present styles that agitate the visual field and expose the malleability of social norms through their conspicuous embodiments (Fleetwood 2011). Embodied performances and creative practices that mobilize aesthetic excess embrace ostentatious styling, hyperfemininities and hypermasculinities, raunch, grotesquerie, camp, voluptuousness, glitter, pink, and gold.

The agitating and racializing force of sexual-aesthetic excess is exemplified in a hyperbolically negative review of artist Kehinde Wiley's work by *Village Voice* writer Jessica Dawson (2015) titled "What to Make of Kehinde Wiley's Pervy Brooklyn Museum Retrospective?" Written on the occasion of the artist's retrospective exhibition, *Kehinde Wiley: A New Republic*, in an awkward quasi-tongue-in-cheek/quasi-serious critical voice, Dawson sets out to undermine what she believes to be Wiley's undeserved status as a highly successful, respected, and popular visual artist. The writer, a white woman, rehearses the trope of the criminally hypersexual Black man in her argument that Wiley's career has benefited from the art world turning a blind eye to his alleged sexual perversity. She writes,

> But look closer at the 50-some objects—painting, sculpture, stained glass—in "Kehinde Wiley: A New Republic," and you'll see predatory behavior dressed up as art-historical affirmative action. Wiley's targets are young people of color who in these pictures are gussied up in the trappings of art history or Givenchy. Judging from Wiley's market and institutional success—in his fifteen-year career, this is his second solo at the Brooklyn Museum—Wiley has proven himself a canny operator seducing an art public cowed by political correctness and willing to gloss over the more lurid implications of the 38-year-old artist's production. (Dawson 2015)

The charge Dawson aims at Wiley is sexual predation upon the young Black men he recruits to pose for his paintings—paintings that quote masterworks of Western art history which exalt white men in power, such as Napoleon, and replace the figures with Black men (see figure I.2). The eroticism that some of Wiley's participants exude is read by Dawson as the result of a "casting couch method" targeted to "young Blacks from the ghetto." Dawson continues, "What Wiley and his subjects do behind the scenes may be none of our business, but his paintings kiss and tell. . . . In what world is

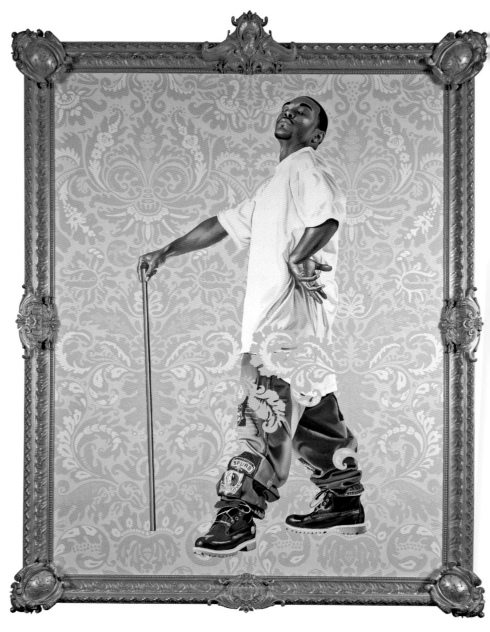

FIGURE 1.2. *Portrait of Andries Stilte II* © 2006 KEHINDE WILEY. USED BY PERMISSION.

a Yale-minted artist who lures young men into his studio with the promise of power and glamour not predatory?" (2015). Dawson's agitated response to Wiley's work ignores the long tradition in Western art history of nude models posing for a painter. In Dawson's view, when a Black man takes up the position of the visionary genius, his methods and intentions must come under scrutiny for potential criminality.

The unacknowledged subtext to Dawson's review is the fact that Wiley is a gay Black man. Thus, in her view, his paintings of feminized and erotic Black male bodies posed against an excess ornamentalism of flower patterns, voluptuous Black figures, and arabesques are the prurient products of his sexual delinquency—not complex representations of Black men's sexuality, so often framed in media representations as one-dimensionally hypermasculine. As Derek Conrad Murray notes, "Kehinde Wiley's images function as a corrective to the fetishistic logic, the thinghood, and the racist erasure of Black queer men from the field of representation . . . a response to the racial and sexual fantasies about Black men that lock them into a state of inherent inferiority" (2015, 110). By reading Wiley as a sexual predator, a "perv" and "perpetrator," Dawson is able to defuse the threat his work poses to the racist and exclusionary art world and to canonical art history. When Wiley poses Black men in positions of power that were once the province of white men, and with a baroque aesthetic of ornamental excess, Dawson feels compelled to contain the political work they perform by framing it as merely "affirmative action"—not a unique and significant artistic practice.

In addition to queer men of color, the bodies of working-class women and girls of color are subject to racialization through the discourse of sexual-aesthetic excess. For example, Latinas have been portrayed as "disorderly bodies" that are emotionally, corporeally, and sexually excessive. In analyzing the news coverage of Marisleysis González, the aunt of Elián González, a young Cuban boy who was at the center of a high-profile immigration and custody case in 2000, communications scholar Isabel Molina Guzmán (2007) notes that the focus on González's public crying, long acrylic finger nails, and formfitting clothes marked her as a brown, unlawful body that did not fit the framework of a proper U.S. subject. The mobilization of González's excessive body discursively unraveled the privileged, model minority status of Cuban Americans and helped to frame them as bad, disorderly subjects who held impassioned demonstrations on the streets of Miami following the decision to return Elián to Cuba.

The hyperbolic, stereotypical representations of Latinas as "forever tacky" (Rodríguez 2014, 3) in visual culture are measured against an imagined

white/middle-class construct of U.S. citizenship. Latina bodies are read as out of control, and thus queer, in the framework of normative embodiment. As Juana María Rodríguez notes, "We [Latinas] swish too much and speak too loudly. The scents we exude disturb the numbing monotony of straight middle-class whiteness. We point with our lips, flirt with our eyes, and shimmy our shoulders to mark our delight. Our racialized excess is already read as queer, outside the norms of what is useful or productive" (2014, 2). Black women and girls' bodies and sexualities are also marked by excess and occupy an untenable position in normative conventions of productive, respectable citizenship.

In her discussion of how Black girls were treated by staff at a homeless shelter in Detroit, Aimee Meredith Cox describes how the white woman director there believed that "acceptable bodies, like acceptable workers (especially line workers), were neat, contained, efficient, stripped of any excess (streamlined), and desexualized. . . . Visible pregnancies, large breasts, exposed midriffs, and wide hips in tight jeans were not only a personal affront to Camille [the director of the shelter] but, she implied, symbolic of what was wrong with the girls in the first place and partly to blame for their current situation of single parenting, and sometimes, their homelessness" (2015, 90). Cox argues that these readings are informed by the historical framing of Black femininity as materially, sexually, and physically excessive.[5]

As subjects who are marginalized and made vulnerable by their positions relative to race and gender, Black and Latina women and girls who embody aesthetics of excess are "thought to be morally wanting by both dominant society and other indigenous group members" (Cohen 2004, 29). For example, Saidiya Hartman notes the disapproval expressed by W. E. B. Du Bois in his sociological observations of young Black women in the early twentieth century, which informs how Cox's contemporary participants are perceived. Du Bois "bemoaned this tendency to excess, the too much, the love of the baroque; the double-descriptive: down-low, Negro-brown, more great and more better; the frenzy and passion; the shine and fabulousness of ghetto girls" (Hartman 2019, 117). The artists engaged in this book are the descendants of the Black women and girls Hartman (2019) poetically evokes in *Wayward Lives, Beautiful Experiments*, which documents how they augured radical formations of intimacy as they migrated to the urban centers of New York and Philadelphia. Like Hartman, I insist on an understanding of my participants as artists to recognize their creative labor in everyday performances of public body presentation and social media self-display, to their dedicated practices of painting, photographing, and sculpting.

Aesthetics of Excess focuses particularly on the ways in which self-styling, art making, and cultural production provide a means for expanding the possibilities of inhabiting inventive bodies that express subjectivity and freedom.[6] Although they are ridiculed, Latina chonga girls embody ethnic pride, sexual autonomy, and indifference toward assimilating to whiteness (see chapter 2). In spite of being subjected to harassment and gender policing, masculine-body-presenting Black and Latina young women find that their styles attract sexual partners and allow them to perform socioeconomic success and self-love (see chapter 3). Nicki Minaj's plasticized aesthetics reframe and reimagine Black women's embodiment by embracing artifice and rejecting respectability (see chapter 4), and girls' encounters with the hypersexual representations of women of color in the work of contemporary Black women artists inspire them to utilize artistic authorship to declare their corporeal and erotic self-determination (see chapter 5).

Through interviews with artists, participatory research with Black and Latina girls and young women, critical readings of art and popular culture, and storytelling autoethnography, *Aesthetics of Excess* argues that the styles embodied by women and girls of color are creative practices that trouble sexual policing and reveal class disparity. Since the bodies of women and girls of color are routinely subject to surveillance in public settings such as schools, workplaces, and working-class neighborhoods, they are especially subject to the violence of what Pierre Bourdieu (1984, 49) describes as "aesthetic intolerance," an aversion that demarcates social boundaries.[7] The racially marked hypersexuality that is ascribed to Black and Latina women and girls takes the fall for the class exclusions that cannot be acknowledged in a contemporary neoliberal context saturated with discourses of meritocracy and mobility. In a neoliberal society, legitimate personhood, or its denial, is determined via visibility and bodily readings (Ngô 2011).

Neoliberalism and Embodiment

Black and Latina women and girls' embodied aesthetics are subject to visual readings that tend to racialize them through denigration or celebration-as-appropriation. Deborah Paradez has noted "the unabashed self-fashioning of working-class women of color whose creative stylings, often derided as excessive, frequently serve as inspiration for mainstream trends" (2009, 45). Like Paradez, I find that the styles of working-class Black and Latina women and girls generate cultural and material capital when appropriated in art and media, while drawing mockery and censure in everyday contexts. Aesthet-

ics of excess are targeted for regulation when embodied by women and girls of color because they signify forms of class, gender, sexual, and racial difference that agitate normative discourses of respectability and social mobility. Conversely, when classified as art or appearing in mainstream popular culture, these aesthetics generate value as ironic, streetwise, and edgy.

In demonstrating the sociocultural processes that enable the traffic and value extraction of aesthetics of excess, this book expands the scholarship on the "racial workings of neoliberalism" (Woods 2007) by mobilizing a transdisciplinary and transaesthetic approach that assesses its gender and sexual politics. It is commonly believed in U.S. popular discourse that when women and girls dress in overtly sexual ways, they are viewed as "low class." I suggest that it is also the coding of class difference in the feminine and masculine body styles employed by Black and Latinx women and girls that racializes them as hypersexual.

My theorizing on aesthetics of excess is inspired by the class, gender, and racial appropriations and transgressions captured in *Paris Is Burning* (1990). The film documents drag competitions held by poor and working-class queer and trans people of color in New York City in the 1980s, which were organized around highly codified categories such as "butch queen" and "executive realness." The primary criterion that measured an effective performance in the ballroom circuit was the achievement of "realness," a body whose considerable crafting work in embodying a category could not be read on the surface. *Paris Is Burning* is the title of one of the drag competitions featured in the film, and it expresses the notion that the spectacular embodiments of the queer contestants involved would set the fashion metropolis of Paris on fire with their fierce inventiveness. I understand Black and Latina aesthetics of excess as setting neoliberal discourse ablaze by revealing the class, gender, sexual, and racial differences it occludes. One of the powers of sexual-aesthetic excess is that it makes class burn.

Paris Is Burning was filmed in the 1980s, when material consumption was intimately linked with status in a new and highly visible form, glorified in films such as *Wall Street* (1987). But today, thirty years later, the politics of consumption among elite populations in the U.S. looks dramatically different. The flashy cars and major-label clothing that once marked an insurmountable class divide are now more accessible to a broader public through increased credit opportunities and outsourced mass production. Thus, the status performance of the social group that Thorstein Veblen termed "the leisure class" ([1899] 2007), which flaunted status position through the possession of objects that had little use value, and thus were not purchased out

of necessity, has been replaced by the more modest consumer practices of what Elizabeth Currid-Halkett (2017) calls "the aspirational class ."

Currid-Halkett argues that, rather than displaying visible consumption of goods, acquisition of knowledge and awareness of social issues are the new markers of high status among upper-class and wealthy populations, who use their money to invest in their long-term life chances through spending in education, health, outsourced domestic labor (such as cleaning and child care), organic food, and yoga classes. Although income and luxury goods still hold sway as status markers, this new elite class is increasingly branding itself as such through cultural capital (Currid-Halkett 2017, 18). Yet consumer studies continue to find that working-class, middle-class, and sub-working-class populations of color purchase conspicuous luxury goods, such as jewelry, cars, and clothing, at a higher rate than white populations of the same socioeconomic groups (Charles, Hurst, and Roussanov 2007; Currid-Halkett 2017).

The explanations advanced for these differences often tell the story of how Black and Latinx populations, aware of how they are viewed in the dominant imaginary as criminal outsiders, utilize consumption as a means to demonstrate their socioeconomic success and inclusion. Such ideas are bolstered by data that show how "increases of mean income of one's own race in the state are associated with reduced visible spending" (Charles, Hurst, and Roussanov 2007, 4)—the idea being that once Black and Latinx populations achieve upper-class standing, the desire for conspicuous consumption declines.

Although these socioeconomic dynamics play a significant part in the consumer and aesthetic practices of Black and Latinx populations, the studies that provide the basis for such ideas are limited by a deficit-oriented perspective that juxtaposes the racialized working classes against monied white populations, as have-nots who are utilizing visible consumption in an instrumental fashion to achieve a defined social goal of inclusion. The consumer practices of Black and Latinx populations are portrayed in such studies as efforts toward securing social status, rather than, as this book argues, the actions of people compelled by erotic desires, aesthetic traditions, community belonging, or expressions of agency and resistance to white bourgeois norms of embodiment, style, and consumption. Perhaps, alternatively, one could conjecture that decreases in Black and Latinx spending on visual goods as they attain higher incomes stems from a related distance from one's community and proximity to less diverse, more elite spaces in which aesthetics of excess would be frowned upon and pose a liability to

membership, with the notable exception of figures like mainstream music artists, reality TV stars, and athletes who are often fetishized as commodities in and of themselves.

The shift of class politics from an emphasis on visible consumables to services that increase life chances stems from the increasing influence of neoliberalism on socioeconomic life over the last several decades. Neoliberalism is both a "political economic theory" (Harvey 2005, 2) and a wide range of market and political practices that gained traction in the 1970s and continue to dominate economic and social life in the U.S. and beyond. These theories and practices call for disinvestment in government social welfare programs and the deregulation of markets in the belief that people would be more liberated by "strong property rights, free markets, and free trade" (Harvey 2005, 2). This massive erosion of social welfare has produced structured insecurity and the maldistribution of life chances across populations (Spade 2015, 9). As a result, subjectivity and body presentation have become the work of self-branding (Banet-Weiser 2011).

Additionally, neoliberalism fails to deliver on its promise of engendering social equality via free market forces and instead promotes particular forms of racialized power (Woods 2007)[8]—namely, the marginalization, policing, deportation, and mass incarceration of populations of color who are viewed as unproductive subjects that weaken the national economy. These dynamics unfold via a discourse which denies that racism exists (Martinez and Rocco 2016). In negating structural inequalities and asserting that all individuals are potential entrepreneurs who can utilize the market for social mobility and wealth accumulation, neoliberal discourse occludes racial and class structures through circulating hegemonic narratives about the putative potential of overcoming one's given economic circumstances and "self-making" (Ramos-Zayas 2012). Such a discourse is especially salient in the U.S., a place in which class "is often held to have no meaning at all" (Harvey 2005, 31). The more rarefied forms of status performance operative today make it particularly difficult to acknowledge class differences, as these new elites appear to hold liberal political leanings, such as concern over the environment.

The decline in U.S.-based manufacturing that generated the service economy and increased value for cultural capital has resulted in the gentrification of working-class Black and Latinx neighborhoods by art galleries, high-end coffee shops, and restaurants. The minimalist industrial décor that pervades gentrified spaces, such as the slick, redesigned warehouses where people of color used to earn a living are now the markers of a new

class divide for folks who cannot afford rent or a five-dollar single-origin cold-brew coffee. Both industrial labor (in the repurposed warehouse) and racialized urban struggle become packaged as marketable throwbacks. The racialized sub–working classes are fetishized by the aspirational class, who read gourmet cookbooks with titles like *Thug Kitchen* and buy "crack pies" at high-end bakeries.

It is in this context that the body aesthetics of Black and Latina women and girls are viewed through a neoliberal lens that assesses how they succeed or fail in practices of self-branding that are thought to produce and reflect their productivity. These bodily readings are rooted in the history of Black and Latina women's racialization in the United States. Hazel Carby has analyzed how young Black women became the targets of social panic in both white and Black communities in the early twentieth century following the Great Migration, due to discourses circulating about their proclivity for engaging in prostitution as a way to avoid hard work in more traditional kinds of jobs. She argues that this discourse emerged from a fear of the new freedoms that migrant Black women found in urban settings, which resulted in acute surveillance of their bodies and sexualities (Carby 1992).

A similar panic over Latina bodies and sexualities also occurred in the early twentieth-century U.S., as young women donning zoot suits, known as *pachucas*, became the target of policing. In a World War II context in which austerity was viewed as an expression of patriotism, Mexican American youth who wore costly, flamboyant zoot suits made with copious amounts of fabric were perceived as immoral consumerists "participating in leisure activities, including *inactivity*" (Ramírez 2009, 58) and therefore as deviant citizens. By donning masculine zoot attire in addition to "up-dos, pencil-thin eyebrows, and dark lips," pachucas "distorted a look popularized by some of Hollywood's leading ladies of the time, such as Veronica Lake and Carol Lombard" (Ramírez 2009, 58). The pachuca's performance of gendered, class, sexual, and ethnic difference resulted in her surveillance and arrest by the Los Angeles Police Department during the Zoot Suit Riots and Sleepy Lagoon incident, in addition to the disfavor of members of the Mexican American community who, like the Black middle class to whom Carby refers, viewed these young women's body aesthetics as a threat to their social inclusion and respectability as hardworking citizens.

Ruth Nicole Brown's conception of booty capitalism is particularly salient for understanding how Black girls' bodies are hailed in the contemporary U.S. political economy. She describes how "booty abounds in the capitalist underpinnings of the United States as it currently exists. White

supremacy and heteropatriarchy, mediated by popular culture, sell an ideal body type: the big-booty Black girl. The premise is fairly simple: the bigger the booty, the more patriarchal protection and privilege one is promised to receive via heterosexual conquest. To be bootylicious, then, is to be read as sexually attractive and marriageable. The irony is Black girls are expected to have big butts yet reap none of the constructed and imagined benefits" (Brown 2013, 206). Neoliberal booty capitalism creates a double bind for Black girls. They are expected to embody the desired sexual excess of bootyliciousness, yet this performance does not result in the promised payoffs of heteronormativity. Instead, embodying bootyliciousness more often punishes Black girls in the contexts of education, employment, and social services.

In refusing or failing to self-brand in line with neoliberal conventions of productivity, bodies signifying aesthetics of excess have the power of unmasking realities of class stratification by signaling forms of class, race, gender, and sexual difference that are intolerable in the contemporary neoliberal U.S. nation-state. These bodies are then policed for the transgression of expressing (in)difference through discursive racialization as sexually and aesthetically excessive, and therefore deviant. In line with neoliberal discourse, these judgments are rarely articulated through rhetorics of class, but rather of style (Bettie 2003). But neoliberalism is not a totalizing formation — through aesthetics of excess, Black and Latina women and girls also embody and perform bootyliciousness for their own pleasure.

Charlas and Body Narratives

In producing knowledge about the art and politics of Black and Latina embodiment and sexualities, *Aesthetics of Excess* centers the collective and dialogical, drawing on my interactions with hundreds of WOTR artists as an instructor, in addition to semistructured group conversations I had with sixty-one participants throughout 2011–2013 at the facilities of WOTR partner organizations, such as Lifelines, which supports queer youth.[9] After its founding in 2004, I remained involved in WOTR in various capacities (program director, instructor, consultant) through 2015, when the project experienced a series of upheavals caused by the departure of the museum's longtime executive director and board members.

Artists are accustomed to working with me as a group through WOTR, and I emphasize the subtleties of their collective exchanges. These dialogues capture how they negotiate discourses of sexuality, race, gender, and

class through performative discussion of body practices: their own, those created by the women artists discussed in workshops, and those they consume in popular culture. Although girls have permission from their parents and guardians to participate in WOTR and in my research, they utilize the workshops as places away from family in which morals are relaxed, thus enabling the exploration of issues and ideas that may be considered taboo.

These group conversations are akin to Meredith E. Abarca's *charlas*: "The methodology of *charlas*, free-flowing conversations, creates a dialogue where unconventional fields of study, of knowledge, come together" (2006, 9).[10] The collaborative spirit of my informal group conversations with WOTR artists privileges multivocality and supports a power dynamic in which participants take active roles in the process, as opposed to the more stringent power relationship that attends one-on-one interviews. Esther Madriz (2003) describes how group discussions often escape the intentions of the researcher, as participants drive and deviate from the conversation. Such digressions, including disagreements among participants, moved me in unexpected and fruitful directions.

My charlas with participants produced what I call body narratives, stories about the experiences, desires, and memories of embodiment. These narratives appear in the book as extended portions of transcripts I excerpt in order to convey the tone of these stories to readers and evoke WOTR artists' unique voices and personalities. My discussions with artists prompted recollections of my own girlhood experiences, which I include in the chapters and interludes as autoethnographic reflections. Like artist Louise Bourgeois's spider women, we used the intergenerational space of WOTR to weave sticky webs of telling, of how we perform, negotiate, and theorize our embodied selves. Body narratives contain stories, icons, and lessons, some inherited and some we risk forging on our own, that shape our understandings of ourselves through aesthetics of excess.[11] When considering that the young women I work with bear the generational burdens of the transatlantic slave trade and colonial violence, "it would not be far-fetched to consider stories as a form of compensation or even as reparations, perhaps the only kind we will ever receive" (Hartman 2008, 4). Inspired by Saidiya Hartman's poetic narrations of Black girls' stories and of Deborah Willis and Carla Williams's (2002) practices of archiving and photographically documenting Black women's lives, the body narratives serve as an assemblage of text and image that evokes flesh and voice. In so doing they constitute a historical archive of twenty-first-century Black and Latina girlhoods.

The webs of storytelling that produced the body narratives were often spun while my participants' hands were busy at work on their art projects in WOTR. Many of the charlas that shaped the chapters of this book were sparked by offhand comments and spontaneous debates among participants during their active art making. This is the time in the workshop when the instructors are doing the least instructing. We make rounds in the room to comment on participants' individual progress or to provide some tips with technical aspects of the project, but ultimately, during art making is when participants become primarily responsible for shaping the tone of the workshop and, ultimately, what gets produced creatively. Therefore, the charlas, processes of art making, and images of work by contemporary women of color artists that catalyze it all are tightly knit together. The body narratives are thus oral, visual, and corporeal all at once. They are the products of aesthetic labor and relations between Black and Latina girls and women—artistic *chusmería*.

Aesthetics of Excess cannot communicate an unmediated portrayal of WOTR artists, but I work to maintain the integrity of what they shared. The girls are not objects of my observation but subjects, in the most complex sense of the term, who stimulate, challenge, affirm, and expand my thinking. I acknowledge them as critical interlocutors in the knowledge production process. Together we make art, ideas, and conversations over Krispy Kreme doughnuts, Flamin' Hot Cheetos, and sometimes tea and Bahamian coconut bread baked by my WOTR colleague and friend Anya Wallace. I honor what they have given me by sharing their creative genius, insights, and experiences.

Rather than providing evidence that helps us know young women of color, the body narratives show how young women of color know and how their knowledge can contribute new perspectives to artistic, cultural, and social knowledge and praxis. I am not so interested in articulating how real girls of color feel about the art and politics of Black and Latina embodiment, but in conjuring how they see and make sense of their own bodies and the bodies they encounter in WOTR and culture—on TV, smartphone, and computer screens, and in their daily lives. Talk among the girls, and in my charlas with the girls, has been mediated by cultural texts such as artworks, popular songs, and music videos that are displayed as part of WOTR praxis or are part of the worlds they bring to the space.

I had worked with participants through WOTR for over six months to one year prior to our semistructured group charlas.[12] Each group consisted of five to twelve participants, and the adult women who worked as casework-

ers or program facilitators would also join at times. The girls had the option of creating their own pseudonym to protect their identity, and if they did not want to create one or could not come up with one, I would create it. In several instances, I had the sense that a participant might have used a name associated with a social networking account, and in those cases, I gave them an alternate pseudonym.

All charlas and relevant WOTR workshops were documented with a voice recorder and later transcribed. I conducted textual analysis of the transcriptions for salient themes and critical commentary regarding body practice, race, gender, class, and sexuality in everyday life, art, and popular culture. In addition to discursive textual analysis of the transcriptions, I have listened to the discussion recordings several times to home in on affective expressions that escaped translation into words and communicated significant insights. At times, the space of the group was one of support among the girls, and at other times of tense disagreements; these dynamics attest to the complexity of the charlas as a research method and to the active roles assumed by participants in driving the discussion, notwithstanding my authoritative role as instructor/researcher.

The two-part semistructured group discussion first asked WOTR artists to describe what their ideal embodiment would be in detail (clothes, accessories, hairstyles, and body modifications, if applicable). I prompted them to articulate their ideal embodiment in order to examine the physical traits and aesthetics that they found to be the most valuable and desirable. Participants wrote descriptions and/or made drawings of their styles on index cards, and I asked them to share their ideal embodiments with the group if they felt comfortable doing so. The index cards were meant to help the girls remember the style they imagined when it came time for them to share. More importantly, utilizing the index cards slowed down the process of responding to my prompt, making it possible for girls to be thoughtful about the style they wished to craft, and to edit and revise their ideas. The index cards also provided me with a document to analyze after the charla had concluded.

When participants were finished with the index cards describing their ideal embodiments, which I collected at the end of the discussion, I asked them questions like, How would this look make you feel? What do you think this look says about you to a stranger walking by you in public? What do you think other girls your age would think about this look? How about other boys your age? Would your parents, caregivers, teachers like this look for you? Why/why not? Is this look inspired by the style of any celebrities? If so, who?

In the second part of the charla, I showed participants images of work by artists taught in WOTR, such as Nikki S. Lee, who draw from the style practices of young women of color, as well as images of pop culture figures, such as Minaj, who were inspirations for girls' styling practices. I also prompted them to comment on images of chonga girls and products related to chongas and Minaj, such as Barbie and Bratz mass-marketed dolls. The unscripted questions I posed to participants in this part of the discussion encouraged them to critically analyze the images and share their thoughts on how they felt the women and girls in these works were being represented, on the meanings of race, gender, sexuality, and class articulated in the images, and on whether the styles or products depicted were ones they would purchase and/or adopt.

Most of the sixty-one participants of the charlas were between the ages of thirteen and seventeen. The youngest participant was ten years old, and the oldest was thirty-one, as several youth-serving professionals participated in the study alongside the girls and young women with whom they worked. Eighteen participants identified as African American, and eleven identified as Anglophone and Francophone Caribbean with references to countries such as Jamaica, Haiti, and the Bahamas. Twenty-five participants identified as Latina or Hispanic, six identified as multiracial, with two naming themselves part Native American, and one did not identify with a race or ethnicity. It is not my aim to frame the insights of these participants as reflecting how young women of color in Miami generally feel about issues of body practice and representation. I work instead to situate the body narratives produced in the charlas within the spaces where I met and worked with the girls. Their responses should not and could not be generalized, but the wealth of insights they presented contribute unique perspectives that have rarely, if ever, been engaged in art history or feminist, sexuality, ethnic, critical race, and queer studies.

Chapter Overview

Chapter 1, "Reading Black and Latina Embodiment in Miami," situates the study within the history of ethnoracial formation and struggle in Miami-Dade County, Florida. In so doing, it raises questions regarding how a relational and comparative analysis of race and embodiment in Miami necessitates an examination of its underresearched gender and sexual politics to illuminate the social, cultural, and artistic workings of aesthetics of excess. Chapter 2, "Sexual-Aesthetic Excess," tracks the deviant figure of the

chonga girl through the realms of Miami folk discourse, popular media, and the elite contemporary art world. The discourses of sexual-aesthetic excess that circulate and congeal in these sites reveal the stakes of chonga embodiment and representation in negotiating the politics of class through debates over ethnicity, gender, and sexuality in Latinx communities and in the realm of cultural production more broadly.

Chapter 3, "Fine as Hell," contributes to research on gender performance and masculinity by centering the insights of Black and Latina young women who identify as gay and fashion masculine body aesthetics.[13] Through engaging their body narratives, I describe the corporeal and psychic pleasures, as well as social injuries, that attend their style practices—personal styles which, in the assessment of normative social discourse, are often construed as deviant masculine excess. I also note how, as revealed in a debate that occurred in WOTR regarding the embodiment of a masculine-body-presenting photographic participant of the Black queer South African artist Zanele Muholi, that the significations of trans embodiment contest the limits of both gender and aesthetic norms.

Chapter 4, "Rococo Pink," assesses the political potential of incarnating fakery for women and girls of color. I examine how the aesthetics of the ostentatious and hyperfeminine French rococo style has been mobilized in images of superstar rap artist Nicki Minaj, and I draw parallels between the critical denigration of the rococo in the eighteenth century with the contemporary vilification of her body. I close the chapter with a discussion of the exhibition and performance *Let's Talk about Nicki Minaj: A Rococo Side-Show/Salon*. The chapter argues that aesthetics of fakery are subject to critique because they disturb notions of racial authenticity, gendered sexual respectability, and established hierarchies of race, class, gender, beauty and sexuality.

Through turning to a more exclusive focus on WOTR praxis and pedagogy, chapter 5, "Encounters with Excess," documents how engaging participants in discussions about the sexual bodies figured in the work of contemporary Black women artists have activated spaces for them to analyze, critique, and/or affirm representations of racialized hypersexuality in art and popular culture. In particular, I explore how WOTR artists have responded to the work of Wangechi Mutu, Kara Walker, and Shoshanna Weinberger. Workshops based on these artists became sites in which girls theorized the heteronormative ways that men gaze upon women's bodies, articulated anger over the exploitation of Black women, exhibited shame when viewing artwork that explored sexuality, and expressed pleasure in crafting their

own representations of erotic bodies, which included works that utilized their own bodies as material. I also interrogate the panic I felt when a Black grandmother, along with her young granddaughters, attended a public lecture I presented on Mutu's use of ethnic pornography in her work. My reflections on that experience, along with WOTR girls' creative responses to the work of Black women artists, provoke consideration of the potential a feminist arts praxis that embraces sexual-aesthetic excess holds for opening spaces for Black and Latina girls to express self-determination and pleasure through encountering the hypersexual.

Last, the epilogue applies the book's argument to recent art world developments in Miami, and in contemporary museum politics more broadly, by telling the story of how the WOTR project itself became a commodity subject to appropriation by both corporate and elite art world entities. I close with a body narrative photo poem, inspired by the creative methodologies and practice of Ruth Nicole Brown (2014), to claim the power and futurities of aesthetic excess for Black and Latina girls and women.

I don't wanna have a rich life but I just wanna dress up and just look nice.
I love dresses, skirts, I love wearing jewelry, spraying perfume. I love things that sparkle.

My mom is in a very tight situation where she has to take care of an old lady and she only gets paid $500 every two weeks. And I ask for money to buy clothes and she can't give me the money, she can't at all, so I'm restricted to just literally this.

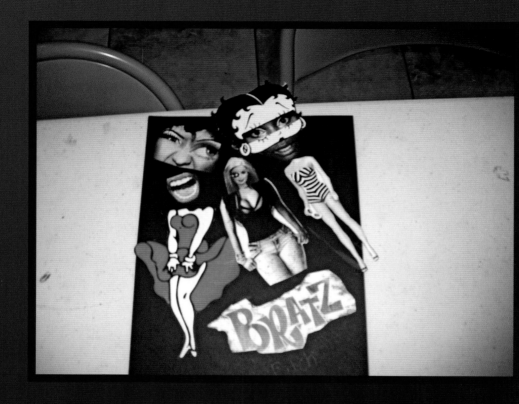

I have an aunt named Betty and she loves Betty Boop.

Me too my aunt loves Betty Boop.

What do you think older women might like about Betty Boop?
Like maybe when they were younger that was their Bratz or Barbie doll.

She's trying to be like sexy.

She sexy; She cute; She fly with her shit

Like she got an innocent face but—

HER BODY

Because they kinda wanna be like her, they like her style, she has her little hair going on, her little dress.

ONE

READING BLACK AND LATINA
EMBODIMENT IN MIAMI

Bundles of vibrant, animal-printed fabric are pressed together to form languid, abstract compositions in artist Nina Beier's series *Portrait Mode* (figure 1.1). In this particular iteration of the project, Beier collected clothing from local thrift shops near the Museum of Contemporary Art (MOCA) in North Miami and placed the garments in frames, transforming them into art pieces as part of an exhibition there in 2011.[1] The works prominently feature clothing patterned in animal prints because the artist observed that it was common among the women's sections in the thrift shops, thus reflecting the aesthetic sensibilities of the city that recirculates among the working- and sub-working-class Haitian and Latinx residents of North Miami, along with the hipsters and cultural workers (such as myself) who shop at popular thrift stores in the area like the Red, White, and Blue off 125th Street. Long associated with hyperfeminine, working-class sexuality and tackiness (think Peggy Bundy of the TV show *Married with Children*), leopard and cheetah prints are patterns embraced by women of color porn performers such as the legendary Vanessa Del Rio and contemporary Black women art-

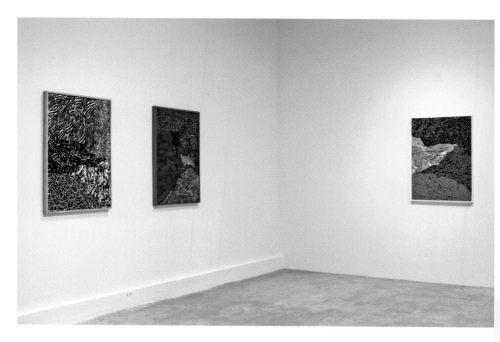

FIGURE 1.1. Installation view of *Portrait Mode* by Nina Beier in Museum of Contemporary Art, North Miami's *Modify, as Needed* exhibition, 2011. PHOTO BY STEVEN BROOKE.

ists such as Mickalene Thomas and Wangechi Mutu. Animal prints mark bodies via an aesthetics of excess, and excess is a style that is very much at home in Miami, an epicenter of conspicuous carnal and material overindulgence. In the Miami version of Beier's *Portrait Mode* project, these objects of quotidian dress are recognized as art.

Miami lends a significant context to this book, as it is the place where I engage Women on the Rise! (WOTR) artists, and where I have witnessed how the contemporary art world is enmeshed in body politics and the racialized class effects of gentrification. It is also the site where the aesthetic excess of my own body and those of WOTR artists are both policed and made possible.[2] As Fredo Rivera notes, Miami is an oceanic "borderland where excess meets precarity, where apparitions of luxury and neoliberal order encounter poverty, depravity, and ecological demise" (2019, 63). It is unique among many other cities in the U.S. for the manner in which sexual representations of women's bodies permeate the social landscape.

Although advertisements depicting eroticized women are common in cities throughout the U.S., in Miami, public space is heavily saturated with large billboards selling liquor and luxury items to tourists coming to enjoy the hedonist party culture of South Beach. Miami has been associated with vice in pop culture over the last several decades, and those vices often reference sexual activity with readily available women. As in other tropical spaces that attract tourists, the promise of an endless supply of exotic, bikini-clad women, in addition to buff and stylish gay men, is a marketing lure. South Beach, however, constitutes a very small portion of Miami-Dade County and is not the spatial context most residents navigate in their daily lives.[3]

In more working- and middle-class neighborhoods, a different mode of hypervisibility of women's bodies is at play. Along main thoroughfares that people use to get to and from work, one finds smaller billboards and bus advertisements that market body-shaping wear and aesthetic treatments for women such as Botox, breast enhancements, hair extensions, and butt lifts. Many of these ads utilize LED technologies, with their bright lights and animations competing for the attention of drivers and passersby (figure 1.2). They often market payment installment and financing plans that present these treatments as economically feasible for women with limited budgets.

Miami is marked by the visuality of booty and beauty, and all women and femmes are hailed by its address. Women are visible everywhere, but it is a glamorized, usually light-skinned cis Latina or white woman who is represented. These images do not reflect the working-class, poor, and unglamorous urban and suburban realities lived by many women and girls of color in Miami.

Despite the images of bronzed, fashionably dressed women depicted in pop culture representations and advertisements in Miami, the financial realities for many women are far from lavish. According to the 2010 census, the median per capita income of Miami-Dade County residents is $20,970, and the median household income is $40,000. Thirty-six percent of women-headed households live below poverty level, and 20 percent of all Miami-Dade County residents live below the poverty level. Thirteen percent of the population are unemployed, and 30 percent are uninsured. Life for the majority of Miami residents is a struggle to maintain working-class, sub-working-class, and middle-class status, and women fare significantly worse when they are single—and a growing number of women with children are.

This is the backdrop against which Miami has positioned itself as an epicenter of the contemporary art market, marked by the burgeoning estab-

FIGURE 1.2. Body contouring advertisement. PHOTO BY AUTHOR.

lishment of museums, galleries, and private collections in the late 1990s and early 2000s, and the hosting of the first Art Basel Miami Beach blue-chip art fair in 2002. As an international art fair originating in Basel, Switzerland, Art Basel has brought the global art market to Miami, prompting local artists to display themselves for its commanding gaze. Although Art Basel Miami Beach has generated considerable tourism and attracted a host of satellite fairs to the city, it has failed to establish a cultural life that is sustaining for local artists after the annual week-long extravaganza is over. In a *New York Times* story about the "unfilled promise" of Art Basel for Miami, such as the closure of influential galleries in the city like Perrotin, they report, "Several other leading galleries that opened in the wake of Art Basel's 2002 arrival have also shut down, while many of the city's most promising younger artists have decamped to New York and Los Angeles in search of greener career pastures" (Sokol 2014).

Local artists cite a lack of collectors and an overall dearth of substantial support for the arts as informing their decision to relocate. The young

artists who have left, such as Ali Prosch, Hernan Bas, Jen Stark, Bert Rod-riguez, and Friends with You, contributed to laying the groundwork for Mi-ami's reputation as a contemporary art center. It was also the labor of lo-cal artists that transformed poor and marginalized areas of the city such as Wynwood into popular cultural hubs. By embracing graffiti and street art through sponsored projects, Wynwood became a destination for locals and tourists that eventually turned toward a focus on consumption, such as high-end restaurants and shops that eventually raised the value of real es-tate, making it unaffordable for the artists and galleries who had established themselves there. In *Culture Class*, an examination of how artists have be-come implicated in processes of gentrification, artist Martha Rosler notes, "Although artists, flexible service workers, and 'creatives' more generally may not be the source of capital accumulation, it is inarguable that the ris-ing value of the built environment depends on their pacification of the city, while the severing of relations to class history—even of one's own family in many instances—has produced at best a blindness, and at worst an ob-jectively antagonistic relation, to the actual character of urban traditions of life and struggle" (2013, 177). The manner in which artists have been called upon to imbue sub/working-class spaces with value has resulted in their possible alienation from the communities they come from, in addition to that of local residents.

I recall WOTR artists commenting with surprise at the sudden popu-larity of Wynwood, as they noted how it was previously an area that many middle- and upper-class folks would avoid visiting due to public safety con-cerns. These girls lived close to the area, and were shocked that it was graf-fiti, of all things, that created the surge of interest and investment. In their experience, graffiti signals the urban class struggle that Rosler mentions and largely results in policing and punishment—not upward mobility and in-ternational recognition. Thus what cultural studies scholar Dick Hebdige (1979, 3) identified in the late 1970s as graffiti's power to "disfigure" social norms has become a key tool of sanctioned and sanitized urban remodeling, a process that the antigentrification activists in Boyle Heights, Los Angeles, are calling "artwashing."[4] It was clear to me in these discussions that the girls did not feel that they were a part of what was happening in Wynwood, despite their proximity to and familiarity with the area. In the end, the era-sure of working-class politics and ways of life brought about through art-driven gentrification has excluded both local artists and community folks. The WOTR artists' observations of Miami's gentrification stem from their particular racial locations in the city.

The 2010 census reports that 64 percent of Miami's population of 2.5 million residents are Latinx, and 18 percent are African American, thus making it unique among regions in the U.S. in terms of racial and ethnic profile, as people of color in Miami constitute an overwhelming majority. Miami markets its large population of people of color as exemplary of diversity, a "global city" (Yúdice 2003); yet racial and ethnic groups are highly segregated. Engaging Miami as a research site allows for an analysis of comparative and relational racialization that examines the social, cultural, and political implications of how populations of color are racialized and how they position themselves in relation to one another. This is especially pressing in a contemporary neoliberal order that utilizes mass incarceration to dismantle Black communities, is hostile to immigration, and pits racialized people against each other in the struggle to obtain jobs and social "benefits" that are becoming ever more scarce (De Genova and Ramos-Zayas 2003; Hong and Ferguson 2011; Ramos-Zayas 2012). Miami's stark racial-spatial segregation stems from the particular histories of the city and Florida more broadly.

Florida's history is marked by nineteenth-century struggles over the land by Spain and the U.S. government as they entered its rough, swampy terrain in attempts to capture Native Americans escaping settler colonial expansion and Black people fleeing chattel slavery in neighboring states. As Marvin Dunn notes, "Because it had been merely an outpost of the Spanish empire, Florida had escaped the destiny of a Caribbean sugar colony. And because it had remained in Spanish hands well into the nineteenth century, it also managed to escape the 'curse of cotton'" (1997, 70). Florida history unsettles conventional understandings of Indigeneity and Blackness in the U.S., as the Spanish authorities referred to the aligning groups of Black and Native people who resisted them collectively in the second Seminole War (1835–1842) as *cimaronnes*, runaways. The term "cimaronnes" later evolved to Seminole. As the Seminole Tribe of Florida (n.d.) describes, "The word was taken into the Maskókî language and, by the mid 1800s, U.S. citizens referred to all Florida people as 'Seminoles.'" The term now describes a tribe that includes descendants from Creek, Hitchiti, Apalachee, Mikisúkî, Yamassee, Yuchi, Tequesta, Apalachicola, Choctaw, and Oconee tribes, along with escaped slaves, who fought against and frustrated Spanish and U.S. forces that attempted to (re)entrench them into chattel slavery, displacement, and genocide.

During the second Seminole War, the Black press argued for Black interest in Native struggles as "editors suggested that the U.S. government had repeatedly betrayed the two communities. For example, they expressly employed the term *native* to describe both black North Americans and the 'Indians'" (Johnson 2012, 167). Yet this alliance between marginalized groups was not without its own racial power differentials, as some Native tribes also held Black people as slaves (Dunn 1997, 19).

Miami was first settled by free Bahamians in the 1880s, who established the town of Coconut Grove and worked in farms and the then-nascent tourist industry as inn staff. The presence of Bahamians and newly free African Americans generated a vibrant Black social life that developed over several decades and spread to other parts of the city. One major hub was Colored Town, later called Overtown, which had renowned cultural venues such as the Avenue that hosted performances by Cab Calloway and Billie Holiday. Yet capitalist expansion in the city, fueled by millionaire developers such as Henry Flagler, was driven to transform Miami into "a Mediterranean dream" for moneyed white citizens (Portes and Stepick 1993, 62). This prompted the development of railroads that fueled segregation as more white people settled in the area. The Ku Klux Klan arrived in the 1920s and was bent on realigning Miami's vibrant Black life with the racial modes of subjection more common in other southern states. By the 1960s, efforts to contain Black communities were furthered by large-scale expressway projects such as the building of I-95 that ran roughshod over neighborhoods like Overtown.

The mid-1960s saw the dramatic influx of Cuban immigrants fleeing the Castro regime, "diverting attention from Miami blacks during the crucial integration period" (Dunn 1997, 319). Most of these arrivals were light skinned and won the majority of public funding available to residents for business development (Dunn 1997, 319). Haitians also began arriving in South Florida at this time but, unlike the Cubans, they were often detained despite having political asylum status. Haitians were also denied forms of aid available to those classified as refugees, such as work permits and other forms of social welfare. Historian Marvin Dunn notes that unlike Miami Cubans' steadfast support for the early waves of Cuban refugees who arrived in the 1960s, "Haitians met outright hostility from some resident blacks" (1997, 322–323).

Such rejections of Haitians among other African diaspora communities in Miami stem from what Sara E. Johnson (2012) describes as the "fear

of French negroes" that emerged in the wake of the Haitian Revolution (1791–1804). Johnson points out that "Vodou's reputation as witchcraft in the minds of an extended American public was damning in and of itself. As tales of bloodthirsty slaves killing their masters circulated, the Haitian revolution was linked to tales of black magic and sorcery" (2012, 81). These historical framings of Haitian aberration were reified through stereotypes about Haitians spreading tuberculosis in the 1970s and AIDS in the early 1980s, after the Centers for Disease Control and Prevention announced that Haitians had increased risk for the disease. As a result, "Haitians were perceived to be not only disease-ridden, but also uneducated and unskilled peasants who could prove to be only a burden to the community" (Dunn 1997, 326).

The next marked wave of immigration to Miami occurred during the Mariel boatlift in 1980. Unlike the Cuban elites who fled the island decades earlier, Mariel refugees were denigrated by both the Castro regime and established bourgeois Miami Cubans. The Castro government framed the refugees as trans and homosexual perverts and/or deviant criminals, and many were treated as such when they arrived on U.S. shores (Capó 2010). The lower socioeconomic positionalities, queerness, and phenotypical Blackness of the *marielitos* also spurred their rejection by established, white-identifying Cuban American communities.

In their landmark study of racial tensions in Miami, *City on the Edge*, Alejandro Portes and Alex Stepick cite a Cuban American official of the city of Miami who commented in 1983, "Mariel destroyed the image of Miami itself for tourism. The *marielitos* are mostly Black and mulattoes of color that I never saw or believed existed in Cuba. They don't have social networks; they roam the streets desperate to return to Cuba" (Portes and Stepick 1993, 21, emphasis in original). The rejection of Afro-Cubans in established Cuban enclaves in Miami led to their settlement in historically Black neighborhoods such as Liberty City.[5] By erasing Afro-Cubanidad from the social imaginary and representations of Cuban exiles (save for tropicalized, sanitary representations in entertainment, embodied in such figures as Celia Cruz, whose Blackness was mediated through an unequivocally anti-Castro stance), Cuban migrants were, as Portes and Stepick argue, not racialized as an ethnic group but rather integrated into the U.S. social fabric as an "ally in the [anticommunist] fight for Cuba and Latin America," thus granting them model minority status (1993, 29).

Portes and Stepick have accurately observed that "Little Havana and Liberty City, the largest Black area of Miami, are scarcely two miles apart; so-

cially they could be in different countries" (1993, 39). It was such segregation and struggles over what Gaye Theresa Johnson (2013) terms "spatial entitlement" that erupted in the 1980 McDuffie race riot in Liberty City, which began on May 17, prompted by the acquittal of Miami-Dade County police officers in the beating death of Black insurance worker Arthur McDuffie by an all-white jury in Tampa, Florida. The riot lasted four days and resulted in eighteen deaths.

Unlike the Zoot Suit Riots of 1943 in Los Angeles, which made both Latinx and Black men the target of white military men's violence (Alvarez 2008), Miami's race riots exposed the violent fractures between Black and Latinx communities. Dunn notes, "Miami's sudden explosion reminded the nation and the world of the fragility of race relations in the United States. The riot destroyed Miami's newly acquired reputation as the rising star of the Western Hemisphere. The city was declared in the national press to be the most racially torn city in the country. In the aftermath of the riot and with the arrival of thousands of immigrants from Cuba and Haiti, the city emptied itself of its white population" (1997, 246). In describing the aftermath of the riot in a 2016 retrospective article, the *Miami Herald* wrote that the "city was scarred" (Johnson 2016). Additional riots followed in 1982 and 1989, sparked first by a Latinx police officer killing a young Black man, and then seven years later after the officer was eventually acquitted in the trial.

The early 2000s saw a powerful response to Miami's racial and class inequalities. In October 2006, a collective of residents, homeless people, and activists occupied a vacant lot in Liberty City, on the corner of Sixty-Second Street and Northwest Seventeenth Avenue, and called it Umoja Village. The village, which organizers viewed as a "living protest," provided living space and a communal organizing structure with a social justice agenda that was against gentrification and for affordable housing for residents displaced and made disposable by Miami's hypercapitalist real estate market. As the village grew more established and prepared to unfold a plan for consolidated living arrangements and a sustained response to gentrification at its six-month anniversary, it was burned to the ground under suspicious circumstances (Rameau 2012). Life in Miami has been and continues to be a racialized struggle over spatial entitlement, and the significations of the body carry the marks of racial, and therefore spatial, belonging.

But how did gender figure in these dynamics? While the historical literature on race relations in Miami alerts us to the scarring caused by Latinx men aligned with the white police state killing Black men, we do not have such stories of violent relations between Black and Latina women in the

city. This is not because there has been harmony, but rather because these struggles occur in gendered contexts that garner less attention yet are no less insidious, as we scar each other through intimate readings of our body aesthetics. The stories of Black women's experiences of the Miami riots go untold and Latinx women's complicity in the violence go unremarked upon.

In *Queer Blacktino Performance*, E. Patrick Johnson and Ramón Rivera-Servera (2016) bring Blackness and Latinidad together through referencing sexual relations and queer spaces forged between Black and Latinx men, but the intimacies they describe are not mirrored in the embodied relations between girls and young women in WOTR. Rather than the racial erotics of desire described by Rívera-Servéra and Johnson, the relations among my Black and Latina participants are shaped by and often provoke racialized-gendered harm, as they read difference-as-deviance on each other's bodies through aesthetics, which become coded through tropes of bad hygiene, bad taste, or overall "extraness." These dynamics are more akin to the class, gender, race, and sexual tensions that Rívera-Servéra engages in his book *Performing Queer Latinidad*, which he terms frictions: "Friction is central to our understanding of these dynamics as it reminds us that cultural exchanges demand adjustments, involve appropriations, and incite conflicts that are formative and simply routine to cohabitation" (2012, 202). The negotiations of embodied aesthetics that unfold in the chapters that follow undercut these historical silences to expose the friction between Black and Latina women and girls that bubbles hotly on the spectacular surfaces of their bodies. And next we turn to working out what meanings are carried by "Black" and "Latina" in a Miami context.

Black and Latina in Miami

Through my work with WOTR, I have always been struck by how most of the girls I encountered through community organizations who partner with the project are Black, when the population of Latina girls in Miami is considerably larger. The racialization of Black girls in the minority-majority city has situated them in communities that are more heavily policed, with increased state and nonprofit intervention in the lives of residents. Thus, I learned firsthand how an ethnically and racially diverse social space can nevertheless replicate the anti-Blackness that is also found in more homogenous cities in the U.S.—let us recall that Trayvon Martin was murdered by a Latinx man in South Florida in 2012.

Crystal Pearl Molinary, *Habana Riviera*, 2011.

It is this context that leads me to frame this study through a lens of Blackness and Latinidad, rather than what would appear to be a more expansive framework of Black and Brown or women of color, as these terms would unwittingly occlude more than they would illuminate about the ways Black and Latinx people live their bodies in relation to one another, particularly in sites like Miami. Recognition and respect among Black and Latina women and girls are offered or denied through what tend to be rather aggressive bodily appraisals, as I have observed in WOTR and in my everyday life in the city. Carrying a Black and Latinx body as a girl and woman is a heavy burden in the U.S., but the chapters that follow show that the uniquely competitive atmosphere of inter- and intra-Black and Latinx social positioning in Miami considerably raises the stakes.

This dynamic played itself out rather dramatically in the fallout I experienced after circulating Miami-based Cuban American artist Crystal Pearl Molinary's photograph *Habana Riviera* (figure 1.3). The work is part of a series of photographs titled *Then Again* (2011–2012), where Molinary recreates photographs of her mother, who was a model and renowned *vedette* performer in 1960s Cuba, with her own body through images she captured during visits to the island in 2011 and again in 2012. *Then Again* is a meditation on time, nation, identity, and the gendered pressures of familial expectations, as she quite literally measures herself up against her mother's body.

In *Habana Riviera*, Molinary and her mother are situated in the same outdoor, poolside area of the iconic Habana Riviera hotel. Despite the fact that

these photographs were taken several decades apart, the manner in which they reveal the passage of time is surprisingly subtle, due to Cuba's particular temporality in which the antique remains the contemporary. The only indicators of change are coded by the vintage patio table in the background of her mother's modeling shot, and the new tropical landscaping in Molinary's more recent image. The heels and panty hose Sonia Perla Gil wears with her bathing suit contrast with her daughter's plastic flip-flops. I selected the image for the promotion of a lecture series I organized in Miami in 2012 called Latina Women and the Body because of its multilayered evocation of history, exile, and diaspora in relation to Latina embodiment that are particular to the Miami context and crafted by a local Latina artist. But I never anticipated the controversy that would arise from circulating it.

Latina Women and the Body aimed to generate a public forum. Scholar Myra Mendible (2007) discussed historical representations of Latinas in Hollywood; professor Dionne Stephens presented her research on how the politics of skin color affect Latina identity formation (Stephens, Fernández, and Richman 2012); and Crystal Molinary and I presented a panel titled "Making Art Out of Excess: Exploring Latina Styles and Sexualities." Molinary discussed how her photographic work is inspired by the ornate body aesthetics crafted by Cuban women both on and off the island, and I talked about the media and art world representations of young working-class Cuban American girls in Miami, pejoratively called "chongas" for their perceived over-the-top styles of conspicuous makeup, gold hoop earrings, and elaborate, gel-sculpted hairdos (the subject of chapter 2). The series was held at MOCA in North Miami with cosponsorship from the Women's Studies Center at Florida International University in Miami, my undergraduate alma mater. At the time, I was working at the museum running WOTR while also conducting research for my dissertation. I collaborated with the museum's graphic designer to create the promotional material for the event, and selected the *Habana Riviera* image that juxtaposes Molinary's body with that of her mother, Sonia Perla Gil, in one-piece bathing suits.

Several days after the postcard invitation for the lecture series was sent out to the museum's mailing list, I received an urgent message from the director, alerting me that a major Cuban American donor and supporter of the museum had called her to express outrage that such a "demeaning" image was circulated to thousands of museum supporters. The donor pulled funding for an upcoming event and threatened further repercussions for the institution if the image was not removed from the museum website immediately.

The issues the donor cited with the photo on the invitation were how it highlighted the women's sexuality, and that the word "Latina" was used in the program title, rather than Hispanic—"Hispanic" being a term they felt more appropriately described themselves and the Latinx community in Miami. The donor suggested that I had a political agenda in selecting the image and framed me as reckless, damaging the Hispanic community through the circulation of this "demeaning" representation. The museum capitulated and replaced *Habana Riviera* with another image from the *Then Again* series that was less revealing of the women's bodies, as they are pictured submerged underwater in the Habana Riviera's swimming pool.

The Cuban American museum donor's view was echoed by many followers of MOCA's Facebook page, who admonished the institution for highlighting Latina "ass" in the promotional image and thereby reifying harmful stereotypes. This position was also shared by senior administration officials at Florida International University, including a white feminist dean who had formerly directed the Women's Studies Center. In response to a flurry of emails sent by the head of university external relations stating that the "degrading" postcard was embarrassing the university through the posters on display around campus, the dean asked why I decided to choose an image that shows a Latina wearing an "ill-fitting" bathing suit.

These resounding critiques did not end with the circulation of the promotional graphic, as days after Molinary and I presented the "Making Art Out of Excess: Exploring Latina Styles and Sexualities" panel, our colleague Dionne Stephens was contacted by an influential contemporary Latino artist from Miami who was in attendance. He requested an audience with Dr. Stephens to discuss how he felt Molinary and I failed to critique Latina aesthetic excess for its collusion with racist and sexist stereotypes and consumerism. He cited my body comportment during the panel (such as "playing with" my hair) as evidencing my problematic, not-Latina-feminist-enough gender politics, which he framed as potentially "disempowering" the girls and young women with whom I engage in visual arts projects.

The lecture series was well attended despite these criticisms, attracting hundreds of community members, artists, and scholars. Although it generated meaningful dialogues among the speakers and audience members, these negative responses stayed with me. Suffice it to say that I was overwhelmed by the attacks on the program at multiple levels, and particularly how the bodies of Crystal Pearl Molinary and myself were brought into their sweep and framed as signifying a misfit and illegitimate Latinidad.[6] Two years later, Molinary and I collaborated on a photographic project titled *Ill*

FIGURE 1.4. Body-shaping advertisement. PHOTO BY AUTHOR.

Fitted, inspired by the girdle and body-shaping underwear advertisements targeted to women that are ubiquitous in Miami's working-class Latinx neighborhoods (figure 1.4).

Our stiff and affected poses in the piece mimic the images found in *faja* (girdle) circulars and are arranged in a grid composition to generate an echoing pattern (figure 1.5). The project pokes fun at the flagrant gender politics of the advertisements, which promise corporeal perfection via butt padding and waist cinching, while also highlighting the odd poetry of their aesthetics.[7] We exhibited the piece in 2014 at Space Mountain, an alternative art space in Miami, and gave it the title *Ill Fitted* as a way to play upon the notions of misfit and unacceptability we were subjected to through the "Latina Women and the Body" fallout in addition to the slang meaning of "ill" as cool or dope. Working-class Latinas create art with their bodies even within the most rigid social structures—we exceed them. The debates that Molinary's *Habana Riviera* photograph ignited are reflective of Miami's specific

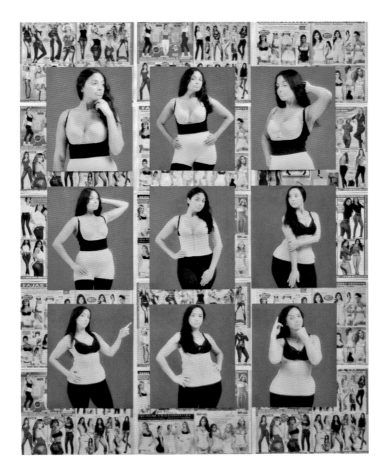

FIGURE 1.5. Crystal Pearl Molinary with Jillian Hernandez, *Ill Fitted*, 2014.

conditions for art making. As Fredo Rivera observes, "Cultural production in Miami is not merely a process of transculturation or hybridity: it can, as well, be a violent, messy, and oversexualized clashing of contradictions. Cultural and artistic expression is also varied and ambiguous, a manifestation of the city's overlapping Latinities. Art and culture reveal a border with which we create New Worlds" (2019, 69).

Upon reflecting on the controversy, I found that critics of *Habana Riviera* were implicitly endorsing what they believed to be a more tasteful image of Latina femininity that drew from a classed, white ideal of thin, flat-assed, feminine embodiment—free of things like cellulite and divorced

from the history of sexual Latina body presentation, like the tropicalized performances of Sonia Perla Gil in Cuba (figure 1.6). Gil's vedette body is linked to the history of Cubana representations in Latin American cultural production such as Golden Age Mexican *cabareta* films like *Victimas del Pecado* (*Victims of Sin*) (1951), which featured Cuban *rumberas* like Ninón Sevilla to signify Afrolatinidad (without Black skin) as a uniquely Caribbean (and thus not Mexican) phenomenon. These representations, often pairing voluptuous light-skinned Cubanas with more dark-skinned, matronly Afrolatina costars like the legendary Cuban actress Rita Montaner, suture Latinx femininity to discourses of Black hypersexuality through tropes of the tragic *mulata* whose gendered downfall is caused by her toxic and uncontainable eroticism, visually signaled by the aesthetic excess of ruffles and sequins on her outfits. Rather than through skin color, the curves of Sonia's and Crystal's shapely buttocks indexed a tacit yet nonetheless intolerable Blackness to critics, thus highlighting how debates around respectability in representation play a major role in determining the meanings and formations of Blackness, Latinidad, class, sexuality, and gender.[8] As artist Lorraine O'Grady notes, "The female body in the West is not a unitary sign. Rather, like a coin, it has an obverse and a reverse: on the one side, it is white; on the other, non-white or, prototypically, black. The two bodies cannot be separated, nor can one body be understood in isolation from the other in the West's metaphoric construction of 'woman.' White is what woman is; notwhite (and the stereotypes not-white gathers in) is what she had better not be" (2002, n.p.). The gendered colonial representational history O'Grady refers to has linked Blackness to tropes of aesthetic excess, a discourse and constellation of practices that visually racializes and genders, and thereby attributes differential value to Black and Latina bodies as a form of class politics.

These are aesthetics that Sonia, a light-skinned recent Cuban immigrant and manicurist I met when I frequented a small beauty shop in North Miami, was pressured to reject. Knowing that I appreciate intricate nail designs, every time I met her for an appointment she would show me new styles she developed or learned through photographs of her clients' hands that she had captured with her smartphone. One day, as she was applying topcoat to my nails to gloss and seal the flower designs she had crafted in black polish to stand out against the bright yellow of the base color, she sighed and told me that she wished she could experiment with her nails as I did. Sonia explained that her husband, who is also a light-skinned Cuban, associates brightly colored nail polish and complicated nail designs with the

La Calle

Sonia Perla Gil

PROHIBIDO EN TELEVISION

Por ORLANDO QUIROGA

• EL "ESTRADA PALMA" está presentando la tercera revista de Rodney, "Prohibido en Televisión", esta vez con una figura de categoría internacional: Armando Oréfiche... VAMOS a señalar algunos defectos de esta presentación, que no sabemos si son debidos a que la vimos el primer día, el terrible primer día que los artistas llaman "ensayo general"... POR EJEMPLO, Oréfiche no debe permanecer en la semi-oscuridad mientras las coristas son alumbradas; Oréfiche no debe tener un piano corriente, con el reverso de tablas frente al público, sino un piano de cola; Oréfiche, aún siendo Oréfiche, no puede resistir siete canciones consecutivas: deben ser, cuando más, cuatro, permaneciendo, claro, la preciosa "Bajo la Luna"...

• AHORA VAMOS A LOS ELOGIOS: Sonia Perla Gil es un precioso adorno para el espectáculo, con su fina figura de porcelana. Ella tiene ese resplandor interno del que están hechas las verdaderas estrellas. El refinamiento y la experiencia que está adquiriendo confirmarán esta afirmación... ALICIA FIGUEROA es otro adorno, utilizado además en el vodevil-parodia de "Estrellita", donde los que se roban el "show" son Nora Ossorio, como la inválida Angelina (una inválida que baila la pachanga, en esta versión de Núñez Rodríguez), y América Castellanos, en el rol de la criada que se mete e ntodo... ONIX MORERA levanta una ovación con sus hilarantes imitaciones de Xiomara Alfaro; Lucy Fabery y Olga Guillot, "dramatizadas" con sus repentes apariciones en los lugares más imprevistos del teatro, y que siempre terminan con la intervención del "director de escena", Alejandro Lugo... ONIX no es una revelación: ya es una fuerte estrella cómica...

• LOS "COMERCIALES" tienen altos y bajos: algunos son muy agradables (como el de los vinos cubanos, con la Ossorio en una fabulosa bata cubana) y otros caen en el mal gusto... LOS BAILABLES de "Bajo la Luna" y el "Caramelito", son de gran efecto, que llega al clímax en el "Sun Sun Babaé", uno de los triunfos memorables de Rodney en "Tropicana"... MARTA Y EL CHECKIS tienen una trepidante rumba, y prueban otra vez que pueden salir a bailar a cualquier país del mundo y gustar. Elena del Cueto hace un número sexy con el Checkis, con esa ausencia refinada que en otra bailarina sería un handicap, pero que en ella es arte y una marca de fábrica... FELO BERGAZA domina el piano con su categoría de siempre, y las luces están muy bien empleadas... EN FIN, "PROHIBIDO EN TV", con sus defectos y sus muchas virtudes, es un espectáculo carísimo que, asombrosamente, se presenta a precios normales. Un punto de atracción en La Habana de noche...

FIGURE 1.6. Clipping of Sonia Perla Gil featured in the Cuban publication *La Calle* in 1960. IMAGE COURTESY OF CRYSTAL PEARL MOLINARY.

Black Haitian women who frequent the beauty shop. He does not approve of her wearing such styles because of this racial association. He urges her to be more natural and "classy."

Sonia's position in the aesthetic and political economy of gendered body practice is mediated by constructs of race and class. Her husband wishes to dissociate his light-skinned Cuban wife from the aesthetic excess of Black Haitian women's bodies, and she is in the position of complying with his wishes due to her dependency on his income, as hers is a low-paying, culturally devalued aesthetic job.[9] The politics of race value Cuban immigrants racialized as white over Haitian immigrants imagined through a threatening Blackness, which results in the affording of asylum and citizenship to Cubans, while Haitian refugees face racism, detention, and deportation. Working-class immigrant women like Sonia are foreclosed from certain modes of self-fashioning in an attempt to leave intact one of their few privileges, light skin. Meanwhile, the Black girls and women who innovate and embody these aesthetics do so under the constant peril of negative social judgment, harassment at school, decreased employment opportunities, and physical harm. Thus, I am not suggesting that aesthetics of excess always presents a liberatory visibility, but that perhaps it could be understood as a dangerous practice of freedom (Pierce 2017).[10] This practice rejects the aesthetics of respectability and instead "bedazzles the scars" of racialized gendered subjectivity and relations between Black and Latina women and girls (Wallace 2018).[11] As a second-generation, light-skinned Latina with a graduate degree, I was buffered against the risks associated with ornate nail designs and thus able to assume them. Sonia's body narrative reminds us that the aesthetics that constitute a form of elite art production for contemporary artists like Nikki S. Lee, parody for the "Chongalicious" performers, and self-expression for subjects with access to educational and cultural capital like myself are made possible by the abjection of other bodies. For Latina women with such privileges, there is always the threat of making an aesthetic misstep and veering toward Blackness, and thus becoming "ill-fitting." As O'Grady observes, "It is the African female who, by virtue of color and feature and the extreme metaphors of enslavement, is at the outermost reaches of 'otherness.' Thus she subsumes all the roles of the not-white body" (2002, n.p.). Perhaps this is why even a monied Cuban American art donor felt threatened by the excess visualized in Molinary's photograph. By protesting the use of the term "Latina" instead of "Hispanic" in the lecture series materials, she was attempting to secure her whiteness. As Daphne V.

Taylor-García notes, "A claim to Spanish lineage mitigates against abject blackness" (2018, 60).

In an important intervention that situates Cuban artist Ana Mendieta's work within a framework of Blackness and coalitional racial politics, Leticia Alvarado reminds us that upon arriving in the United States through the Operación Pedro Pan program that placed exile children in foster homes in the early 1960s, Mendieta was harassed by white people in the midwestern communities where she was placed as a "nigger." Through embracing corporeal abjection, Blackness, and relational coalitions among racialized women as an aesthetic and political strategy through her performance and curatorial work, Alvarado argues that Mendieta's practice "prompt[s] us to move beyond a politics of liberatory visibility which is often paired with aesthetics of respectability" (2015, 82). Alvarado offers instead that "abjection, as an aesthetically based political strategy, can serve as the basis for addressing political injustice, invoking broader collectivities beyond conventional identity categories even as we remain attuned to the particularities which create the abject realm" (2015, 82).

As subjects who are seen through a racialized, classed, and gendered lens of abjection, Black and Latina women and girls, through aesthetics of excess, make ornamental and artistic the experiences of being seen as ugly in relation to white femininity. As neoliberal white supremacy and Latinx aspirations to whiteness undermine coalition building between them, Black and Latinx women and girls are forced to do the dirty work of inflicting such racial wounds upon each other as a result of what Afrolatina artist and cultural theorist Zahira Kelly (2016) terms "Baina Colonial." Baina Colonial is the colonial bullshit that places Black and Afrolatina women in the bull's-eye of racialized gendering through both spectacularization as exotic sex objects, and wholesale cultural erasure. The differential gendering and colorism that made my mother the target of Black girls' violence in her Bronx high school in the 1970s due to righteous anger over the social privileges afforded to her through her light "Spanish" skin shaped the anti-Blackness that compelled her to tell me that a Black girl who pulled my hair in elementary school did so because she was jealous of my "good hair," and that I needed to respond violently in turn. This is Black and Latina scarring. The only people we can access to make pay for our pains is each other through shaming, rejection, and physical violence.

For example, Zahira Kelly's social media commentaries on the pervasive anti-Blackness and colorism in Latinx communities are often met with at-

FIGURE 1.7. Zahira Kelly, *Baina Colonial Comic #3*, 2016.

tacks by other Latinas accusing her of reverse racism by claiming a Black rather than mestiza identity. Alternatively, others argue that all Latinas are Afrolatina, and thus that her attention to issues of colorism is unwarranted and divisive. These responses are illustrated and critiqued in Kelly's *Baina Colonial* comic (figure 1.7). The subject position of Afrolatinas is so threatening to the Latinx and Latin American social order that it appears unavailable and therefore unnecessary and invalid. Thus, many Afrolatina girls I worked with through wotr would describe themselves as mixed or biracial, rather than Afrolatinx (not a single participant I ever worked with described herself as Afrolatina).

As Kelly's comic illustrates, Afrolatinas are often placed in a bind of disavowal, their experiences of gendered racialization either erased under discourses of *mestizaje* and Latinx racial inclusion, or viewed as not authenti-

cally Black in the Black/white U.S. cultural imaginary. This phenomenon recently played out following the skyrocketing success and visibility of Afrolatina rapper Cardi B, who has had to defend her Blackness in interviews where her identity as a light-skinned woman of Dominican and Trinidadian descent was called into question. In her responses to such questions she has stated,

> We are Caribbean people. And a lot of people be attacking me because they feel like I don't be saying that I'm black. Some people want to decide if you're black or not, depending on your skin complexion, because they don't understand Caribbean people or our culture. I feel like people need to understand or get a passport and travel. I don't got to tell you that I'm black. I expect you to know it. When my father taught me about Caribbean countries, he told me that these Europeans took over our lands. That's why we all speak different languages. I expect people to understand that just because we're not African American, we are still black. It's still in our culture. Just like everybody else, we came over here the same fucking way. (Zendaya 2018)

By referencing shared histories of slavery and colonialism, Cardi B situates her Afrolatinidad as a diasporic, or what Sara E. Johnson (2012) calls "transcolonial," formation. As E. Patrick Johnson and Ramón Rivera-Servera state, "While the black Atlantic slave trade inaugurated a nonvoluntary diaspora, one by-product of that event was not only the syncretic process of African and Latina/o American cultures, but also the queering of the Atlantic itself" (2016, 4). This also supports Taylor-García's call to disturb conventional area studies formations, as their geographical frameworks do not adequately account for transcolonial histories. Taylor-García (2018, 8) activates "the viceroyalty of New Spain" as a term in her analyses of gender, class, race, and coloniality to attend to how the territories of the viceroyalty, which included Florida, Mexico, Central America, and the East and West Indies, among others, have a shared history of Spanish colonization despite their specific cultures.

Aesthetics of excess are the classed/racialized/gendered by-products of transcolonial conquest. Decades of sexual relations between white men and Black housekeepers on Caribbean islands where European women were absent, Omise'eke Natasha Tinsley has noted, "at once institutionalized and domesticated slavery's social imbalances, embedding them in the realm of the intimate in ways that partnerships between slaves could not" (2010, 12). Tinsley (2010, 13) observes that free women of color eventually outnum-

bered white men, white women, and free men of color. This unsettling formation to the planter colonial state resulted in the creation of sumptuary laws aimed to curb the new freedoms of women of color. Such laws aimed to keep them "from being classed too closely to white ladies but also legally restricted their ability to be gendered like them, ensuring that the latter's femininity never looked or sounded like the former's (even if they attracted the same sexual partners). . . . They carefully mythologized a split between the luminous attraction of white ladyhood's receptive femininity and the glittering seduction of brown womanhood's aggressive voluptuousness" (Tinsley 2010, 13). In other words, these were legal efforts to contain their aesthetics of excess. Artist Firelei Báez, a Dominican Republic–born artist of Haitian and Dominican parentage, explores these aesthetic politics in her practice. In works such as Sans-Souci (2015) (figure 1.8), she references the tignon law established by the Spanish governor of Louisiana in 1786 that forced women of color to cover their hair, as it was believed to attract the attention of white men, diverting their gazes from white women. In response, the artist states, women of color "started making the most beautiful headdresses imaginable, to the point where they became the fashion in Europe" (Báez 2015). In Báez's work, the elaborate ornamentation of the tignon takes on a life of its own, expressing the subjectivity of the figure, whose facial features are obscured save for her arresting gaze. Black and Latina women and girls transform transcolonial prohibitions into raw material for aesthetic innovations, which then become appropriated Euro-American trends.

Thus, the framework of Blackness and Latinidad that operates in this book is a diasporic, transcolonial one, as the WOTR artists I engage are primarily from the Caribbean.[12] But rather than attempting to conjoin the terms "Black" and "Latina" into something like Blacktina, or use "women of color" or "brown" as a thematic, it is necessary to reflect the ongoing debates in popular culture, such as Nicki Minaj's claim that Cardi B has made anti-Black statements, other Black women on social media pointing out that Cardi B benefits from her racial ambiguity, and how WOTR participants and artists like Zahira Kelly and Firelei Báez situate themselves within the debates, by keeping these terms in productive tension.[13] Black and Latina are not discrete entities, but volatile formations that in various contexts bleed into, crash, and retract from each other. Blackness, however, is positioned as a hotly contested central core of these formations. It organizes the meanings attributed to women's and girls' bodies across racial categories and mediates how they are valued. This is why the negotiations of aesthetics of excess

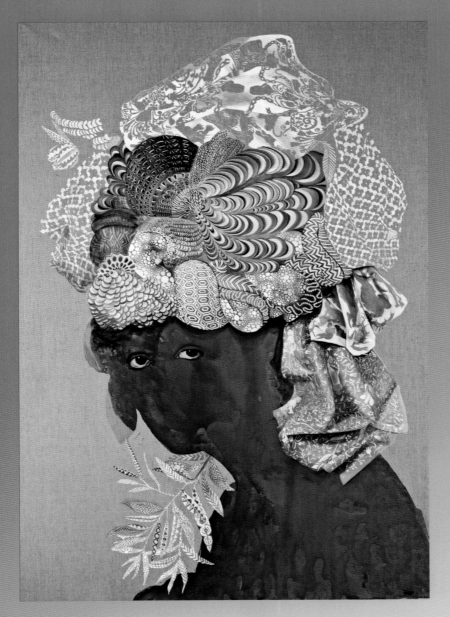

FIGURE 1.8. Firelei Báez, *Sans-Souci (This threshold between a dematerialized and a historicized body)*, 2015. Acrylic and ink on linen, 108 × 74 inches. © FIRELEI BÁEZ. COURTESY OF THE ARTIST AND JAMES COHAN, NEW YORK.

among Black girls, artists, and cultural producers make up the bulk of this book. To phrase it succinctly—they have the most at stake.

By centering the politics of Blackness and Latinidad, I do not intend to erase the other forms of racialization that exceed the dominant framing of these terms. To this end, Claudia Milian has persuasively argued for a problematization of dominant understandings of Latinx brownness (as Mexican American formation) and Afrolatinidad (as Hispanophone Caribbean formation) that continue to exclude considerations of Central American racialization. Milian posits that "Central America and U.S. Central Americans denote dark brownness not so much through the chameleonic shades of brownness affixed to Latino and Latina colorings. The heart of this darkness lies in the roles of Central Americans as guileless, rustic beings who supply the U.S. and normative Latin American world with strikingly unusual, underdeveloped, and disadvantaged 'things' that disorient U.S. Latino and Latina brown bodies" (2013, 124). Milian shows how the notion of Latinx brownness is variously marked through geographic locations and forms of labor, beyond notions of a universal Latinx mestizaje, and as such are normative signifiers that can be denied to criminalized groups such as Central Americans. Unlike places such as California, in Miami, due to its large Central American, South American, and Hispanophone Caribbean populations, brown does not hold normative currency as a signifier of Latinidad. Yet throughout this book I follow Milian in remaining attentive to how "dark brownness [an abjected brownness] and blackness live ambivalently in relation to each other" (2013, 113, emphasis added).

I do not use Black and Latina to reference phenotypical or national categories, but they nonetheless emerge as the girl and women artists I engage variously define themselves as Hispanic/White, biracial or mixed, Haitian, Jamaican, and so on. Thus, the categories my participants employ splice and bend the tethers of race and ethnicity to national, linguistic, and bodily markers. As we disidentify, work "on and against" (Muñoz 1999) these racializations, we also work on, and (too often) against, each other. As Grace Hong and Roderick Ferguson note, feminist and queer of color movements need to be relational and "fundamentally organized around difference" in order to "do the vexed work of forging coalitional politics through these differences" (2011, 9). This demands the kinds of women of color feminist engagements Alvarado describes cultural workers and theorists Ana Mendieta and Gloria Anzaldúa engaging in: "As Anzaldúa would do in print, Mendieta's contemplation of darkness, preita-tud, demands a comparative and relational approach that beckons conversation on the forging of racialized

communities where women of color understand themselves in relation and response to white male domination and white feminist exclusion, as well as to each other, pre-existing and internalized beliefs, ideologies, and racial hierarchies of home, represented in the figure of the 'mother'" (Alvarado 2015, 71)—the mother who said the Black girl is jealous of your *pelo bueno* (good hair), the mother who tells you not to stay too long in the sun or to marry a white man to *adelantar la raza* (advance the race). Light-skinned Latinas do not suffer the denigration, erasure, and physical violence experienced by Afrolatinas, and African American girls are not subject to the framings of savagery that Haitian girls are subject to, but what we do share is being viewed as ill-fitting under patriarchal transcolonialist white supremacy. We also share a commitment to making aesthetics out of our difference, and it is to those risky practices of freedom that the following chapters turn.

Through agitations and arguments, as well as expressions of admiration and support, Black and Latina women and girls generate relationship through aesthetics of excess. This looks like:

Marsha Johnson & Sylvia Rivera
Solange, Beyoncé, & Selena[14]
La Goony Chonga & Bootychaaain
Vaginal Davis & Alice Bag/Cholita!
Ntozake Shange's colored girls dancing together to Willie Colon
Ruth, Anya & Jill.

 TWO

SEXUAL-AESTHETIC EXCESS

OR, HOW CHONGA GIRLS MAKE CLASS BURN

In the contemporary moment of post-Latinx popular culture crossover, unlike when I was growing up in the 1980s, Latina bodies are fixtures of the media landscape in the U.S. We are familiar with Shakira's hips, Jennifer Lopez's ass, and Sofía Vergara's voluptuous shape. The unlikely figure of the young working-class Latina chonga girl has also taken her place in visual culture, appearing in works by influential contemporary artists, viral YouTube videos, major newspapers, and television talk shows. Through her travels along these sites she is variously marked as an object of mockery, disavowal, disgust, urban cachet, and, sometimes, ethnic pride. This chapter examines how chonga bodies are disciplined in public discourse and everyday talk because of the shameless ways their bodies mark class difference. My analyses of chonga body politics move from comments about chongas made by young Black and Latina artists I worked with through WOTR to representations of chonga girls in the varied sites of print and YouTube media, Spanish-language television, and contemporary art. Chonga style has been framed in media and vernacular discourse as an undesirable and de-

viant mode of embodiment that warrants ridicule, yet images that draw on chonga aesthetics in contemporary art have received critical acclaim and institutional recognition.

"Chonga" is a colloquial term that appears to have originated in the Cuban American community in Miami in the mid-1980s or early 1990s. The chonga could be understood as a younger version of the feminized, gossipy Latinx figure of the *chusma*, or the chusma-as-teenager. Chusma identity, or *chusmería*, has been described by José Esteban Muñoz as antithetical to "standards of bourgeois comportment":

> Chusmería is, to a large degree, linked to a stigmatized class identity. Within Cuban culture, for instance, being called *chusma* might be a technique for the middle class to distance itself from the working class; it may be a barely veiled racial slur suggesting that one is too black; it sometimes connotes gender nonconformity. In the United States, the epithet *chusma* also connotes recent immigration and a general lack of "Americanness," as well as excessive nationalism—that one is somewhat over the top about her Cubanness. The sexuality of individuals described as *chusmas* is also implicated. The prototypical *chusma*'s sexuality is deemed excessive and flagrant—again, subverting conventions. (1999, 182)

In addition to the chusma, another figure is analogous to the chonga—the young urban *chola* or homegirl, a West Coast Chicana counterpart to the chonga whose style is marked by intricately sculpted hairdos, dark eye and lip liner, large gold hoop earrings, flannel shirts, and work pants. As in Muñoz's framing of the chusma, Rosa Linda Fregoso (1999, 78) has recognized cholas as generators of "oppositional practices" who reject norms of sexual respectability and bourgeois values. Like chusmas and cholas, chongas undermine the sexual policing of Latina girls through their sexualized body presentations. Chongas express indifference toward portraying an assimilated white middle-class identity by embracing intricate and dramatic modes of hair, nail, and makeup styling that signal ethnic difference. As their aesthetics stem from and are reflective of poor and working-class urban spaces, chonga bodies signal class disparity in a neoliberal society that masks its structural workings—they make class burn.

In my relational analysis of chonga racialization, I will describe how they are positioned in relation to Blackness, a racial coding that is undesirable in contemporary mainstream discourses about Latinx mainstreaming that privilege white identification. For many Latinxs, the sexual-aesthetic excess

of chonga styles conforms to the worst stereotypes of young Latinas as poor, ignorant, and hypersexual, and these styles make girls targets for mockery and intervention. Styles indicate ways of life, and my research shows how chonga styles are often perceived as signifying working-class or poor positions (Hernandez 2009). The class performances of chongas complicate notions of attainable class mobility for Latinxs, resulting in their disavowal through tropes of bad taste, hypersexuality, and racial deviance by Latinx communities that are invested in aligning with normativity.

U.S. census data reflects the mainstream Latinx desire for white identification. Following the 2000 census, anthropologist Arlene Dávila (2008, 2) noted how Latinos were framed as successfully assimilating into the U.S., as many identified as white or rejected racial classification altogether by selecting "some other race." That trend was echoed in the 2010 census data, where the majority of Latinxs identified as white (53 percent) or some other race (37 percent). In the 2010 census statistics for Miami, the groups of Latinxs who most identified as only white were of Cuban and South American origin— and in Miami, Cubans and South Americans have established considerable political and economic power (Yúdice 2003). These data indicate the extent to which Latinx identity in Miami is framed via whiteness. It is significant to the study of chonga discourse to see this frame of whiteness because it informs the ethnic and racial values through which chonga girls in Miami are perceived to be found wanting. According to Dávila (2008), the politics of race for Latinxs are obscured in mainstream media through emphasis on physical markers, traditions, and ethics that are said to be in line with "American values," such as whiteness, hard work, and close family ties. In stark contrast, chonga bodies conspicuously signal leisure and forms of class, racial, and sexual difference that are occluded in these efforts for Latinx inclusion in the realm of "good" or what Marcia Ochoa (2014, 40) calls "sanitary" citizenship.[1] Ultimately, then, the sartorial styles of chonga girl bodies become social liabilities, or bad public images for Latinx communities.

"Chongalicious"

Although chongas have been colloquial figures in Miami for several decades, they became the center of popular discourse in the city through the satirical YouTube video "Chongalicious" (Chonga Girls 2007). It was posted on YouTube on April 1, 2007, tallied almost one million views within several months, and has amassed over seven million views to date. The video was created by Latina teens Mimi Davila and Laura Di Lorenzo, then drama

FIGURES 2.1 AND 2.2. "Chongalicious," YouTube video screenshots.

students attending an arts magnet high school in Miami.[2] The girls neither anticipated nor initially worked toward garnering widespread media attention. "Chongalicious" was meant to be a silly faux music video circulating among a group of friends for laughs, but it became a local and later national pop culture phenomenon (Lush 2007).

In "Chongalicious," Davila and Di Lorenzo don tight outfits and vigorously move their butts to electronic beats as they enact the sexual-aesthetic excess attributed to chongas. The clothing that serves as their costumes consists of a basketball jersey worn as a formfitting minidress, a one-piece spandex short jumper, and metallic gold flip-flops and plastic mesh slippers festooned with sequined flowers, the kind commonly found in corner stores and flea markets in working-class Latinx neighborhoods. The girls wear large hoop earrings and dark red lipstick. Their hair is wrapped in buns worn high atop their heads, and the lower portion of their hair flows down to their shoulders in waves (see figures 2.1 and 2.2).

The opening shot of the video is a close-up of the girls shaking their asses to rapid electronic Miami bass beats. They then turn to face the viewer and begin to perform the "Chongalicious" song with animated hand gestures and simulated thick Latinx accents. A schoolmate recorded the performance in the interior of Davila's home and outdoors in a housing complex. The work emulates the genre of the music video through the emphasis on the girls' dancing and a montage of varied scenes edited to synchronize with the song. Most of the shots are close-ups that capture scenes of the girls looking into mirrors, styling their hair and makeup using glue for gel and Sharpie pens for lip liner, flirting with a young man on the street, push-

ing each other around, and sloppily eating pizza and smearing it over their mouths. These hyperbolic, slapstick parodies serve to convey the chonga's overindulgent nature and excessive or trashy application of beauty products. The performers speak in the voice of chongas and address the viewer/camera with a confrontational attitude throughout the work. This is a sample of the lyrics they rap in unison:

Chongalicious definition arch my eyebrows high
They always starin' at my booty and my panty line
You could see me, you could read me
Cuz my name is on my earrings
Girls got reasons why they hate me
Cuz they boyfriends wanna date me
Chongalicious
But—I ain't promiscuous
And if you talkin' trash, I'll beat you after class
I blow besos—muuuuaaah![3]
I use my Sharpie lip line
And ain't no other chonga glue her hair like mine
Chongalicious

Although they claim not to be promiscuous, the lyrics nevertheless typify chongas as sexualized, antagonistic toward other girls, violent, and hypervisible ("You could see me, you could read me"). In a later segment of the video, the performers make references to the chonga's lower-class status by describing her as "ghetto" and stating that she buys her "bling" at the flea market for $2.99.

"Chongalicious" crossed over from YouTube to traditional print, radio, and television outlets in South Florida. It was featured in a news segment by the internationally broadcast Spanish-language network Univision, and the song "Chongalicious" frequently rotated on Miami's popular music station, Power 96. Despite its seeming status as a media-generated sensation, "Chongalicious" circulated virally via the social networking accounts of Miami locals prior to its intensive media blitz. A host of spin-offs and parodies of the video eventually appeared on YouTube such as "Preppylicious," "Hoochielicious," "No More Chongalicious!!!," and Davila and Di Lorenzo's sequel videos "I'm in Love with a Chonga" and "Chonga Ladies/Chola Ladies." The number of hits these later videos have attained, in the hundreds of thousands, seems minimal compared with those of "Chongalicious." The coverage on chongas, particularly in Spanish-language media,

has persisted since 2007. An episode of the Univision talk show *Cristina* that featured the "Chongalicious" performers aired in January 2009, and You-Tube users continue to post comments on the original video several times a month.

"Chongalicious" was a contemporary iteration of *choteo*, a Cuban parodic form that emerged on the island in the nineteenth century. Alison Fraunhar notes that "choteo is irreverent, satirizing both high and low; by providing a safe space to ridicule and criticize authorities and people of high social and economic status, it might seem to have functioned as a strategy of intervention and social change, but instead it served to preserve the status quo. Choteo's barbs are likewise directed at the lower classes and disadvantaged races as a way of reminding them to know their place in society (and to stay there)" (2018, 58). The mockery and ridicule of chongas in popular culture and everyday discourse stems from the social anxieties smartly dressed Afro-Cubanas spurred in colonial men in the nineteenth century, and the social agitation instigated by chongas' flagrant disregard for assimilation or modesty in body presentation continues to make them a target, as played out in my charlas with WOTR artists.

"Just Like, a Lot of Extraness . . .": WOTR Artists Define Chongas

The emerging hypervisibility of chongas following the explosive reception of the 2007 YouTube parody video "Chongalicious" prompted me to conduct a research study with Miami residents on the topic in 2008.[4] Unable to locate a single reference to chongas in scholarly literature at the time, I reached out to members of the Miami community, through family and friends, and invited them to share their own definitions of chonga identity. Their responses painted a picture of chongas as young Latina women who:

- wear ill-fitting clothes that are either too baggy or too tight, apply an excessive amount of gel to their hair, don large gold hoop earrings engraved with their names in cursive lettering, use heavy eye and lip liner, and are adorned with large amounts of gaudy jewelry;
- live in poor and working-class areas of Miami-Dade County such as Hialeah, Sweetwater, Westchester, and Cutler Ridge;

- are "reffy," a term used in Miami to denote recent refugees who are viewed as loud, crass, and unable to master either English or Spanish, thus speaking Spanglish; and
- are unintellectual and apathetic about gaining skills and bettering themselves through education.

The characteristics attributed to chongas are tinged with failure. They fail at acculturating, being unable to speak English correctly or without an accent. Their flaunting visibility is perceived as foolish, as "they are not aware of how ridiculous they look in public." Moreover, participants observed that the label "chonga" functions in homosocial youth contexts to identify, exclude, and deride ("Girls that hate on each other," "Mainly females describing other females," "Everyone who wants to offend someone else, mainly a girl"). The study revealed that there is little to be desired in embodying the chonga identity. Like an embarrassing cousin one is reluctant to introduce to friends, the chonga is not a figure to be associated with, as she loudly speaks her broken English and wears all the right commodity items (like jewelry and trendy clothes) in the wrong way. The deployment of the term, and the attendant laughter it induces, can enable Latinx youth to distance themselves from her hypersexual, hyperethnic, and underclass inscription.

From 2011 through 2013, several years after my initial chonga study, I had charlas with sixty-one WOTR artists about chongas. I asked if they had seen the "Chongalicious" video and what the term "chonga" signified to them. Since five years had passed since the video received a surge of media attention, and because contemporary youth media trends are fleeting, I was not expecting so many participants (about 90 percent of them) to be familiar with the video and to say that they had recently viewed it. This demonstrated the staying power of the "Chongalicious" video in sustaining the viewership of youth of color.

In a conversation I had in 2012 with Latina girls in the Sweetwater area of Miami, which is a primarily working-class community of recent Latinx immigrants, a shy eleven-year-old girl who gave herself the pseudonym "Big Bird" and identified herself as "Hispanic/White" said that she had heard the word "chonga" before as it had been used to describe her and a friend. But she was quick to add, "Not like, [because of] what we wear cuz, we wear a uniform and everything but we try. It's kind of stupid cuz we pretend like if we're them but we're really not." Asking young women in Miami about what it means to be a chonga did not yield responses that differed significantly from those articulated by the participants of my 2008 questionnaire,

attesting to the discursive power of the chonga script of bad subjectivity. As Big Bird's comment suggests, chonga identity is perceived as a characterization or mode of parodic performance, something fun to play at and try on, not an authentic or legitimate mode of self-production or self-presentation for girls.[5] I found the descriptions of chongas as "low-class," "ghetto," and aesthetically and sexually excessive repeated manifestly in my charlas with the girls.

What did not appear in the earlier study of 2008, but was articulated in these more recent charlas, were WOTR artists' theorizations of the chonga figure's appropriation of Blackness. In the earlier study, one participant made a reference to the chonga's relation to Blackness by suggesting a lexical connection to Afro-Cuban spiritual practices, positing that perhaps the term "chonga" stems from the name of the Santería orisha Chango. But in my later charlas, participants were much more candid about their thoughts on race and chonga style. The groups in which these issues were raised consisted overwhelmingly of African American and Black Anglo- and Francophone Caribbean girls, with either no Latinx girls present or very few. Black girls' comments on chonga embodiment reflect how they gaze upon the chonga body and see cultural and corporeal appropriation, rather than potential relation or affinity.

The chonga's desire to emulate Blackness was repeatedly referenced in my groups with Black girl artists as a primary reason for why her style is perceived as outlandish. In answering my query about why people think that chongas are ridiculous, Betty Boo, a thirteen-year-old artist who identified herself as Haitian, said, "It's like, they're trying to be Black. The long nails, the makeup, the earrings, that's stupid, yeah." The other Black girls in the group nodded in agreement with her. This group discussion was held in Coconut Grove, a historically Black community in Miami that, since being gentrified decades ago, has marked economic disparity between the Black community and the more newly established rich, white, and Latinx residents.

In my group discussion with Black girls at Lifelines, a center for queer youth, Q, a twenty-five-year-old artist who identified as Bahamian and African American, defined the chonga as "a Hispanic girl that puts on a lot of makeup and a lot of hair products." Alaika, a Haitian American artist in the group, retorted, "No, it's a Hispanic girl that's trying to be Black. Because this [pointing to the picture of chonga girls on the cover of the New Times I projected on the wall] is what Black ghetto girls do. This is the Hispanic version of a Black ghetto girl." When I prompted this group to define chonga

style, Q stated, "Just like, a lot of extraness. Every time I saw a chonga she had like forty bracelets on each arm." Alaika added, "The name bracelets! And when they walk around all you hear is cling cling cling cling cling!"

When I specifically asked them to share their thoughts on how chongas were portrayed in the "Chongalicious" video, Q said it represented

what a typical chonga goes through in her day. In the video you see them putting on the makeup, doing groceries and stuff like that. Me and my friends laughed at it when we first saw it because that's what we were like. Our friends who were chongas [who saw the video] were like, "Oh that's what we do." Let's go do the nails, the hands. So [in the video] we're looking at what they do at home. Yes they're being picked on [in the video] but it's one of those things where, it's like—that's what y'all do.

Before Q could finish, Alaika excitedly interjected,

Cuz I'm like [to chongas] y'all must take a lot of time just to do, like, the curl in the hair and certain things, and they're like [in a simulated Spanish accent], "Yeah I have to get up at five in the morning to get my hair like this and da-da-da . . . go up there and get my nails done." It's stupid, it's worthless. It's worthless. At the end [of the day] you have to get home and take like a good five-hour bath just to get all that goo off of you and then start all over again in the morning—to me, it's worthless. But to each his own, you know?

Q responded,

I think it is creative because of the simple fact that it's their culture more or less, so it's like they're not trying to look like everyone else and they found ways to stand out and make themselves look different. Like African American women, they stand out to try to make themselves look different, so they put the weave in, some put the extra stitches in, some lock their hair, some cut their hair—they do things to stand out, to look different. Same thing with them [chongas]. It's not a waste of time for them, because they stand out to look different. People will look at them, maybe for a good reason, maybe for a bad reason, but people are looking at them for a reason. So they get some attention.

Where Alaika sees failed and futile attempts by Latinx girls to mimic Black forms of self-fashioning, Q articulates the identity work of chonga style as signifying difference. She frames the relationship of chonga style

to Black women's aesthetic body practices, not through a rhetoric of failed imitation, but through an understanding of the politics of dignified visibility (Bettie 2003) in a political economy that would otherwise discipline them into neoliberal forms of being in the world: a world in which perhaps you would refrain from wearing so much gel on your hair, or makeup on your face, where you would think twice before putting those extra stitches in, as these practices can cause you school, work, and social problems. Q's understanding is particularly significant given the often-antagonistic relationships between Black and Latinx populations in urban areas of the U.S. such as Miami and Newark, New Jersey, where Latinxs disavow Blackness and inflict violence upon Black communities, which shapes responses such as Alaika's (Portes and Stepick 1993; Ramos-Zayas 2012).

Anthropologist Ana Y. Ramos-Zaya's (2007) ethnographic research reflects my Black girl participants' observations of cultural appropriation. She has found that, for many Latinx youth in Newark, the process of becoming American entails establishing proximity to Blackness rather than whiteness (86). Ramos-Zayas has explained that, in contrast to the perceived "backwardness" of recent immigrant youth, the notion of Blackness negotiated by her participants was imbued with cultural capital stemming from its associations with modernity and cosmopolitanism via hip-hop culture. She observed how performances of Blackness were very carefully evaluated among youth of color, with failed iterations resulting in denigration and loss of face. Like the chongas described by my participants, many Latinx youth in Newark were perceived by fellow Latinx and Black youth as lowly "wannabees" (Ramos-Zayas 2007, 90).

Because the dominant meanings of Latinidad in Miami are so oriented toward whiteness, the manner in which the chonga's aesthetic embodies a creolization of Afrolatinx and African American stylistic sensibilities is regularly occluded. Its Black diasporic origins are displayed but unnamed. Due to the visible and hegemonic power of Latinx communities in Miami, the Black girl artists I talked to may have perceived the chonga's citation of Blackness as a form of stylistic gentrification. Their understanding of chonga style in this way is plausible when considering Ramos-Zayas's research finding that the appropriation of Blackness by Latinx youth "generally failed to engage discussions of civil rights, segregation, and inequality or lead to enduring coalitions with African Americans in Newark" (2007, 86). In sum, while Latinx and Black youth may share aesthetic practices, they do not necessarily build coalitions together because of their shared styles. Because of these politics, I mobilized the charlas with WOTR artists on chon-

gas as a potentially productive space to have open dialogues with Black and Latina girls (as a Latina) about their shared and distinct experiences of body crafting and body policing.

When considering the race politics that shape discourses of Latinx mainstreaming through valuations of whiteness, the chonga's association with Blackness signals a deviance that is to be disavowed in Latinx communities. Yet, as diasporic subjects with limited means, chongas are *rasquache* bricoleurs of style, picking up whatever elements they encounter that fit their tastes and identities.[6] As Tomás Ybarra-Frausto notes in his theorization of the playful Chicanx aesthetic sensibility and cultural practice of *rasquachismo*, which is often viewed as exhibiting the kind of working-class bad taste attributed to chongas, "Resilience and resourcefulness spring from making do with what is at hand (*hacer rendir las cosas*). This use of available resources engenders hybridization, juxtaposition, and integration" (Barnet-Sanchez 2007, 61). Rather than being understood as cultural innovators remixing ethnic styles, chongas were perceived as fashion failures or problematic imitators of Blackness among the participants in my research and in dominant Miami discourse. With few exceptions, my research with Miami residents exposed a durable and hegemonic view of chonga girls as deviant and devoid of "complex personhood" (Gordon 2008, 4). The negative valences of chonga embodiment, however, have not prevented them from becoming value-producing brands in the cultural sphere.

Branding the Chonga Body

After gaining celebrity in South Florida through "Chongalicious," Davila and Di Lorenzo aimed to capitalize on the chonga body by branding it to sell themselves as emerging actresses, with the goal of crossing over from YouTube to more lucrative teen and tween venues such as MTV, Disney Channel, and Nickelodeon. Communications scholar Sarah Banet-Weiser (2011) has examined how young women's performances on YouTube often function more as promotional tools than modes of self-expression, which helps explain how the "Chongalicious" performers were presenting the chonga figure as a brand. In describing the neoliberal politics that undergird girls' YouTube video production, she notes, "The fact that some girls produce media—and thus ostensibly produce themselves through their self-presentation—within the context of a commercially-driven technological space is not only evidence of a kind of empowering self-work but also a way to self-brand in an increasingly ubiquitous brand culture" (Banet-Weiser

2011, 284). The performers of "Chongalicious" were not attempting to present themselves, but rather to embody the chonga trope as a comedic shtick. The attention they garnered with their YouTube video, however, prompted them to brand and thus sell themselves as performers who could reach the sought-after market of Latinx youth. To this end, Davila and Di Lorenzo secured agent representation through the talent agency Uno Entertainment.

On the Uno Entertainment website, promotional photographs of the girls, without chonga regalia, market them as actresses, comedians, and "YouTube starlets." Uno Entertainment applies the gendered language of old Hollywood, "starlets," with its attendant associations of feminized whiteness, to YouTube production in order to brand the girls as wholesome and potentially profitable marketing investments. A banner on the website reads, "YouTube starlets, actresses, comedians, and writers Mimi Davila and Laura di Lorenzo aka Chonga Girls present their own spin on the news with Chisme News and other stuff, Enjoy!!! With a coast-to-coast fan base of over 8 million 14–24 year olds, Mimi and Laura have an insider's fluency with urban youth and Hispanic-American culture, and they celebrate and poke fun at their surroundings in a way that brings everyone together."[7] Here the logic of marketing ("youth fan base") merges with the logic of neoliberal multiculturalism ("urban youth and Hispanic-American culture") to make the mockery of working-class Latina girls, as performed by Di Lorenzo and Davila in "Chongalicious," benign and in good taste. Mockery of the chonga body is employed by Di Lorenzo and Davila to create a brand and achieve publicity. Rather than being framed as "mean girls" ridiculing their Latina counterparts, Davila and Di Lorenzo are presented as sanitary citizens who bring "everyone together."

In the *Miami New Times* story on "Chongalicious," reporter Tamara Lush makes efforts to articulate to the reader how unlike chongas Davila and Di Lorenzo really are: "In character, they are brash, sexy, bold creatures. They seem self-assured rather than the moody, curious girls they really are. . . . They have noticed that guys like them better as chongas, a fact that makes them more than a little depressed. Both girls get plenty of looks from guys as they walk down the street in their chonga wear—but not, for example, when they are sitting in their AP English class, wearing sweatshirts, jeans, and glasses" (2007, 30). Lush problematically bemoans the girls' failure to attract male attention when they are not embodying the chonga role, which reinstates the slut–versus–good girl dichotomy. Additionally, the writer draws attention to the girls' upper-class status—in stark contrast to the poor and working-class status of chonga style. In her report, Lush continually refers to the fact that the girls reside in Aventura, an area of Miami-Dade County

replete with luxury high-rise condominium developments and a large mall with exclusive stores and boutiques. When describing how the girls came up with the idea for the video, she recounts the story of how they conversed about the "chonga-like" outfits worn by girls in the school cafeteria and secures this admission from Davila: "We were kinda making fun of them" (24). In Lush's framework, the roles of chonga and intelligent young woman are mutually exclusive. Davila and Di Lorenzo are applauded for their clever parody and are protected from the negative ramifications of embodying the sexual-aesthetic excess of the chonga identity through allusions to their intelligence, modest form of dress, and upper-class lifestyle.

Uno Entertainment's website reinscribes this narrative of normalcy in the photos of the girls displayed on its home page. The background consists of images of the girls as chongas against a pink background, to remind the visitor of their brand. Overlaid upon this backdrop is a publicity shot of the girls out of costume, wearing light-colored, plain shirts and no makeup, smiling cheerfully at the camera. Yet the makeup that they used to construct the chonga mask seems more difficult to take off than they had imagined. Despite their continued marketing and public relations work, the "Chongalicious" performers have yet (as of 2020) to achieve crossover success. This stems from the association that has been forged between the performers and everyday chonga girls. The attempts of Uno Entertainment to brand Davila and Di Lorenzo as multitalented starlets cannot wipe away the ethnic, aesthetically excessive smudge of working-class chonga girl identity. Although their performance as chongas on YouTube reached a wide audience, the connection that was established between them and real chongas positioned them as unfeasible products for the teen/tween media enterprise. Unfortunately for aspiring and talented young women such as Davila and Di Lorenzo, Latina girls can only fit a narrow range of roles, ranging from the marginalized excess of chonga girls to the dramatic dorkiness of the T V show protagonist of *Ugly Betty*, to the new normative cool of Latina stars like Selena Gomez.

The flat performance of chonga identity branded by Davila and Di Lorenzo, and their resultant typecasting, resurfaced in an April 2016 YouTube video starring Davila and Di Lorenzo as, yet again, chonga girls (Pero Like 2016). The April 2016 video was produced by major web-based news and entertainment company Buzzfeed, under their new division of Pero Like, which generates content for young English-speaking Latinx audiences. The four-minute Pero Like video, titled "Women Transform into Chongas," opens with a confession by a self-described former chonga, a light-skinned

Cuban American woman wearing light makeup and a relaxed outfit of a graphic T-shirt, cardigan, and loose-fitting skirt. She rehearses the narrative that appeared in my research with Miami residents—that of the ex-chonga who assumed the style in her youth and has since evolved into a more mature mode of body presentation. Her confession is followed by commentary from another young Latina woman who, unlike the first speaker, is not Cuban American and is unfamiliar with chonga style. Donning a long dress and no makeup, she explains that where she grew up in the Midwest, there "weren't a lot of people taking big fashion risks." Davila and Di Lorenzo then appear on screen in character, introducing themselves as chongas, the epitome of "fashion risks." In affected high-pitched nasal voices, they exclaim, "Hey guys! It's the chonga girls!" Nine years after the "Chongalicious" video made them cultural sensations in Miami, Davila and Di Lorenzo are still playing the same role due to the continued constraints on Latina representation and labor in entertainment.[8]

Dressed in outfits similar to those they wore in "Chongalicious"—athletic gear, dramatic makeup, big earrings—they explain that they are really excited to learn that there are girls out there who are unfamiliar with chonga style, as this provides the opportunity to "upgrade" them. Their mission is to educate modestly dressed Latinas on how to embody chonga aesthetics so that they may fashion less boring, more sexy versions of themselves that will enhance their ability to attract male sexual partners.

The video follows the performers shopping in Santee Alley in Los Angeles, a popular flea market that they compare to a similar site in Miami, as they select the elements of the ensembles they are crafting for the non-chonga girls.[9] While they walk through the flea market stalls, the camera veers away from them to focus on the signs that read, "99¢ Fashion Jewelry," thus underscoring the underclass position of chongas in a quasi-ethnographic mode. Shopping in such a place is presented as part of an explicitly staged parodic performance, not as a practice employed regularly by working-class Latinas with limited budgets.

After the chongas complete their shopping trip, they then have the modestly dressed Latinas try the outfits on and do their chonga makeup. One wears a red, skin-tight dress that accentuates her cleavage. The other (as pictured in figure 2.3) wears a leopard print halter top with a plunging neckline along with hip-hugging turquoise pants. A pink patterned scarf is wrapped atop her head with a dramatic bow. Both don large faux gold necklaces, bracelets, and earrings. During the reveal, the makeover subjects laugh at their reflections in the mirror, thus making it clear that although they may

FIGURE 2.3. Screenshot of Pero Like's "Women Transform into Chongas" video.

like what they see, they would never really dress that way. Whatever seductive possibilities may be offered by chonga embodiment are immediately foreclosed by the makeover subjects' self-mockery. The confidence that the video protagonists describe as the spirit of chonga style appears too uncomfortable and risky for them to perform with any hint of seriousness. This is likely due to the fact that chonga sexiness is achieved via the assumption of styles procured in places like flea markets; class shame may sometimes hold more sway than embodied pleasure.

The "Women Transform into Chongas" video, which collected over two million hits within a month of its release, has generated meanings of chonga identity that are in line with "Chongalicious" and the other chonga texts we have engaged thus far. Comments by YouTube users on the video include statements such as

- "95 percent of Hispanic girls go through this stage" (Diana Garcia).

- "It's an act right? If it's an act it's hilarious and I love them, if it's not, it's kinda sad" (Melody Loft).
- "So Mexican ratchets basically" (Cullen Riley), which received the response, "Chola = Mexican ratchets, Chonga = Cuban/ Puerto Rican ratchets."
- "Most of my cousins are chongas [laugh emoji] and I am just that nerd in the background" (Cinthia Bolanos).

This brief sampling reveals the unwavering persistence of the trope of chonga as stupid, juvenile, and "ratchet," that is, crass, hypersexual, and low-class.

Viewers also felt that the video offered a false promise of educating the viewer on chonga culture, as expressed by user Julita Minkštimaitė, who wrote, "To me (person that has nothing to do with this culture) this video made it seems like a 'chonga' is latin cheap girl or whore. I came here to find out what chonga was . . . didn't help." Although it is not possible for any cultural text to portray a complex representation of chonga girls writ large, this user calls out Pero Like for the reductive manner in which chonga culture is framed. Buzzfeed is not the only media company that has attempted to appropriate and capitalize on the mockery of chonga-esque aesthetics. Other corporations have been profiting off these appropriations for years. In 2011, MTV created a juxtaposition of bodies similar to that found in the Buzzfeed and "Chongalicous" videos by drawing on Selena Gomez's Mexican heritage to brand her with a marketable sexual-aesthetic excess that was posed against a contrasting respectability.

Good/Normal Selena versus Bad/Chola Selena

In a culture industry that is targeting the growing population of Latinxs in the U.S. with aggressive marketing tactics, the figure of the light-skinned Latina girl has emerged as a vehicle for attracting audiences and consumers. Media scholar Angharad Valdivia (2011) has noted that light-skinned Latinxs serve as viable marketing products for a wide, normatively white audience, as they do not embody the threat of difference and political power of African Americans. Valdivia's contention is supported by images of light-skinned Latina young women that continue to emerge in popular culture via chonga media, such as the promotional video for the 2011 MTV Euro Music Awards (EMAs) in which Selena Gomez is styled to look like a chonga/ chola-esque alter ego in juxtaposition to her normal, conventionally fashionable style (Selena Gomez 2011). The video clearly articulates a dichotomy

between good and bad Latina girl subjectivity and body presentation by contrasting a modest, respectable, upper-class performing, feminine Selena Gomez against an unruly, aesthetically excessive, sexual yet masculinized, working-class chola identity. This representation of chola embodiment is enmeshed and in conversation with the larger aesthetic and social politics that shape the valuations and devaluations of working-class Latina girls like chongas.

The promotional MTV EMA video opens with a scene of Gomez looking at her reflection while sitting at a vanity in a hyperfeminine rococo-styled bedroom with pale pink walls and ornate pink furniture. The Selena who looks in the mirror is wearing light, natural makeup, delicate jewelry, a strapless, flowing white top, short denim shorts, and stiletto heels. Although the short shorts and cleavage sexualize her image, they are in keeping with styles that are fashionable among contemporary celebrities. As she sits at her toilette, Gomez contemplates how hosting the MTV EMAs marks a new level of success in her life. Her moment of staged, modest self-reflection and self-confidence is abruptly interrupted by an alter ego Selena Gomez dressed in chola style, which is similar to that of chongas but with a masculine edge mixed in via loose-fitting work pants and shirts such as those designed by brands like Dickies. She wears big gold bamboo hoop earrings, baggy jeans revealing boxer shorts, sneakers, and a loose-fitting flannel shirt buttoned at the neck. However, MTV "sexed up" chola style and downplayed the masculinity associated with it by having Gomez wear the flannel shirt unbuttoned to reveal her feminine bra and flat stomach, a look that is not typical of vernacular chola styles (see figure 2.4).

The alter ego Chola Selena suddenly intrudes into the hyperfeminine bedroom and begins to rap about how all of the attention is going to be on her during the MTV EMAs. In contrast to the soft, melodic "congratulations to me" that Normal Selena sings, Chola Selena raps "S-E-L-E-N-A to the Gomez, yeah you know I'm the dopest!"[10] Chola Selena jumps on furniture and uses curse words that are bleeped out throughout the video. Chola Selena performs an egotistical, vulgar, and unruly personality in juxtaposition to the pretty, restrained, and feminine Normal Selena.

The pairing of these two Selenas seeks to display the tough edge that is beginning to emerge as Gomez becomes an adult, shedding her Disney Channel image as the teenager Alex in the family sitcom *Wizards of Waverly Place*. Although Alex's character was confident and often abrasive in the TV show, she did not dress or act at all like the chola-styled alter ego in this MTV promotional video. In order to fit the marketing logic of MTV culture, she

FIGURE 2.4. Screenshot of Selena Gomez's MTV Euro Music Awards video.

must be fashionable, sexy, and edgy—but the edge of the chola is in excess of acceptable, safe images of Latina girls that are consumable in the culture industry. The chola version of Selena is meant to be a humorous deviation from what is her normal, classy yet sexy behavior.

In response to the promotional video, the entertainment news website On the Red Carpet posted a story about the two Selenas that included a poll, where readers shared what they thought about Gomez's alternative look (Allin 2013). In the poll, most readers rejected the notion that chola embodiment would be an improvement to Gomez's image, and nearly 50 percent of respondents found her new look "funny, but hopefully temporary."

As in the reception of "Chongalicious," we find in the response to the two Selenas that the aesthetics of poor and working-class Latina girls are appropriated to execute a joke. The lives of Latina girls and, in popular media, images of chonga-esque young women are often juxtaposed against images of young women in proper dress. The visual rhetoric of juxtaposition between normative embodiments and sexual-aesthetic excess outlines a clear

demarcation between desirable and undesirable embodiments and corresponding attitudes for young Latinxs. Media culture presents Latina girls with a false choice between assertiveness and composure, sexual/bodily confidence and modesty.

This is a dynamic that Chicana artist Judith Baca engaged in her landmark work *Las Tres Marias* of 1976, a multimedia project of which the primary work is a nearly life-size triptych in which two drawings of Chicana women flank a mirror. One side depicts the artist in the dress of a 1940s pachuca with teased hair, severely lined eyes and brows, and long nails. Disinterested in the viewer, she looks outside the picture plane as she puffs on a cigarette. The panel on the other side depicts a young Chicana in the less feminized but nonetheless stylized dress of 1970s cholas that incorporated menswear. Baca has described how the title refers to the three dominant tropes of femininity available to Chicanas: the whore, the mother, and the virgin.

In centering the deviant femininities signified by pachuca and chola embodiment in *Las Tres Marias* (Fregoso 1999; Ramírez 2009), Baca engaged Chicana embodiment as a performance of power. The piece stemmed from memories of being warned by her mother not to follow in the footsteps of her pachuca cousin, who was part of a gang in Watts, Los Angeles.[11] To this end, Baca was sent to a Catholic school. Yet even there, she would recall how pachucas would "take up the entire school yard" as they linked arms. "I just loved it. I wanted to be like that. I loved that idea of power." For Baca, the chola's and pachuca's embodiment is understood as a performance of gendered power that speaks to a white masculine gaze: "You can get close, and you might even desire me, because I'm sexy as hell, but don't you touch me. You can't touch me, because I'm dangerous" (CAA 2018). The interactive triptych invites Chicanas to situate themselves in relation to their chola and pachuca cousins. As they approach their own reflections in the mirror, they become positioned to intervene as the third *Maria*, to negotiate and claim what power and body presentation mean to them. By negating the possibility of a third Selena, the MTV "two Selenas" video maintains a binary that forecloses the potential for identification with the chola, or the creation of an-other identity. Though Cuban American and Miami Latinas do not have a hold on the white imagination in the U.S. as cholas and pachucas do through their threatening association with the Zoot Suit Riots and gangs, they are also known as women and girls you are provoked to look at but not mess with.

The ways that chongas typify a sexualized hyperethnicity marked as "low-class" have been demonstrated through the definitions of chongas articulated by the Miamians who participated in my research studies in 2008 and 2011–2013 and the representation and reception of chongas and chonga-esque Latinas in popular media, such as the YouTube video "Chongalicious," the "two Selenas" video created for MTV, and Buzzfeed's "Women Transform into Chongas" video. In addition to these readings, chongas themselves have faced direct confrontation about their style, even so far as being literally posed against bourgeois white femininity and its attendant embodied propriety.

One such instance of direct confrontation occurred in 2009, when the international Spanish-language network Univision aired an episode of the popular talk show *Cristina* on chongas (YLGA22 2009). The blonde and light-skinned Cuban American talk show host herself, who critiqued the style of the chonga girls she invited on the show, embodies the social aspirations of normative, bourgeois white Latinidad, with her conservative blazer suit outfits, ordered hairstyle, neutral makeup, and restrained comportment. The *Cristina* episode staged a scene in which chonga embodiment was both regulated and radically affirmed. Each self-proclaimed chonga girl on the panel was seated next to a light-skinned Latina in modest, contemporary trendy dress that served as her opposite. The chongas were asked questions about their failed attempts at beauty that prompted them to defend their mode of dress. The normal non-chonga Latinas on the panel, labeled *finas*, a term used in Miami to denote finery and classiness, barraged the girls with negative comments as they pontificated about proper feminine class, dress, and style (figure 2.5). The overall purpose of the show was to mock the chonga girls and advise them to change their style so that they would not look ridiculous.

In true tabloid talk show fashion, a segment of the episode featured a "chonga makeover" in which the gay, light-skinned celebrity stylist Rodner Figueroa stated that he was going to transform a "pretty" woman into an "ugly" woman by turning a "well-dressed" audience member into a chonga. Through the performative makeover, the homonormative Latino stylist sustained heteronormativity and racial/ethnic/class hierarchies by disciplining the bodies of chonga girls and "scaring" them into abandoning their "ugly," excessive look. This reflects what Mimi Thi Nguyen describes as the makeover's aim "to improve the fashion victim's appearance but also to instruct

FIGURE 2.5. Screenshot from *Cristina* show, chonga makeover episode.

her on how to evaluate and regulate her body (as a sexual body, a laboring body, and a civic body) in the future" (2011, 375). The talk show indeed asserted a body pedagogy for Latina women and girls that emphasized the importance of policing, by oneself and others, to ensure an effective class performance of Latinidad that is particularly gendered and racialized.

In this *Cristina* episode, a seventeen-year-old, self-described chonga named Elizabeth Sanchez was on the panel, and she claimed to have been the inspiration for the "Chongalicious" video created by Davila and Di Lorenzo.[12] She wore large, bright neon-colored combs that pierced a tight bun on her head, tight short shorts, a black crop top, heavy makeup, and numerous bangles and necklaces. In the show, she was consistently called "vulgar" by a tall, thin woman with a fashion model physique who had blonde straightened hair. Elizabeth became increasingly agitated during the show due to the consistently negative comments directed at her. Elizabeth said that she would continue to dress like a chonga, no matter what advice they offered to persuade her to the contrary. When it was time for the audience to respond to the panel, Elizabeth's mother stood at the microphone stand and said that she wanted to defend her daughter, who was an honor roll student. Emboldened by her mother's public statement, the young chonga girl proclaimed, "Yo puedo salir ahora vestida asi porque yo tengo el balance

academico y social que puedo vestirme como yo quiero. Lo que tengo aqui no me lo quita nadie." (I can go out right now dressed like this because I have the academic and social balance that I can dress the way I want. What I have here [pointing to her brain] no one can take away from me.) I do not draw on Elizabeth's speech act as an example of how chonga style can be appreciated as normal through a narrative of academic achievement—what interests me about her performative (and perhaps scripted) statement is the manner in which her chonga body talked back to and queered dichotomies between sexualized self-presentation and academic performance, feminized grooming practices and power.

I also locate radical politics in the statements made by the other chonga girls on the panel who did not mention school or work success, but pointed to the significance of their self-determination in crafting their embodied presentations, and disdain for the bourgeois morals articulated by the women who judged them. They described their style as exhibiting more freedom than the dress employed by the finas, as they stated that they wanted to appear "different," and were not interested in conforming to norms of proper femininity. The chongas on the Cristina episode explicitly articulated how their body crafting is a practice that opposes efforts to discipline Latina bodies.

Although the "Chongalicious" performers were not able to capitalize on their hypervisibility to enter into the mainstream culture industry, the consistent portrayal of and interest in chongas in Miami, and in international Spanish-language media more broadly, evidences how this abjected body is a valuable brand nonetheless—as it guarantees some measure of recognition, attention, and commentary. That the presentation of chonga bodies incites agitated expressions of disgust and ridicule reveals how Latinx communities nevertheless take a queer pleasure in appropriating and consuming them. Chongas are figures that the Latinx community will likely not let go of, even if it insists on their spectacular marginalization.

Chongas in High Culture

Though it seems unlikely, given the ways in which we have seen the chonga body defined as signifying low culture and aesthetic failure, chonga-esque young women became the improbable darlings of the high art world in the early 2000s. In what follows, I examine how the sexual-aesthetic excess of chonga-esque bodies in the realm of contemporary art has facilitated the inclusion of some artists of color in the mainstream art market, unlike main-

stream popular culture. The presentation of these chonga bodies in contemporary art has generated considerable critical acclaim. In notable contrast, this acclaim has legitimated cultural capital for the artists in ways that were not possible for the "Chongalicious" performers, nor for the self-identified chongas who have been disparaged in public, in the media, and in everyday discourse.

Turning our attention to the politics of Latinx representations in fine art is important for understanding the power relations that shape the circulation of aesthetics of excess. The art world is a patently privileged space in which visual meaning making is imbued with an authority and value that excludes working-class, gendered, and racialized subjects such as the young artists I worked with through WOTR. In fact, I founded WOTR precisely to appropriate the rarefied resources of the art world while engaging girls in its knowledge and debates. My goal was not to facilitate the girls' inclusion in an institution that is unconcerned with, if not hostile to, their existences and communities—but to make possible the activation of spaces in which they can speak back to, learn from, and create culture beyond the boundaries of the museum/gallery system in ways they find meaningful. As someone who regularly traverses the incongruous spaces of elite institutions (museums/galleries/universities) and working-class ethnic communities (my own in addition to those of my participants), I turn to the high art world now because I understand, following theorists such as Stuart Hall (1996), that low and high cultures are continually coimbricating and coconstituting each other. The lucrative deployment of chonga-esque style in the art world is seen specifically in the visual production and careers of artists Luis Gispert and Nikki S. Lee.

Luis Gispert's Chonga-esque Cheerleaders

The works that launched the career of the internationally recognized Cuban American artist Luis Gispert were a series of widely exhibited photographs titled *Cheerleaders* (2000–2002), which feature a multiracial cast of young women donning cheerleader uniforms with hair, makeup, and accessories that reference chonga style such as large gold hoop earrings, conspicuous makeup, acrylic nails, stylized ponytails, and athletic shoes. The young women in the photographs enact scenes ranging from the fantastical to the mundane, from posing in luxury vehicles to floating weightlessly in the air. The poses assumed by the bodies in the images often cite canonical baroque art historical narratives such as Mary mourning the body of Jesus.

FIGURE 2.6. Luis Gispert, *Untitled (Chain Mouth, a.k.a. Muse Ho)*, 2001.
USED WITH PERMISSION.

In *Untitled (Chain Mouth, a.k.a. Muse Ho)* (figure 2.6), Gispert references contemporary artist Bruce Nauman's *Self-Portrait as Fountain* (1967–1970), which is a play on art historical conventions of statuesque male nudes. Often described as a reference to Marcel Duchamp's readymade *Fountain* of 1917, Nauman playfully conflates his body with an object by capturing himself unclothed and spewing a stream of water from his mouth. Unlike Nauman, Gispert utilizes the body of a young woman to execute the parodic gesture in *Untitled (Chain Mouth, a.k.a. Muse Ho)* instead of his own. The description of the subject as a "ho" in the title and the manner in which her makeup, hair, and costume are styled inscribes her within the sexual-aesthetic excess attributed to chongas. Gispert grew up in Cuban American enclaves in Miami, where he likely encountered chonga discourse. Where Nauman emits a thin jet of water from his mouth in *Self-Portrait as Fountain*, the female figure in *Untitled* expels a long, thick, phallic gold chain. The sexual athleticism on display is reinforced by the cheerleader uniform, which symbolizes a type of

girl that is usually framed as being, like the chonga, sexually available, immature, surrounded by men, and hostile toward other girls.

Most of the young woman's body is decked in gold. The ornamentation makes her seem otherworldly and goddess-like, but the tattoos that ring her arm and belly button situate her in contemporary culture. The tattoo, coupled with the frosty blue eye shadow she wears (which is considered out of step with current conventions of taste and style), further signifies her as a trashy subject. The lack of a contextualizing background in the photograph leaves the eye to wander ceaselessly around her body. Enticed and guided by the ornaments, the viewer, like her, is visually arrested by her form. The green chroma-key background that frames the performances of Gispert's cheerleaders divorces them from a social context and indexes them as types on view.

In regards to the "Chongalicious" performers in character, the *Miami New Times* newspaper article employed a similar approach in their photographs of those girls, who are captured against an empty background.[13] These images represent chongas as spectacles and stock characters. The positioning of the young women's bodies in the images recalls Byzantine religious icons that situated biblical figures against solid, gilded backgrounds. These icons served to communicate the primacy and powers of the figure being presented—to exalt the subject. Yet in Gispert's images, the chonga-esque young woman's privileged position in the frame against the empty background has the alternate effect of fixing her. Her iconicity makes her knowable as a character (rather than a mysterious figure of authority), while simultaneously imbuing her aesthetics with visually seductive magic.

Art historian Krista Thompson (2009; 2015, 261–262) has argued that Gispert's images emphasize the constructedness of representation by refusing to give the *Cheerleader* figures pictorial or personal depth. Thompson suggests that Gispert's emphasis on the hypervisibility and shine of bling, the copious amounts of jewelry worn by the figures in the photographs, draws attention to the limits of visibility rather than revealing knowable and commodified racialized subjects. In this analysis, the figures in the photographs are seen as blurred and possibly freed of visual conscriptions through the blinding lights of bling.

Thompson persuasively argues that Gispert's photographs reveal the constructedness of representation by centering on denaturalized staging, poses, and digitally enhanced effects. But the images nevertheless fashion (re)presentations of aesthetically racialized young women that fulfill the

scopic demand for spectacular, attractive, and uncomplicated displays of young women's bodies. I find that the considerable negative space in the photographs neutralizes the shine of the jewelry in the images and draws the eye to the sharply focused figures on display. The conspicuous styles embodied by the young women in the photographs led to their celebrated consumption, perhaps because they represent an exotic form of representation that, until then, had not been commonly seen in mainstream contemporary art. The art world was ready for the consumption of "ghetto girls" (most of whom are light skinned), especially those who can't talk back.[14]

The *Cheerleader* series, completed soon after Gispert's graduation from Yale's Master of Fine Arts program, was ripe for commodification by the art world. In the *Miami Herald* article "Homecoming: Luis Gispert Returns to His Miami Roots as a Major Art World Player," published on October 14, 2007, reporter Tom Austin introduces Gispert to the reader by recounting the unpredictable success of the *Cheerleader* series. Austin explains how "Gispert's image of an airborne cheerleader was featured in the 2002 Whitney Biennial, then bought by the Whitney and used in a Biennial advertising campaign." The chonga images successfully branded Gispert as an up-and-coming artist versed in racialized street or urban aesthetics, thus giving his work a marketable edge. He has since exhibited work at the Royal Academy of Art in London, PS1 Contemporary Art Center, and Guggenheim Museum Bilbao, among other prestigious venues. The aesthetic excess of the chonga-esque girls in his photographs facilitated his success, which was lauded in Miami through the local success story discourse expressed in the *Herald* article.

Paradoxically, the denigrated chonga body became a symbol for Miami's growing cultural cachet as an international center for contemporary art. *Cheerleaders* was created soon before Miami Beach became the host city for the blue-chip contemporary art fair Art Basel in 2002, which marked the city's legitimacy as a cosmopolitan site that offers more than sex and sand. Gispert's photographs enable the adoption and positive valuation of chonga-esque embodiment in the art world through referencing a ghetto fabulous visual rhetoric that is found in popular portrayals of Miami in mainstream culture, such as in the video game *Grand Theft Auto: Vice City*. His citation of the art historical canon in the photographs and the circulation of his work in the fine art market situate the images in a more highly valued cultural register, and this edge provides a way for art collectors and institutions to feel fashionable, in the know, with an ear to the streets. The pleasure garnered from the chonga's idolized visual representation, however, is not echoed in

Miamians' descriptions of her corporeal presence in their day-to-day en-
counters, for which she is derided.

Nikki S. Lee's Chonga-esque "Hispanics"

Chonga embodiment has been a lucrative style to mobilize not only for art-
ists from Miami. New York–based artist Nikki S. Lee's images of chonga-
esque young women, featured in *The Hispanic Project*, were part of the
Projects series of photographs that launched her celebrated career. *Projects*
(1997–2001) documents the artist's interactions with groups such as punks,
skaters, and yuppies. She began work on the series several years after mov-
ing from South Korea to the United States to study fashion and photogra-
phy in New York City. The artist would approach members of subcultural
groups, explain her artistic project, and obtain permission to document her
interactions with them as a character. Lee underwent physical transforma-
tions through weight gain and loss, makeup, and costume in order to situate
herself in these milieus. The snapshot-style photographs serve to document
the artist's success in entering these American spaces, and in the critical lit-
erature, she has been described as a "chameleon" or someone "infiltrating"
these various subcultures (Chase 2007; Kaplan 2005; Lee 2008; Smith 2011;
Waltener 2004).

In *The Hispanic Project*, Lee images herself posing primarily with Latina
women around New York City, and her embodiment reflects their style. She
dons low-cut and stomach-revealing tops, tight jeans, large gold hoop ear-
rings, thick eye and lip liner, and curly hair worn in long gelled tresses or
gathered up in a bun high atop her head (see figures 2.7 and 2.8). In the pho-
tographs, Lee and her interlocutors are situated in informal, recreational
settings such as the New York Puerto Rican Day Parade, hanging out at the
beach, or engaged in animated conversations on building stoops in a New
York barrio. In one of the few domestic scenes in *The Hispanic Project*, she
is shown tending laundry hanging outdoors in a tenement yard while she
holds a small child on her hip. Her facial expressions in the photographs
tend to be serious, as she performs the tough attitude culturally attributed
to the working-class Latinas she emulates.

Although Lee's images are not as blatantly staged as those of Luis Gispert,
who posed his chonga-esque girls against a green chroma-key screen, there
is a similar representational flatness to Lee's photographs, as they redeploy
stock representations of young women of color carrying babies and display-
ing their bodies. As in Gispert's work, Lee's images of chonga-esque young

FIGURE 2.7. Nikki S. Lee, *The Hispanic Project (20)*, 1998. COURTESY SIKKEMA JENKINS & CO.

and keeps their hearts close to hers. She further explains how wearing the *azabache* and the charm of La Caridad del Cobre, the patron Virgin Mary of Cuba, on the chain helps her maintain faith and wards off the evil eye.[18]

The camera angle is fixed in an extreme close-up throughout the video, which emphasizes her face and chest as she continually plays with her hair and the rings on her hands as she talks. The viewer's eye is drawn to the shine of the jewelry and the movement of her hands as she gesticulates. It is not only the character's narration of the significance of the jewelry that gives the viewer a more profound appreciation of her style, but the emphasis on the aesthetics of the accessories themselves, and the lovely sounds they make, that articulate how donning excessive amounts of jewelry can be a practice informed by artistic, stylistic, spiritual, identitarian, and emotional considerations. The trinkets worn by Molinary's chonga character extend the embodied self not only through shine, but also through sound and movement.[19] This results in her occupation of social space and simultaneous protection from it, not only through charms endowed with special powers, but through the signification of a style that is associated with working-class women who talk and fight back: although chongas have a soft side, they decide to whom they reveal it.[20]

Unlike the images of chonga-esque young women created by Luis Gispert and Nikki S. Lee that frame the chonga body at a flattening, voyeuristic distance, Molinary brings chonga corporeality up close to the viewer, creating an intimacy that is absent in the other visual representations we have thus far considered. The chonga's face and hands, given the added complexity of movement through the medium of video, conduct the work of more sophisticated meaning making. In conversation with the work of Gloria Anzaldúa (1990), Deborah Paradez observes that the face "is an instructive surface of the body from which Chicana and other Latina feminists can theorize about the resistant embodied practices often adopted by women of color" (2009, 128). Molinary's face in close-up transmits theories regarding the complex art of Latina body practices. Queer theorist Juana María Rodríguez's comments on the power of Latina gesture to trouble racialized norms through an embrace of excess further illuminates the force of Molinary's performance: "When we are not understood, when previous attachments that mark us as savage and foul adhere to our skin despite our best intentions, when we are called upon to testify against ourselves about that for which we have no language, we can know that it is due to someone else's failure of imagination, their inability to read the moving marks of our gestures" (2014, 3). Drawing from Rodríguez, we can understand readings of chonga bodies that see aes-

thetic and social failure as the result of the viewer's incapacity to appreciate artistry and engage complexity.

The persona in "Off the Chain" concludes the video by stating, "I love everybody that gives me jewelry, and I love all my jewelry, and I love wearing my jewelry because it reminds me of the people that I love." For poor and working-class young women of color, relationships, spirituality, and valuable objects like jewelry take on added significance for sustaining and surviving life. I recall obtaining similar charms from family members as a child. I also have memories of my mother and grandmother pawning their jewelry, the only objects of value that they owned, to get through tough financial situations. Latina embodiments of sexual-aesthetic excess can articulate the few pleasures that attend challenging lives. If life isn't "Off the Chain," at least our bodies can be.

Chonga bodies make class burn through their explicit, corporeal staging of poor and working-class girlhoods that draw glaring attention to class exclusions and hierarchies. These are structures that are denied in neoliberal discourses that celebrate social mobility and meritocracy. The chongas' performance of sexuality through ethnically marked and hyperfeminine aesthetics—the jewelry, gel-sculpted hair, conspicuous makeup, and tight outfits—burns a bedazzled hole into this blanket discourse of neoliberalism. I have shown how the chonga body is enmeshed in a variety of social discourses that generate aesthetic value from the presentation of working-class Latinx aesthetics while they are simultaneously denigrated in everyday discourse because they mark a rooting in and orientation toward Blackness. Because they are perceived as perverting or misusing the potential or "promise of beauty" (Nguyen 2011) to maximize life and claim normative belonging in society, chongas are framed as "ineligible for personhood," to use Lisa Cacho's (2012, 6) framing.

Yet I have also strived to demonstrate how chonga aesthetics exceed regulatory efforts through acts of body crafting, speaking, and visual production that assert the artistry, complexity, and humanity of working-class Latinas—like the chonga girl whose makeshift memorial I used to pass regularly as I walked through the parking lot of the Museum of Contemporary Art where I worked as a youth educator (figures 2.12 and 2.13). Her name is Paola Cordoba, and she was killed in a fight with another young woman in April 2011 outside a bar in North Miami that is in close proximity to the museum. Real chonga girls live real lives, and their public, hypervisible bodies, instead of making us laugh, should remind us of the pride, performativity, pleasure, and struggles of Latina existence.

FIGURES 2.12 AND 2.13. Street memorial for Paola Cordoba, North Miami.
PHOTOS BY AUTHOR.

Even when our bodies have been battered by life, these artistic "languages," spoken from the body, by the body, are still laden with aspirations, are still coded in hope and *"un desarme ensangretado,"* a bloodied truce. By sending our voices, visuals and visions outward into the world, we alter the walls and make them a framework for new windows and doors. We transform the *posos*, apertures, *barrancas, abismos* that we are forced to speak from. Only then can we make a home out of the cracks.

— GLORIA ANZALDÚA

THREE

"FINE AS HELL"

THE AESTHETIC EROTICS OF MASCULINITY

As a place away from home, participants have used WOTR as a space for assuming masculine embodiments through a project inspired by the work of contemporary artist Cindy Sherman and local Miami artist Crystal Pearl Molinary. Both utilize makeup and costume to document their performances of multiple subjectivities using photography. Many of Sherman's figures are drawn from and transform stock representations of women in art and film, and Molinary's characters are inspired by the flamboyantly dressed Latinas she encounters in working-class Miami neighborhoods, like Hialeah.

In the WOTR workshop based on Molinary's and Sherman's work, instructors bring bags of clothing, wigs, and accessories, which include masculine clothing items such as camouflage shirts, bubble jackets, baseball caps, and men's tank tops. The WOTR artists are prompted to create and embody a character of their imagining and to document the styles and personas they create with photographs. Although most of the participants in a given group tend to utilize the more feminine clothing in the selection, there are usually

FIGURE 3.1. Artwork created by WOTR participant artist.

several girls who craft and perform a masculine character. Oftentimes, these artists seem somewhat hesitant about utilizing these masculine items, but they eventually overcome their discomfort, don the clothing, and material-ize their concepts for the photographs, as in the student artist in figure 3.1, who was inspired by the style of rapper Lil Wayne.

The art and politics of WOTR artists' masculine styles were performed corporeally and also through our charlas (conversations). For example, in re-sponse to my question about what her ideal embodiment would be, a sixteen-year-old girl who described her ethnicity as Hispanic and gave herself the pseudonym Dimple (due to the dimples on her face) had this conversation with me:

DIMPLE: My hair the way it is, picked up. It would be shaved, plaited.
A tattoo of a money sign behind my ear, some big diamond earrings—

some grills [gold tooth caps]. My eyebrow piercing. Snake bites [two lower-lip piercings]. A red-and-black stripe Polo. Some Dickies, some red-and-black Jordans. A red-and-black fitted [nonadjustable baseball cap]. A gold Jesus diamond piece [charm]. Tattoos up to here [sleeves from the elbow to the shoulder]. A gold bracelet. I'd feel raw [cool] as hell. People would think that I'm a rich-ass dyke [chuckling].

JILLIAN: What do you think people who would see you out in public think about this look?

DIMPLE: If they were straight girls, they'd be like, "She looks like a boy." And if they were gay, they'd be like, "That girl is fine as hell."

Dimple's description of her look is rich with detail that conjures textures, patterns, colors, designer labels, and the shine of gold and heavy ornamentation of tattoos and piercings. Dimple refers to the key elements of a fresh, masculine, contemporary hip-hop style as embodied by hardcore rapper Plies, whom she mentioned as a style inspiration. She articulates her mastery of this masculine style with references to grills, fitteds, diamond pieces, Polos, Nikes, and Dickies.

Despite being very soft-spoken, Dimple performed confidence when sharing her ideal embodiment in group and seemed comfortable discussing her ideas with the other WOTR artists and myself. Though she was able to be open about her lesbian sexuality and masculine mode of embodiment, she was sometimes the butt of jokes by girls in her therapy group at a drug rehabilitation center in Miami that at the time had a residential program for adolescent girls. For example, when I brought a bag of Hershey's Kisses to the group one day and asked them to distribute it, girls laughed when Dimple asked me if I wanted a kiss. When she accidentally brushed by me during a WOTR workshop, one of the girls sardonically joked, "Miss, she's just trying to touch you." Although the discourse on sexuality was relatively open among that group of girls, Dimple's sexuality drew particular and often teasing commentary. Though their banter was never mean spirited, and she would often laugh with and tease the other girls in turn, interactions like these demonstrated how Dimple's nonnormative gender presentation and sexuality aroused some anxiety and had to be regularly negotiated by the girls through humor in order to facilitate her inclusion as the only lesbian-identifying, masculine-gender-performing member of the group.

Although Dimple was able to deflect the girls' aggressions with wit, it did not change the fact that in the end, the straight-identifying girls decided

whether or not she was an insider or outsider. This dynamic seems to be one that Dimple also navigates in public, outside of girls-only spaces. For example, when I asked her what she believed boys would think about her ideal embodiment, she responded, "They'd say, 'Is that a bitch?! [i.e., Is that a woman?]' It's funny to me. I laugh when it happens." Humor appears to be a mode of survival that allows her to maintain a sense of dignity as she negotiates homophobic and sexist reactions to her queer performance of gender and sexuality.

Dimple would commonly wear her long, wavy brown hair back in a simple high ponytail, and the sides of her head were shaved. She wore no makeup and would often don Bermuda shorts, simple Polo-style shirts, and brand-name high-top sneakers. The kind of self-esteem she expressed when she made statements such as, "They'd be like, 'That girl is fine as hell!'" was connoted nonverbally by the sure way she carried her tall, broad frame and her bright, easygoing, dimpled smile. She exuded confidence, despite sharing how she experienced bullying in public by boys, and telling me that her family would disapprove of the tattoos and gold jewelry that she would acquire if she could: "My mom would say that's low class."

According to Dimple, her mother associates the jewelry and tattoos she desires with "low-class" hip-hop culture, with its connotations of Black masculinities and poor street life. This is likely due to the fact that the particular kind of clothing and body modifications she desires, and the way she would wear them, are inspired by the dress of contemporary hardcore rap artists, whose work stems from the racialized working-class aesthetics of gangsta rap in the 1990s. As Miles White (2011, 69) notes in his study of rap and the performance of Black masculinity, the emerging genre of gangsta rap in the 1990s centered the Black masculine body and highlighted post–civil rights era tensions between middle- and upper-class Black people who fled the inner city and the poor and working-class members of the community who were left behind. Thus, for light-skinned Latina girls like Dimple in Miami, with the city's powerful, politically conservative, white-identifying Latinx population, the aesthetic excess of tattoos and gold jewelry, and their attendant references to poor and working-class Blackness, are causes for correction in the embodiments of light-skinned masculine Latina girls, or hyperfeminine chonga girls, who are inspired by hip-hop style. This racialized reading of body aesthetics views conspicuous consumption as marked by poverty, rather than wealth; visible abundance is read as overcompensation for lack.

Yet, what gender-normative, classist, and racist readings of styles like Dimple's do not account for is how the performance of conspicuous consumption marked by tattoos and jewelry index self-sufficiency and economic success in some Black/Latinx subcultures. Dimple's body narrative about her mother's view of proper class reveals how class often describes much more than a socioeconomic position. As demonstrated in the discourses surrounding Latinx chonga girls explored in chapter 2, class often entails a performance of racial, gender, and sexual respectability, rather than actual purchasing power or wealth. In a social and cultural context in which Black and Latinx people are still viewed as subjects who belong outside high-class spaces, there is pressure for these communities to excessively perform respectability in order to be legible as legitimate class subjects. This performance entails the inconspicuous modes of consumption practiced by the aspirational white classes, who are invested in the acquisition of knowledge and cultural capital, and whose socioeconomic privilege is masked through a putatively progressive political ethos (Currid-Halkett 2017).

For the parents of many light-skinned Latinx youth such as Dimple, distance from Blackness, even when this Blackness is monied, is an effort to secure socioeconomic mobility for their children. We can infer, then, that according to Dimple's mother, the performance of masculinity which her daughter desires would make class burn through a display of conspicuous consumption that is linked to Blackness. Notably, sociologist Nicholas Vargas (2015) has found that despite the growing rate at which Latinx are self-identifying as white in demographic studies like the U.S. Census, they are not read as white by others unless they are perceived to be both light skinned and upper class.

Despite risking the protections and privileges afforded to girls who embody normative femininities, masculine-body-presenting woTR artists described how their dress afforded them erotic pleasure through the performance of financial power (in Dimple's words, being seen as a "rich-ass dyke") and sexual attention ("They'd be like, 'That girl is fine as hell!'"). Dimple's use of the term "rich" is worth noting here, as it carries different connotations than "wealthy." "Rich" harkens to the visible performance of class popularized in the 1980s, which, although culturally glorified, has also been looked upon as a period of greed, material excess, and moral degradation—to be "filthy rich." Rich means you want people to know you have money, and in the context of the contemporary aspirational class, people may not know that your yoga pants cost over $100.

But masculine-body-presenting woтк artists are uninvested in the embodied performances of the aspirational class, as they have no desire to assume the respectable aesthetics that would potentially facilitate their belonging. Rather, the masculine-body-presenting woтк artists with whom I had charlas fetishize the trappings of the rich and mine their concomitant erotic currency, a phenomenon that anthropologist Louisa Schein (1999) describes as "commodity erotics." For example, a Black masculine-presenting artist in a woтк workshop once described a fantasy scenario to her friend while working on her paper sculpture project, in which she would dress up like a successful businessman in order to lure a good-looking woman to her home, and that when they would finally be alone, she would reveal her feminine body and assuage the woman's anger at her deceit by performing amazing oral sex. For this artist, donning a masculine suit, and thus signaling economic success, would be a powerful strategy for achieving her sexual aims and, in turn, for providing pleasure to her partner through an eroticized performance of class. Rather than signaling greed, my masculine-body-presenting participants enact performances of masculine financial power to convey that they can take care of themselves and their partner, both economically and in bed.

Such pleasures come at a high cost for gender-nonconforming, masculine-body-presenting women and girls of color, whose styles are often met with social disapproval, as expressed by discrimination, harassment, and violence. Examples of such violence include the 2003 murder in Newark, New Jersey, of Sakia Gunn, a masculine-body-presenting fifteen-year-old Black girl who self-identified as lesbian, by a street harasser. Gunn's murder received little press attention compared to the media response generated by the murders of gay white youths, such as Matthew Shepard.[1]

In 2006, a group of gender-nonconforming Black lesbians, some known as the New Jersey 4 (Renata Hill, Patreese Johnson, Venice Brown, and Terrain Dandridge), defended themselves against the verbal and physical assaults of a street harasser in New York City. Rather than indicting the man who attacked them, the state instead arrested the New Jersey 4 for fighting back. They served several years of prison time and were smeared in the media as a gang of animalistic and wildly aggressive lesbians.[2] By ignoring their status as survivors of heterosexist violence, these narratives reflected and reinforced the discursive framing of Black women's masculinities as deviant, intolerable, and worthy of punishment. In examining the politics of embodiment for genderqueer Black women, Kara Keeling notes, "Violence also underpins the labor required of aggressive female masculinity

and the political economy that secures such phenomena as black masculine unemployment, rising rates of incarceration, and feminicide" (2009, 578). In our current social climate, violence is an inescapable threat and reality for gender-nonconforming working-class people of color, and they cannot expect empathy from the public nor justice from the state (Spade 2015). These severe social realities and media narratives occlude the pleasures that attend the masculine body presentations of queer young women of color, which are achieved by assuming the aesthetic excess of Black and Latinx masculinities and appropriating, through embodied performance, the socioeconomic power conferred on rich cismen for their own ends. By weaving together the masculine body narratives of my lesbian Black and Latinx participants, many of whom hail from the Caribbean, this chapter conducts the work that Omise'eke Natasha Tinsley describes as imagining and documenting how brown women are "keeping sweetness among themselves" (2010, 4).

By lovingly tracking along the conceptual paths opened by my participants' body narratives, this chapter thwarts the totalizing discourses of victimization to instead explore how their masculine bodies reflect their sense of identity through the performance of what they term their "ego," which provides them with avenues to self-expression and sexual satisfaction. I discuss how they negotiate assuming masculinities in their social and familial contexts, and conclude with an analysis of a heated debate in a WOTR workshop sparked by the display of a photograph, created by artist-activist Zanele Muholi, of a masculine-body-presenting subject that my participants read as a ciswoman with facial hair. The ways WOTR artists derided the masculinity presented in the photograph as excessive because it signified the potential of a trans identity evidenced the often unwieldy ways that they attributed meaning and value to gender variance through discourses of aesthetic excess.

The Body Narratives of Style Blues

The WOTR artists' engagements with masculinity harken back to those bold and gratifying embodiments practiced by Black blues women such as Ma Rainey and Gladys Bentley in the early twentieth century—who indulged in cutting a figure in top hats and tailored suits. In addition to these queer histories of gender-nonconforming body presentation, the body narratives of my participants parallel the tension between pleasure and pain, power and subjection that is the unique force of blues music. My inspiration for naming their body narratives "style blues" in this chapter stems from Angela Y. Davis's analysis of Black women's expressions of erotic desire and emotional

turmoil in blues music. As Davis notes, "What gives the blues such fascinating possibilities of sustaining emergent feminist consciousness is the way they often construct seemingly antagonistic relationships as noncontradictory oppositions. A female narrator in a woman's blues song who represents herself as entirely subservient to male desire might simultaneously express autonomous desire and a refusal to allow her mistreating lover to drive her to psychic despair" (1998, xv). Beyond its ability as an art form to express such opposing feelings and desires, the blues is a historical and aesthetic archive of the avowals, made by Black women, of lesbian desire and masculine body presentation. We see these desires and styles exemplified in Ma Rainey's song, "Prove It on Me Blues" (1928), in which she sings,

> Went out last night with a crowd of my friends,
> They must've been women, 'cause I don't like no men.
>
> It's true I wear a collar and a tie,
> Makes the wind blow all the while
> Don't you say I do it, ain't nobody caught me
> You sure got to prove it on me.

Ma Rainey makes it clear that, like Dimple, masculine dress makes her feel fine as hell.

The WOTR artists often refer to themselves and the members of their communities as gay, even though they are aware of the term "queer," as it was in circulation in the Miami-based GLBTQ youth–serving organizations through which I interacted with them, which I refer to as Lifelines and the Coalition for GLBTQ Youth.[3] The term "gay" is sometimes viewed as a retrograde and problematic identification that indexes homonormativity, but it is important to note that the use of the term by my youth participants stems from their working-class communities. "Gay" has significance and meaning to them in their self-production and social practices, and thus I respect and draw upon their use of it here. As Tinsley notes in her study of women who love women in the Caribbean, "*Queer* is only one construction of nonheteronormativity among many—and listening to other languages, and others' historically specific sexual self-understandings, is crucial to broadening the field" (2010, 6).

The theorizing engaged in by the young, gender-nonconforming Black and Latina artists I work with, like the early Black feminist blues, is marked by seeming paradoxes that they frame as "noncontradictions" and varied, at times coexisting experiences of pleasure and pain. This blues genealogy

compels me to read their narratives with nuance. In chapter 2, I explored how the ethnically marked, hyperfeminine, sexual-aesthetic excess of Latina chonga styles has been and continues to be disparaged among young women in Miami, and more broadly in the discourses surrounding chonga girls in culture and media. My interactions with and observations of young women in Miami revealed that, in order to fashion an acceptable embodiment for young women of color, it is not only hyperfeminine excess that is to be avoided. My participants made it clear that masculinity is an even more vilified mode of aesthetic expression. Although the modes of gender nonconformity signified by chongas and masculine-body-presenting young women are not commensurate, they conduct similar cultural work by signifying difference in a culture that violently insists on its occlusion. The young gay women I work with term their gender-nonconforming masculine body presentations their "stud" styles, and so I frame chonga styles and stud styles as distinct iterations of sexual-aesthetic excess. The sexual-aesthetic excesses of stud masculinities are negatively judged through rhetorics of sexual, gender, racial, and class otherness.

Working-class communities of color in the U.S. are always already imagined as gender and sexually deviant. This has been expressed in influential social studies such as the Moynihan Report of 1965 and Oscar Lewis's book *La Vida: A Puerto Rican Family in the Culture of Poverty* in 1966, which framed the gender performance and sexual behavior of Black and Latinx single mothers as the primary cause for the economic, social, and educational struggles of communities of color. This discourse continues to be echoed through films such as *Precious* (Lee 2009), which tells the story of a poor, young Black woman who is an incest survivor subject to the abuse of her pathological mother, who is single, cheats the welfare system, and does not work. In the mass-market film, which provides a much less nuanced depiction of poor Black girlhood than the novel upon which it was based (*Push* by Sapphire [1996]), Precious finds redemption by dedicating herself to education and performing selfless motherhood to her two young children. Such cultural texts demonstrate Roderick A. Ferguson's (2004) contention that the framing of Black gender and sexual deviance has been attended by and functions through discourses that link the overcoming of social marginalization and inequality with the performance of normative and respectable gender, sexual, and family formations.

What makes the sexual-aesthetic excess of chonga girls and the masculine-body-presenting young women I engage here threatening is that they, intentionally or not, refute the demand to perform gender normativity and

aesthetic respectability. In the case of chonga girls, the hyperfemininity they perform draws agitation due to the manner in which they make class burn by revealing the racialized economic disparities occluded by neoliberalism, but it is important to note that the excess sexuality read on their bodies is often assumed to be heterosexual. The masculine bodies of the young women of color I engage in this chapter are also subject to negative critiques that are linked to class, but these bodies are also read as sexually queer, thus heightening the threat they pose to the heteropatriarchal order and raising the stakes of these body practices for the participants who employ them.

Unlike femininity, masculinity has been positioned in U.S. culture as indicative of the possession of material, social, and political power (Connell 2005; Halberstam 1998). Thus, the perceived trespass of women into masculinity is met with intense hostility as it signifies an appropriation of power. Jack Halberstam (1998) has observed that masculinity becomes perceived as excessive and threatening in normative discourse when it is performed by men of color. For women of color in marginalized communities, choosing to assume masculinity can be a life-or-death decision, especially because the poor and working-class aesthetics they sometimes embody are similar to those of Black and Latinx men—whose lives and bodies are made disposable through police violence and mass incarceration. Taking on such styles thus marks the bodies of women of color as similarly devalued. Black masculinity is often framed as "dangerous, prone to trickery, promiscuous, and contaminated" (Snorton 2014, 9). Latinx masculinities are normatively perceived as "'lazy' and 'immoral,' potentially 'criminal,' and always 'illegal'" (Cacho 2007, 185). Given these realities, this chapter takes seriously the meanings, politics, and affects that stem from the pleasure of working-class youths of color who self-identify as gay women, looking and feeling "fine as hell" in masculine bodies. The masculine styles innovated and practiced by my participants conduct critical work in asserting self-worth, a radical act given this social context. This self-worth is narrated in participants' style blues through the performance of a confident ego that stems from their erotic relations, and these sexual relations are shaped by the performance of monied masculinities.

Masculine Ego and Erotics

Wicky, a seventeen-year-old Black Jamaican artist, has big brown eyes and a wide smile that reveals her sparkling metal braces. At the time of our charla, she had short, straightened black hair that reached her chin and framed her

round face. She prided herself on her academic performance and would often arrive at wotr evening art workshops at Lifelines with her soccer gear on. Wicky was an especially outgoing member of the group, usually gossiping with friends at the center about who they were "hooking up" with. The description she offered of the clothing she would wear as part of her ideal look was simple:

> wicky: No braces. On a normal day, I'm in some nice comfy boxers and some nice low jeans to show the boxer line—and a simple shirt.

> jillian: What is it that you like about your boxer shorts and your jeans?

> wicky: Oh my god, do you know how sexy that is?!

> jillian: Because you find it sexy in other people?

> wicky: No! Because girls find it sexy in *me*!

> jillian: What do you think girls like about it?

> wicky: It's cute. It's attractive.

> jillian: But what do you think they like about it? Is it sexy because it's underwear? Is it sexy because it's masculine?

> q [interjects]: It's just sexy. It's masculine. I associate that with a masculine female. So, I'm just like, "Take off the pants" [starts chuckling].

> wicky: No, it's serious! When I go to my . . . um . . . friend that's at fiu [Florida International University], and I have just this much showing [indicating with her fingers an inch or so of boxers], it makes things [sex] much better.

In this passionate and playful commentary, Wicky and Q indicate that masculine clothing items such as boxer shorts heighten the erotic charge of their encounters with other women, which reflects how butch body presentation is a potent signifier of sexual prowess among queer women of color (Yarbro-Bejarano 1997).

My participants' conversation revealed that what makes the donning of boxer shorts erotic is that it is known by the parties involved in the sexual exchange that there is not a penis under the pants and boxer shorts. Part of what drives the desire is the subversion of femininity, the incorporation of masculine power that the boxer shorts symbolize, and the attendant asso-

ciations of visible underwear with a cool masculine sexuality. The display of boxer shorts under pants has been a trend among young men in hip-hop and skateboarding subcultures since the 1990s, continuing through the recently popular hipster and emo styles. The style practices described by Q and Wicky enable femme girls who are attracted to masculinity but not to men to enjoy masculine corporeal embodiment while engaging in sexual relationships with women. Simultaneously, these style practices boost the confidence of the masculine women and girls who choose to partner with femme girls.

When I asked Wicky how her ideal look would make her feel, she responded, "Like if I could pull any hoe."[4] Masculine dress provides a method for her to feel that she could attract any girl of her liking. The performance of masculine ego was also a topic discussed in a WOTR group by Q, a twenty-four-year-old Black woman who wears shoulder-length dreadlocks and is a mentor figure much loved by the youth at Lifelines. Q describes herself as a "stem" (stud/femme) because she moves in and out of masculine and feminine embodiments. Q's everyday style would range from feminine floral dresses and sandals to basic jeans, sneakers, and T-shirts. When she shared her ideal look, she described two different outfits, one for a feminine embodiment and one for a masculine embodiment.

> I would be 5'9". Don't ask why—I would be shorter. My [dread]locks would go down to my lower back. I would still be the same thickness. I love my thickness, but I want smaller feet so that I am able to wear heels, at least be able to wear heels and be tall. No glasses, I love my glasses, but they're annoying. I will have at least fifteen tattoos. I have a tattoo that I want on my arm. I'll just be walking around with pumps and a dress. That's my girly side of me. If it's just my boyish side, I would be in some black jeans, white button down with a blue vest on, wearing my cap with my braids locked backward, stud earrings, shoes, most likely Perry Ellis.

Q's fluid construction of gender identity is further articulated when she discusses her various tattoos of yin-yang symbols, which represent to her the duality of feminine and masculine that she embodies and balances in her life. She explained, "I already have three yin-yangs on me. So, I just have a fascination with them because of the simple fact that it's the diversity, there's the good and the bad, and that's how I see myself. There's Q, and like I said, there's Kevin. It's just Q comes out more than Kevin. Kevin is my boyish side." Q and I are Facebook friends, and I have seen photo posts

FIGURES 3.2 AND 3.3. Q as Kevin Xavier Thomas posted with hashtag "prettyboiswag";\.
FIGURE 3.4. Picture collage by Q juxtaposing Kevin with stem style.

she has shared of herself as a stud, and others in which she highlights her stem identity by juxtaposing her feminine style as Q with that of Kevin, her alter ego. The photos she has posted on Facebook, which she has given me permission to reproduce here (figures 3.2–3.4), convey the complex performativity that attends her styling practice—her wide smile and colorful dress as Q, contrasting with the restrained and serious posture of Kevin.

Some of the masculine-body-presenting young artists I worked with talked about feeling particularly confident and powerful in their masculine dress, often using the term "ego" when describing the identity that attends their masculine embodiment. Wicky described her masculine embodiment through an ego narrative of boyhood. When I asked her what her ideal look would communicate to a stranger in public about her identity (her low-riding jeans revealing her boxer shorts), she responded, "That I'm gay. Because, it's basically describing what my egotistical side is, which is a little boy, a tomboy." It is notable that rather than framing herself as performing manhood, Wicky draws on the rhetoric of boyhood to index a more playful, youthful, and malleable mode of masculine gender performance.

The narratives of my participants articulate the processes by which they understand masculine egos to project their inner selves to others, and how masculine egos are projected to themselves by their bodies.[5] The WOTR artists not only framed "ego" as constituting a truthful sense of themselves, but

they also mobilized the word to mean a particular iteration of the self that possesses self-confidence and often performs the possession of money. For example, I recall Dimple describing her ideal embodiment as signifying to others that she is a "rich-ass dyke." So the ego here is not only a mode of subjectivity, but also a particular feeling of self-possession that attends that subjectivity. The feeling of self-possession that marks the ego my participants describe is shaped by its association with monied masculinity, and was articulated in Q's body narrative as well.

Q described her look as Kevin as embodying the most confident or "egotistical" aspect of her subjectivity, in contrast to the feminine styles she tends to wear more often. Note the contrasts she outlines and performs:

JILLIAN: So, Q, if you're walking around as Q in your ideal look, what would people know about you?

Q: The simple fact that I'm confident, and I really don't care. It's more or less how I am now, like, when I throw on the dress, the makeup, the whole girly-ness—it's one of those things, people [pauses]. . . . Honestly, in my head I have low self-esteem, but it's one of those things—I guess I portray confidence. Because if I feel pretty that day, people are like, "Oh, she's cute," or "She has confidence." And people walk up to me and stuff like that, and I'm like, "Uh, why are you walking up to me?" and they're like, "You're cute." "Really?" Like in my head, I'm like, "Whatever." So I just walk away. I guess I portray that confidence, but in my head, I'm like, "Really?" . . . eh . . . [shrugging her shoulders].

JILLIAN: If you're walking around like Kevin, what do you think people will know about you?

Q: That I have an ego. Especially when I used to do it in the past, I would always go to the mall, and my friends would love it, because I would have on my jeans. I don't do the whole baggy thing when I do boyish—I do clean. Like, you could tell I'm doing well [financially] type of look. I like to wear the button-ups and the vests, so every time I used to do that, I would have females walk up to me and be like, "You must have a job or somethin'." They would walk up to me because I have that confidence. I have on my hat and my braids, my braids pulled back, so I would have that swag going on, and females would just love it, because it seems like I was confident, and I would go up to people more easily, and they would just be like, "Hey, how are you doing?"

It was so much easier. With me it was with ease. Because I'm already tall, I'm broad. It was one of those things where, it came out so naturally. I don't know—it was just confidence. People saw that I was really confident. I exuded that confidence more when I was dressing boyish.

Not only does Q say that dressing in a masculine fashion makes her feel confident, but her diction changes as she describes embodying Kevin. As Kevin, she talks about having "swag," or swagger, in her interactions with women. In discussing her style as the feminine Q, she frames herself as passive, when people come up to her, and she does not believe that they are genuine in their compliments—their attention makes her uncomfortable. As Kevin, who embodies financial success by looking like he has a good job, she takes on the active role of introducing herself to other women and feels that her confidence is more genuine. There is a marked contrast between the narration of Q's "I guess I portray that confidence," and Kevin's "I have that confidence."

Like Q, my participant Kay, a seventeen-year-old Panamanian American artist, also expressed how a masculine style of embodiment would allow her to feel more like herself:

KAY: I hate wearing feminine clothes that accentuate my curves. Especially because I don't like going out and the way guys look at you. I fucking hate it. The thought of leaving the house like that freaks me out. I feel disgusting, and I don't feel like myself. I feel like I'm wearing someone else's idea of myself, and it's someone else's idea, and it's not mine, and it bothers me, and I wish I could change that. I would eliminate all the girl clothes in my closet that my mother insists on buying, even if I tell her I'm not gonna wear them. I wish I could wear the jeans and T-shirt and blazer combination because it looks really good on dudes, but I've never been able to try it out properly. I've never had the opportunity.

Both Kay and S. Lion, a twenty-six-year-old Jamaican American artist I worked with through WOTR's collaboration with the Coalition for GLBTQ Youth in Miami, described how, in their ideal embodiment, they would have smaller breasts so that the masculine clothing items they like would fit them better. Kay discussed how her breasts developed rapidly in middle school: "I have really mixed feelings about it [her breast size]. Because I like wearing boys' clothes. But I don't like the way it looks when I look in the mirror because my chest is big." S. Lion said, "I've had big breasts since a really

young age, and I feel more masculine, but my body type isn't, so it doesn't really match that, and a lot of times people view my breasts and view it as feminine. I also feel like, for the clothes I wear, it would look better if my breasts were smaller, and I don't wanna wear bras all the time." My charlas with Q, Kay, and S. Lion show how the restricted, gender-codified manner in which clothing is designed does not allow for gender-nonconforming young women to feel satisfied with their bodies, nor with how they look, when wearing the masculine clothes that they choose as a way of expressing their subjectivities. As my participants talked about the confidence they feel, or believe they would feel, in masculine dress, they often shared how they navigated their gender-nonconforming body practices at home.

Family members and especially participants' mothers were referenced as most significantly affecting their ability to assume masculine styles. This was a central focus of Bright's comments in the group discussion at Lifelines. Bright, a twenty-three-year-old Jamaican American artist, has a very feminine style that is marked by bright colors and bold patterns, as her pseudonym suggests. On the night of our charla, she was wearing a straight medium-length black hair weave with blunt bangs, soft makeup, pink nails, a black-and-white herringbone-patterned hat, short denim shorts, a fringed white shirt, lots of shiny jewelry, and open-toed platform sandals. In our conversation she discussed the evolution of her style from masculine to more feminine:

> BRIGHT: When I was in high school, and, you know how you dress like your favorite rapper? So Lil Wayne is my favorite rapper. So, back then, I had locks in my hair, so I went and got some cargoes and this army fatigue thermal that he had on. It was this whole thing from a picture that he had on. And I walked in the house, and my mom was looking at me like I was crazy. She was like, "What is this? This a new style or somethin'?" That definitely wasn't okay—at all.
>
> JILLIAN: Is that something that a lot of girls did, dress like guy rappers in high school?
>
> BRIGHT: No, it was just during Spirit Week. Oh no, I love dressing like a girl. Would I dress like a boy if my mom accepted it? I don't know....

Bright remained pensive for a while after making this statement. It seemed as if, in that moment, she realized that she might have taken on an alternative style, if she felt she could. When imagining what she would look like embodying masculinity, she exclaimed,

BRIGHT: I'll be a hot boy. I'll be a hot boy! I was a tomboy when I was in middle [school]. I was like that girl that, if you saw me in a skirt, you'd be like "dayum." When we were in middle school, we had to wear a uniform, and it was shorts and a Polo [shirt]. And I hung with boys. I had five best friends. We all hung out together. We were bad and got in trouble in school. We all hung out with the boys. So when I dressed in girl clothes for picture day, everybody was like, "That's what you look like without the uniform?" But I think if my mom wasn't strict, and if she wasn't against the whole gay lifestyle, I would dress in boy clothes.

Now my baby sister. She's kind of like how I was in middle school. She's eleven, and I'm like, "Let's go get our nails done and our feet done," and she's like, "No, that's too girly. No, I don't like looking like girls. No, I don't like skirts. I don't like dresses." And I'm like, "Please, Lord, please, I hope she don't be gay."

JILLIAN: [I misheard her statement and asked] You hope she's gonna be gay?

BRIGHT: No, I hope she don't!

ALAIKA: You don't want that, because of what you went through.

BRIGHT: If my baby sister would be gay, my mom would fault me for that. Cuz my baby sister is up under me all the time. You gotta have really really thick skin to be gay because you need to put up with a lot of comments. I had one of my friends—I was up in college—and she was like, "Um, so, I think I like girls." And it threw me because I was like, "Where did this come from?" She's Dominican, and to me, Dominican people are like Black people. There are gay Dominicans, but it's not accepted.

Like my best friend, she's gay, and I remember she would hide it from her mom, and she was talking to this girl like a dude, but her mom thought it was a boy, and when it came out, I was like, "I don't wanna be in the house." And when my friend told me that she wanted to be gay, I was like, "It's a lot you gotta deal with. People are gonna say stuff." Like, my mom is one of those people, that she's gonna say what-ever comes in her mind, like, she doesn't care. And today I was hang-ing out with one of my friends, and she was like, "When do I come in your house?" and I looked at her like, "You will never make it through my front porch."

JILLIAN: So your mom knows? But you just try to keep your gay friends away from your house so that you don't have to deal with her?

BRIGHT: She knows, but I keep it away. That's how I do it. A femme, yeah, okay, come over then, but a butch or a stud, are you crazy?! Oh no! I'll be over the balcony—like, it's not happening—it's not happening at all.

JILLIAN: And why the stud, because your mom thinks that is who you're gonna like?

BRIGHT: No, because she "knows" that they're gay. It's more obvious.

Here, Bright articulates a view of Black and Latinx communities as having little tolerance for queer sexualities and gender presentations. In this comment she implicitly compares Black and Latinx families to white communities, which reflects popular discourses that frame people of color as acutely homophobic while ignoring the heterosexism that pervades white mainstream society (Decena 2011; El-Tayeb 2012). In another part of the conversation, she discusses how her mother's homophobia keeps her from establishing relationships with studs because she needs to keep them away from her family, as they appear to make queerness burn through their "obvious" embodied marking of lesbian sexuality. Bright feels that she would be unable to pass off such a relationship as platonic. Thus, her mother's regulation of her style also results in a policing of Bright's sexual life. In response to these dynamics, Bright works to police the body presentation of her sister in turn, to protect her from having to face similar struggles.

From what I heard young artists share in WOTR, the labor of educating girls into normative and respectable forms of body presentation tends to fall upon the women and girls in the family. Women of color filmmakers have powerfully captured these intragender modes of policing in films about queer Black and Latina girlhoods such as *Mosquita y Mari* (Guerrero 2012) and *Pariah* (Rees 2011). Although the father figures in these films attempt to discipline their daughters into normative performances of sex and gender, the mothers grapple much more intimately and intensely with their daughters, which often results in conflict. Both films present these relationships with complexity by pointing to how larger gendered and racialized societal pressures and economic realities have shaped the perspectives of these mothers, and the viewer comes to understand them as women who are subject to policing and oppression at various levels themselves. Although the fathers may seem more accepting and cool with their queer daughters, it is

because of the privilege they have as men to avoid disputes with their children, when that dirty work goes to the moms.

This conflict over body presentation between mother and daughter plays out in the body narrative of S. Lion. Like Bright, S. Lion used school as a space in which to embody masculinity away from home: "Throughout school I would dress boyish, but I couldn't wear boys' clothes, so I would wear sports clothes because I was always playing sports. I would have to change in my friend's house to really wear them [boys' clothes]." When I asked her how her parents have reacted to her mode of dress, she replied, "My dad never said anything because he never talked much, but my mom always wanted me to dress like her pretty little girl. But we have a cool relationship, so she didn't put too much pressure. Now she's so used to it, so sometimes she'll even compliment me on my outfits, 'I like that outfit. You look nice,' or whatever. So she's okay with it now." My participants' stories suggest that they have had close, strong, and loving connections to their mothers, connections which are now strained by the mother's perception that the daughter refuses to please her by persisting in masculine forms of dress. Mother-daughter body policing is difficult for participants to handle because of their close proximity to their mothers in the home space, as well as their relative lack of control over the space and any money to be used for purchasing clothing. They can leave school when the last bell rings, but at the end of the day, they need to come home.

Thus, Kay negotiates carefully between her desires for gender nonconformity and her mother's strict restrictions on dress by toeing a fine line between femininity and masculinity. When discussing her ideal hairstyle in our charla, she said, "I wish I could go shorter, but I can't, because this haircut is short enough to where I can feel boyish but long enough to wear it so it makes my face more feminine, so my mom is cool with it, and my family is cool with it—so they can say, 'She looks pretty now,' and I say, 'I feel more like myself.' So it's a nice in-between space, but I wanna do me, but I can't do that right now." Kay has carefully gauged her family's expectations to assume a hairstyle that would both express her subjectivity and avoid sanction. Nevertheless, she looks forward to occupying a space outside of this liminality in which she could exercise more power over her body presentation.

When I asked Q how her family reacts to her different styles, she responded,

My mother loves it when I'm more girlish, because when I was younger, she would try to take me shopping to do the matching outfits, and I

would cry. I would be like sixteen years old in the mall—she took me to the mall one time, and she tried to get me to put on matching cargoes with a top, and I completely cried and flipped out because I didn't want it. I didn't like anything like that, so now when we go shopping, I actually do grab the tights and the dresses and stuff like that, and she loves it. She's like, "Yes! I finally get the daughter that I want." But at the same time, when she sees me getting my briefs, my T-shirts or whatever, she doesn't say anything because she still gets what she wants, so she's like, "Okay, I learned to accept it. You do you. When you're having your boy days, that's fine, whatever, but I love it when you're a girl."[6]

S. Lion, Kay, and Q have established both tacit and explicit understandings with their mothers through which they are able to strategically mark their bodies as masculine, while simultaneously consuming feminine items and styles that also satisfy their mothers' normative investments and restrictions. The styling of adolescent and young women's bodies can be sites of struggle, as parents and guardians attempt to form the subjectivities of their children in ways that fulfill their expectations through the disciplining of their bodies (Foucault 1977). Although these conflicts hinder girls' self-expression in injurious ways, it is important to note that these parents' expectations are likely shaped by an awareness of the kinds of social punishment and violence their daughters' gender nonconformity may likely be met with. I do not wish to justify the gender policing that occurs in these family settings, but rather, to humanize these relationships with the aim of understanding how larger realities of heterosexism structure the power dynamics of the intimate spaces that young women of color must negotiate, especially those whose families are dealing with the entwined oppressions of racial, ethnic, and class marginalization.

My own vivid memories of difficult experiences with my mother over dressing and grooming myself are conjured by Q's story about crying while shopping in the mall with her mother for clothes. When I was fifteen, I decided against having the traditional *quinceañera* that would be customary for a Latina girl from my community in Miami. I appeased my mother's desire for a quinceañera portrait by having a photo session in a simple party dress at Glamour Shots. I felt ambivalent about the photo shoot. On the one hand, I was excited about having attention lavished on me by a hairstylist and makeup artist, but at the same time, I felt extremely awkward about it. I felt nervous while taking the pictures, being told to hold my gaze, raise and lower my chin, and hold on to tacky props without moving.

The one thing that made the process worth it for me was the hairstyle they gave me. They took my long curly hair, blow-dried it, and flat-ironed it straight. It made me look older, and I felt attractive and confident. When the stylist was finished with me, my mother looked at my hair and began to cry uncontrollably. She told the hairstylist that he made me look too old, that I was just a girl, that he went overboard: "This is for a fifteen-year-old girl, not a woman!" Despite my protests, she instructed the stylist to wash the style out of my hair, and what resulted when dry was a frizzy, wavy halo of hair that I thought looked horrible. Then I was the one crying.

I despised the way my hair looked in the photos because it reminded me of the women in melodramatic Latinx soap operas airing on Spanish-language network television at the time. It agitated me to see myself resemble this particular kind of ethnic gender ideal. It was something my mother wanted to see in me, but not at all what I felt was an expression of myself. The Glamour Shots quinceañera adventure became an emotional ordeal where my body became the object and subject of contention, as my mother was faced with the reality of my nearing adulthood.

Kay expressed a similar feeling of corporeal misrecognition in regard to her ethnicity. In describing her ideal embodiment, she spoke about a tattoo that she wanted on her chest that would read *patria*, meaning "nation" in Spanish. In explaining why she wanted this word tattooed on her body, she said, "Because I wrote this poem about my grandma, and she really liked it, and I really love my grandma. So I want to have some sort of connection to her, and the line was, 'con tu cuerpo de barrill y tu corazón de patria no me parezco a ti.' It doesn't translate very well. It almost translates insultingly, 'with your body like a barrel and your heart like the fatherland, I don't look like you.' It doesn't sound very nice in English—in Spanish, it's nicer." Kay's poem expresses a failure of recognition when gazing upon her grandmother's body, which she describes as operated by a heart that symbolizes the nation of Panama. Both the poem and Kay's desire to mark her body with the word "patria" perform a complex disidentification (Muñoz 1999) that both embraces and rejects ethnic and national identity.

Kay's discussion of her style negotiations at home reveals how the mothers of my masculine-body-presenting participants exhibited some openness in their interactions with their daughters. For example, Kay went on to talk about how she would like to own more sneakers, but that her mother would not buy her any more unless she wore more sandals: "If I don't buy feminine clothes, she won't buy me even androgynous clothing—she refuses to. It's like a trade embargo, is what it amounts to." Kay expressed hopes for

more freedom in her body crafting when she begins to attend college in San Francisco, which is a vast distance away from her family in Miami. As she described how she was beginning to be able to go shopping by herself for college clothes, Kay explained,

> The embargo thing is not as big [lately], because I can go out and buy things myself. I think on some level, my mom is kinda coming around, too, at least a little bit. It's sometimes a big swing. I don't know what day I'm gonna catch her on. Because I recently bought this jacket, and it's just really nice, and my mom complimented it and was like, "Yeah, it's a really nice jacket." The fact that she can be honest with herself about the jacket is promising, but I think it's gonna get better when I go to school.

These narratives reveal how Black and Latina mothers, who are normatively imagined as acutely homophobic, are rather flexible about and supportive of their daughters' masculinities and sexualities. It appears that femininity need not necessarily be performed in a normative fashion. Rather, it seems that their mothers feel that through obtaining feminine clothes, the sandals and the dresses, even if they are never worn, their daughters nevertheless maintain the potential to accomplish femininity, to use Marcia Ochoa's (2014) phrasing. These body narratives are mother/daughter-style blues. These blues tell of the tension between the mothers' subtly recognizing that their daughters look "fine as hell" in masculine clothes through offhand compliments, while also being burdened with policing their daughters as a strategic choice based on their own experiences of navigating hostile social environments. Despite the stress of navigating their bodies and sexualities at home and in public, woTR artists nevertheless insisted on finding ways to express their ego, perform socioeconomic power, and obtain erotic pleasure through masculine aesthetics of excess.

They drew on their relationships with each other for support and inspiration as they took on their innovative aesthetic risks. When discussing her ideal look, Wicky shared that the style was not inspired by any celebrities or by pop culture, but rather that her friend Alaika, a young Black Haitian woman, was her point of reference in crafting a masculine style: "It's inspired by Alaika. She made me see that no matter [pause] . . . she made me have the courage to do it [dress in boy's clothes], that's what she did. She led by example. Before I came here [Lifelines], I didn't feel comfortable doing that. Now, I'm just like, whatever." When I asked Wicky how she dressed before meeting Alaika, she responded, "I dressed, like, the same, but I wasn't

confident about it. Don't get me wrong—I still pulled numbers [picked up girls]." As Wicky's story suggests, the queer space of Lifelines affords the opportunity to meet other young women with similar experiences and body expressions, reflecting what C. Riley Snorton (2017, 162) observes as the "alternative set of relations" offered by Black sociality as a site for expansive decolonial gender articulations. The Black gay youths at Lifelines create a place where they can experiment with styles that they otherwise would not feel comfortable wearing. Wicky's account is important, as it points to the ways in which young artists of color create their own style subcultures and provide each other with support that boosts their confidence, in contrast to the many scholarly and popular discourses on girls and fashion that focus on how pop culture and media are negatively influencing body image, discourses that often leave out girls of color, especially those who are gay.

"Women Should Not Have Facial Hair": When (Trans)Masculinity Becomes Excess

My charlas with masculine-body-presenting WOTR artists prompted the instructors to create a workshop that centered on artists who explore and/or embody masculinity in their practice, such as Ana Mendieta, Catherine Opie, Frida Kahlo, and Janine Antoni, among others. The workshop has since been conducted at a variety of organizations that serve girls, not just those that have a mission to serve queer youth. My colleague Anya Wallace and I presented one of these workshops at Lifelines one night with a group of about six to eight young gay men and women—at the time, WOTR workshops were presented there with mixed-gender groups. We read poems by Audre Lorde and Cheryl Clarke together, and discussed the work of Black South African activist/artist Zanele Muholi.

Muholi documents the lives of Black queer and trans people in South Africa through the portrait photography project *Faces and Phases* that began in 2006 and continues as of this writing. Muholi utilizes their activist methodology to capture the corporeal styles that Black genderqueers have developed to create a historical archive. In describing the series, Muholi writes, "'Faces' express the person, and 'Phases' signify the transition from one stage of sexuality or gender expression and experience to another."[7] Although the series centers on the Black lesbians and trans men in their community, Muholi also understands *Faces and Phases* as conducting an important kind of self-work. Noting that they do not have photographs of their own family members, an "erasure [that] was deliberate and is true for many

black families across the globe" that has caused an emotional void due to a feeling of disconnectedness from their genealogy, Muholi explains, "In each photograph that I take, there is a longing and looking for 'me.' I am capturing the black, beautiful portrait of my young self" (2014, 6).

By presenting the work of Lorde, Clarke, and Muholi together, Anya and I aimed to spark charlas with the youth at Lifelines about how race, gender, and colonial legacies inform the lives of queer Black people both inside and outside the United States. We also discussed how these writers and artists have utilized creative means of raising consciousness about discrimination and queer Black people's sexualities and subjectivities. As we looked at images of Muholi's work, the group commented on the clothing styles of the people in the photographs, whether they liked them or disliked them, and some of the young women in the group talked playfully about being attracted to the women in the images.

The tenor of the lively discussion took a dramatic turn when we displayed an image that Muholi had captured of a masculine-body-presenting Black person, Phumzile Nkosi, wearing a white shirt and black sweater vest.[8] In the photograph, Nkosi is bald, with breasts discernible beneath their clothes, and they had a small tuft of wiry facial hair under their chin. The Lifelines group read Nkosi as a masculine ciswoman, probably due to the ways in which some of them self-identify as ciswomen who are studs.

Q was the first one to judge the photo negatively. She did not like the facial hair and said that it ruined Nkosi's otherwise well-put-together stud look. She thought this was a woman who had crossed the line in terms of gender nonconformity. The idea of the stud, she explained, was to look like a masculine woman, not just like a man. Alaika chimed in, along with Johnny, a young man at Lifelines who frequently attended our workshops. Johnny was very harsh in his judgment of Nkosi's body and was disgusted by the facial hair. When I asked why, he said, "She's a woman, and women should not have facial hair. That is something she should take care of." None of the young women in the group came to the defense of Muholi's photographic participant. Only two boys in the group contradicted the overall derision toward the participant's facial hair. Stanley, a young Haitian American man who always had strong and assertively argued opinions, was particularly vocal in his defense of Nkosi's beard and told the group that it was not right to judge the way people express themselves with their body.

Alaika, never one to pass up the opportunity for a debate, got very agitated and screamed at Stanley, asking him if it would be okay if people walked around nude in the streets. For Alaika, social acceptance of what

she perceived as a woman's beard would amount to social acceptance of public nudity. Although both nudity and facial hair would be expressions of a natural state of the body, participants argued that the manner in which the participant in the photograph did not modify their body made them appear "unnatural," as they read the participant's body as that of a stud woman. The program liaison at Lifelines joined the discussion and tried to prompt the group to consider how they were being discriminatory against gender-nonconforming people, and Alaika subsequently walked out of the room, upset because she felt she was being attacked.

Anya and I were unprepared for such a forceful response and did not anticipate that the photograph was going to spark such a heated conversation among the group. Our experience that night made it clear that, even in spaces where youths embrace queer life, there are limits to the gendered embodiments that they will accept, and in this instance that limit was demarcated as an orientation toward trans embodiment. Even as they lament about how normative constructions of gender and sexuality restrict their lives, they also police boundaries of embodiment and sexuality. I believe that masculinity is particularly difficult for these young women, not only to embody in their own lives but also to negotiate living with, and how to understand it in other women, genderqueers, and trans people. The social pressure to make their masculinity normative in some way is formidable. It appears that in order to embrace some forms of gender nonconformity, they have to denigrate others, in order to attain a sense of normalcy.

In her essay "Feminine Stubble," Rachel Burgess, who self-identifies as a Black lesbian, describes how people in the lesbian spaces she frequents react to the growth of hair she has under her chin. The facial hair makes her body difficult for others to read. People in queer contexts do not believe that she is a biological woman, and straight people think that she has a medical condition. She contends that the social construction of gendered bodies makes men the only appropriate bearers of facial hair, and the same constructions make women with such hair seem unattractive and/or sick. As a Black woman, the reading of Burgess's body engenders an even more volatile process. As Snorton notes, "In apposition with transness, blackness, as, among other things, the capacity to produce distinction, has come to structure modes of valuation through various forms, producing shadows that precede their constituting subjects/objects to give meaning to how gender is conceptualized, traversed, and lived" (2017, 175).

Burgess theorizes that what makes her body so displeasing to people is that it compels them to engage with difference in a neoliberal context. She

finds that the silences and glossing over of questions of difference and embodiment (in regard to race, class, gender, and sexuality) facilitate women's collusion in the social construction of beauty and gender. People often try to give Burgess advice on how to get rid of her "problem," pity her, or provide her with theories about what kind of medical issue might be causing it. She writes, "What I embody both brands me and keeps me hidden from the view of some heterosexual people and some in the LGBTQ community. I am visible because I am marked first as black, then as hairy. However, the *way* I am marked and how this visible, bodily performance of gender is constructed also makes me invisible. I interrupt both heteronormativity and lesbian performances" (2005, 232, emphasis in original). Like Burgess, the hirsute participant photographed by Zanele Muholi caused an interruption and eruption in our discussion of Black queer subjectivity and creative production.

I later wondered if WOTR artists' negative reactions to Muholi's image were expressions of transphobia and cissexism. The interaction that night stayed with me as I continued to work on this book, and I raised the issue of the reaction to the photograph in a group discussion at Lifelines in 2013, held a year after the initial charla on Muholi's work in the WOTR workshop that Anya and I led.

The young women at Lifelines in 2013 who participated in the group that night included Q, Alaika, Tamyra, Suzie, Ruth, and Juby. Q and Alaika were the only ones present that day who had been part of the initial discussion on Muholi's work in 2012. Q and Alaika were also the only self-identified studs in the group. Juby was dressed in a feminine style. Ruth, Tamyra, and Suzie were dressed in gender-neutral casual dress, such as jeans, T-shirts, basketball shorts, and loose-fitting workout pants, and wore no makeup.

As most of the participants there that day were not present in that contentious discussion, I described the reactions of those participants in the initial debate on the Muholi photograph and displayed the image on the wall through a projector hooked up to my laptop. I asked them, "Do you think that the problem they had with the facial hair is that it seems to be trans?" Juby responded, "It's nasty! I don't want no man!"

JILLIAN: So it's an aesthetic thing?

RUTH: You play into the stereotype. It really irks me. You need to wear a tie or a vest to look like a stud?

TAMYRA: Exactly.

ALAIKA: But you should see me, cuz when I wear my tie, I'm looking good for real—I'm just sayin'.

RUTH: You play into the stereotype [of gender norms]. You play to it, but it doesn't make you who you are. Your clothes don't make you who you are. So by wearing these clothes, what you trying to say? You're really trying to prove a point to someone? Who wants to wear a tie all day?

Q AND ALAIKA [in unison]: But we're not talking about clothes [meaning that the conversation was supposed to be centered on the facial hair in the photograph].

Q: But there are people who are not Americanized, who are in Third World countries. She's like [Nkosi], "I have facial hair, whatever, like, okay. I'm masculine, so I'm gonna rock my hair." But what difference would it be if that person was feminine and had masculine hair? It's just her chemistry.

Q, in a marked contrast to the negative judgment about the participant's facial hair that she expressed over a year before, articulated legitimacy for the hair through allusions to an alternative aesthetic context in Africa and to biology, citing Nkosi's possible chemical makeup. Ruth continued, "I wax my mustache. I have a mustache right now, and in pictures, it looks ridiculously dark. And it's not that I'm ashamed—I just look better without my mustache."

TAMYRA: I don't think it's the way you're dressed that makes you, but it's your personality shown through your dress. It's like the way I feel this [indicating her outfit] looks like a dancer. So, I dance, so—I'll put on an outfit that looks like a dancer to me. Tomorrow I'm gonna go wear an outfit that will remind me of Candy Land [an annual rave event in Miami].

RUTH: You are adding to the stereotype. You are adding wood to the fire. When a woman who is a stud has the facial hair, it's adding wood to the fire. Who is to say that because you're a man, you have to have facial hair?

ALAIKA: It is [reinforcing the stereotype]. It's like, "Are you a male or a female?" You can be a female dressed like a male, but once you start growing the facial hair and all that, you start becoming the other one [male].

Although Ruth fervently argued that studs reify stereotypes by crafting masculine bodies that draw on traditional signifiers of manhood such as ties, vests, and facial hair, she performed a similar reification of normative masculinity by describing how these elements do not belong on what she perceived to be a woman's body. Ruth finds it hard to believe that anyone would choose to wear a formal article of clothing like a tie all day, as it is associated with work, and Alaika retorts with a playful remark about how good she looks in them: "You should see me," she says. Although Alaika defends the stud's right to don men's attire, she agrees with Ruth that facial hair on a stud transgresses a significant boundary, citing the inability to read a clear-cut biological sex on the body as the problem.

Ruth, Juby, and Alaika then diverted to a discussion about how an additional negative element of the facial hair is that it is not hygienic, remarking that beards carry odor. I asked them, "Well, you're talking about the facial hair like your problem is an aesthetic/hygienic thing, but isn't your issue that you think this hair doesn't belong on what you think is a woman's body?"

ALAIKA: You're a stud. There is nothing wrong with you being a stud, but by growing a beard, you are trying to get that male role.

JILLIAN: Is that transphobia, or trans discrimination?

ALAIKA: It's not, I mean, it would be . . .

TAMYRA: It's the inability to put this person in a box that makes people upset. It's like, "Are you a girl? Are you a guy?"

RUTH: What makes me upset is that you're playing to men, cuz that's what men have. Men have beards, and she's trying to be masculine.

At this point, the debate crescendoed into a cacophony with all members of the group, with the exception of Suzie, shouting over one other to make their points. Q, raising her voice to quiet the others, aggressively asked Ruth, "Do you know their story?! Do you know their story?!," referring to Muholi's participant. Alaika turned to me in resignation and said, "I feel like this is a year ago. To me, we are having the same argument."

RUTH [to Q]: We're talking about this person [pointing to the image]. What do you see? She's trying to dress like what?

Q: I don't know what she's trying to dress like.

RUTH: What is she trying to dress like?!

Now Juby and Alaika broke the thick, electric tension growing between Ruth and Q by jokingly shouting in unison, "She's trying to dress like a man!" as they extended their arms to give each other a hard high-five slap, laughing. Ruth, still serious, said, "Exactly, she's trying to be a man because that's what a man is supposed to look like."

Q: Who said that's the way a man is supposed to look like? You talk about a box? There is no such thing as a box.

RUTH: She's adding to the stereotype.

Q: Okay, so tell me—what's the stereotype?

RUTH: That to be a man, you need to have facial hair and look like that.

Q: I know women who have facial hair—I know women who look like that.

RUTH: We're talking about this woman who happens to be a lesbian. We're not talking about random straight people.

Q: It doesn't make a difference. Then you're the one conforming to the stereotype. Because you're like, "She's a lesbian, so this means this. She's masculine, so she has to be this. Because she's a stud, it has to be this."

I intervened at this point, as it was evident that not even Juby and Alaika's goofy antics were going to quell the argument between Ruth and Q.

I raised the history of similar conflicts among women in the 1970s, when feminists launched a critique of butch-femme aesthetics. The issue of butch-femme body presentation continues to strike a nerve and is mired in politics of class and race, as well as those of sexuality and gender. In response to the denigration of butch-femme roles among feminists, scholars and writers such as Joan Nestle (1992) and Elizabeth Lapovsky Kennedy and Madeline D. Davis (1993) have shown how, rather than reproducing heterosexism, butch-femme has marked gender and sexual nonnormative difference and served as a mode of social and sexual organization for lesbians of the 1930s through the 1950s.

Butch-femme aesthetics were less visible in the 1960s and 1970s, due in part to the influence of feminist politics. In the essay "All Dressed Up, but No Place to Go? Style Wars and the New Lesbianism," sociologist Arlene Stein examines its resurgence in the hyperconsumer culture of the late 1980s: "Eighties butch-femme—if it can accurately be termed such—is a self-

conscious aesthetic that plays with style and power, rather than an embracing of one's 'true' nature against the constraints of straight society" (1992, 434–435). Stein notes how the late 1980s not only augured a return of butch-femme but also occasioned the commodification of feminine lipstick lesbian styles that were appropriated by pop icons such as Madonna. These body practices indicated a kind of lifestyle lesbian existence centered on apolitical, postfeminist, neoliberal notions of personal choice and consumption.

My masculine-gender-performing participants merge the discourses of an inner masculine ego with notions of gender presentation as a kind of choice that is marked by the consumption of particular brands and clothing items like Nike and Perry Ellis. The historical, subcultural context for situating the body aesthetics of these young women of color does not follow the dominant narrative of lesbian style in feminist and LGBTQ studies—a narrative that began in the working-class bar cultures of the 1930s through the 1950s was followed by a suppression of butch-femme embodiment during the radical feminist eras of the 1960s–1970s that worked to eliminate codified gender presentation, and finally developed into the more consumer-based body practices of the 1980s that continue today. In contrast, I work with young Black and Latina women who have different positions in relation to the formations of butch-femme sexual aesthetics. My participants' aesthetics are situated specifically within queer of color histories of body presentation and erotics (Snorton 2017; Vargas 2010).

For example, in *Boots of Leather, Slippers of Gold: The History of a Lesbian Community*, Kennedy and Davis (1993) describe how the participation of Black lesbians in the butch-femme bar culture in Buffalo, New York, of the 1930s–1950s was constrained due to institutionalized racism. Black lesbians developed an alternative scene that centered on house parties held on the weekends, often running from Friday night through Sunday evening, with breaks for church in between. Many white lesbians of the same era embodied a butch aesthetic with signifiers of working-class masculinity, such as rolled-up blue jeans, boots, and T-shirts. However, Black masculine lesbians, termed "studs" in addition to "butches," would often craft their body styles through more elegant and expensive fashions that signaled financial success. Kennedy and Davis write, "Studs had high standards for dressing up, and often cut an elegant image in three-piece suits. . . . Black lesbians adopted this more formal look even on week nights. . . . Whenever they went out they wore starched white shirts with formal collars and dark dress pants. Their shoes were men's Florsheim dress shoes worn with dark nylon socks. They had their hair processed and wore it combed back at the sides and cut

square at the back. Studs put a great deal of money and energy into their clothes, buying the best" (1993, 163–164). I find echoes of the fastidious stud style of the past in the descriptions of stud dress given by Q, who works to craft a formal stud embodiment consisting of sleek, tailored, expensive clothes.

The debate over the photograph by Zanele Muholi, and the charged affects it induced, demonstrated the vicissitudes of gender performance and identification negotiated by my participants. As Judith Butler notes,

> Identifying with a gender under contemporary regimes of power involves identifying with a set of norms that are and are not realizable, and whose power and status precede the identifications by which they are insistently approximated. This "being a man" and this "being a woman" are internally unstable affairs. They are always beset by ambivalence precisely because there is a cost in every identification, the loss of some other set of identifications, the forcible approximation of a norm one never chooses, a norm that chooses us, but which we occupy, reverse, resignify to the extent that the norm fails to determine us completely. (1993, 86)

Understanding the ambivalence that attends processes of identification helps explain why contradiction and paradox so mark the style blues narratives of WOTR artists. There are no outside gender logics for them to work from—anything they construct or resignify will be the product, or by-product, of an order that preceded them. They want to claim legitimacy for women who embody masculinities, but they also value their ability to clearly read sex/gender as male/female on the bodies of others. Some articulate a notion of innate femininity that impels them to negatively judge stud style and subjectivity for being male-identified, despite the fact that the feminine identity they refer to is a normative construct. Yet the fact that some of my participants' views on and practices of gender presentation have changed over time, such as those of Q and Alaika, reveals how they practice flexibility in their negotiations of gender constructs as their own "faces and phases" shift and transform. It is also likely that the young women I work with expressed more rigid notions of gender in group charlas than those they enacted in their everyday lives. This was demonstrated by how there were no hard feelings among the group that night as the conversation meandered to other matters—as it often does in the lively space of Lifelines.

Like the complex ambivalences that mark the narratives of the blues women, we can understand the debates I have shared here as expressions

of the disidentificatory ways WOTR artists negotiate norms of gender and sexuality through their body presentations, artwork, and performance practices (Muñoz 1999). The charlas among the queer young women of color I work with evidenced a keen critical ability and knowledge among them, and a willingness to participate in difficult dialogues that conduct local yet significant work toward expanding the possibilities of gender presentation and body aesthetics for Black and Latina women and girls.

Conclusion

The blues narratives of the young Black and Latina artists I work with express how masculine aesthetics provide them with access to sexual pleasure, a means of expressing their subjectivity, and a mode of performing financial success as signaling the ability to care for themselves and others, both economically and sexually. Their displays of conspicuous consumption (or their desires to do so) are an important aspect of what makes them feel attractive, even when, in some instances, their class performances may be derided due to their relation to Black and Latinx masculinities perceived as retrograde and deviant. Even though Dimple understood the gold chains, sneakers, and caps she desired in her ideal body presentation as potentially marking her status as rich, her mother would nevertheless read this style as "low-class" due to its racial valences and aesthetics of excess.

Stud styles inspired by hip-hop culture are devalued because racialized masculinities are negatively framed as improper or excessive in their displays of affluence. Even though these bodies signal the financial success that is celebrated in American capitalism, the expressive manner in which this prosperity is displayed transgresses normative notions of proper taste. Whereas chonga bodies are denigrated for too obviously signaling poor and working-class existences, Black and Latinx hip-hop masculinities are shunned for being too obvious in their flaunting of disposable income (or limited income that is perceived to be utilized irrationally).

This exposes a paradox in neoliberal discourse, in which upper-class status can be assessed as low-class if marked by racialized bodies that draw attention to the particularities of class station (Miller 2009). Whereas the wealth displayed by people of color via consumption could be read in a neoliberal frame as indexing the fruits of productivity, hard work, and success, it is instead understood as indexing pathological consumption (or waste), leisure, and deviant modes of earning money (Vargas 2014). As Clyde Woods notes, "Many present-day social theorists continue to bemoan the lack of

humility among impoverished African Americans; but these scholars have yet to understand the global epistemological stance of 'self-made and Blues rich'" (2007, 46). Through divergent modes of gender presentation, both chongas and studs make class burn.

Thinking through the mobilization of the term "ego" which my participants employed to describe the subjectivity that is expressed through their masculine dress, I explored how their varied assumptions of masculine styles craft complex expressions of their gender and sexual difference. However, the manner in which participants engaged with Zanele Muholi's image of a masculine-body-presenting Black participant with facial hair revealed their own normativities, particularly in what they perceived as the proper boundaries of female masculinities and, more broadly, the complicated ways they negotiate understandings of gender and embodiment. Together, these narratives tell the story of how, in Miami, working-class young women of color who self-identify as gay, along with their mothers, lovers, and friends, navigate survival in a hostile culture, but also do much more than that. They create new modalities of embodiment and sexuality for themselves and others as they move through their everyday lives with style.

The politics of looking and feeling "fine as hell" coalesce in my thinking into a collective blues lyric that speaks to my participants' declarations of pleasure in masculine embodiment, and I close with these here:

MA RAINEY: Wear my clothes just like a fan, talk to the girls just like any old man.

ALAIKA: You should see me, cuz when I wear my tie, I'm looking good for real, I'm just sayin'.

Q: I like to wear the button-ups and the vests / I have on my hat and my braids pulled back / I would have that swag going on, and females would just love it.

BRIGHT: I'll be a hot boy! I'll be a hot boy!

WICKY: I'm in some nice comfy boxers and some nice low jeans to show the boxer line / Girls find it sexy in me!

DIMPLE: I'd feel raw as hell. People would think that I'm a rich-ass dyke.

MA RAINEY: 'Cause they say I do it. Ain't nobody caught me. / Sure got to prove it on me.

A LETTER TO THE WOMEN IN MY LIFE, IN PARTICULAR
FOR THOSE WHO DO NOT YET UNDERSTAND WHAT I'M DOING
IN THEIRS AND MAYBE NEVER WILL.

/ MAYRA RODRIGUEZ

/

I was born on January 12, 1995.

Raised in Tijuana to the smell of taco vendors, confused de un lado a otro. Ni de aqui ni de alla. History rooted in the café farms in Zacatecas, manos to mold masa, and a legacy of kick ass mujeres you just don't fuck with.

Mi jefita, a mujer chingona from Mexico el D.F, whose crazy laugh always soothes my soul, while it manages to scare everyone else around me. She makes the best flautas and tacos dorados de papa and chiles rellenos.

Her Mexican hips mark the floor each time she dances cumbias to the beat of the Blue Angels.

A mujer who after her mistakes and continual imperfections, is constantly going against domesticity and gender roles, actually, always went against domesticity and gender roles.

She sped the process of divorce, although I don't blame her for that, leaving my dad to raise two younger girls, leaving me to be someone I am yet to have in my life.

You needed, you need, time to reconcile what you lost. Married at 16, 4 kids later, 41 years of age I don't blame you. I respect a womyn who seeks her agency, but as your daughter I am still having to negotiate whether through your soul searching and decision-making, I lost mine.

/

I learned from the best. The sweetest strongest mujer I know.
Abuelita Sol, whose name is a clear reflection of the ray of sunshine she shines on all of us,
She warms a cold space with her presence, her ability to care and love, unconditionally,
with no strings attached, expecting nothing in return.
Mujer, sangre indigena,
Imagen, symbolo de Tonantzin, reina de reinas sin comparación
bronze in color,
Beautiful reflection of the best qualities of Mexico.
Oaxaquena, hands soft as tissues but yet carrying so much history,
cared for her man as much as he cared for his woman.
Till death do you part, you held him in his last seconds of life, as you brushed his hair,
He knew you were safe,
He knew you were strong.
He searched for you.
He knew you were the backbone of the family, caring for a man who lost a limb, paralyzed
on the left side of his body, diabetes took him and you still, after 30 plus years, remain
firmé, ready to love and be loved.
He survived for so long for you. He survived for so long because of you.
A flower with damaged petals, nunca deja de ser flor.
Only the best can see it for what it is. Beautiful with its different shades of brown,
the smell shifts into something more refined.
A love story, ready to be imitated by the best of them all.
I hope to love as much as you do.
I hope to be loved as much as you are loved.

You might be surprised, at the tone of these words. I am surprised in writing them.

Like a window, open me when it's beautiful outside, shiny and dry, with a bit of breeze. When it's cold, rainy and gray, don't open it. Keep it shut. Don't fear having to expose your shame, hiding behind bible verses. Religious images. Maybe then your salvation will come.

I am constantly told you are off-limits.

Constantly reminded of my queerness.

Having to strategically park in certain spots to properly say goodbye.

Having to look down, unconsciously, every time you're in the room.

Having to stay outside, feeling uncomfortable in a place that used to feel like a home away from home.

Having to feel sad for not having acceptance from someone whom I owe nothing to.

I feel like I had to come to terms with my sexuality, not because I was prepared to, or because my stereotypical tomboy attire "outs me," or because I was sure of who I was, but because in a place where my sexuality became my only identity, I had no other choice than accepting it.

You might be surprised, at the tone of these words. I am surprised in writing them.

Through it all. It may seem like I am still not over it. I haven't been able to build a wall that is indestructible, shame resistant, and anti-colonial.

I haven't been able to check my privilege, having two parents, where the need to "come out" was never something significant, necessary, relevant, or important.

Growing up dad always looked at my brother and said, when you have a girlfriend, always know to love and respect her. While turning to me, taking the time to smile, and saying, whenever you choose whoever you choose, just remember to love them and respect them.

Even after three years of being with a person that makes me feel complete.

That makes me feel that despite everything, no matter how hard, how difficult, I am worth it. Is something I have to thank you for.

You raised an amazing human being.

Besides her own identity, conflicting with your own ideals of a perfect daughter.

Besides her "choices" in choosing the person she's with.

Blaming me for turning her a certain a way,
Blaming me for feeling as if I have taken something from you.
Blaming me for feeling ashamed.
Because through feelings of sadness, anger, frustration and confusion, just know, I am
thankful, I am appreciative, and I admire you.
Because through long graveyard shifts, your love is expressed in different ways. Took me
a long time to realize that.
I am still trying to navigate your mind, putting myself in your shoes. Walking with them,
to realize they will never fit.
I don't blame you for your lack of acceptance.
I know you need time, I know you need space, I know you need to come to terms with
something so strange, to you.
Because although you don't understand what I am doing in your life.
Always know I am grateful for being picked by the woman you raised.
You might be surprised, at the tone of these words. I am surprised in writing them.

/ Mayra Rodriguez was a student in my fall 2014 Latinx Sexualities undergraduate course at
the University of California, San Diego

I am often talking to Hilton [Als] on the telephone about many things. One of the things Hilton got me to talk about was my childhood, as he often does. Amused as he can be by my childhood obsessions of like Helen Willis and Mary Tyler Moore, and my pink telephone, and all those things you [Hilton] get me to say over and over again. But what was really important to me thinking that day when [we] were talking was also that I decided I wanted to be a curator when I was fifteen years old. It was my junior year in high school. I didn't just say I wanted to be a curator; I wanted to be a curator at the Whitney Museum.*

* Thelma Golden talking to Hilton Als at the Whitney Museum of American Art in a panel discussion moderated by Huey Copeland on the twentieth anniversary of the landmark exhibition Golden curated there in 1994 titled *Black Male: Representations of Masculinity in Contemporary American Art*. Video documentation at Whitney Museum of American Art (2015).

CHELMA GOLDEN'S PINK TELEPHONE
TRANSPORTED HER TO
THE SITE OF HER
GIRLHOOD
DREAMS
LIKE ROCOCO MAGIC.

FOUR

ROCOCO PINK

THE POWER OF NICKI MINAJ'S
AESTHETICS OF FAKERY

The Trinidadian-born, New York–raised hip-hop superstar Nicki Minaj (Onika Tanya Maraj) was a recurrent topic of discussion among the girls in WOTR workshops throughout 2012 and 2013. The frequency and intensity of their engagement with her body led me to address it in our group conversations about popular culture. Sometimes girls would recite her rhymes, but usually when Minaj was invoked, it was in the context of theorizing her body: what it looks like now, what it looked like before she gained celebrity, and how it was influencing other girls. The issue of Minaj's body was often framed as a narrative concerning fakery against authenticity, creativity versus marketing strategy. These conversations were animated by the WOTR artists' sometimes simultaneous feelings of pride, disgust, disappointment, and admiration of her.

When Minaj was just emerging in underground rap videos in 2006 and 2007, she assumed a baseball cap and hoodie-wearing street style. Later, in stark contrast, the figure of Minaj that appeared in videos such as Lil Wayne's "Knockout" in 2010 was a highly affected and baroque body clad in

bright pink lipstick and a blonde wig with cotton candy blue-and-pink high-lights. Blonde hair, pink, and girlish candy colors have been Nicki Minaj's trademarks since her association with Lil Wayne and his Young Money la-bel. Although she invoked Barbie doll aesthetics early in her career, even posing as if she were trapped inside pink Mattel-brand packaging on the cover of her first mixtape, titled *Playtime Is Over* (2007), Minaj's body began to more directly signify white Barbie embodiment with the release of her first album, *Pink Friday*, in 2010. Although Minaj's skill in delivering rhymes contributed to her success in the music industry, the body she displayed fo-mented her rapidly growing recognition in the media. Minaj's performance of various alter ego characters in her music, elaborate body presentation, and adoption of the Barbie brand have made her the target of critiques in media and everyday discourse concerning "bad" body and race politics. She is viewed as conforming to Eurocentric norms of beauty and stereotypes of excessive Black female sexuality.

In addition, Nicki Minaj is often perceived as having a fake body modi-fied by plastic surgery. Discourses about the artist's fakery have circulated in various cultural sites. Her counterfeit form has been referenced in raps by other artists. In the promotion of her single "Lookin Ass" in 2014, she uti-lized an image of Malcolm X, which sparked a negative backlash by some in the Black community who found this usage offensive. A video circulated on social media juxtaposing a speech by Malcolm X on Black self-hate with im-ages of Minaj's body, centering on her blonde hair, hourglass body shape, and skin complexion. Troublingly, it continues to be common sense to perceive women of color who appear to be citing Euro-American body aesthetics as expressing pathological racial shame. Minaj has confronted these critiques in interviews, which I discuss in more detail below, and in several songs, from her 2014 hit "Only" ("worry 'bout if my butt fake, worry about ya'll niggas us straight") to her much-celebrated verses in Kanye West's song "Monster" (2010) where she raps, "And if I'm fake, I ain't notice cuz my money ain't."

This chapter reframes the critical optic through which we view Minaj's body, and the bodies of women and girls of color more broadly, by assess-ing the political potential of incarnating fakery through a hyperfeminine aesthetics of excess. In particular, I examine how the aesthetics of the ro-coco, a European visual style marked by ornate designs, rich textures, pastel hues, and sensuous femininities that emerged in eighteenth-century France, have been mobilized in images of Minaj. The curvaceous forms, floral de-signs, and gilded surfaces of the rococo eventually fell out of fashion and became associated with frivolous, fake, and vain women as Enlightenment

discourse, which privileged reason and truth (authenticity), grew more influential, and ushered in the clean, masculine order of neoclassicism. I use the term "rococo" in this chapter to signify an eighteenth-century style, but I also employ it to more capaciously index what art historian Melissa Hyde (2006, 14; 2014, 338) describes as a cultural mode of being, thought, and representation that centers women, femininity, nonnormative masculinity, dreams, and resistance.

Drawing a parallel between the critical denigration of rococo style in the eighteenth century with the contemporary vilification of Minaj's body, I argue that the rapper's rococo aesthetics of excess are subject to critique because they disturb notions of racial authenticity, gendered sexual respectability, and established hierarchies of race, gender, beauty, and sexuality— hierarchies that are undergirded by the sexist and racist conceptions of personhood and science that marked Enlightenment discourse (Mercer 1987; Schiebinger 1999). Drawing from Uri McMillan, I understand Minaj's body presentation as "an elastic means to create new racial and gender epistemologies" that also entails the risk of "assuming faux identities in the public sphere" (McMillan 2015, 6, 5). My interest is to expose and trouble the aesthetic policing of women and girls of color that operates both within their communities and in larger cultural discourses. The femininities signaled by conspicuous rococo-esque ornamentation are intolerable in a culture that values the white masculine as the authentic (Halberstam 1998). Thus, Minaj's consistent association with the pink plastic of Barbie dolls occasions backlash and denigration. I suggest that unlike working-class Latina chonga girls who reveal the economic inequalities occluded by neoliberal discourse through their hyperfeminine aesthetics, which result in censure and marginalization, Minaj has been able to accrue cultural and material value through her similarly made-up body. This is due to the fact that it has been presented in tandem with neoliberal rhetoric in her songs and interview statements, especially in the period prior to the release of her album *The Pinkprint* in 2014. I show how Minaj's neoliberal discourse is buttressed by and communicated in significant part through her citation of Barbie in body presentation and visual branding. In what follows, I examine how gender, race, and political economy shape the manner in which Minaj deploys the Barbie brand in order to highlight how sexual-aesthetic excess can generate cultural value in certain sites while eliciting derision in others due in significant measure to the class politics of neoliberalism.

I assess the political power of embodying fakery by analyzing several interrelated representations and discourses: the framing of Nicki Minaj's body as

plastic among the artists in Women on the Rise!; Minaj's embodiment and invocation of Barbie in her music and branding; the neoliberal rhetoric that attends this branding; contemporary artist Francesco Vezzoli's portraits of Minaj that style her as an eighteenth-century courtier in French rococo style; the rococo-esque video for her song "Stupid Hoe" of 2012; and, last, *Let's Talk about Nicki Minaj: A Rococo Side-Show/Salon*, a performance and exhibition I presented at the alternative art venue Space Mountain in Miami, Florida, in 2014. Through these analyses I suggest that the label "fake" is mobilized to discipline women and girls of color into performing sexually respectable racial authenticity by deriding their potential to signify radical modalities of gender, race, class, and sexuality through their body aesthetics, as these reveal the contingency of the normative order. I locate a potent political potential in embodying pink and plastic for racialized women who are continually subject to what Hortense Spillers calls "high crimes against the flesh" (1987, 67).

I write as the feminist daughter of Cuban and Puerto Rican immigrant parents, inspired by the ornate and sensual body styling and feminized interior spaces crafted by my mother and grandmothers. Although there are significant differences between Cuba, Puerto Rico, and Minaj's Trinidad, there is an attention to and intimacy with cultural and racial intermingling that stems from the unique colonial histories of these islands, which also share aspects of ostentatious styling and overt sexualities—along with class, racial, and sexual respectabilities, which are constantly being negotiated. Here I invoke Johnson's productive notion of the transcolonial as a frame through which to see the "inventiveness and viability of intercolonial contact zones" (2012, 3). Therefore, I read Minaj from the vantage point of my girlhood in the working-class ethnic enclave of West New York, New Jersey, where my Puerto Rican mother gave me Barbie dolls when I did well in school. I played alone in my Cuban grandmother's baroque living room in her Union City apartment, which was decorated with floral-patterned velvet and metallic gold wallpaper and heavy drapes. Staring up at the cheap crystal chandelier while lying on the floor, I would listen to the classical music station or my Janet Jackson or Bananarama records, imagining I was an alluring court lady with powdered wig and made-up face. While creating paintings on notebook paper with nail polish, I would pretend I was at a salon. These fantasies, which were also marked by a feeling of eroticism ("I'm your Venus, I'm your fire, at your desire"), were sparked by the reproductions of pastoral rococo paintings that were displayed in the homes of my family members—coquettish ladies being courted by smartly dressed, feminine men.[1] I incorporated these consumptions of white femininity into my self-production through practices of

girlhood play that formed my sexual, creative, and gender subjectivities without demanding a sacrifice of my ethnic identities—they coexisted, however messily. In recalling these memories, I conjure my Cuban grandmother's curio cabinet, which held ceramic figurines of white rococo couples that were positioned in close proximity to tchotchkes of roosters, horses, and *carretas* that symbolized the rural life of working in sugarcane fields that my grandfather left behind on the island. High and low culture, labor and leisure, the European and the Cuban were all situated in the same field.

Melissa Hyde has noted that the conception of the rococo as a "beautiful, languid dream . . . deployed to resist, or at least to critique, various kinds of cultural authority and norms (whether political, artistic, gendered, or racial)" has been consistently overlooked (2014, 340). The dreams and fantasies of girls of color are also some of the least recognized sites for politics or revolution, but these are potent spaces that, like the rococo, are often decorated in pink. When I gaze upon Minaj's body, I think of similar girlhood fantasies she has had, which she references in her songs. This dreamscape is materialized in the video for "Moment for Life" (2010), the hit single from her first solo album, *Pink Friday*. The video opens with a shot of an illuminated medieval storybook in vintage Disney animated film style that reads, "Once upon a time there lived a king named Nicki. One day, while sitting on her throne, she received an enchanting visit from her fairy godmother. She would remember that moment for life." The rapper is in a rococo-styled bedroom (figures 4.1 and 4.2) wearing a long and elaborate blue princess gown while sitting at a vanity having a discussion with her fairy godmother, who is also played by the artist (and dressed in pink). Minaj tells her fairy godmother that she wishes to savor this moment of success, releasing her first album on a major label, for life. Minaj then raps:

> In this very moment I'm king
> In this very moment I slay Goliath with a sling
> In this very moment I bring, put it on everything
> That I will retire with the ring
> And I will retire with the crown, yes
> No, I'm not lucky, I'm blessed, yes
> Clap for the heavy weight champ, me
> But I couldn't do it all alone, we
> Young Money raised me, grew up out in Baisley
> South side Jamaica, Queens and it's crazy
> Cause I'm still hood, Hollywood couldn't change me

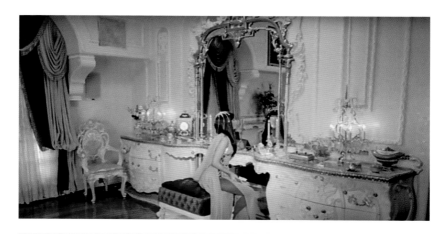

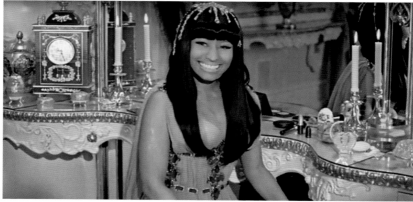

FIGURES 4.1 AND 4.2. Stills from Nicki Minaj's "Moment for Life" video.

Invoking a genderqueer subjectivity of both princess and king, Minaj declares her position in the mainstream through a visual avowal of hyperfemininity, thus refusing to forego her pleasure in artifice in order to gain a place in the masculine order of hip-hop.

Packaging Nicki Minaj

In elaborating my arguments, I work from an understanding that Nicki Minaj is a cultural product performed by a woman who does not fully control when, where, and how she is fashioned. What is known, seen, and heard of the artist is heavily constructed by the labor and interests of recording industry executives, stylists, photographers, video directors, music produc-

ers, fashion editors, marketing firms, and corporate sponsors. In recognizing the role of these factors in (re)presenting her, I also do not wish to silence a Black woman who has a significant measure of influence in determining what she raps about and how she is portrayed. Minaj writes her own raps and has been vocal about the importance of women rappers creating their own work. I read her as an image that is circulating multivalent meanings of gender, race, sexuality, and class in mass culture—not as a fully autonomous author. Yet, acknowledging these complexities does not foreclose my recognition of the artist as someone who had powerful girlhood dreams of a successful, creative life that have since come to fruition.

Minaj's potential to agitate gender, racial, sexual, and class norms is not a result of her unmediated agency, but the analyses that I perform here reveal the cultural work conducted by the layered significations of her body. The culture industry's profitable efforts to craft her image cannot fully contain the diverse ways her body is consumed by audiences who have a range of racial, class, gender, and sexual identifications. Although Minaj has considerable privilege, and lives a vastly different lifestyle than myself and the working-class young artists of color I work with in WOTR, I believe that engaging her aesthetics of excess can offer a critical optic for richer, more nuanced understandings of the body practices of women and girls who negotiate discourses of racial and gender authenticity, along with sexual respectability, in their day-to-day lives, which are mediated by mass-culture images.

Plastic: Girls Theorizing Minaj's Body

Minaj's body was the subject of many impassioned debates that erupted in WOTR. Take for example the interactions that followed my question about whether participants liked or disliked Minaj in my charla with Latina girls from a working-class area of southwest Miami:

JILLIAN: Do you like Nicki Minaj?

BIG BIRD: I love her.

JILLIAN: What do you like about her?

ARIEL: Well, she's very confident about herself, like, she doesn't care what people think of her, like, the way she dresses.

[Girls in group chime in]: Yeah, that's true.

BIG BIRD: Is she a real person?

JILLIAN: What do you mean?

BIG BIRD: Yeah, cuz, when you see her she's plastic, okay? Cuz they say that she's plastic. That's what I've heard.

The group laughed after eleven-year-old Big Bird, who appeared younger than her age, revealed that she thought that perhaps Nicki Minaj was not really human. The laughter was broken by Terezi, who in a high-pitched and whiny voice exclaimed, "I don't like her! She's too fake! And I don't like fake people!" I asked what made her think Minaj is fake, and she replied, "In one of her videos I remember watching with my friend, you could see her butt and it was like bigger than her head and it was like horrible! All of this was popping out [gesturing to her breasts and buttocks]." When I inquired whether what Terezi dislikes about the rapper is that she reveals her body, she responded, "She's, like, over-exposed." Thirteen-year-old Terezi described her personal style ideal in our charla: "I would have black hair with red at the tips. I would wear a big hoodie and jeans, with red Converse. I wouldn't wear makeup or too much jewelry because that isn't my natural self." Terezi's construction of her body, which she articulates through a discourse of "natural," and which is rather gender neutral as well, is a stark contrast to the hyperfeminine body aesthetics of Nicki Minaj, whom she judges as fake in both body and personality.

Other girls came to Minaj's defense in response to Terezi's comments. Ariel, a fourteen-year-old girl who had painted each of her nails a different color and described her trendy and feminine ideal embodiment as "high-waisted shorts, hipster shirt, bracelets, makeup, combat boots, my hair would be straight and long," highlighted Minaj's experimentations with style as part of what she admires about her.

ARIEL: I love Nicki Minaj.

JILLIAN: Why?

ARIEL: I think she is amazing. I know that sometimes she dresses . . . like that [nonverbally indicating Terezi's earlier comment about body exposure]. That's what she actually wanted.

BIG BIRD: I love her but she copied Lady Gaga.

ARIEL: No, but Lady Gaga doesn't wear clothes like that. I think Nicki Minaj has fun, like, she's always changing her hair. Her hair is cool. She has lots of wigs.

Ariel withheld judgment of Minaj for the sexual manner in which she presents her body because she attributed agency on Minaj's part in crafting it and having "fun" with changing her appearance. When I asked this group what their parents would think if they dressed like Minaj, they responded with statements like, "My mom wouldn't like it" and "No they wouldn't," citing Minaj's sexualized body presentation as what would cause the problem.

Big Bird's initial comments about Minaj's plastic body referenced rumors regarding her plastic surgery–enhanced derriere, which came up in almost every one of my charlas with WOTR artists. In Terezi's description of a Nicki Minaj video, she framed the artist's buttocks as symbolizing a kind of grotesque body exposure that she linked to inauthenticity. These discourses circulate beyond the girls' talk, as Google searches of the artist and terms like "surgery" often result in amateur before-and-after image juxtapositions generated by people online. These often pair what appear to be family snapshot photos of the artist as a younger woman with more current images in which her skin appears some shades lighter, her body looking fuller and more voluptuous. The artist has neither confirmed nor denied that she has modified her body through surgery, but what these before-and-after images ignore is the manner in which becoming a mainstream celebrity entails highly professionalized makeup, hair, wardrobe, and image design work that can result in vastly transformed modes of appearance, in addition to the changes that occur in a person's body with time due to a variety of factors.

Discussion of Minaj's "fake" and "plastic" body among WOTR participants was often narrated through a comparison between her body when she was first emerging in the hip-hop scene and how it appeared after her visibility in the mainstream. In particular, the Black girl artists in WOTR often linked the changes in Minaj's body to marketing strategies. C. Kold Blooded said that she "got a lot of *that* done," as in "had plastic surgery," and that "Lil Wayne paid for it so that she can look like Barbie. She was real cute how she was. [Now] she looks plastic." Anya Wallace, a WOTR instructor, asked artist Corey Anna what she thought made Minaj look good before the fame, and she replied,

> Her natural self. She had like natural black hair. She had curly hair then. And um, she used to not wear the crazy outfits. Then after she got signed and I think she released her mixtape—it went good but it didn't go as good as they expected and then she changed up everything, like, her body. She had got her butt done. She got like the stomach, everything perfect—that's not what it's all about. She didn't re-

ally have all that when she first came out. She was normal. She had braids like everybody else, normal, dressed like a girl. She wasn't crazy.

I could feel a sense of loss in Corey Anna's comments, as if a figure she had once looked up to disappointed her. Her repetitive use of the words "normal" and "natural," and affirmations of Minaj's former prettiness, articulate a notion of the unnecessary nature of the changes in her body. It seems as though part of what Corey Anna critiques is Minaj's removal of racial markers such as her black hair and braids, which she may see as distancing the pop star from the Black community.

These narratives of fakery, however, often coexisted with comments from both Black and Latina girls that framed Minaj as an inspiration for their own desires to wear bright, tight, dramatic, and revealing clothing. In fact, sometimes within the same discussion, girls would both laud and deride her. For instance, in the part of the charla where I prompted girls to write or draw their ideal embodiment on index cards, a recently immigrated thirteen-year-old Haitian artist who gave herself the pseudonym Betty Boo, which suggests her affinity for a hyperfeminine and eroticized aesthetic, pointed to drawings she created of geometrically patterned and neon-colored outfits when it was time to share with the group. She described her drawing of a girl wearing a purple, striped, formfitting shirt and short shorts as "like a Halloween costume. I like the shorts and that shirt." When she directed the group's attention to another drawing she made of a fluorescent green striped dress with a tight bodice and short, bouncy skirt, she said, "And this is Nicki Minaj," implying that the style was inspired by the rapper. When I asked Betty how the outfit would make her feel, she said, "Good."

Sixteen-year-old K Baby, who is Haitian American, described her Minaj-inspired outfit as composed of "a half-belly shirt with shorts for a summer day. Colorful, it has to be colorful. Braids with plaits in my hair, sandals, little pretty sandals that I'll go out with. A whole bunch of colorful bracelets that match the outfit and earrings." In our discussion, K Baby related her look to Minaj's style through the short shorts and vibrant color palette. Her animated discussion of the outfit expressed a palpable pride in her body's appearance. Neither Betty Boo nor K Baby expressed reluctance to cite their adoption of Minaj's style during the embodiment discussion. However, when it came to the subsequent part of the charla where I displayed images of Minaj through a projector for the girls to respond to, Betty Boo and K Baby made statements such as, "She be wearing half clothes like, if her titties not showing her butt showing, if her butt not showing her stomach

showing," and "She directing little girls the wrong way because everything on her is fake."

Reluctant to make the girls feel defensive, I did not raise the contradiction of their previous approval of her style and its inspiration of their own when they made these comments, a decision that I am still ambivalent about. What occasioned this dramatic shift in perspective? Was it my posing of what the girls may think I believe is a bad image? I think WOTR artists might have felt pressured to vilify Minaj's embodiment because I presented it to them as an adult educator, whereas earlier in the focus group they did not anticipate that I would bring her up. Putting Minaj's body on display in the all-girl group context may have also incited them to perform class and sexual respectability, racial authenticity, and gender solidarity for each other. Heterosexism encourages girls to bond over negative critique of other women and girls, and with the dearth of woman of color figures in mass culture beyond a few major pop stars, the girls I work with probably feel much is at stake for them in how Minaj embodies gender, racial, and sexual subjectivity.

The narratives of WOTR artists point to the complexities of how they consume gendered, raced, and sexualized bodies in mass culture, and their comments led me to explore in depth the politics of Minaj's aesthetics. In assessing the potential of corporeal fakery to agitate established hierarchies of gender, race, beauty, and sexuality that privilege middle- and upper-class white ciswomen, I am interested in probing the hegemonic aesthetic values that inform some of their comments, and which often prompt them to deny the pleasures they may take in embodying styles such as Minaj's, which played out in our conversations. These values, legitimated by sexist and racist ideologies, communicate to girls that hyperfeminity and conspicuous sexuality are improper and dangerous for them to embody (Hernandez 2009), and poor and working-class girls of color often pay a higher price than white girls for transgressing stylistic norms, which is something that they are all too aware of. The hyperfeminine styles of cultural figures of color such as Nicki Minaj and the Latina chonga girls I engage in chapter 2 disfigure normative values of style by embodying sexual and aesthetic excess. Yet, as I explore in what follows, women of color's embodiments of aesthetic excess may be culturally valued if they are framed through a neoliberal ethos.

NICKI MINAJ *Pink* FRIDAY

FIGURE 4.3. Nicki Minaj's *Pink Friday* album cover.

"My Name Barbie Bitch"

On the cover of her 2010 debut album *Pink Friday* (figure 4.3), Nicki Minaj is posed against a pastel pink backdrop and seated stiffly on the floor. She stares blankly at the camera and wears an elaborate gown that resembles the dresses worn by glamorous Barbie dolls. The image presents Minaj as more body than persona, more doll than human, more pretty than hardcore. Rather than critiquing this image for presenting a woman of color as vacuous, I argue that Minaj's aesthetic stages the body as persona and pretty as hardcore, which by extension portrays gender, race, sexuality, and class as corporeal performatives. In his discussion of Black women artists who utilize avatars in their performance works, Uri McMillan offers the notion of "performing objecthood." In this framework, the body is staged as "pliable

matter" in an "adroit method of circumventing prescribed limitations on black women in the public sphere while staging art and alterity in unforeseen places" (McMillan 2015, 7). Hyperbolic body display and the performance of objecthood have primarily generated the meanings of Minaj as she has more successfully penetrated mass culture. Presenting herself as a doll not only makes her a consumable product but frames Black women's embodiment as a performative amalgam of signifiers, not an essentialized mark of race (Fleetwood 2011; Higginbotham 1992; Johnson 2003; McMillan 2015).

Yet, as I explore below, cultural critics have framed Minaj's fakery as evidencing her corrupt body and race politics. She is regularly charged with colluding with stereotypes of Black women as hypersexual and of upholding Euro-American beauty standards at the expense of signifying pride in Blackness. The rapper has responded consistently to such critiques. For example, when talking to *Out* magazine, she stated, "It's interesting that people have more negative things to say about me saying 'I'm Barbie' than me saying 'I'm a bad bitch.' . . . So you can call yourself a female dog because that's cool in our community. But if you call yourself a Barbie, that's fake" (Ganz 2010). Whereas white women performers with elaborate body displays such as Lady Gaga are celebrated and viewed as cultural innovators for the crafting of their bodies in the dominant culture, Minaj is held to a standard of racial authenticity that undermines her aesthetic creativity. Beyond signifying a perceived racial inadequacy and embodied spectacle that was once attributed to Michael Jackson (Fleetwood 2011; Mercer 1994), within communities of color, Minaj's body may also be devalued because its race performance also transgresses modes of gendered respectability through its sexualized display. In addition to being judged for her hypersexuality, the rapper has been mocked for the exaggerated facial expressions she used to make when performing and being photographed, and for assuming alter ego personas in her music such as Roman, Martha, and Harajuku Barbie, who each have specific attitudes and accents. Minaj's statement to *Out* magazine expresses frustration with the manner in which these critiques have circulated in Black communities in particular.

In assessing the politics of race, gender, sexuality, and authenticity, it is useful to consider the practices of early twentieth-century Black female artists, such as vaudeville performer Florence Mills, who, like Minaj, often wore blonde wigs. Mills's donning of blonde hair likely made her body consumable to white audiences, but scholar Jayna Brown has shown that her

appropriation of white embodiment did not hinder her from making racial critiques. Brown notes that Mills consistently claimed her Black identity through making public statements such as, "We [Black folks] do not seek white people's society, and we are a happy family, although a large one. In America we have our own restaurants and cabarets and theatres, and your people come to see our shows" (2008, 245). Similarly, Minaj often shouts out her "West Indian people" in concerts and interviews, and has called out racism.

For example, there was widespread entertainment news coverage on Minaj's claim that Steven Tyler, the leader of the rock band Aerosmith and former judge on the panel of the hit television show *American Idol*, made a racist statement when he said that she was not a good addition to the *American Idol* panel. Tyler drew upon a discourse of fakery in his contention that if a contemporary, undiscovered Bob Dylan–like performer were to be a contestant on the show, "Nicki Minaj would have had him sent to the cornfield! These [contestants], they just got out of a car from the Midwest somewhere, and they're in New York City, they're scared to death. . . . [They need] to be judged by people that [are] honest, true" (Michaels 2012). Tyler not only frames Minaj as fraudulent, but portrays Midwestern (read white) subjects as beings who, in a racially diverse space such as New York City, would be threatened by a troubling Black female presence like her. Through her Twitter account, Minaj responded, "You assume that I wouldn't have liked Bob Dylan??? Why? black? rapper? what? . . . , you haven't seen me judge one single solitary contestant yet! . . . That's a racist comment. . . . Lets make [Steven] a shirt that says 'No Coloreds Allowed'" (Michaels 2012). In a neoliberal society that advocates postrace color blindness, Minaj-as-Barbie brings racial politics into discourse.

Minaj as Neoliberal Barbie

Hit the Hot Topic, Nicki Minaj hoodies
I'm a brand bitch, I'm a brand
Got to Harlem, and get Cam
It's dipset, get your dick wet
Boarded the big jet and got a big check
Now you tell me, who the fuck is winning
— NICKI MINAJ, "I Am Your Leader"

I want to show girls that the possibilities are endless. That's my goal—
to not only do it for myself, but to show them I can do whatever I put my mind to.
I don't give a damn if I was born poor, I can come out of this shit with
something to offer my children and grandchildren.
— NICKI MINAJ (quoted in Hattenstone 2012)

Despite the fact that Minaj's plasticized body has been subject to considerable negative judgment, she has nonetheless been able to build a massive fan base and generate vast cultural and material capital while embodying the kind of racial, sexual, and aesthetic excess that working-class women and girls of color, such as chongas, are vilified for. Unlike chongas, who unmask the class structures denied by neoliberal discourse through their body aesthetics, Minaj produces value through her body by presenting it in tandem with neoliberal rhetoric, particularly in the period prior to 2014. Her neoliberal discourse is buttressed by and communicated in significant part through her citation of the Barbie brand in body presentation and visual branding.

The rapper has framed girls' identification with Barbie dolls as stemming not only from their desire to look attractive, but also as reflecting their hopes for career success (HipHopStan 2009). In interviews she often cites her family's economic struggles as a major part of what drives her work ethic. In the quote above, she rejects notions of social constraint—"I don't give a damn if I was born poor"—in determining access to wealth. This attitude is reflective of and produced by neoliberal discourses of social mobility, whereby hard work and determination are positioned as vehicles for responsible subjects to overcome given socioeconomic circumstances and achieve financial success without government assistance. In reifying this ideology, Minaj's mobilization of the Barbie icon is quite fitting.

In *Barbie's Queer Accessories*, visual culture scholar Erica Rand (1995) demonstrates how the doll is an emblem of neoliberal political economy. Rand describes how a range of consumers shift and queer Barbie's meanings through forms of play and appropriation that exceed the racist and heteronormative discourse laid out by the Mattel corporation that produces her. Rand observes that in order to occlude Barbie's history as a spin-off of a

fetishized German sex toy, Mattel has focused on articulating narratives about the "infinite possibilities" embodied by Barbie through her various career and clothing options, rather than providing a historical or detailed character narrative about the product's persona. The sexual excess of the doll remains visible but goes unremarked upon and hence becomes a viable product for children through recourse to a neoliberal ideology. Rand notes, "In other words, Barbie's infinite possibility is the infinite possibility of hegemonic discourse. It reinforces hegemonic discourse predominant in the United States at large, which describe[s] freedom in ways that benefit rather than challenge people in power. It suggests that all 'we girls' can be anything today with little more than self-confidence, determination, and some luck and without necessitating economic or social change; white people, men, and capitalists can stay where they are" (1995, 85). Thus, the feminism of equal opportunity articulated by Minaj in several songs and many interviews, like that of Barbie, is a neoliberal discourse that speaks out for marginalized people while also buttressing late capitalist political economy.[2]

Minaj's embrace of neoliberalism is framed through consistent references to the transformative power of her individual work ethic. This work ethic, and the manner in which Minaj has achieved her success in the male-dominated rap industry, was framed by many WOTR participants as an important part of what makes her deserving of mass media visibility. Many expressed their positive valuation of her work ethic through references to the rapper's transgression of gender norms. For example, the WOTR artists I work with through a community activist organization in the historically Black Miami neighborhoods of Overtown and Liberty City made statements about Minaj in our group conversations such as, "She's trying to be a girly girl but then again she tryna show that girls can be in the rap game too." When I asked how they think she's trying to prove that she can achieve the same success as artists who are men, Tashell said, "She kills them—*off*! Just like, the stuff she says, people be like, 'Wow, a girl said that.'" Tashell's voice rose when she said this, and I could sense her pride in Minaj's skills and gumption in engaging in the same kind of sexual, violent, and materialistic braggadocio that is typical of raps composed by mainstream male hip-hop performers. The transgression of gender norms that the girls observe Minaj performing through what they believe to be her superior rap skills over established men artists generates pleasure in their listening.

Q, a WOTR artist, connected Minaj's shameless approach to crafting her body, her overt expression of sexual desire, and her defiance of gender scripts as enabled by financial success:

You listen to her music and she's like, "I fuck, but I got more bank than you. You don't have to take care of me. I could do my own. I don't have to worry about the bullshit—I can do what the fuck I want and not give three flying fucks." That's her attitude. "Yes, I can dress however I want because I don't care. I got bank—I can do what I want." She's not like these other females who are under different rappers because they still need to get their fame or whatever. Nicki has her spot in Cash Money. She doesn't need to worry about that so she's like, "I'm gonna just do me."[3]

Q's narration of Minaj's "I don't give a fuck" attitude reflects a posture that the artist repeatedly articulates in her songs. It's a semifeminist (financial independence from men), postfeminist (I did it on my own) discourse that equates the subversion of sexism with purchasing power (Arthurs 2003). I am loath to suggest that this rhetoric is indicative of a radical anticapitalist or feminist politics. However, there may be room to locate political potential for young women of color in Minaj's particular kind of neoliberal discourse, which stems from the rapper's marginalized racial, class, and gender positionality. The gendered meanings seen in mass media that are accessible to young women, particularly poor and working-class young women of color, often do not communicate the same kind of self-determination and creative skill presented by Minaj, and in that distinction, I see political potential.

In Minaj's discourse, purchasing power and financial stability are claimed by a Black woman who, in the capitalist order of things, is positioned to be excluded from the economy as a consumer and to function perpetually as an exploited laborer living under financial precarity. This is a reality that Minaj has known well, growing up in a poor urban community and working service jobs such as waiting tables at Red Lobster. Minaj's success has inspired some of the girls I work with to believe that self-making is possible even when the odds are against them, and they express hope despite the fact that their status as poor or working class does not seem immanently surmountable. They believe in what their hard work can do for them in the future. Should we deny these girls' dreams by framing them as the result of media brainwashing and false consciousness? As my citations of their thinking have shown, they are astute theorists of political economy and cultural politics on their own. They are aware of the workings of neoliberal capitalism and their position within it, and can therefore be strategic about how they navigate and possibly better their lives through practices such as dedicated work.

Young artists' negotiations of Minaj's neoliberal discourses were further elaborated in a conversation among thirteen- and fourteen-year-old African American girls in a WOTR workshop. Our discussion turned to the topic of Nicki Minaj's work ethic after several of the girls, while working on their art projects, were reciting Minaj's song "Beez in the Trap" from her then recently released album *Pink Friday: Roman Reloaded* (2012). The chorus of the song is:

> Bitches ain't shit and they ain't sayin nothing,
> a hundred muthafuckas can't tell me nothing,
> I Beez in the trap, bee-beez in the trap;
> I Beez in the trap, bee-beez in the trap.

I told the girls that I had seen the video for that song recently and was unclear about Minaj's meaning in the phrase "beez in the trap," even after listening to the song many times. Destiny explained to me with a measure of pride that what Minaj's phrase "beez in the trap" references is the time she puts in working at the recording studio. "Trap" is slang for the location where drug deals take place, and Nicki "beez"/is, as in "I be/I am," in the site where she labors. Destiny conveyed her admiration of Minaj for the manner in which she frames herself as a hardcore businesswoman who puts in the time, making it possible for her to take down her opponents, to swing and hit on a "big bitch," as she states in the lyrics.

The neoliberal message of the song has been received not only by the young women of color I work with, but in the media as well. In "Nicki Minaj's Song 'Beez in the Trap' Teaches American Values of Hard Work and Dedication," a story published on the online political policy blog *Mic*, writer Ethan Case (2012) extols Minaj's politics: "For a generation of millennials displaced by the economy and looking for a way to achieve the success that was promised to us, Nicki teaches us to keep a self-confident and positive outlook. As her newest single reminds us, success doesn't come overnight. You must *beez in the trap* if you want to get anywhere" (Case 2012, emphasis in original). Rather than critiquing global capitalism for the rapidly vanishing job opportunities for youth in the U.S., even those who are college educated, Lane instead lauds Minaj for providing a soundtrack of uplift, personal responsibility, and hard work to get folks through the economic malaise.

Although Minaj's songs and videos continue to celebrate her wealth and purchasing power, the lyrics in her 2014 album *The Pinkprint* depart from her previous work in that they express the considerable costs of being a highly successful neoliberal subject. The songs question what success

means for someone who comes from a marginalized background. This is most pointedly conveyed in the track "All Things Go," in which she asserts the importance of valuing one's family and personal relationships because money and fame have not protected her from hardship.

> I lost my little cousin to a senseless act of violence
> His sister said he wanted to stay with me, but I didn't invite him
> Why didn't he ask, or am I just buggin'?
> Cause since I got fame, they don't act the same
> Even though they know that I love 'em
> Family ties, broken before me, niggas tryna kill him, he ain't even
> call me
> And that's the reflection of me, yes I get it, I get it, it was all me
> I pop a pill and remember the look in his eyes, the last day he saw me . . .

> I love my mother more than life itself, and that's a fact
> I'd give it all if somehow I could just rekindle that
> She never understands why I'm so overprotective
> The more I work the more I feel like somehow they're neglected
> I want 'Caiah to go to college, just to say "We did it"

Minaj and her family are struggling with premature death due to community violence, family alienation, and climbing the social ladder through education, "just to say 'We did it,'" to prove that positive change is possible. In sharing these experiences, she presents narratives that poor and working-class girls of color can relate to, while still allowing them to hold on to their dreams and hopes for the future, as the chorus states:

> Cause I'mma ride out with you still the night is young;
> We keep goin', we go, we go, we go
> We wake back up and do it all again
> We know, we know, say fuck the world, we ridin' 'til the end.

Minaj's navigation of neoliberal rhetoric, life, and embodiment are complex and inseparable from the spaces she has come from. Thus, with time, Minaj's "Barbie dreams" have also revealed how neoliberalism is just as responsible for hardship as it for accomplishment within the confines of racial capitalism.

Minaj's appropriation of the plasticized Barbie, and of the exalted white femininity the doll embodies, marks her body as racially transgressive because she does not fashion herself in the image of the Black Barbie dolls marketed to girls of color that have dark hair and skin (Chin 2001; Urla and

Swedlund 1995). To take up white femininity in such a way is to show how whiteness is open to semiotic resignification by women of color. These negotiations of class, gender, race, and self-presentation provide a context for my reading of the meaning making produced when her body appears in the pages of a high-fashion magazine in portraits created by a celebrated contemporary artist who styles her in the image of an eighteenth-century rococo courtier—the kind of woman who was viewed as the incarnation of fakery, corrupt aristocracy, and feminized excess.

The Aesthetic Deviants of the Rococo: Portraits of Minaj by Francesco Vezzoli

In examining the body politics of Minaj's fakery, I analyze a spread in the November 2011 edition of the fashion magazine *W* in which she is styled by contemporary Italian artist Francesco Vezzoli, and the video for her song "Stupid Hoe" (2012), both of which feature the ornate femininity of rococo style, albeit in starkly different ways. Eighteenth-century rococo aesthetics centered on the white female subject as muse, and Minaj's embodiment of this style marks her trespass into this privileged visual field. The rapper's highly performative and ornamental visual styling, especially from 2009 to about 2013, which featured bright pink colors, dramatic hair and makeup, and elaborate, experimental fashions, can be described as rococo.

Francesco Vezzoli gained attention in the art world by appropriating canonical works by artists such as Leonardo da Vinci and replacing the original figures in the images with the faces of supermodels such as Naomi Campbell and Cindy Crawford. The artist is interested in the cultural obsession with celebrity and the iconic status of famous women in particular. Like Minaj, Vezzoli has been framed as something of a fake—an artist whose work has too intimate a relationship with the market. In the interview of Vezzoli that accompanies the photographs of Minaj in *W*, Klaus Biesenbach, then director of MoMA PS1, a major art world tastemaker, directs rather aggressive questions to the artist, suggesting that he has recently sold out to the art market by departing from his earlier work as a performance artist to center his practice on celebrity. Vezzoli's practice, like that of eighteenth-century rococo artist François Boucher, is devalued through a rhetoric of inauthenticity that stems from his association with "vain," feminine women.

The photo story by Vezzoli styles Minaj as a courtier in French rococo style. Rococo imaging emerged in the late eighteenth century and is marked by opulent surfaces, bucolic landscapes, fleshy, voluptuous figures, and pas-

tel pinks, blues, and greens. In *Making Up the Rococo: François Boucher and His Critics*, Hyde (2006) describes how the vilification of the rococo style, and of Boucher in particular, emerged in the late eighteenth century in tandem with early Enlightenment discourse. These negative judgments sought to police the gender and class transgressions that were signaled by the perceived aesthetic excess of rococo style, which came to symbolize for critics the moral and material decadence of the French aristocracy. Hyde analyzes how the politics of adornment signaled the subversion of social hierarchies in eighteenth-century France, and how this transgression was symbolized by the body practices of women—namely the practice of applying makeup, or rouge, to the face. It was believed that the conspicuously made-up women of the court used their bodies to conceal their illegitimate positions in high society, as they were perceived to have come from less-than-noble families. Panic over the apparent performativity of class resulted. Major social and political figures such as Madame de Pompadour, the head mistress of King Louis XV who was a patron of Boucher, performed her application of makeup in the public company of the court; she then became a target of criticism for embodying feminine deceit and social climbing. These women were perceived as undeserving of their privileged stations.

Such judgments are echoed in the cultural discourses surrounding Nicki Minaj's "fake" body and the manner in which she allegedly modified it for market success. Minaj's raps and body aesthetics, even when crafted with elite fashion items, continue to index her working-class roots, as she wears fancy clothes with hip-hop swagger. Her market success has not resulted in a disavowal of the marginalized spaces she comes from, as she consistently shouts out "hood girls" in her songs. In addition to maintaining her Jamaica, Queens neighborhood identity, Minaj's embracing of artifice combines with the marked sexuality of her dramatically curvaceous body, as seen in her large breasts and buttocks, and makes her an illegitimate paragon of class in the racialized, gendered, and classed hierarchies of beauty in the U.S. that continue to exalt thin, lithe, light-skinned Anglo-American women with perceived natural beauty. Although her neoliberal Barbie performance has facilitated her success in mainstream popular culture, the raced, gendered, and classed aesthetics of excess she embodies continue to make class burn. Minaj's sexual-aesthetic excess is the kind of signification that haunts the bodies of women of color in the high-culture spaces of art and fashion, making them appear questionable, if not illegitimate. Yet, as a fellow aesthetic deviant and fake, Vezzoli was a fitting mediator of her appearance in *W* magazine, as his eye was honed in on the complicated art of her excess.

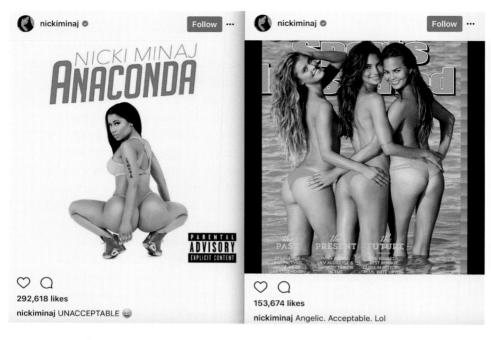

FIGURE 4.4. "Anaconda" Instagram post by Nicki Minaj.

Minaj has disavowed class-inflected respectability herself through the purposeful sexual staging of her body. For example, she acted against her management's wishes when selecting the photograph that would be used for her highly successful 2014 single "Anaconda." The image featured the artist photographed from behind in a spread-eagled squat position in a pink thong, pink bra, and sneakers, with her head turned around to face the camera with a steady and commanding gaze. The image drew negative backlash in the media as vulgar and hypersexual, which the artist responded to via Instagram posts that juxtaposed her image with the then-current issue of *Sports Illustrated*, which featured three thin topless young white women in thongs photographed from the rear at a beach (figure 4.4). By placing the accompanying caption "Angelic. Acceptable. Lol" on her post of the young women on the *Sports Illustrated* cover and "UNACCEPTABLE" with the post of her "Anaconda" photo, the artist directly critiqued the double standard that sanctions white women's sexual display in mainstream spaces while vilifying that of a Black woman as inappropriate, dangerous to youth, and excessive.

The pink outfit that Minaj wore in the "Anaconda" photograph once again signified her body through a visual lexicon of hyperfemininity: Pink

poses threats to the patriarchal aesthetic values of Euro-American culture. In eighteenth-century France, rococo artist François Boucher was disparaged for his marked use of pink in his paintings. Hyde (2006) notes how for art critics of the time, the color indexed the decline of art practice that was brought about through the growing participation of women in the art world through their commissioning of portraits that reduced serious male painters to lowly "makeup artists." Pink evoked the bodies of women who were framed as surface and no substance, and whose excessive approaches to body crafting reflected those of prostitutes. The fact that Minaj has consistently used pink for her branding likely feeds the discourse of fakery, which stems from sexist devaluations of feminine aesthetics as frivolous at best and morally debased at worst. Minaj has celebrated her use of the color in lyrics such as "some pink pumps, pink thumbs, and tu-tu; some pink lips, pink blush on my youtube . . . some pink toes in my pink Jimmy Choo-choos," and "pink wig, thick ass, give em' whiplash."[4]

Minaj's sexualized body presentation, coupled with her rococo style, marks her deviance from norms of sexual and stylistic respectability. In fact, Vezzoli cited Minaj's performance of hypersexuality as what prompted him to draw on rococo style in executing his portraits of the rapper: "In her performances, Minaj makes very explicit and challenging use of her beauty and her body, so I thought of comparing her to some of the most famous courtesans in history" (Biesenbach 2011).[5] Vezzoli fashioned her in the image of influential women of the French court, such as the Marquise de Montespan and the Comtesse du Barry, who obtained their positions in significant part through the adornment and sexual capital of their bodies. In Vezzoli's photographs, Minaj's body is swathed in complicated, feminine dresses constructed from lustrous fabrics festooned with bows, tulle, and ribbons. Heavily ornamented gilded frames accent the photographs and cite rococo painting display. In the images, Minaj's facial expressions range from subdued to dramatic, consisting of intense stares, looks away, and awkward half smiles. The femininity of the photographs is softer and more digestible than the visual chaos of her Harajuku Barbie styles, which combined Barbie aesthetics with the ostentatious fashions of trendy Japanese youth, but the softer and more digestible styling does not make her appear more naturalistic or approachable in the portraits. Although the rapper is more fully clothed in Vezzoli's images, which may appear to be a mode in which she will be taken seriously and viewed as more classy in the high-fashion venue of W, attention to the politics of rococo style reveals that these costumes are just another layer through which her body expresses gendered, sexual, and aesthetic transgression. Rather than a sim-

plistic notion of classiness, Minaj can be read as performing a mode of Black femininity in some of Vezzoli's photographs that is classed, a hardcore expression that is informed by her working-class background and community that complicates the citations of European women's portraits in the project, as she imbues their soft femininity with a hip-hop edge.

For example, in *Rococo Portrait of Nicki Minaj as Françoise Athénaïs de Rochechourat de Mortemart, Marquise de Montespan* (figure 4.5), the rapper stands in profile in an elaborate lavender dress while gripping a metallic brown curtain with both hands. The curtain runs snakelike down the length of her body, framing its sensuous counters and drawing the eye to her buoyant and accented décolletage. Minaj's delicate, yet firm hold on the curtain makes it appear like a strangled phallus. Her makeup and well-coiffed black hair are naturalistic and soft, contrasting with her wide open eyes that reveal the whites. Minaj's face in the photograph is similar to the expression she makes when embodying her angry, masculine alter ego Roman, giving her a menacing appearance.

Minaj is seated frontally in an intricately decorated white gown in *Rococo Portrait of Nicki Minaj as Jeanne Bécu, Comtesse du Barry* (figure 4.6), the image that was used for the *W* magazine cover. She wears a gray wig gathered into a tight, orderly bun on the side of her head and looks out at the viewer with a defiant gaze, holding a lyre in one hand and a wreath of roses in the other. At her feet are a palette, paints, brushes, and an embroidery frame enclosing Vezzoli's initials. The image serves as a collaborative self-portrait, the lyre representing Minaj's musical practice and the needlepoint and paints at her feet indexing the tools of Vezzoli's trade as a visual artist. Minaj's position in the chair indicates that her legs are open wide underneath her voluminous gown, from which a foot enclosed in a dainty, ornately patterned shoe emerges.

At her feet are not only Vezzoli's craft materials, but also the broken, classically styled bust of a female figure. The bust at her feet can be read as indicating the rapper's challenge to the visual history of idealized white womanhood. In examining the investment of Victorian culture in generating social discourses and visual cultures that generated clear racial divisions between black and white, Jennifer DeVere Brody (1998) discusses the aesthetic politics of nineteenth-century Euro-American sculpture, which revived the styles of antiquity. In noting that white marble Greek sculpture was perceived as authentic when in fact it was a fake version of the antique, as Greek sculptures were originally painted, Brody quotes a letter of January 15, 1874, that playwright Henrik Ibsen wrote to British writer Edmund Gosse: "We

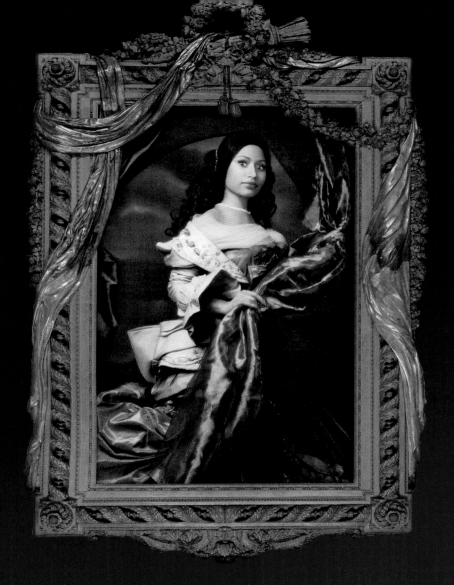

FIGURE 4.5. Francesco Vezzoli, *Rococo Portrait of Nicki Minaj as Françoise Athénaïs de Rochechourat de Mortemart, Marquise de Montespan*, 2011.

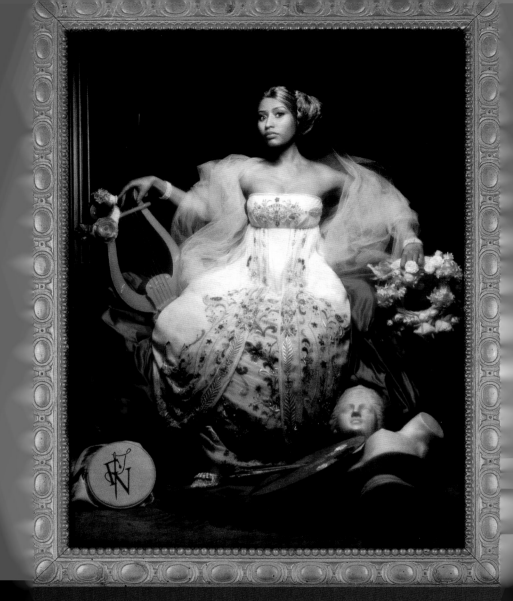

FIGURE 4.6. Francesco Vezzoli, *Rococo Portrait of Nicki Minaj as Jeanne Bécu, Comtesse du Barry*, 2011.

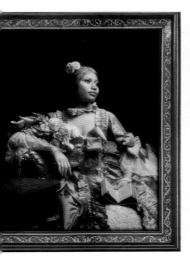
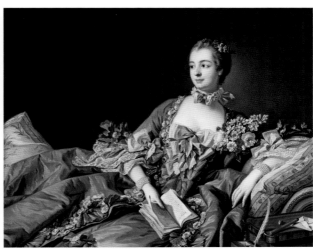

FIGURE 4.7. Francesco Vezzoli, *Rococo Portrait of Nicki Minaj as Jeanne Antoinette Poisson, Marquise de Pompadour*, 2011.

FIGURE 4.8. François Boucher (1703–1770), *Portrait of Madame de Pompadour*, ca. 1758. Oil on canvas, 37.9 × 46.3 cm. NG429; 4698. NATIONAL GALLERIES OF SCOTLAND. © NATIONAL GALLERIES OF SCOTLAND, DIST. RMN-GRAND PALAIS/ART RESOURCE, NEW YORK.

are no longer living in the age of Shakespeare. Among sculptors there is already talk of painting statues in the natural colors. Much can be said both for and against this. I have no desire to see the Venus of Milo painted, but I would rather see the head of a Negro executed in black than in white marble. Speaking generally, the style must conform to the degree of ideality which pervades the representation" (Brody, 1998, 72). In the view of this cultural arbiter, black skin would require an authentic depiction, as it does not possess the idealized beauty of white skin. In the photograph of Minaj as Jeanne Bécu, Comtesse du Barry, the aesthetics of white femininity in the form of the marble bust, and the labor of Vezzoli, a white male European artist, indicated by the paints and initials on the embroidery frame, come under her staged and stoic command. One finds not a lack (of femininity) under her dress, but signs of generation and destruction.

It is fitting that Vezzoli would depict Minaj in the image of the Marquise de Pompadour (figure 4.7), who was a major patron of François Boucher. His photograph is a direct citation of Boucher's ca. 1758 painting *Portrait of Madame de Pompadour* (figure 4.8). Vezzoli finds a rococo predecessor in

Boucher, the artist accused of selling out and celebrity worship. In framing Boucher's landmark painting *Madame de Pompadour at Her Toilette* (*Jeanne-Antoinette Poisson, Marquise de Pompadour*, 1750, with later additions; figure 4.9) as a portrait of Boucher and an allegory of painting, Hyde (2006) posits that the painting "roundly declares that Boucher—and his famous sitter—embraced their status as makeup artists." I find that, like Boucher and Pompadour, Minaj and Vezzoli also perform a declaration of allegiance through aesthetic deviance, particularly in his image of the rapper on the *W* magazine cover, which he embellished with an image of a disembodied eye crafted from textile that appears to drop down her face like a tear, doubling the intense gaze she directs at the viewer (figure 4.10).

The symbols of joint authorship that conspicuously appear in the portrait of Minaj on the *W* cover reference the practices of Minaj and Vezzoli as musical and visual artists, and signal their alliance. As Hyde elaborates in reference to Boucher and Pompadour in *Madame de Pompadour at Her Toilette*,

> By figuring Pompadour as the author of her own appearance and identity [as she is shown preparing to apply makeup], this painting declares that an image of a woman could be more than an image of a made-up identity; it declares that a woman could make up her own identity. What is more, the painting suggests that the toilette of the woman always precedes the more durable art of the painter. As de Plies had maintained, there is not art before makeup; makeup is not only the surface of representation but also its prerequisite foundation.
>
> Understood as an image that alludes to Pompadour looking at and representing herself, *Madame de Pompadour at Her Toilette* undercuts traditional notions of authorship, as it conflates the categories of woman as object and male painter as subject. (2006, 128)

Drawing from Hyde's insight, I ask, what does it mean for a Black woman as object to be conflated with a white male artist as subject? Minaj uses Vezzoli as he uses her, since he makes possible the trafficking of her once working-class racialized body in both high art and high fashion registers. Black female bodies, framed in the colonial Western imaginary as objects of sexual, domestic, and agricultural labor, have been persistently excluded from these realms of high art and fashion, save for common tropes of primitivism and exotic otherness, sometimes framed as a titillating monstrosity, a visual trope she has also assumed for claiming power in representation as a Black woman.

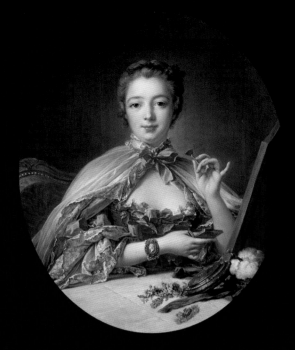

FIGURE 4.9. François Boucher, *Jeanne-Antoinette Poisson, Marquise de Pompadour*, 1750, with later additions. Oil on canvas, 81.2 × 64.9 cm (31 15/16 × 25 9/16 inches). Frame: 99.8 × 84.5 cm (39 5/16 × 33 1/4 inches). HARVARD ART MUSEUMS/FOGG MUSEUM, BEQUEST OF CHARLES E. DUNLAP, 1966. 47. PHOTO: IMAGING DEPARTMENT © PRESIDENT AND FELLOWS OF HARVARD COLLEGE.

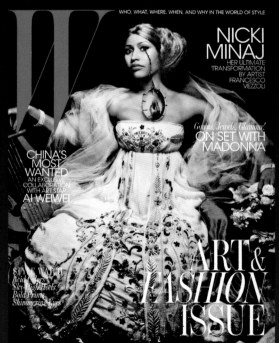

FIGURE 4.10. Cover of November 2011 issue of *W* magazine.

FIGURE 4.11. Still from Nicki Minaj's "Stupid Hoe" video.

The Angry Barbie as Rococo Baartman

Minaj hyperbolically evokes primitivism and monstrosity, along with her Barbie aesthetic, in the music video for her song "Stupid Hoe" (2012). The video portrays hypersexual Black women's bodies against elaborate eighteenth-century-style rococo gilded interiors (figure 4.11) and blinking pink tableaux. The rapid, choppy editing of the video that syncs with the frenetic beats of the song can be compared to *papillotage*, a term used to describe the blinking, flickering treatment of light in paintings by rococo artists that denoted feminine coquetry and frivolity (Hyde 2006, 94–95).

Directed by the popular hip-hop video creative Hype Williams, "Stupid Hoe" is composed through a vibrant Minaj-rococo palette of contrastingly pale and garish pinks and blues. The content consists of various images of the rapper performing the song while seated in a Barbie-pink luxury car wearing a pink wig and holding a large gold chain with the Barbie logo, posing in contorted positions, dancing erotically in a catlike outfit while enclosed in a cage, and rapping directly to the camera, at times with a group of women dancers in the background. Minaj's makeup and costume are spectacular, futuristic, and otherworldly, and in some scenes her body is digitally modified, giving her huge, animal-like eyes.

The lyrics of "Stupid Hoe" consist of insults the rapper aims at a woman rival, and many read it as a specific attack on rapper Lil' Kim, as both have made disparaging remarks about each other in the press. I read an unortho-

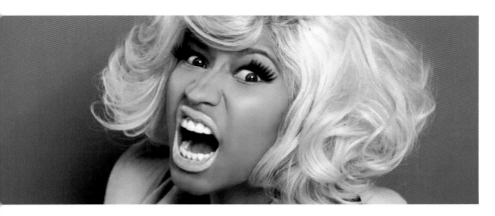

FIGURES 4.12 AND 4.13. Stills from Nicki Minaj's "Stupid Hoe" video.

dox feminism and antiracism in Minaj's performance of anger in the video, and a monstrous, rococo-inflected hypersexuality that, as I will show, has presented a rather indigestible and agitating embodiment of Black womanhood, as evidenced by the negative critical reception of the video in the media. I suggest that the "Stupid Hoe" video recalibrates the racial, gendered, and sexual optic through which Black women's bodies are surveyed by deploying this hypersexuality that disturbs and resists easy consumption.

In a climactic scene in the "Stupid Hoe" video, an image of a nude, brown-skinned woman's body is superimposed over footage of Minaj making dramatic infuriated faces (figure 4.12). The image of the body appears and disappears from the frame in time intervals so short the screen appears to move more rapidly than a blink, creating the strobing papillotage effect. The body looks doll-like: cold, plastic, stiff, and lifeless (figure 4.13). It is

cropped by the camera in the frame from the shoulder area to the upper thighs, thus obscuring the head, legs, and feet. The form is set against a solid Barbie pink background with no depth of field and is positioned in profile, evoking the ethnographic historical images of the Khoisan women from the Eastern Cape of South Africa disparagingly termed Hottentots by colonizers. Yet the body in the video does not resemble the standard Barbie doll form, despite the messaging of the plasticized flesh and the color pink. The figure has large, round, protruding buttocks that starkly contrast with its flat stomach. A styled steatopygia—this is Barbie as Saartjie Baartman, the Khoisan woman exhibited in Europe in the nineteenth century as the Hottentot Venus.[6]

In the video, the still of the brown female body in profile alternates with moving images of Minaj's face donning a glamorously styled, short pink wig and pink lipstick. The passivity of the body is juxtaposed against Minaj's warrior-like faces, with wide-open eyes and snarling mouth, which are framed at close range from the shoulders up. In effect, Minaj functions as the missing and very animated head of the inert Black Venus. Racist history is haunted by Minaj, a Black woman righteously enraged. The assertive and disorienting presentation of her fake body, through the display of plasticized flesh, appears digitally created and hence not a revelation of her real carnality at all. With this reference to accusations of her fakery, the video responds to the public policing of her body through imagery that evokes the longer history of fascination, desire, disgust, and othering of Black women's embodiment.

Minaj announced on Twitter that the video would not be released on network TV, stating that she did not want her art to be tampered with. Simultaneously, rumors spread in the media about the banning of the video by Black Entertainment Television (BET) due to its sexualized imagery. These rumors were puzzling in that the video did not include imagery that was any more sexual than hip-hop and R&B videos that are commonly shown on music television. I suggest that what caused the most disturbance was perhaps the Barbie-Baartman scene I describe above.

The work of Marcia Ochoa may add context to this reading of Minaj. In Ochoa's study of the performance of what she terms "spectacular femininity" in contemporary Venezuela, and the body modifications employed by both cis and trans beauty pageant contestants in particular, she notes that unlike the negative judgments of plastic surgery that circulate in the U.S. through discourses of nature-perverting artificiality, such transformations are viewed in Venezuela instead as modes through which the latent perfec-

tion of the body is materialized through plastic surgery. These procedures are seen to work in concert with nature, not against it. Yet even in this context, the mark of what constitutes a deviant "excess" in corporeal modification is defined by "the body that has become monstrous in its plasticity" (Ochoa 2014, 176). This is an aesthetic criterion that also has currency in the U.S., where plastic surgery, despite its negative connotations, is a major industry. Minaj's large plasticized ass appears monstrous to the normative gaze, which accepts plastic surgery insofar as it can pass as natural and go unremarked in mainstream discourse—it must be tasteful. Spaces that celebrate excessive plastic bodies, such as strip club and porn cultures, are not perceived as legitimated or culturally valuable sites, though this is currently changing with the rise of pop culture artists like Cardi B.

Minaj is not the first hip-hop artist to be perceived as embodying racial shame and loss of integrity and power through the transformation of her body. In the late 1990s and early 2000s, rapper Lil' Kim was viewed as attempting to look white as she began to wear blonde wigs, light-colored contacts, and appeared to have undergone facial surgery. Visual culture scholar Nicole Fleetwood views Lil' Kim's performance of race and gender as an appropriation of white femininity that reveals the "unnaturalness of white beauty" (2011, 144). Yet Fleetwood finds that by presenting race and gender as "highly manufactured and purchasable goods," Lil' Kim is often perceived as "a familiar spectacle who is no longer spectacular" (2011, 144). Thus, even when Black women who perform the artifice of race are recognized for complicating gendered racial-aesthetic hierarchies, they can nonetheless be viewed as failures. Both Minaj and Lil' Kim's overt and unapologetic presentations of their plasticized bodies demand that their complex personhood (Gordon 2008) be acknowledged.

Can these body modifications have aims more expansive than simply providing mass media visibility? What pleasures might they offer these women? Is it possible to separate racial and gender presentation from forms of capitalist branding and legibility? Kobena Mercer has also problematized the notion that racial authenticity in body presentation is an inherently antiracist project when he notes that discourses of natural Black beauty, often thought to be signified by hairstyles such as dreadlocks and Afros, stem from "an ideologically loaded *idea* created by binary and dualistic logics from European culture" (1987, 41, emphasis in original).

As Minaj anticipated, when the "Stupid Hoe" video finally circulated online, it was subject to negative critiques concerning representations of hypersexuality, sexism, and racism. In composing his criticism of the video,

MTV blog writer Sam Lansky wrote an open letter to Minaj in which he expressed his disappointment with her for poaching Lady Gaga's aesthetics and for the sexual excess conveyed by the "big ol' bouncing booties" in the video. Chastising her for not "knowing better," he rhetorically inquired, "Were you [Nicki Minaj] trying to make this video feel sort of grimly mechanical in its blatant sexiness (which at times starts to feel sexist)? I want to give you the benefit of the doubt and say that all that nasty grinding was intended to parody artists who exploit their sexuality to sell records. . . . But when a parody of something is virtually indistinguishable from the thing being parodied, the whole point has a way of getting lost, and everything ends up just self-cannibalizing" (Lansky 2012). Lansky's primary problem seems to be that the sexual signals conveyed by the shaking buttocks and gyrating bodies in the video do not carry a promise of emotional investment from the women of color performing. The mechanical nature of the typological Black feminine sexuality staged in the video appears too empty and objectifying for the writer, who draws on the hyperbolic and raced rhetoric of self-cannibalization to refer to the harm Minaj inflicts upon herself through signifying this joyless sex. His viewing was unpleasant, and I posit that, in some ways, the video was crafted to be.

The rococo-esque visual overload of the video, coupled with Minaj's menacing faces, purposefully disturb what would typically be an enjoyable mainstream hip-hop video, one of many that traffic in Black women's shaking asses for heteronormative male consumption. It is the absence of parody, and the possibility that Minaj is knowingly utilizing her body for career success, that make the video troubling to the critic. Neoliberal discourse eschews terms such as "exploitation," and perhaps the image of Minaj working Black women's bodies, including her own, for the market in such an explicit fashion raises an unwelcome specter of raced sexual-economic exchange, the grotesque kind that contemporary artist Kara Walker daringly portrays in her perverse tableaux of the antebellum South that feature illicit encounters between slaves and masters.

Minaj appears to reject the discursive protection of parody, as she is not invested in disavowing the fact that her sexualized body is tied to the market, recognizing perhaps that any such protection or conferral of respectability is ultimately policing. Due to the continued cultural devaluation of performative artifice and rococo aesthetics, the critical reception of "Stupid Hoe" foreclosed the feminist and antiracist meanings that can be read in the video. It was further derided in the feminist blog *Jezebel* in a piece titled

"Nicki Minaj's Stupid Hoe Video Features Writhing, Disappointment," in which Dodai Stewart wrote,

> Most unfortunate are the shots of Nicki Minaj in a cage, a la Shakira. We have discussed black women in cages before—most notably Amber Rose and Grace Jones. It's a tired, troubling visual. In this context, we're supposed to see Nicki as threatening, wild, dangerous. But the objectification and exoticization of black women is steeped in racism. Our history includes centuries of slavery in which black people were chained, shackled, muzzled, and yes, caged. Nicki placing herself there doesn't invoke terror, and not just because she's popping her booty. Male rappers telegraph menace through threats of violence, brandishing guns or boasting of assaults and drive-bys. Is there a good way for a black woman to show she's a force to be reckoned with, without reverting to ancient stereotypes of the sexualized beast, the predatory Jezebel? Absolutely. But Nicki hasn't found it yet. (Stewart 2012)

The history of Saartjie Baartman's display as the Hottentot Venus has critically overdetermined readings of Black women's embodiment, sexuality, and performance into the limited frameworks of objectification, exploitation, and victimization, as race and visual culture theorists Jennifer C. Nash (2008) and Anne Anlin Cheng (2011a) have argued. I see Baartman in the "Stupid Hoe" video, but I also see Minaj perverting and exorcising the historical script through her jarring juxtapositions of hyperfeminine aesthetics and intimidating, gender-nonconforming facial expressions. In the *Jezebel* article, Stewart values the rote, hypermasculine brandishing of guns by male rappers over the more imaginative performances of figures like Grace Jones and Minaj—who present monstrous images of Black female sexuality that, while profitable and colluding with stereotypical fantasies about their bestial sexuality to varying extents, present bodies that are nonetheless indigestible in the face of respectability politics and established aesthetic hierarchies. Even if the negative critiques of Minaj work to draw more attention to her brand, her body is nevertheless presenting an alternative mode of woman of color fashioning that agitates the visual field through sexual-aesthetic excess.

Minaj's hyperfeminine rococo style engages the fastidiousness of Black dandyism, which Monica L. Miller describes as "a sometimes subtle, sometimes entirely obvious, but always fabulous appropriation and revision of fancy clothes that is less a 'hidden transcript' with which African Americans

preserve a sense of themselves, than a highly readable performative text that is subject to interpretation and translation and more often than not functions as a challenge" (2009, 16). Minaj's fancy clothes and rococo aesthetics are the mediums through which her challenges to gender, race, and sexual hierarchies are bodily articulated. Her ornate styles reject hegemonic notions of racial authenticity, gender normativity, and classed sexual respectability. Minaj's fakery, rather than being understood as a form of racial betrayal, can be considered instead as a technique for negotiating the meanings of her practice and overdetermined gendered and racialized body. Her fake, plastic, shifting, sexually and sartorially excessive incarnations serve as layered skins between her subjectivity and market iconography. In this, Minaj's performance practices are similar to those of Black women entertainers who are her precursors, such as Josephine Baker. Anne Anlin Cheng has explored how Josephine Baker's seemingly nude performing body was in fact a multilayered sheath through which she clad her body, the presentation of a flesh that is not flesh at all. Cheng's assessment of the politics of Baker's body are applicable to Minaj because she, like Baker, "collapses the difference between persona and representation and, in doing so, critiques the assumption of authenticity and embodiment utilized by *both* liberal criticism and colonial racism" (Cheng 2011, 161). The perception of Minaj's body as problematically overexposed ignores the manner in which her form is a palimpsest that complicates notions of racial authenticity through trespassing into feminine whiteness, rather than aspiring to it.

From 2013 to 2015, Minaj's style shifted into a more subdued, but still hyperfeminine, sexual and performative mode. Although she has been wearing her hair black, pink and blonde wigs still make an appearance, as does her glimmering, stone-encrusted pink microphone. The art on the cover of her 2014 album *The Pinkprint* (figure 4.14) is a voluptuous vaginal form that appears to have been crafted from a thick mound of pink eye shadow—a rococo-spirited homage to the creative force of makeup.

It is through fakery, and the plasticized pink that marks it, that we can locate the possibilities Minaj's aesthetics have generated for more imaginative ways of being and embodying for women and girls of color. Rejecting the vilification of hyperfeminine aesthetics and discourse of racial fakery, which are tangled up with notions of gender, class, and sexual respectability, can make it possible for girls like WOTR artists K Baby and Betty Boo to embrace inventive, colorful styling and feel good through the creative presentation of their bodies, a pleasure that discourses of respectability and bodily inauthenticity work to foreclose. As Poca Hantist, the pseudonym

FIGURE 4.14. Cover of Nicki Minaj's album *The Pinkprint*, 2014.

of a seventeen-year-old mixed-race Latina, African American, and Native American WOTR participant, commented about Nicki Minaj, "I think that she's going against males. It's like, 'I'm dressed like Barbie and I'm still getting attention.' She's showing girls can do it too—girls can rap too."

Let's Talk about Nicki Minaj: A Rococo Side-Show/Salon

By way of conclusion, I share *Let's Talk about Nicki Minaj: A Rococo Side-Show/Salon*, a performance and exhibition held in Miami, Florida, in 2014, which stemmed from my research on the rococo portraits of Minaj created by Francesco Vezzoli. As I reflected on WOTR participants' various modes of engaging Minaj's music and body, I recalled my own negotiations of cultural products like Barbie dolls, and the class, gender, and ethnic dynamics that shaped my girlhood and, later, my community work and scholarship. In fall 2013, I took the position of assistant professor of ethnic and critical gender

studies at the University of California in San Diego and made a dramatic shift from the community spaces I was sharing with girls in Miami to that of the academy. Although my work with the girls in Miami was fulfilling, more than I can express, working with them through the institution of the art museum and its attendant politics became taxing and unviable for me for a host of reasons—specifically, the cultural devaluations of girls and women of color that I analyze in this book were revealed to me intimately through my experiences in the museum context. I eventually found purpose in teaching students at the university as a new assistant professor, but I was still missing the collective of artists that had surrounded me back home in Miami through WOTR. I also missed seeing the dramatically styled bodies of Black and Latina women out in public, and the gaudy, rococo-esque aesthetics of the city itself.

In San Diego County, feeling far removed from my family and friends, I found myself turning to art and poetry, the way I did as a teenager, to process these feelings and also to channel the immense inspiration generated through my immersion in Nicki Minaj's music and imagery, which was initially sparked by the girls. I decided to present a performance and curate an exhibition in Miami during a summer trip in 2014 that would provide a public forum back home and outside of the academy to engage in charlas similar to those I had had with WOTR girls and my circle of women of color artist and scholar friends.

My idea for the exhibition also came from attending the Hip Hop and Punk Feminisms conference organized by Ruth Nicole Brown, Mimi Thi Nguyen, Fiona I. B. Ngô, Karen Flynn, and Susan Briana Livingston at the University of Illinois at Urbana-Champaign in December 2013. At the conference, scholarship was presented with and by cultural producers. Admission was free and art workshops took place throughout the day, capped by live performances at night by local, national, and international women musicians. It was an unforgettable convergence of the creative and scholarly processes that drive me, and the energy it created among those who attended was palpable.

Let's Talk about Nicki Minaj: A Rococo Side-Show/Salon was an ephemeral interactive performance project, exhibition, and happening that took place for one night at the alternative artist-run venue Space Mountain in Miami on July 24, 2014. In addition to my performance and installation *Let's Talk about Nicki Minaj*, it featured works by artists Rosemarie Romero, Anya Wallace, Kevin Arrow, and Crystal Pearl. Rosemarie Romero presented her *Porn Nail$* project, a mobile nail salon that provides free manicures and gossip to clients through Tropi-camp performances, Latina kitsch, and rela-

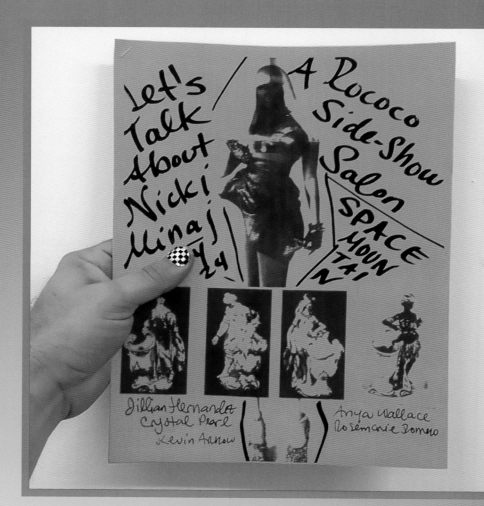

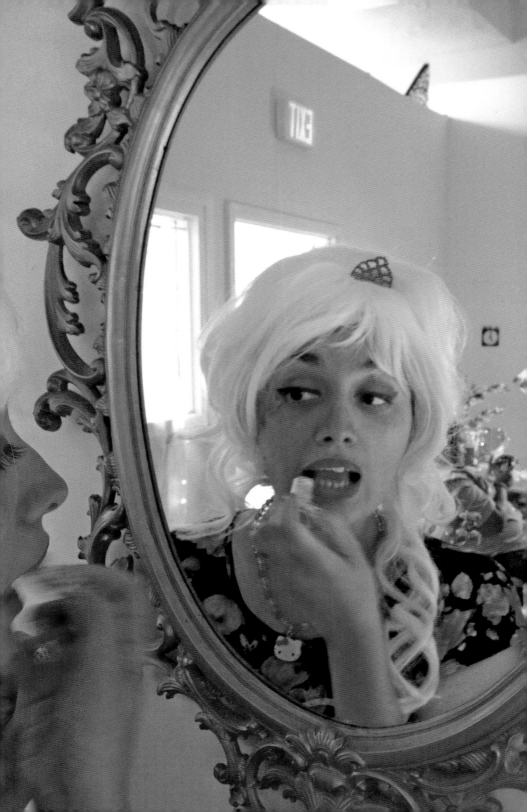

FINDING FREDA

She must have come that night.

Thursday in July in Little Haiti.

Smelling the cake frosting & tasting the nail polish

It stuck to our fingernails and she danced with us

In quiet possession

Like a lady

Holding on to our pinky fingers

Rose told me about her in a Facebook message

"She's a goddess of beauty and pink"

Anya told me that Ebony told her too, and it was the next day

She came.

She sat with us in the salon because the pillows and the lights were pink.

Because we were celebrating each other.

They say she doesn't like women but I know that's not true.

She has a queer side. A woman-loving-woman side, however you may take that.

I brought her home with me from Miami.

Oiled & fragrant.

She has taken up space.

In me and without.

Pink is her color.

/ JILLIAN HERNANDEZ, AUGUST 2014

More upper class Haitians "make food" for Erzulie Freida than for any other loa in Haiti. Forever after the consecration, they wear a gold chain about their necks under their shirts and a ring on the finger with the initials E.F. cut inside of it. I have examined several of these rings. I know one man who has combined the two things. He has a ring made of a bit of gold chain. And there is a whole library of tales of how this man and that was "réclamé" by the goddess Erzulie, or how that one came to attach himself to the Cult. I have stood in one of the bedrooms, decorated and furnished for a visit from the invisible perfection. I looked at the little government employee standing there amid the cut flowers, the cakes, the perfumes, the lace covered bed and with the spur of imagination, saw his common clay glow with some borrowed light and his earthiness transfigured as he mated with a goddess that night—with Erzulie, the lady upon the rock whose toes are pretty and flowery.

/ ZORA NEALE HURSON, *TELL MY HORSE: VOODOO AND LIFE IN HAITI AND JAMAICA* (1938, 127–128)

a rococo side-show/salon

FIVE

ENCOUNTERS WITH EXCESS

GIRLS CREATING ART, THEORY,
AND SEXUAL BODIES

The Women on the Rise! (WOTR) community arts project worked with girls at multiple community sites, one of which was Waves, a residential detention facility for pregnant and mothering girls who were committed to the juvenile justice system. Waves offered a quasi-home setting for the girls, who had rooms they shared with their children and child care during the day while they attended therapy and educational sessions. The campus in south Miami-Dade County was a cluster of connected houses with surveillance cameras throughout and enclosed by an electric gate, where one had to be buzzed in to enter and park. Launching WOTR was a particular challenge at Waves. Anya Wallace and Crystal Pearl Molinary, the instructors who visited there while I was directing WOTR at the Museum of Contemporary Art in North Miami, reported a particularly hostile response from the Latina and Black girls there, both to the instructors themselves and to the artwork they displayed during workshops. The girls openly criticized what the instructors looked like, were verbally aggressive toward each other, and had

agitated responses to the work of the feminist artists they learned about, like Shoshanna Weinberger, who creates grotesque images of women's bodies.

Molinary and Wallace had the sense that the girls' responses were due in part to some of the institutional dynamics at Waves; the girls were under constant surveillance and were openly criticized by the women overseeing them for perceived failures in their mothering (viewed as a result of the girls' wayward sexuality), education, self-fashioning, and overall comportment, even during WOTR workshops. This reflected what Aimee Meredith Cox describes as "the terms through which educational, training, and social service institutions attempt to shape young Black [and Latina] women into manageable and respectable members of society whose social citizenship is always questionable and never guaranteed, even as these same institutions ostensibly encourage social belonging" (2015, 7). The instructors felt that, due to the palpable ways in which the girls were consistently framed as social citizens of questionable standing, their added participation in WOTR was perhaps too much for them to take on in a day filled with interactions with adults trying to educate them.

Since WOTR is a visiting project, the instructors and I were eager to meet with our liaison at Waves, a psychologist who provides therapy for the girls, to learn what issues the girls might be facing and discuss how WOTR could potentially deliver our workshops differently in hopes of improving the relationship between the instructors and the girls. Wallace, Molinary, and I succeeded in meeting with our liaison, but were completely unprepared for what we heard. When the instructors discussed what was happening in the workshops, the liaison suggested that our discussions on contemporary women artists and the art projects we engaged the girls in were too complex, thus going over their heads and upsetting them. We informed her that we often experience negative responses from the artists with whom we work, but that eventually, rapport builds and the workshops become fruitful spaces that the girls look forward to. We were there to figure out how to make WOTR work at this particular site.

Steadfast in her view that the girls were incapable of participating, the liaison suggested that if we continue, we should conduct simpler projects: "Why don't you have them paint flowers?" She then explained that many of the girls there had been sexually abused and claimed that the girls were mentally "stunted" at the age that the abuse occurred: "So if they were seven when the abuse happened, they pretty much have the intellectual capacity of a seven-year-old." Moments like these, when the adults who regularly work with Black and Latina girls in social service, educational, or governmental

institutions reveal their profoundly deficit-oriented view of them, remind us WOTR instructors of our mission—to provide creative time for the girls to do the work of complex self-expression. The space of WOTR is not safe and may at times be perilous due to the context, content, and power differentials it negotiates, but it is more often affirming once the dust settles and the instructors and the girls let their guards down.

When Black and Latina girls work the tools of representation with their own hands, when they work as artists, they can challenge the constant policing of their bodies and sexualities and, more importantly, create new possibilities for their embodiment through the articulation of their multifaceted identities. These are representations that are not found in pop culture videos, nor on the walls of influential galleries or museums. Through turning to girls' creative encounters with Black women artists who engage the aesthetics of the grotesque, this chapter explores how their work as cultural producers holds radical possibilities for bolstering their sexual and bodily self-determination.

For example, in the WOTR workshop based on the work of Wangechi Mutu, participants view images of her collages and discuss her use of fashion magazines as source material. We focus in particular on how Mutu's images critique the valuation of idealized white femininity and the consumption of luxury goods such as diamonds, which are mined in Africa under dehumanizing and exploitative conditions. Mutu is known primarily for her collages that craft otherworldly hybrid figures by combining images of models from high-fashion magazines, racialized pornography, and ethnographic photographs of African villagers (figure 5.1). Her work variously addresses issues of political and gender-based violence, race, and beauty politics by culling, juxtaposing, and troubling figurations of Black women's corporeality in visual culture. Through the grotesque aesthetics she employs, which conjoin images of humans, animals, plants, and machines (Connelly 2003), Mutu's work conjures ambivalent responses to the erotic presentation of Black women's bodies. In previous work, I have referred to this approach as the "ambivalent grotesque" (Hernandez 2017).

The ambivalent grotesque describes the enticement and disgust that attends the consumption of sexual and ethnographic representations of racialized women, racialized women's concomitant rejection and embrace of such images, and, drawing from Mikhail Bakhtin's (1984) influential theorization on the grotesque, the fluid composition and juxtaposition of bodily images, such as those Mutu creates. The ambivalent grotesque is also the frame through which girls and women of color see racialized erotic images,

FIGURE 5.1. Wangechi Mutu, *Hide 'n' Seek, Kill or Speak*, 2004. Paint, ink, collage, mixed media on mylar, 42 × 48 inches. COURTESY OF THE ARTIST. THE STUDIO MUSEUM IN HARLEM; MUSEUM PURCHASE MADE POSSIBLE BY A GIFT FROM JEANNE GREENBERG ROHATYN.

with attention to the complexities of pain and pleasure, power and subjection that they carry and communicate for both viewers and producers.

The ambivalent grotesque is a fitting interpretive modality for analyzing sexual images of women of color from working-class backgrounds because we experience the push and pull of forces of respectability and stereotype critique, along with arousal and delight, in our depictions as sexually excessive (Shimizu 2007).[1] Ambivalence describes mixed feelings. Therefore, the ambivalent grotesque is not to be understood as a static dichotomous binary, but rather as mobile multiplicities of feelings, aesthetics, and interpretations that hold elements in tension that are often at once complementary, contradictory, and coimbricating. In the passages below, I discuss how the responses by WOTR artists to the work of artists like Mutu, Kara Walker, and Shoshanna Weinberger in the space of WOTR were marked by the vicissitudes of the ambivalent grotesque.

For the art project component of the Mutu project, we provide the girls with a wide selection of popular magazines targeted to women (some purchased, others donated by WOTR instructors or supporters) and prompt them to create hybrid, grotesque, and otherworldly forms inspired by Mutu's aesthetic by cutting out fragments of the bodies they find in the magazines. In one particular workshop in July 2014, with a group of about twenty eleven-to-thirteen-year-old Black girls, one participant found a picture of the popular music artist Beyoncé in a magazine and began to cut it out. She then asked me to help her find a different body that she could attach to her Beyoncé head. As we flipped through the magazine together, we only saw the bodies of white celebrities and models displayed over and over again. We continued to search, and she nodded her head, as if to say, "This is *not* what I'm looking for." It became apparent to me that she was trying to locate a Black woman's body to pair with the Beyoncé head. I then brought an issue of *Essence* magazine to her worktable and said that she would probably find something she'd like there. "What magazine is this?" she asked excitedly, then looked back at the initial magazine we flipped through and nodded her head with disapproval, like the first magazine was wack for having so few images of Black women.

During WOTR workshops based on Mutu, I am always interested in the ways the artists flip through the magazines to select the images they will work with, as the workshop tends to elicit their theoretical commentary and observations about gender, race, sexuality, and representation. For example, in another workshop, one girl said that she was working on a collage that juxtaposed images of women who are "always" on the covers of maga-

zines, with pictures of more "regular"-looking women who never make it on the cover (figure 5.2). In a clever play on the Cover Girl brand logo she found on an ad, the participant cut out and spliced the logo, placing the heading "Cover" on one side of the page, under which she placed images of beauty products and photos highlighting jewelry, cleavage, and the airbrushed faces of fashion models. She then positioned the heading "Girl" on the opposite side of the page, where she placed an image of a woman of color smiling, and a white woman in sunglasses with a deadpan expression. She explained that the women under the Girl heading just seemed to be going about their business and were not overly concerned with their appearance.

In another Mutu workshop, a Black girl was searching for an image of a "Hispanic" girl or woman to use in her collage and found nothing except an image of Latina women in frilly *rumbera* outfits from an ad promoting a tropical-themed nightclub show (figure 5.3). She cut one of the women's bodies out and topped it with a Barbie head, a clever hybridization that mocked the typological ways the women in the ad were depicted. An-

other artist worked diligently and lovingly on an image of Nicki Minaj that she had found and cut out from a MAC cosmetics advertisement. She surrounded Minaj's body in her composition with vibrant colors and shared her work proudly with the other girls, explaining that she was a fan (see epilogue). In another piece, an artist cut out a story on competing businessmen with the heading "Big Man" and burlesqued the image by giving them mouths taken from images of women's bodies (figure 5.4). She also affixed high heels and earrings to the men and talked about how you rarely see images of women in these stories about business success.

In centering these conversations and artworks generated by the girls, this chapter turns to a more exclusive focus on the praxis and pedagogies of the WOTR art project. I draw on my experiences working with Black and Latina girls as a WOTR instructor to document how engaging them in discussions about the sexual bodies figured in the work of Black women artists have activated spaces for them to analyze, critique, and/or affirm racialized erotic representations in art and popular culture—in short, how they tarry with aesthetics of excess. I do not attribute these girls' practices to WOTR, as girls of color engage in theorizing on a daily basis, and therefore their art making and critique is not something the project teaches them to do. Yet I am compelled by the negotiations that unfold in the unique gender- and arts-specific performative space of WOTR. In particular, I explore how WOTR participants have responded to the work of Mutu, Weinberger, and Walker, artists whose point of departure is the sexual-aesthetic excess of Black women in representation, and who mobilize grotesque aesthetics. The WOTR workshops based on these artists became sites where girls

- theorized the heteronormative ways that men gaze upon women of color's bodies,
- articulated anger over the exploitation of Black women,
- exhibited shame when viewing artwork that explored sexuality, and
- expressed pleasure in crafting their own paintings and sculptures of erotic, aesthetically excessive, and grotesque bodies, including art making that used their own bodies as material.

Later in the chapter, I interrogate the panic I felt when a Black grandmother, along with her young granddaughters, attended a public lecture I presented on Mutu's use of ethnic pornography in her work.

My reflections on that experience, along with WOTR girls' creative responses to the work of Black women artists, invite us to consider the poten-

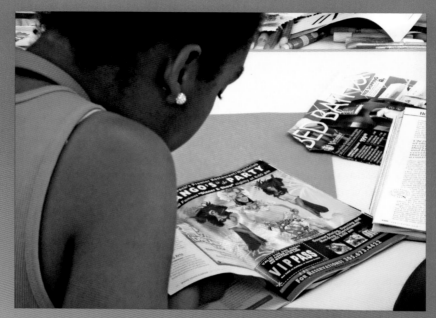

FIGURE 5.3. Detail of *rumbera* collage by WOTR artist.
FIGURE 5.4. "Big Man" collage by WOTR artist.

tial of feminist arts praxis that embraces sexual-aesthetic excess to open spaces for Black and Latina girls to express bodily and sexual self-determination and pleasure. The artworks, conversations, and reflections I share here exhibit what feminist artist and scholar Ruth Nicole Brown describes as the "creative potential of Black girlhood" or "Black girl genius"—"a frame of organizing dependent on the energetic charge of creativity to move ideas and people. In this framework, potential, as in energy, is invoked as a property of collectivity" (2013, 187). I apply Brown's work on Black girlhood, creativity, and knowledge production to read the collective exchanges and works produced in WOTR and to suggest what those exchanges and artworks offer for more expansive understandings of Black and Latina sexualities, embodiment, and genius.

Strange Fruits: Engaging Shoshanna Weinberger's Grotesques

The work of artist Shoshanna Weinberger exposes the perversions of dominant constructs of woman of color beauty and sexuality. A Newark, New Jersey–based artist raised in Kingston, Jamaica, and Montclair, New Jersey, by a white Jewish father and Black Jamaican mother, Weinberger frames her work through a complex multiracial perspective. She playfully refers to herself as a "strange fruit," purposefully evoking the dense racial affect of Billie Holiday's protest song. Fragmented images of mules in her work also symbolize her biracial identity by referencing the term *mulatta*. In her work *Zulu Jew* (2004), she presents a tongue-in-cheek self-portrait that combines the various racial and ethnic semiotics of her body: an abstracted and disembodied head, marked with black-and-white zebra stripes, is topped by soft, billowy puffs of brown hair.

Like Mutu, Weinberger also explores the politics of Black women's sexual embodiment by employing a grotesque aesthetics of excess. In "Attack of the Boogeywoman: Visualizing Black Women's Grotesquerie in Afrofuturism," art historian Jared Richardson reads the imaging work of Minaj, Mutu, Walker, and Weinberger, and asks, "What kind of power does the grotesque offer to Black women in relation to their monstrous representation?" (2012, 20). Richardson argues that grotesque aesthetics provide a means through which Black women can complicate and shift between representations of both hypersexuality and respectability, stereotypical tropes and complexity (2012, 22)—the kind of negotiations I call the ambivalent grotesque. Weinberger depicts the fluidity of Black women's ambivalent grotesque precisely through the image that epitomizes Black women's essentialism—that of

Saartjie Baartman, the Khoisan woman from the Eastern Cape of South Africa exhibited in Europe in the nineteenth century as the Hottentot Venus.

Black feminist theorist Jennifer Nash has noted how the figure of the Hottentot Venus has become a trope through which Black feminists articulate notions of the injury Black women suffer through their sexual representation in the visual field. Nash argues that "in mobilizing the Hottentot Venus to critique dominant representations of Black women's bodies, Black feminism has permitted a pernicious sexual conservatism, wearing the guise of racial progressivism, to seep into its analytic framework. By sexual conservatism, I refer to Black feminism's tendency to foreground examinations of Black women's sexual exploitation, oppression, and injury at the expense of analyses attentive to Black women's sexual heterogeneity, multiplicity, and diversity" (2008, 52). Weinberger has said that she is both "inspired and appalled" by the life of Saartjie Baartman.[2] Rather than articulating the narrative of Black women's pain that Nash critiques, Weinberger gives the icon of the Hottentot Venus a futuristic life as an otherworldly grotesque.

The bodies in Weinberger's work, many of which are rendered in silhouettes that evoke nineteenth-century images of the Hottentot Venus, are incarnations of excess. Masses of flesh are tied into shape by thick gold chains; headless bodies with proliferations of breasts and asses are clad in tight, metallic bras, their straps binding the bulging skin into one corpus (see figures 5.5 and 5.6). In many of Weinberger's works, the static outlines of Black women's bodies verge on collapsing into formlessness: if a line, chain, or bra strap were to become undone, they would signify nothing but heavy, amorphous mass. This tension is achieved through her uniquely baroque and simultaneously economical approach to image making. The paintings are at once simple and ornate, direct and vague, representational and abstract, beautiful and ugly. Although bound by history, Weinberger's grotesques survive, and they evoke radical corporeal futures through their perverse hyperboles of beauty and sexuality.

This futurity is anticipated in pieces such as *Wandering Hatchling* (2012). The painting centers on a headless Black femme body rendered in a silhouette against a blank background. The black outline of the figure starkly contrasts with the off-white paper. Gold chains are wrapped around the body, framing its torso, waist, and six breasts. They dangle between her thighs and recede into the empty background to which she appears to be tethered. The body stands in profile, cutting a mutated yet strangely attractive figure. Raising a high-heeled foot commandingly above the ground, the body appears to be in the process of walking out of the picture—out of our sight.

FIGURE 5.5. Shoshanna Weinberger, *Potbelly Porn Star and the Rise of Bacon*, 2012. Gouache on paper, 74.25 × 60 inches. © SHOSHANNA WEINBERGER.

FIGURE 5.6. Shoshanna Weinberger, *Wandering Hatchling*, 2012. Gouache on paper, 16.75 × 22.5 inches. © SHOSHANNA WEINBERGER.

Crystal Pearl Molinary had worked with Weinberger on installing an exhibition of her work at Carol Jazzar Gallery in Miami in 2012. Inspired by that experience, Molinary came up with the idea of developing a workshop in which we would present Weinberger's work to the girls to discuss issues of Black women's representation in visual culture. The Weinberger workshop, which the WOTR instructors developed collaboratively in response to Molinary's proposal, consisted of a slide show discussion in which we displayed images of Weinberger's work to participants, gave them an overview of the history of Saartjie Baartman, and discussed images of contemporary women of color performers such as Nicki Minaj, Lil' Kim, and Jennifer Lopez, whose sexual staging of their racialized bodies is a constitutive element of their performance and imaging. Our aim was to engage the girls in an open-ended and potentially sex-positive discussion about representation and to explore a history of Black womanhood left ignored by their school curricula.

The hands-on art projects we developed as part of the Weinberger workshop consisted of a watercolor activity in which the WOTR artists were instructed to respond, using paints in any way they wished, to the group discussion on Black women's visual representation. We let them know that drawing nude body parts would be okay and that they did not have to worry about us sanctioning them for depicting sexual content. The second Weinberger activity, which we would conduct in a subsequent WOTR session, was a project in which participants were prompted to create three-dimensional versions of Weinberger-esque femme forms.

Molinary created headless soft-sculpture forms of women's bodies that the girls were able to dress and manipulate with bras, panties, and plastic gold-beaded chains. Materials for this project also included girdles and butt-lifting underwear that the girls were free to stuff with batting to create their own sculpture bodies. The dynamic interactions we had with the artists as part of this workshop, and the images they produced, elicited a range of responses that included the shame that many of them felt about women's erotic embodiment, in addition to their expressions of empathy, social critique, and corporeal pleasure.

One of the issues that Weinberger addresses in her work is the manner in which many women survey each other in the ways that heteronormative men do by implicitly adopting their erotic gaze. In my discussions with the artist, Weinberger has noted how women read each other's bodies in order to size them up, to identify shortcomings or attractive features that make them feel superior, threatened, and/or envious. These dynamics often played out

in WOTR sessions, where girls would insult each other for purported styling failures, or talk negatively about the bodies of women in popular culture such as Nicki Minaj (as discussed in chapter 4). This is a topic that the girls engaged in our group conversations, such as when a Latina girl was discussing her ideal embodiment: "I'd be five feet eleven or taller. Breasts smaller. Longer, curly brown hair that reaches my knees. Eyes green or blue." When I asked what other girls or women would think of her look, she said, "Women would be less inclined to talk to me. They would probably wish that they looked like me, too. That would make it easier to make closer friends because only a certain kind of person [woman] will talk to me. People that don't get jealous because of the way I look. They wouldn't judge me because of the girls I hang out with."

She expressed the notion that achieving her ideal embodiment would result in the envy of other women and girls, perhaps due to the possession of attributes associated with whiteness, like light-colored eyes. Yet, interestingly, she does not frame this as hindering the development of relationships with other women, as she believes that inhabiting such a body would facilitate developing close, genuine relationships with women who are confident and nonjudgmental.

As instructors, our own bodies became ensnared in competitive gender dynamics in WOTR at times. I recall a class in which I met a group of new girls, and within five minutes, one of them was sarcastically asking me if my shoes were uncomfortable because I wasn't walking properly in them. When discussing this issue of intragender body surveillance, a WOTR student mentioned how some people criticized Angela Bassett for her muscular figure in the Tina Turner biopic *What's Love Got to Do with It* (1993), which deviates from normative ideals of women's embodiment.

In the Weinberger workshops, some WOTR artists negatively judged Weinberger for rendering "nasty" nude bodies. One artist suggested that Weinberger needed some kind of psychological intervention that would help her stop crafting such disturbing sexual images. Another artist once asked us if Weinberger had a husband. When the instructors and I asked why she wanted to know, she said that she imagined it would be weird for him to have those images of naked women lying around the house. She thought that it would also be uncomfortable for Weinberger, as he would likely be sexually aroused by those images. We asked the group if, given the fact that Weinberger's paintings are much more grotesque than the titillating sexual representations of women in mainstream popular culture, they really thought that a man would find the images erotic. Many of

them chimed in, answering, "He's a man," and that he would not be able to help himself. This particular class consisted of about fifteen teenage Black girls.

It appeared that Weinberger's grotesque aesthetics of excess were what elicited the girls' agitated responses. Jjena Hupp Andrews argues that engagement with images of grotesque bodies in the classroom "can provide unique opportunities to understand socially and politically charged issues such as inequality, prejudices, injustices, and difference in unique, potentially powerful ways. The grotesque has the ability to disrupt the status quo, which forces the viewer to choose between contending with the disturbing image and turning away in disinterest and denial. . . . This visual and visceral jolt can become a starting point for students as individuals, in small groups, and as a class, to engage with possible reasons why such an image affected them so strongly and to examine the assumptions embedded in their reactions" (2015, n.p.).

Artists' discussions on gender in Weinberger-based workshops reflected Andrews's insights on how the grotesque body invites confrontations with injustice. Weinberger's grotesque forms prompted many WOTR artists to theorize about heteronormative cismale hypersexuality. For example, while we were displaying a nineteenth-century cartoon depicting Saartjie Baartman on display as the Hottentot Venus surrounded by a throng of Europeans, both awed and disgusted, a girl joked that one of the men was saying to Baartman, "Let me get that number, though." Another followed with, "I wanna grab that booty." The WOTR artists consistently articulated a notion of men's visuality as sexually driven, violating, insatiable, compulsory, pathological, insensitive, and objectifying. This perspective is informed by how they have experienced their own bodies surveyed by heterosexual cisboys and men.

As one Latina participant noted, "At our age, they [boys] are out of control, immature. They are horny. If they see a girl in booty shorts and a crop top, they are gonna go up to her. But if they see a girl with pants and long sleeves, they will look away. Guys at this age, they don't think about it. They don't go up to a girl because of her personality, they go up to a girl because of her body and her face." Participants also noted the double standard that frames conservatively dressed girls as unattractive but "good girls," and those who reveal their bodies as attractive but "slutty and deviant." As thirteen-year-old Julia, who identifies as multiracial (African American, Cape Verdean, Native American, Caucasian), asserted, "I think that if I would wear a blouse and nice pants and sandals and all that stuff, they would

think I'm a nice angel, an appropriate little girl who doesn't do anything—super sweet, that's not a rebel. I guess that's what they [boys and people in general] would see. But if I would wear booty shorts and a crop top and [Air] Jordans [sneakers], they would think, 'Oh, she's just trying to attract guys' or whatever." The theorizing of WOTR artists such as Julia recognizes that they occupy impossible positions within the limiting normative frameworks of attractive versus ugly, and bad versus good femininity, while garnering none of the rewards promised by booty capitalism (Brown 2013, 206), the sexual economy that poses marriageability as a benefit for Black girls appealing to men's desires.

This is probably why we found that many WOTR artists felt anxious and somewhat ashamed by Weinberger's conspicuously sexual bodies. Some would avert their eyes from the screen projection while her work was displayed; others would laugh. There was a pervading sense that representing women's bodies in such an open, grotesque way was dangerous and deviant. For instance, artists often mentioned the body presentations of prostitutes in our discussion of Weinberger's artwork, particularly when we viewed the *Freak Show* series of paintings, which figure grotesque, faceless women's bodies donning feather boas, high-heeled shoes, and devil horns. Unlike the blank background compositions of many of her other works, the bodies in the *Freak Show* series are framed by curtains that signal their performance and display. Recognizing that the display of the female form in Weinberger's *Freak Show* echoed that of Baartman, it appeared that the girls wanted to perform distance from the sexual-aesthetic excess ascribed to Black women, as the images expose the sinister racist and sexist underpinnings that attend booty capitalism.

In addition to sexuality, artists also engaged in discussions of race and beauty incited by Weinberger's images. Some felt an affinity to the artist due to their own identity as multiracial. One mixed-race girl said that she connected to Weinberger because she has a mix of white and Black hair: "It's too hard to manage, so I just end up getting a perm." Another wrote on her WOTR project feedback form that she enjoyed the Weinberger project because, as a biracial girl, the artist "understands [her] struggles." When we talked to a class of Black teenage girls about the racist Euro-American beauty standards that have been hegemonic in the U.S. and frame Black women as less attractive, one of our students, a dark-skinned girl with long, thick braids who wore no makeup, said, "Everybody's tryna be red with good hair," meaning that, due to these beauty politics, people want to be light skinned ("red") and have smooth, straight hair.

The complexity and depth of our discussions found physical form in the works the artists created for the Weinberger project. Some expressed their sadness about and empathy with the story of Saartjie Baartman through paintings that depicted images of nude Black women crying, or fragmented Black women's bodies in chains (see figures 5.7 and 5.8). Others expressed their outrage about the racism she experienced through text, writing words and phrases upon the watercolor paper like "shamed," "show closed," "abused," "never forgetting," "free one color of a human," and "bring sadness to our times" (see figure 5.9). Meanwhile, others wrote sex-positive and affirming messages like "sexy power" and "inner beauty" (see figures 5.10 and 5.11). One participant depicted images of female sexual pleasure, lips and tongues and vaginas carefully rendered and voluptuous (see figure 5.12).

The Weinberger workshop became a space where varying articulations of Black and Latina girls' sexual and embodied pleasures and pains intermingled and resounded. It was a space of racial, gender, and sexual critique, but also a site where erotic modes of woman of color self-display were celebrated. For instance, a discussion on Weinberger's work in a class of thirteen-to-fourteen-year-old Black and Latina artists was interrupted by Julia. When the WOTR instructors displayed an image of Lil' Kim photographed nude with Louis Vuitton logos branded on her body, Julia raised her hand and asserted to the instructors and the group that she would refuse to participate in any bashing of Lil' Kim due to the fact that she exhibits her body. Julia's critical intervention sparked a lively debate among the students about stripping as a legitimate possibility for women's social mobility.

For many of the younger, eleven-to-twelve-year-old artists in Weinberger workshops, the images of erotic female bodies they created became taboo, tainted objects, and they would rarely take the paintings home. When WOTR instructors took photographs documenting their work, they often moved away from the worktable in order to avoid being pictured with it. The WOTR instructors and I also observed a phenomenon we playfully termed "last-minute boob" among ourselves. We noticed that, when girls who refrained from painting nude female bodies realized that workshop time was about to end, they would furiously add groupings of breasts to their works, relishing what they could of a space in which such an aesthetic transgression would go unsanctioned. Thus, the space of the Weinberger lesson was one where

FIGURES 5.7– 5.12. Work by WOTR artists: (*left to right, top to bottom*) need somebody to love me; body in chains; sad story; inner beauty; sexy power; bodies and lips.

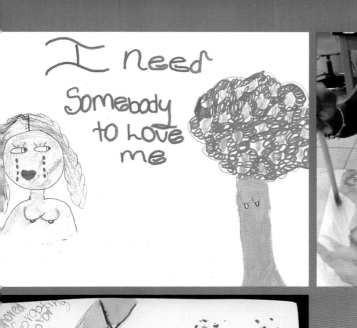

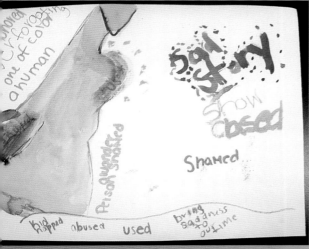

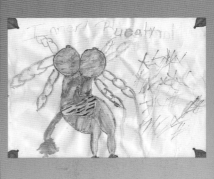

girls engaged in the modes of creativity and visual reading marked by the ambivalent grotesque. They would verbally perform sexual respectability by expressing disgust and distance from the grotesque sexual-aesthetic excess of the bodies in Weinberger's work, yet, when it came to the practice of art making in the workshop, gave themselves leeway in celebrating and reveling in what they perceived to be taboo woman of color sexual embodiment (figures 5.13 and 5.14).

Overall, participants seemed to enjoy working on the three-dimensional Weinberger project more than the watercolor painting. When we arrived at our workshops with the soft-sculpture bodies, bras, panties, batting, girdles, and fake gold chains, the girls would giddily construct monstrous bodies with multiple, enormous breasts, buttocks overflowing with stuffing from their bikini underwear, and conspicuous displays of jewelry. These initial experimentations often resulted in the artists realizing that they could create sculptures out of their own bodies, and they would furiously begin to fasten bras and slip layers of panties on over their pants and shorts, stuffing them with batting to create distorted silhouettes. They would erupt in laughter as they helped each other stuff bras to create cleavage or panties to simulate huge booties. Cell phones were routinely brought out by the girls to capture their grotesqueries. Through manipulating these socially overdetermined and sexually charged body parts and undergarments with their hands, and collaboratively fashioning them with other girls, the project seemed to elicit a feeling of control for them in the construction of their own bodies.

Saidiya Hartman's essay "Venus in Two Acts" provides context for appreciating the force of what the WOTR artists created in these workshops. In describing how enslaved Black girls who were subject to sexual violence were often recorded in the archive as "Venus," Hartman shows how the name functioned as a signifier for Black girl sexual flesh—it is a naming that "deface[s] and disfigure[s]" (2008, 10). The pedagogy of grotesque excess at WOTR generated a site for working through, rather than against, defacement and disfiguration to produce images and embodiments that looked and felt like Black girl pleasure and power. The girls, with guidance and blessings from their ancestors, engaged in the healing work of what Hartman describes as bearing what "cannot be borne: the image of Venus in chains" (Hartman 2008, 14). Such magic cannot be evoked by sight alone, but the images in figures 5.15 and 5.16, renderings by Black women artists based on photos WOTR instructors took of the Weinberger sculpture workshops, conjure the spirit of the girls' embodied creativity without subjecting them to voyeuristic

FIGURES 5.13 AND 5.14. WOTR artists working on Shoshanna Weinberger sculptures.

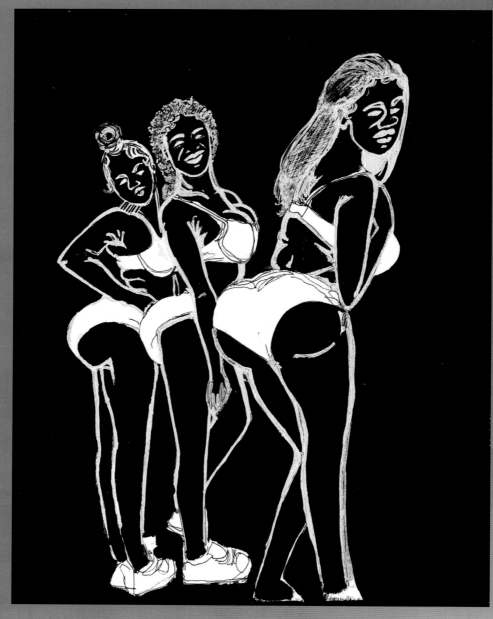

FIGURE 5.15. Mekha McGuire, *Exxxcess*, 2017. © MEKHA MCGUIRE.

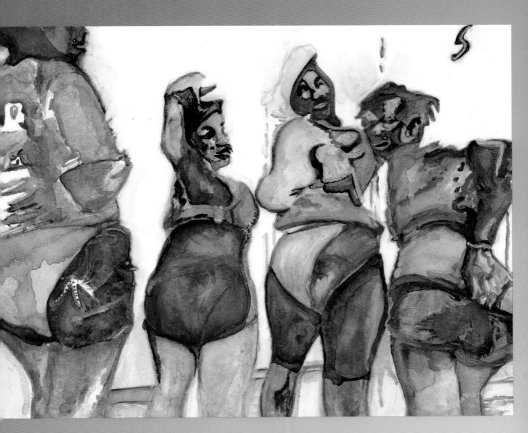

FIGURE 5.16. Anya M. Wallace, *Ruby Redaction*, 2019. Watercolor and ink on paper, 12 × 16 inches. © ANYA M. WALLACE.

display. Anya Wallace and Mekha McGuire's paintings serve as Black redactions and annotations, to use Christina Sharpe's (2016) framing, that respect the girls' collective and personal vulnerability and confidentiality as they performed these aesthetics of excess and raised Venus.[3]

The elated raucousness that would ensue among the artists as we worked on the three-dimensional Weinberger project sometimes caused discomfort in the organizations that collaborated with WOTR. At one institution, we were asked not to let the girls leave the classroom and for no one to be allowed in, as important donors were visiting, and the administration did not want the girls to be seen wearing huge breasts and asses over their uniforms. A staff member was ordered to station themselves in front of the classroom door to prevent this from happening. The behavior of the staff at our partnering organization reveals the threat that girl and woman of color aesthetic excess poses to conceptions of normative, proper, productive embodiment. Not only was the sexuality signaled by the girls' bodies perceived as anathema to the mission of the organization to provide educational access, but the joy they took in crafting these bodies was seen as especially unruly, as it was not the performance of class, racial, and sexual shame and discipline expected from girls in need of programmatic intervention because they come from working-class families and troubled communities.

Despite the (false) promises offered by booty capitalism to girls of color, Brown observes that they organically "know that hypersexualized images of girls generally do not cause such a stir on an everyday basis, as they have been subject to explicit surveillance strategies for most if not all of their lives. From music videos to commercials and television shows, that Black girls' bodies are often in service to everyone's desires but their own is mocked by Black girls' swagg that knows everyone is looking at them" (2013, 205). By displaying their bodies as creative projects and receptacles of knowledge, WOTR artists' wreckless theatrics (Brown 2014) in the Weinberger workshop— posing, laughing, documenting, debating—exhibited the mocking swagg(er) that Brown (2013) refers to by highlighting the false construct of girl of color "big booty" essentialism, as they literally created and affixed large asses onto their bodies.

Simultaneously, the artists also indulged in the pleasures of big-booty essentialism in ways that surveilling adults found threatening to the performance of proper girlhood, as the educators at the WOTR partner organization felt they needed to hide the girls' bodies to avoid losing institutional support. Engaging young Black and Latina artists with Weinberger's work and the history of Saartjie Baartman demonstrated the possibility for

powerful expressions of woman/girl of color pleasure, pain, criticality, and whimsy, to coexist in relation to a history of racialized gender oppression but not fully determined by it. Like the figure in Weinberger's *Wondering Hatchling*, girls and women of color may be chained but are always capable of walking off the stage.

Black Women's Sexual Excess as the Unexpected: Girls Engage Kara Walker's *A Subtlety*

In the summer of 2014, Anya Wallace and I developed a WOTR project based on the exhibition *A Subtlety, or the Marvelous Sugar Baby* by Kara Walker that was on display in Brooklyn, New York, from May 10 through July 6, 2014. We had taught the girls about Walker's image production before, particularly the cut-paper dioramas of Black silhouettes drawing from antebellum images of plantation life in the South, for which she became internationally known in the art world. These images often depict explicit and dramatically staged scenes of sexual liaisons between masters and slaves, in addition to renderings of violence inflicted upon slaves from whites and also among the slaves themselves. Her images visualize the underacknowledged perversity that undergirds U.S. race relations that continue to unfold via police violence, mass incarceration, and stark disparities in access to health and education resources.

Our initial WOTR workshops based on Walker's work, presented in 2006, centered particularly on her images of women and girls as a way to prompt conversations regarding race, U.S. history, and gender politics, such as white women's complicity with the slave economy and the differential gendering of Black and white women more broadly. These workshops included hands-on projects in which the girls would work collaboratively to create nineteenth-century-style silhouette portraits of each other using flashlights and black-and-white paper. They worked in groups to pose against the walls of the spaces where we worked and traced each other's profiles with pencils. Some girls would opt to create their own narrative scenes out of cut paper affixed to poster board, rather than creating portraits.

Several years later, we were inspired by the monumental new direction Walker employed in *A Subtlety, or the Marvelous Sugar Baby* to have the artists engage with her practice again. Walker's project was commissioned and organized by the New York arts-based organization Creative Time. Situated in the abandoned Domino Sugar Factory in Brooklyn, New York, which was slated for demolition, Walker created a grouping of sculptures that refer-

enced the slave labor associated with sugar production. Thus, the full title of the work is, "At the behest of Creative Time Kara Walker has confected *A Subtlety, or the Marvelous Sugar Baby,* an homage to the unpaid and over-worked Artisans who have refined our sweet tastes from the cane fields to the kitchens of the New World on the Occasion of the demolition of the Domino Sugar refining plant." The manner in which the Domino Sugar plant was still seeping molasses from its walls and had mounds of sugar sitting on the rafters prompted Walker to research the history of sugar production and consumption.

In considering the power relations that shaped the economy of sugar, Walker decided to reference an object known as a sugar subtlety in imperial Europe. Sugar subtleties were sculpted, decorative centerpiece confections made from sugar, nuts, and marzipan that were only to be consumed by those of high social standing. Walker's *A Subtlety* was a towering seventy-five-foot-long, thirty-five-foot-tall figure of a nude Black mammy figure in the form of a sphinx, seated on all fours and fashioned out of refined white sugar (figures 5.17 and 5.18). She was flanked by a grouping of life-size molasses figures of Black boy field laborers, holding baskets and bunches of bananas. As the works were fashioned from sugar, they melted during the summertime run of the show and were eventually destroyed, thus highlighting the passage of time that has marked the slave trade, industrial modes of production in the U.S., and cultural representations of Blackness.

Referencing the trope of Black women's "exotic" hypersexuality as "brown sugar" (Miller-Young 2014), the nude sphinx embodies an uncommon juxtaposition that pairs the mammy headscarf with an arched-back position that conspicuously displays her hourglass shape, buttocks, and vulva. Walker has noted that this sphinx is not from antiquity but rather from the New World. In describing the sculpture, the artist has said, "The mammy, although she is bent over in this gesture of supplication, I don't feel like she's there to be taken or satisfied or abused in any way. She's sort of withholding. I don't want to make her into a non-sexual caretaker of domesticity. She's powerful because she is so iconic and so monumental and so unexpected. If I've done the job well, then she gains her power by upsetting expectations one after the other" (Forster 2014). As Amber Jamilla Musser notes, "The Sugar Baby acts as reminder of the violent nature of the desire for sugar, for sweetness, for disposable ('free') labor, for forgiveness, for brown women, for accessible vulvas, but also remember is still a participant in her own economy of sensuality and appetite" (2018, 37). The representational innovation Walker executes in the project is the fusing of two of the most pervasive tropes of Black

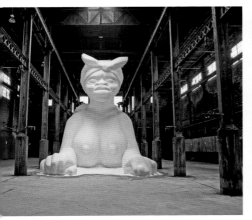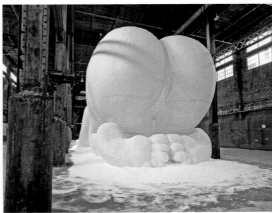

FIGURES 5.17 AND 5.18. Kara Walker, *A Subtlety, or the Marvelous Sugar Baby*, 2014. Installation views. COURTESY SIKKEMA JENKINS & CO.

womanhood—unattractive, asexual mammy and enticing, sexually excessive brown sugar—to frame Black woman's sexuality as unexpected and powerful, rather than the always already known, denigrated, and exploited.

The particular group of artists whom we worked with on the *Sugar Baby*–based WOTR project included many who had previously participated in the Weinberger workshop. In contrast to the lesson on Weinberger, the girls were relatively muted in their responses to images of the project in group discussions—perhaps because Walker's approach to fashioning the sculptures in the project was not grotesque, and possibly because they had already processed similar issues in the Weinberger project. Although there were some chuckles among the artists when we displayed the backside of the sphinx that showcased her buttocks and genitals, overall, the girls did not express the same kind of disgust they did with Weinberger's images, nor did they frame the artist as possibly pathological for crafting this highly sexual body.

In the *Sugar Baby* workshop, we displayed some of Walker's earlier cut-paper images and discussed the connections between those earlier works and the project at the Domino Sugar Factory. After observing how much the artists enjoyed working on the three-dimensional project inspired by Shoshanna Weinberger, we invited them to create their own small-scale sphinx sculptures using modeling clay. Instead of the shame that marked the girls' engagement with nude bodies in the Weinberger lesson, the girls

drew nude forms in their preparatory drawings for the sculptures with no instruction or prompting from us. As Wallace had visited the exhibition prior to the workshop, she supplied four-by-six-inch prints of the photos she took of the *Marvelous Sugar Baby* installation for the artists to work from if they wanted to draw more directly from Walker's work.

Although some of the artists made jokes about the exposed body of Walker's sphinx, the overall tone in these workshops was one of intention, as they were laser-focused on creating their work. As in the Weinberger project, participants commented on the historical exploitation of Black women and heteronormative male consumption of women's bodies. However, these critiques were primarily expressed visually rather than verbally. One artist drew an image of a woman with her breasts exposed and a chain wrapped around her neck (figure 5.19); another composed a drawing of a man gazing excitedly at an image of a nude woman on television with the caption "big booty girls," which she juxtaposed with the alternate image of a woman in a work outfit with a long-sleeved blouse, tie, and belted pencil skirt with a caption reading "powerful" in large lettering (figure 5.20).

Notably, many of the artists' sphinx sculptures departed from their preparatory drawings in both form and content. While the drawings tended to center on experiences of suffering, dominant tropes, and dehumanization, the sculptures they created drew much more directly from Walker's erotic sphinx (see figure 5.21). As in the three-dimensional Weinberger project, the girls seemed to relish using their hands to craft sexual women's bodies by and for themselves. In contrast to the visual pleasure they noted that men derive from consuming women's bodies, the WOTR girls celebrated the sexual-aesthetic excess of women's embodiment that is derived by the artistic authorship of women of color, that of Walker and of themselves.

The three-dimensional works the WOTR artists created in both the Walker and Weinberger workshops have led me to consider that perhaps the intimate and corporeal mode of hand making provides them with more direct access to what Audre Lorde calls "the erotic as power." She writes, "When I speak of the erotic, then, I speak of it as an assertion of the life force of women; of that creative energy empowered, the knowledge and use of which we are now reclaiming in our language, our history, our dancing, our loving, our work, our lives" ([1984] 2007, 55). Lorde asserts that women's erotic power has been suppressed under patriarchy, making it appear dangerous and deviant when not in the service of men. Perhaps it is that suppression that compels the girls to negatively judge the aesthetics of excess of Black women's sexuality. In working with their hands, however, they may come

FIGURES 5.19 AND 5.20. WOTR artist work in response to *A Subtlety*.

FIGURE 5.21. WOTR artists sculpting sphinxes.

into contact with that source of creative energy and carnal, "nonrational knowledge" that Lorde ([1984] 2007, 53) attributes to the erotic.

Witnessing the WOTR artists' work on the Walker, Mutu, and Weinberger projects has prompted me to understand that this artistic authorship opens avenues for them to more openly claim woman/girl of color erotic self-determination and pleasure. This echoes what L. H. Stallings (2015) argues in an analysis of the groundbreaking anthology *Erotique Noire* (1992). Stallings notes that the Black women who edited and published their writing in the anthology "demonstrate what can occur when the gaze on the body is one's own or same sex. The book, and all erotic writing read and written by Black women thereafter, becomes quite potentially a girlfriend relationship in which [erotic] funk can find a space to grow, prosper, and create radical Black female subjectivity in wild safety" (2015, 76). The creative girl and woman of color–centered space and pedagogies of WOTR cultivate wild spaces for these negotiations to unfold, and often in ways the instructors and

I could never predict. Pedagogies of aesthetic excess embrace and give rise to the unexpected.

Grandma's Erotic Lessons

The pedagogies of aesthetic excess employed in WOTR often extended beyond the space and time of a particular workshop for everyone involved. For example, one of the Black girl artists who participated in the *Sugar Baby* project told us that, following the class, she watched the PBS *Art21* video about the project online with her grandmother, and that her grandmother was so inspired by the work that she printed out a picture of Walker's sphinx and displayed it in her house. Hearing this story reminded me of another Black grandmother, whom I encountered in May 2014 at the Museum of Contemporary Art in North Miami, while I was giving a lecture as part of the adult programming of the Girls Summit on Mutu's use of ethnic pornography. She sat in the audience with her two granddaughters, who appeared to be about eight to ten years old, while she worked on a knitting project.

The Girls Summit is a program I launched at the museum in 2012 in order to bridge the gap between the scholarship on girls being produced in the academy and the girl-centered praxis being developed by teachers, youth educators, and artists in South Florida. The aim of the program was to facilitate dialogues that would productively expand the work and approaches conducted in both contexts. The Girls Summit presents some programming intended for girls, but it is geared overall as an educational and networking project for scholars and professionals who center girls of color in their work. Thus, as my lecture on Mutu was titled "Grotesquerie, Racial Pleasure, and Pornography: The Erotics of Female Embodiment in Wangechi Mutu's Work," I was not expecting to see young girls as I looked out onto the audience and prepared to begin speaking.

When I saw the girls and their grandmother, I paused, stammered, and decided to inform the audience before commencing that my presentation would include sexually explicit images from pornographic magazines. I was expecting to see the girls and their grandmother immediately rise and leave the lecture hall—but they sat and stayed, the grandmother continuing to work on her knitting project on her lap unphased. In my nervous discomfort, I repeated the warning and gave a long pause, hoping that it would prompt them to go, but they remained, and I had to move on.

Although I was accustomed to engaging girls in discussions of sexual presentations of women of color, many of which included nudity, I had never

displayed images from pornography in WOTR lessons. This is due in part to knowing that this would be unacceptable to partnering organizations, but also to my own (unacknowledged) view that such images would perhaps be of little pedagogical value or, at worst, injuring to the girls in terms of the discomfort it would produce in viewing them. Although I have written about how the raunch aesthetics in hip-hop by women of color transmit queer and feminist teachings (Hernandez 2014) and have used such music in WOTR workshops with participants over eighteen, the pornographic image itself is something I had apparently kept out of WOTR praxis.

The panic I felt when this grandmother made the choice to allow her granddaughters to hear the lecture prompted an instant confrontation with my uneasiness with and ambivalent (grotesque) thinking about pornography. The experience made me realize that I had never thought "girls" and "pornography" together, perhaps because it is so unthinkable in our society, outside of concerns around the creation and consumption of child pornography. Perhaps, at the time, I was working from a conception of pornography that, like Audre Lorde's, positioned it as the antithesis of the erotic. Lorde writes that "pornography is a direct denial of the power of the erotic, for it represents the suppression of true feeling. Pornography emphasizes sensation without feeling" ([1984] 2007, 54). Could sensations, such as those sparked by working with one's hands, be mobilized to inspire girls to access and express their creative/erotic power? Can pornography be of use to feminist of color pedagogical praxis?

The grandmother's act of radical sex education, after making me profoundly uncomfortable, inspired me to think: "Maybe she thinks that the girls would likely encounter such images on their own while they navigated the internet, and that this space would be a better context for encountering them. Maybe she knows that, as Black girls, the meanings of gendered sexuality framed in these magazines are ones that they will likely negotiate as they grow up, and that this talk may prepare them to confront and complicate those meanings. Maybe confrontation, instead of avoidance, is the more productive approach to engaging girls in sexual education." I decided that, since the girls were there with a family member and I had made the obligatory announcement about content, I would proceed with the talk as planned. I did not pass over the sexually explicit images of Black women engaging in autoeroticism, nor did I skip over parts of my paper. Notably, several adult women of color in the audience rose from their seats and left in disgust when I displayed images of Mutu's source material from Black pornographic magazines that captured women masturbating and displaying

their breasts and genitals Yet, grandma stayed, looked, and listened, and so did the girls. There was lots of discussion after my lecture was over, but the girls and their grandmother left right after I was done, likely to have their own conversations about what they had just seen and heard.

This experience was echoed for me when the WOTR artist talked about her grandmother printing out an image of Walker's sexy sphinx to display in her home. Some visitors to the exhibition at the Domino Sugar Factory felt that Walker was irresponsible in crafting a monumental image that embraces the expressive sexuality attributed to Black women, prompting them to feel that they needed to protect the sphinx from the racist/sexist gazes of the men and white folks who visited the installation.[4] But this grandmother of a WOTR artist instead found inspiration, connection, and affirmation prompted by her conversation with and likely hopes for her granddaughter. These hopes probably include the ability for her granddaughter to experience pleasure and freedom in crafting her body and sexuality.

These grandmothers' approaches to engaging sexual representation can be situated within Stallings's (2015, 60) concept of "Mama's porn," which she describes as the practices of mothering women of color collecting and consuming erotic material from a wide range of sites, such as gossip, the internet, sex toys, and sexually explicit music. The grandmothers and the girls recognize woman of color genius when they sense it, create it, and perform it. In WOTR and its reverberations, this visual/artistic genius is employed in the service of propagating the woman of color sexual rebellion to which Stallings refers in her analysis of the *Erotique Noire* anthology. Stallings notes that in Lorde's framing, the sensation that attends pornography is framed as "inordinately bad, without use, empty, and superficial, and thus denies how sensation is a 'unit of experience alongside feeling' that is particularly salient for women and trans subjects of color whose bodily experiences fall outside of normative frameworks" (2015, 223). Although sex-positive woman of color cultural production, scholarship, and praxis are often touted as new and "not your grandmother's" kind of feminism, the negotiations and practices I have described here attest to how sex radicality is often taught to us by our mothers, grandmothers, and the girl-loving women in our communities.

Like the cooks and field laborers Walker pays homage to in *A Subtlety*, Black and Latina women and girls are innovative artisans of embodied aesthetics and sexualities (which is why their creations are so often subject to appropriation and commodification). I share this narrative about my panic not to suggest that engaging hypersexuality and pornography are the sole or always-appropriate forms of engaging Black and Latina girls in pedago-

gies that promote sexual freedom. I share instead to propose, as a result of my own praxis, that encounters with aesthetics of excess, when activated in collective spaces that value and center women and girls of color, can provoke brilliantly unexpected expressions of creativity, connection, and knowledge.

LONG HEEL / RED BOTTOMS

LONG HEEL / RED BOTTOMS

I wish I could, but we can't wear heels. I would love to dress like that at school because you would feel good everyday and you would look good and it would help you learn better because you feel good.

I love shoes, I love heels. I love heels. There are some new shoes with some
red bottoms, so I'd have a whole bunch of them, the whole collection.

How would you feel?

Confident. I feel if I step out of my house then I'll be, I don't know. . . .
I feel like, I don't know. I feel like . . . I'm trying to look for the right word.
'Cause usually when I step out of my house I don't feel confident and if I had
those clothes I would feel confident.

Why do you think you are not confident when you walk out of your house?

It's hard to explain why.

So you're not happy with the clothes you have now?

I am happy with some of them and some of them are awful.

Are they things your family buys for you that you don't like?

Sometimes I have to wear them, especially for my mom. It makes her happy.

What would people think about you if they saw you on the street [in your ideal outfit]?

Like wow, she got money. Not like carries herself well but, . . . yeah, like, she's pretty,
like, "Awwww, she's pretty."

What would other girls and women think of this look?

My social status would be like over the top because I'd have all these clothes.

What would boys/men think?

I don't care what they think. What men think. I don't care what they think.

How about your family?

I think they would be like—I don't think they would really like it. Probably my mom, but probably not my dad.

What would be your dad's problem?

Probably the heels.

Why do you think he wouldn't like the heels?

Because he's like, look at these girls with these long heels and red bottoms. Because there is this song and they be like "long heels red bottoms" and he doesn't like it, so if he would ever see me like that he would pretend that he don't know me.

What doesn't he like about the song?

It's not the song—just the fact that the song isn't really saying anything important. It's just saying "long heel red bottoms."

What's this? Serious, answer, Ms. Trina private dancer
long hair don't care, left no evidence like I won't dare
Now they trying to smell from my perfume
If it was not me then whom?
I'm talkin about could've came out tonight wearing
J's skin tight jeans, with a word but HEY!
Thought it was time for a change
I'm guilty what can I say, kinda like M.I.A. in this bitch
WHAT, WHAT, whats good?
Hating on me then bitch what's hood
I said it, I'm a problem, I get it but DIAMOND PRINCESS ain't with it
I'm about my dough, gettin my cash
I'm what everybody staring at
They see me in

long heel, red bottoms, long heel, red bottoms
long heel, red bottoms, long heel, red bottoms
stay up, stay up, stay up, stay up, in your
stay up, stay up, stay up, stay up, in your
long heel, red bottoms, long heel, red bottoms

/ TRINA, "LONG HEELS RED BOTTOMS"

Everybody's tryna be red with good hair.

How

confidence
helps them grow

It builds their feeling of belonging.

BUILT FOR THE FUTURE.
READY NOW.

If my hair isn't done, I won't really dress up in school. So, like say
if I get my hair done tomorrow like Thursday, if we have school,
I would come to school looking my best because I just feel good.
Certain things make you feel better.

*Yeah you're right. If you get your nails done you'll wanna put on a ring
or something that show it off, that gets attention, stuff like that.*

Your own way, like how you dress—others can get jealous and try to go
expensive on you and try to outdo you, try to get the same thing better.

*That's why they stopped us from wearing jeans [in school] how we used to
last year because people used to come to school in full outfits and stuff.*

Expressing yourself.

SOCIETY

What do you mean by society?

Some people have their own style. I mean everybody has their own style but society plays a big role in how people dress and how people get this stuff. So, even still like how she likes to dress may not be how everybody else likes to dress. How I like to dress might not be how she likes to dress—but the majority may rule.

If a whole bunch of people are wearing this style, this is what everybody thinks is what they have to wear. But they might not look at her style and say, "Oh, that's a good style too—that would make me cute too," because she may put it together in a nice way—but not everyone may recognize it so society pushes them towards what is popular.

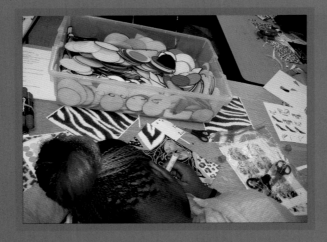

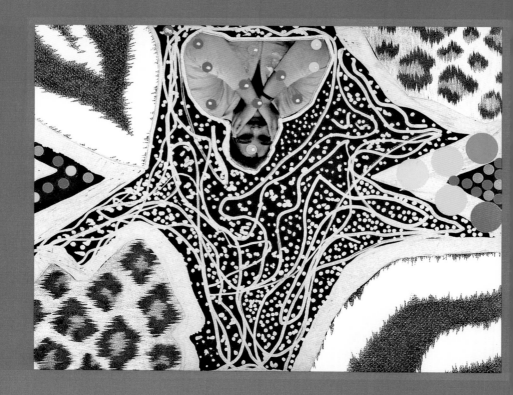

INCOMPARABLE

HAND IN HAND

WITH

LOVE

for

1

anOTEr

i

want

CHANGE

in

My

WORLD

A WHOLE NEW

woman

THE NEW

THE ULTIMATE

Works by Women on the Rise! artists inspired by Yayoi Kusama, Lorna Simpson, and Lorraine O'Grady.

I had to *take* pleasure, take like steal
Because the work is often not my own
Even if I create it

A project
I came up with in 2004 as a new education assistant at the Museum of
 Contemporary Art in North Miami
I heard about the growing number of girls entering the juvenile justice
 system
I wondered if they had a space in detention for creative expression—
 for some kind of pleasure
And they didn't

So I activated an art space with them, the girls
A space for conversation and making inspired by artists like Lorraine
 O'Grady, Lorna Simpson & Yoko Ono

The project, Women on the Rise!, grew, branching from the detention
 center to twelve other partner institutions in Miami, reaching
 hundreds of girls a year
With success in the nonprofit industrial complex,[1] came the demands of
 the institution
"Grant write," the MOCA director said, and "train other people to do the
 work"
It wasn't a request.
So I sat in an office, missing the work of making and ranking and
 learning and failing
The collages and the photographs
Producing culture with girls, the generation of a girls' culture, and all
 the inspiration it was to me

Now I was at a desk, writing grants not only for WOTR, but also for the
 museum as a whole
Absent from those holy workshops that were so much more than
 church
This was success, so I had to leave; I had to seek pleasure, because the
 pleasure of art with girls was taken from me

So I decided to go to grad school at Rutgers in Women's and Gender
 Studies
To think through my experiences with the girls
It was 2007
I dedicated myself to writing down and archiving some WOTR lesson
 plans[2] because I never had the time to do that while working for
 the museum
I later learned that in that same year, MOCA had registered WOTR as a
 copyright under their name—due to the fear that I would "take"
 the program with me
Because the work is often not my own
Even if I create it

Right as I was leaving Miami for grad school in 2007
A discourse in the city was circulating that was mocking Latina girls
 disparagingly called chongas
The discourse was spurred by a YouTube video called "Chongalicious"
Which framed them as ignorant & crass

Chongas were the girls I was disciplined into *not* becoming
Seeing the image on the cover of the *New Times*, the vibrating pink and
 Latina minstrelsy
I realized I had a ton of theorizing to do
And I did
Writing that chonga bodies trouble the sexual policing of girls of color,
 and convey a spectacular indifference to assimilating white
 middle-class subjectivity
The chonga body is subject to shaming in public discourse for
 signifying difference in a contemporary context that interpellates
 Latinx through post-race, neoliberal discourses that promise
 social mobility in exchange for cultural erasure

Chongas can't be tamed, and people feel threatened by their lack of shame
For working-class Latinas, shame is the affect the dominant culture
 (& our own) believes is most appropriate for us—and gratitude
For women and girls of color to *take* pleasure in anything, especially in
 the crafting of our bodies, is an act of social disruption

My work on chongas became the basis for my thinking about girls,
 sexuality, race, class, and embodiment since, as manifested in this
 book
Although pink was mobilized to infantilize and ridicule chongas, I have
 embraced it as a way to occupy dissident girlhood, as has Nicki
 Minaj
Rococo like pink & lace
Long nails & stilettos in Wangechi Mutu's *Eat Cake*
Shiny like Dimple's fine as hell gold chains
Sharp & dandified as Kevin
and
Voluptuous as Kara Walker's *Sugar Baby*

I presented my work on chongas at a girls of color conference at
 Southern Connecticut State University
I didn't know that in the audience was my future *socia*, Anya Wallace
She presented a series of beautiful portraits of Black girls she was
 working with in Savannah
As I saw the images and heard her story, I knew she was someone I
 needed to meet

It was an instant recognition.

This was in 2010.

I was in the process of moving from New Jersey back to Miami because
graduate school as a single mother with no support system was
depleting me

I returned to Miami to do my dissertation research with WOTR artists

6 months after I got back home, Anya, who is from Ft. Lauderdale,
moved back to South Florida as well, and we began our WOTR
work together

What I know about Black girlhood pleasure I learned from her.

/

We always knew that we were having a good time

Coming up with new projects

Meeting with the other instructors

Sharing our stories about what was happening with the girls

We had flexible schedules, and not much money but seemingly enough
to sustain our trips to thrift shops, T.J.Maxx, and fancy lunch spots

Sitting in the car talking into the evening after a workshop

Having each other over for food

Lusting after the next ridiculously greasy Cuban breakfast at La
Carreta

Our relationship itself was a creative work

And all driven and inspired by the relationships we were building with
the girls through
Art.

We formed the strongest bonds with queer Black girls and young women
at Lifelines

One of our favorite moments with them was a portrait workshop
inspired by the work of Zanele Muholi

But the work was not our own

Even if we created it.

/

It was 2013. I had finished my dissertation.

It was time to find an academic job.

But I didn't want to leave.
I didn't want to leave Women on the Rise!, my friends, my family,
 Miami
Didn't want to drag my daughter to another place where she would have
 to adjust again
So, I asked the director of MOCA if I could work full time, run WOTR
 and other museum projects, and she said it was not possible
So I entered the academic job market
And then Anya took over the program
And found herself needing to leave WOTR & the girls 6 months after
Because the museum administrators were undermining her authority
 in running the program
Using the kind of white woman passive aggressive tactics that you just
 can't bear if you love yourself
Even though they had never met our girls, or cared to.

/

So I took a tenure-track position in Ethnic Studies and Critical Gender
 Studies at UCSD
And I don't want to seem ungrateful for an opportunity, but it was such
 a difficult transition
Being a professor was not at all what I had imagined it would be as a
 grad student
It made me question my purpose, my work, my value

That same fall in 2013 Anya moved to continue grad school in residence
 at Penn State.
Everything was shifting
There seemed to be no ground other than our phone calls and texts to
 each other
At least we had Facebook through which to continue our conversations
 with the Lifelines girls

Something that gave me nourishment and power during this transition
 was the Hip Hop and Punk Feminisms conference organized
 by Ruth Nicole Brown and her colleagues at the University of
 Illinois, Urbana-Champaign

I was particularly excited about seeing Las Krudas perform, and meeting
 the Chicana punk pioneer Alice Bag, whose memoir *Violence Girl* I
 had recently read

Meeting Alice Bag inspired me to write about the pain of my girlhood
 experiences
Through giving words to this pain I set on a path of healing
The process gave me inspiration for creating a class on Latinx
 sexualities that invited students to bring their stories,
To bring their creativity,
To make something out of the process of learning,
To fruitfully disrupt our discipline in the academy
It was a taking of pleasure
That was spring quarter, 2014
Anya came to San Diego and visited the class
We met Zanele Muholi who was visiting campus as well
It was a redemption
Of all that appropriated work
Of all the scars it had left on me
Unbedazzled.

/

The reflections above trace my movements through Women on the Rise!,
the academy, and aesthetics of excess—those visual and corporeal prac-
tices that mark Black and Latina bodies through spectacular ornamental-
ity. These aesthetics are often read as indicating the sexually deviant and
unproductive character of Black and Latina girls and women. I have argued
that these responses stem in significant part from the ways that aesthetics
of excess make class burn and disrupt colonial circulations of cultural value.
Whether intended or not, these visual and bodily practices shun the neolib-
eral call to erase socioeconomic difference and perform capitalist productiv-
ity and gender respectability.

 Instead, the women and girls of color who embrace aesthetics of excess
work their bodies and their cultural production with an artful luxury that is
deemed unfit for poor and working-class folks—beyond their station. Like
the working-class Black and Latina girls who fashion their bodies through
a "fine as hell" dandified masculinity that performs purchasing power for
erotic aims. And the hundreds of WOTR artists who mock the limited repre-

sentations of Black and Latina sexuality through playful and inventive uses of collage, painting, sculpture, and body art. Aesthetics of excess are regularly subject to denigration in social discourse when incarnated by working-class women and girls of color, but they have also produced cultural and material capital when appropriated by elite contemporary artists like Nikki S. Lee and Luis Gispert. I have explored the art and politics of Black and Latina embodiment through my interactions with WOTR artists. And, in 2014, to my shock and anger, WOTR itself became the target of art world appropriation.

Women on the Rise!, Race, and Art World Disturbance in 2014

I founded WOTR at the Museum of Contemporary Art (MOCA) in North Miami in 2004. The museum was an institutional hybrid. As it received a significant portion of its operating budget, such as the building lease and several staff salaries, from the city of North Miami, it was considered a city department. But it was also a 501(c)(3) nonprofit organization governed by a board of directors. The museum received funding from local, state, and national sources, along with foundations, individuals, and corporate entities. In 2010, MOCA launched a capital campaign for a $15 million expansion of its original 3,500-square-foot exhibition space. When a proposal was submitted to the voters of the city of North Miami in 2012 to create a bond issue to fund the expansion, it failed. The following year, Bonnie Clearwater, the long-time director of the museum, resigned, likely due to fallout from the vote.

In the midst of the power vacuum caused by Clearwater's departure, the MOCA board, upset by the city's failure to fund the expansion, explored the possibility of relocating the museum from the primarily working-class, Haitian immigrant enclave of North Miami to the more exclusive locales of South Beach or the Design District. The board initially planned to move MOCA's permanent collection of six hundred artworks in a merger with the Bass Museum of Art in Miami Beach. But MOCA abandoned these plans and later sued the city of North Miami in order to facilitate the establishment of a new museum that would be housed in Miami's Design District. The Design District is a small area of the city, spanning a mere five city streets, brimming with major designer-label shops such as Cartier, Dior, Fendi, Givenchy, Armani, and Tom Ford. Streets populated with makeshift tenements crafted by homeless residents are found just several blocks away. This new institution would eventually be named Institute of Contemporary Art (ICA), Miami.[3]

The MOCA board, composed primarily of high-profile, wealthy, white art collectors such as Irma Braman, did not reflect the majority of the residents of North Miami. In fact, during the seven years I worked there, I witnessed the constant frustration of board members and other high-level supporters who felt that North Miami was undeserving of an elite contemporary art institution. Board members at times requested that police be on hand during evening board meetings to protect them from potentially criminal residents.

Despite the fact that the city of North Miami established the museum and made its operation possible, the board's lawsuit allowed them to cut ties with the city and take 150 artworks with them, one-quarter of MOCA's permanent collection, to create a new institution. In 2014, ICA opened at the Moore Building in the Design District and in 2015 announced that it was going to begin construction of a new building that subsequently opened in 2017. The very same board members who bemoaned the city of North Miami voters' refusal to use taxpayer money to fund the museum expansion did manage to accomplish the funding of the construction of a new building in the exclusive and exponentially more expensive locale of the Design District just a year after leaving MOCA. The actions of the board reflect a trend identified by *New York Times* arts writer Ben Davis: "For museum executives, the dirty secret of expansions has been that they are often motivated by the need to have some exciting new thing to rally board members and interest potential patrons. These institutions depend heavily on rich people to fund them. Those rich people like to pay for flashy new buildings; no one wants to donate to boring old museum upkeep" (2016, para. 5). The overinvestment in capital campaigns has resulted in major layoffs at museums and an increased dependence on corporate sponsorship. The departure of the MOCA board thus appears motivated by a desire to take elite culture out of a working-class and predominantly Black neighborhood when its residents rejected the building plan.

This all occurred in 2014, after I had relocated from Miami to San Diego to take a tenure-track job at the University of California. I learned from staff still at MOCA that part of the board's lawsuit included not only the 150 permanent-collection artworks, but MOCA programs, including WOTR, which the museum copyrighted in 2007 following my move to graduate school.

Upon learning of the board's intentions, my WOTR colleague Anya Wallace and I launched a letter-writing campaign to WOTR-collaborating organizations to alert them of the hostile takeover of WOTR by the departing

board. I wrote a letter to the MOCA staff person in charge of education who was going to establish the new institution with the board. I expressed my outrage and threatened to contact media outlets if they succeeded in acquiring the program. The agitation and letter-writing campaign was effective, as the board dropped WOTR from the lawsuit.

Yet this was a bittersweet victory. One of the most difficult aspects of this was learning that some WOTR instructors were colluding in the attempt to take WOTR to ICA, which caused serious damage to our relationships. Some instructors felt betrayal and disbelief—feeling that the social justice vision of WOTR required that it stay in the working-class immigrant context of North Miami. Others felt that moving the project to ICA would ensure its future, as it would have a stable funding source.

When I eventually visited MOCA after all the legal dust had settled, it was like a ghost town. The board had taken all of the books and DVDs used for WOTR, along with computer equipment, art supplies, and cameras, to ICA. A bare-bones staff at MOCA was struggling to apply for funding, as the board also succeeded in taking many grants along with them. The local and national media stories about the board departure tended to vilify the city as an ineffective government bureaucracy that failed to respond to MOCA's needs and applauded the board members' decision to take their cultural capital elsewhere.

In response to the silence regarding the class and racial politics of the board departure, MOCA's new director, Babacar M'Bow, published an anthology in 2014 titled MOCA: Re/claiming Art, Power, Ideas, and Vision in an Ethnically Plural Community (M'Bow, Boyce Davies, and von Lates 2014) with critical analysis of the former board's actions and art criticism by feminist academics of color such as Carole Boyce Davies and Satya P. Mohanty. The anthology is interspersed with images of people of color exploring MOCA galleries—highlighting the new mission and audience of the museum on the occasion of its first post–board departure exhibition, *Third Space: Inventing the Possible*, that was on view from September through November 2014.

The exhibition and accompanying anthology proposed a new vision for MOCA as "no longer the elitist center for the exclusivity of the few! It no longer appears in opposition to popular culture. It represents the continuity and exceeding of expectations regarding our human condition" (M'Bow, Boyce Davies, and von Lates 2014, 16). Sadly, this inspiring work was not followed by institutional success. M'Bow was ostracized by the cultural community in Miami due to his open criticism of the departing board and faced considerable challenges in securing funding for the museum. Major MOCA

supporters, like the John S. and James L. Knight Foundation, transferred their funds to ICA, revealing the inner-circle politics of wealthy donors and foundations in the city. And MOCA staff who left to work at ICA failed to submit final and interim reports for some MOCA grants, thus making the museum ineligible to apply in the following year.

Following the MOCA board's departure in 2014, WOTR was unable to reach girls in the way it previously had. Anya and I would return in the summers of 2014 and 2015 and try to scrape together materials as we volunteered in the name of MOCA to keep the project going. But beyond the summers, there was only so much we could do, as Anya was in grad school, I continued teaching at UCSD, and the other WOTR teaching artists had to find work opportunities elsewhere.

In 2016, M'Bow was fired from the museum amid accusations of sexual harassment, and, after a hiring hiatus of two years, the city of North Miami appointed Chana Budgazad Sheldon to the post of MOCA director in January 2018. A known player in the local art scene, as she had previously directed the alternative art space Locust Projects, Sheldon's hiring generated hope among some WOTR instructors of a potential revival of our work together. This excitement quickly dissipated, however. When Sheldon interviewed Anya, who had previously served as a WOTR director and instructor, for the newly reopened position of curator of education, Sheldon asked Anya how she went about navigating relationships with WOTR partners given that the work we did was so, and I quote, "risqué." Predictably, Wallace was not offered the position.

Being perceived as risqué was a dynamic that WOTR instructors routinely had to negotiate, particularly in our relations with the white women who worked at MOCA during our tenure there. Our work ethic was often treated as suspect. It appeared that our instructor meetings, often punctuated with laughter and rich, delicious foods, were too much fun, and the fact that we worked off-site in the community meant that we were therefore too unsupervised and must have been up to some kind of trouble. These white women often wanted to have a say in how we presented WOTR to donors and the public, and, materially, how it was funded. As a motley crew of women of color artists and creatives committed to generating feminist trouble, it was clear that our presence and work in the museum context were agitating to the status quo. In retrospect, it is remarkable that we were able to sustain this praxis in a museum setting for as long as we did.

Following Sheldon's hiring, WOTR instructors continued to reflect on these upheavals at MOCA with bitterness, sadness, and anger, especially in

the wake of the MOCA board's departure in 2014, which we thought might have occasioned an opportunity for the museum to embrace a more radical vision, such as that laid out by M'Bow when he was hired. In the same year, M'Bow wrote, "It was grossly unfair that a small city which had been spending a million and half dollars a year to support a Board that never cared for its citizens was faced with the dismantling of its most important future asset. The myopic vision of a certain privileged class, the senselessness of the intense, inexorable damage to the institution and the former Board's enigmatic refusal to be held accountable all raised the uncomfortable suspicion that perhaps, after all, the art world has no genuine order" (2014, 13). As M'Bow noted, the disturbances at MOCA revealed the failure and true classist and racist character of the mainstream art world, the nonprofit industrial complex, and neoliberalism. An emphasis on ownership led the board to pillage the museum as in a colonial conquest, hinting that, all along, they had felt that the museum did not belong to the public.

Repeating the Gesture, Disrupting Miami's Art Order

The fallout of the MOCA board's departure was one manifestation of the larger trend of gentrification and artwashing that has steadily been gaining momentum in Miami since the early 2000s. Local artists tended not to overtly critique these developments, for fear of risking their careers among a small but powerful circle of elite collectors who hold considerable sway in Miami-Dade County's major art venues (and even run their own, such as the Rubell and Margulies collections, to name a few). This silence was dramatically broken when, in 2014, the same year as the MOCA board's departure, the Miami-based, Dominican Republic–born artist Maximo Caminero smashed a vase that was part of an exhibition of the politically dissident Chinese artist Ai Weiwei's work at the Pérez Art Museum Miami (PAMM, previously the Miami Art Museum) (figure E.1). This occurred shortly after PAMM opened a new $220 million building in what was formerly Bayfront Park in downtown Miami (now renamed Museum Park), an area that used to be a gathering place for youths and homeless people.

Inspired by the documentation of a well-known 1995 piece, displayed in the 2014 PAMM exhibition, of Weiwei's irreverent act of smashing a Han dynasty (206 BCE–22 CE) urn, which critiques Chinese nationalist cultural patrimony and the exalted valuation of historical objects, Caminero repeated the gesture by breaking one of Weiwei's modified vases, partially coated with paint, as an act of protest of the exclusion of local artists from

FIGURE E.1. Screenshot of Maximo Caminero smashing Ai Weiwei vase at the Pérez Art Museum Miami.

Miami's premier art spaces. Caminero told the alternative weekly paper *Miami New Times*, "I did it for all the local artists in Miami that have never been shown in museums here. They have spent so many millions now on international artists. It's the same political situation over and over again. I've been here for 30 years and it's always the same" (Miller 2014).

The very politics that Caminero critiqued were then mobilized to frame his act as one of vandalism, not as an art performance with a political critique. For example, the *New York Times* described Weiwei's application of peach and green paint to the Han urns as a "reimagining," while Caminero's act was described as one of destruction. While Weiwei, an international artist whose work is highly valuable, is seen as a creative provocateur in his demolition and alteration of ancient cultural artifacts, Caminero was framed as a criminal. He subsequently served two days in jail, was placed on probation for eighteen months, and was mandated to provide two hundred hours of community service and pay $10,000 for the lost value of Weiwei's work. The punishment meted out to Caminero reflects what Aruna D'Souza (2018) notes as the art world's privileging of art objects over justice, and the ways race plays a constitutive role in determining which artists can lay claim to the right of free speech. Caminero pleaded guilty to criminal mischief and apologized to Weiwei for destroying the vase, possibly under the advisement of his lawyer to mitigate against further legal action against him. Caminero's act was sanitized in local and national media accounts as

misguided. In one news story, his lawyer stated, "My client learned what is appropriate and inappropriate behavior for an artist to participate in." The message? Only blue-chip international artists can cause trouble in Miami, and local artists of color better stay in line and know their (non)place.

As Susan E. Cahan notes, "Since the founding of the first American museums in the mid-nineteenth century, social closure has been a barrier to change, and even though museums have become more populist in the last fifty years, the fact of racial discrimination persists" (2016, 2). Thus, while artists of color such as Caminero have been brought to account for affecting the value of prized art objects and disturbing the rarefied peace of the museum environment, white artists such as Kelley Walker and Dana Schutz, whose painting of Emmett Till titled *Open Casket* (2016) was included in the 2017 Whitney Biennial and remained on view despite sustained protest from Black artists, scholars, and cultural workers, have been able to inflict harm with relative impunity upon communities of color in the museum context.[4]

These differential conferrals of value in the art world were brought to account following the 2016 opening of an exhibition of Kelley Walker's work titled *Direct Drive*. It was his first solo museum show and was organized by the Contemporary Art Museum in St. Louis, Missouri, by curator Jeffrey Uslip. *Direct Drive* included works such as *Black Star Press (rotated 90 degrees)* (2006), which reproduced images of Black protesters from the 1963 Birmingham movement being attacked by white police officers on canvas, their surfaces smothered with chocolate. In another series of works included in the exhibition, Walker created large-scale reproductions of the covers of contemporary magazines targeted at men of color, such as *King*, which feature the erotic presentation of Black women, and altered the images with toothpaste (the titles of the work refer to the brand Aquafresh plus Crest Whitening Expressions), which is slathered on the women's bodies and resembles ejaculate.

The 2016 *Direct Drive* exhibition at the Contemporary Art Museum was presented in the wake of the Ferguson protests in the same city, sparked by the 2014 police killing of Michael Brown. *Direct Drive* was met with dissent by the Black community of St. Louis, voiced in part through an open letter written and circulated by concerned Black staff of the Contemporary Art Museum and their allied coworkers. The letter took the museum leadership to task for mounting an exhibition that was out of touch with community concerns. They wrote, "As black staff members, allies, and community members are constantly inundated with the recurring and semi-daily deaths of black people at the hands of the police (even during the immediate days following the exhibition's opening), works within the *Black Star Press* in-

flict additional insult and injury to the injustices of our time. To provide a white, male artist the entirety of the museum and include works of this nature positions the museum and its staff in implicit support and perpetuation of these societal ills" (Voon 2016).[5] When an art talk was organized by the museum as an attempt to address these concerns, Black audience members reported that their questions were met by the artist and curator with hostility and condescension. Though Walker, the museum, and the Paula Cooper Gallery, which represents him, have refused to make the documentation of the artist talk public, the exhibit's curator, Uslip, has since apologized for shutting down the conversation. Uslip subsequently resigned following the demands of the Black museum staff and the broader Black community. The museum director, Lisa Melandri, however, still holds her post.

The visceral materials of chocolate and toothpaste used in Walker's work index the corporeal excess and *suciedad* (Vargas 2014) attributed to Black bodies. In the hands of an artist who is a cisgender white man, such a gesture can result in a culturally and materially lucrative venue for the continued spectacularization of anti-Black violence and the appropriation of Black erotics and sexual aesthetics. Reproductions of the artworks in question have appeared in much of the press coverage regarding the controversy and, as a result, have provided further means for the circulation and valuation of Walker's work and name.

Meanwhile, WOTR artists who embody aesthetics of excess continue to be subject to disciplining and cultural extraction. The appropriation of WOTR did not end with the establishment of the copyright by MOCA in 2007 and the MOCA board's departure in 2014. In 2016, my partner alerted me to a picture on Instagram of a T-shirt, posted by a hipster clothing company called Om Weekend, that looked just like the WOTR logo and T-shirt. I was stunned at the unmistakable resemblance, and particularly of how these Om Weekend T-shirts were being modeled by thin, blonde, white women—not at all like the Black and Latina artists who participated in WOTR (figures E.2–E.4).

I was now witnessing a for-profit entity pillage the work of WOTR and appropriate the logo that was donated to our nonprofit project by the feminist artist Andrea Bowers. Women on the Rise! as a logo was transformed by Om Weekend to fit bodies that do not signify aesthetics of excess. This is how WOTR was able to take on a marketable life, as it was languishing in the nonprofit context, while the artists of WOTR were erased.

The truth of the matter is that WOTR was always underresourced and undervalued, even during MOCA's most successful times. The program was

RISE!
THE
ON
WOMEN

MUSEUM OF CONTEMPORARY ART, NORTH MIAMI

FIGURE E.2
Women on
the Rise!
logo.

FIGURE E.4 Om
Weekend image.

given just enough funding to do the work of performing MOCA's outreach to the community—outreach that was also touted during appeals to donors. But it was never prioritized when the WOTR staff had bigger ideas for its evolution, such as artist residencies and exhibitions that would juxtapose work by the artists taught in WOTR and the artwork that it inspired the girls to create. In fact, most exhibitions of work by participants were held in community spaces that were not designed for the display of art. When we were allowed to showcase participant artwork on-site at MOCA, it was in the small project space outside the main building—portions of the large galleries were always off-limits. As museum workers who were women of color, our roles were confined to those legible as education, which is labor

perceived as less intellectual and less significant than curatorial work. The WOTR collective worked from a view that education, scholarship, and curation are synergistic, rather than discrete processes. But the curatorial potential of WOTR praxis was never allowed to develop. Such projects could have extended the reach of our work to transform museum power structures at an institutional level by working to train, showcase, and hire more Black and Latina curators, especially among the WOTR artists. Like the girls and women who embody aesthetics of excess, WOTR was allowed to be visible as long as it stayed in its place. This is why its dedicated instructors often found themselves leaving the project for positions that afforded more autonomy.

The attempted takeover of Women on the Rise! by ICA in Miami was merely an effort to use its social justice brand to conceal the more sinister aspects of ICA's institutional founding. While ICA received funding to implement a pink-washed version of WOTR-style programming without using the name, MOCA in North Miami continued to struggle for years just to operate. Miami's nonprofit industrial complex aided in the eventual demise of WOTR.

And yet, at the conclusion of this book, I resist the pessimism induced by neoliberal racial capitalism and its classed gender politics. As I consider all the participants' body narratives in these chapters and the subsequent history of WOTR, I instead embrace a decidedly punk and hip-hop stance of defiance and DIY cultural production. Like the *Let's Talk about Nicki Minaj* project, it is possible to create spaces outside the institutional matrix. Although the work may be less visible, it may very well have more power in sustaining the relationships and communities that mean something to us. Black and Latina women and girls often find a way, even when we fail and are failed.

I want to close with a body narrative photo-poem, an aesthetics of excess take on a creative method developed by Ruth Nicole Brown, which was inspired by the performative writing found in June Jordan's *Who Look at Me* (1969) and M. NourbeSe Philip's *Zong!* (2008). Brown developed the anti-narrative photo-poem method to document and process her experiences working with Black girls through Saving Our Lives, Hear Our Truths (SOLHOT), a space that celebrates the complexities of Black girlhood(s) through radical creativity (music making, performance, photography, poetry, Black girl games). Through cross-writing, Brown evokes the mutability between Black girlhood, her own voice, and the girls in SOLHOT to "build a mutually constructive relationship between image and words, and remain honest" (2013, 113). Inspired by Brown, I conclude this book by responding poetically to images and body narratives, both my own and those I have collected from WOTR artists, to document the beauty, truth, knowledge, and

joy of their artistic and embodied practices, which are uncontained by neo-liberal politics. My hope is that the body narrative photo-poem will conjure the power of Black and Latina aesthetics of excess, past, present, and future.

/

The problem is one of aesthetics.
Of style.
Of our varying shades of brown looking like art.
It scares them.
They want to wash my makeup off, but it is essential.
Art.
It is not meant to hide anything about me.
It's what my grandmother taught me.
Puerto Rican eyes in thick black liner to look back and protect.
To look back and protest.
To attract and beautify.
Metallic nail polish and rings on, even though we work in sweatshops.
Don't worry about how we spend our money (because you don't care
 about how we live).

/

Don't worry about the music I listen to, or the dolls I play with.
(I know you don't really care anyway.)
I *know* I'm playing.
Am I not allowed to do that either?
What my family teaches me, what I see
 on TV and talk about with my
 friends,
I re-mix it ALL.
Anything but passive.
Look at my room/space.

La Virgensita.
Ana.
Elsa.
Olaf.
& Nicki.
PINK.
This is where *I* live. With my mommy.
And my Bratz dolls.
We kiss you goodbye.

/

Tashell said, *"I think Barbies are kind of what Caucasian people look like*
and Bratz are like what Black people look like. So it's like, we can
relate more to Bratz dolls. They have curves and they have big lips."
Zayan said, *"Bratz I think is positive. It shows the young girl that there are*
different types of stuff. Barbie just has one white girl."

/

(We are) So much more than one anything.
And.
Even if we traced it out for you, you still couldn't see.
Which means that it's for us.

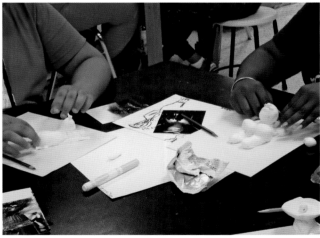

Kara Walker said the Black Venus is a sphinx secret, and my
 grandmother agreed.
She printed out a picture of the Sugar Baby and put it on her kitchen wall.
PINK.

/

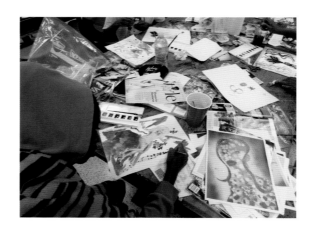

We're not scared or ashamed of the booty.
We build our bodies (like)-art.
And smile.
The line between fake and real is one we skip across, and laugh at.

/

I don't need a crystal ball to tell me when I'm SEXY.
And I love the way Nicki looks in that magazine.
Sometimes I like dressing like Lil Wayne.
Especially with the bubble jacket and tattoos.

/

Black/Latina Venus.
21st century.
He, she, or them, you can call me.
I float through time and space
In my body wrapped in gold and
Majestic
As a lightning bolt
In my space that is the center
Where I'm not alone
Where things feel good
and I create.

Introduction

Parts of the introduction originally appeared in "'Miss, You Look Like a Bratz Doll': On Chonga Girls and Sexual-Aesthetic Excess," *National Women's Studies Association Journal* 21, no. 3 (2009): 63–91, and "'Chongas' in the Media: The Sexual Politics of Latina Girls' Hypervisibility," in *Girls' Sexuality in the Media*, edited by Kate Harper and Vera Lopez (New York: Peter Lang, 2013).

1. This is not an exhaustive list of all the women artists who have participated in WOTR as past, visiting, or short-term instructors, directors, assistants, or interns. Here I center on those with whom I have worked most closely on the project. I would like to acknowledge Shara Banks, Vanessa Garcia, Kathleen Staples, Kristen Stoller, Susan Lee Chun, Rosemarie Chiarlone, Naomi Fisher, and all those who at any point in time were a part of WOTR.

2. I draw from Yessica Garcia Hernandez's (2017) analysis of the antifandom of the legendary Chicana performer Jenni Rivera. Hernandez suggests that expressions of agitation by antifans conduct significant work in circulating social discourses among Latinx communities for policing the sexuality and body presentations of women and girls.

3. I use the term "visual economy" in a manner similar to that of Krista Thompson, whose definition draws from that of Deborah Poole (1997), as attention to "the circulation of objects and images in local political economies and across global networks—to emphasize the industries and economies surrounding image production" (Thompson 2015, 24).

4. By using the term "embodiment," I work to, as Elizabeth McDowell (1999, 39) describes, mark the "sense of fluidity, of becoming and of performance" that attends the relations between bodies and society.

5. Cox (2015) cites Nicole Fleetwood's notion of "excess flesh," a concept that "attends to the ways in which black female corporeality is rendered as excessive overdetermination and as overdetermined excess" (Fleetwood 2011, 9). The overdetermined meanings and visual representations Fleetwood refers to are colonial narratives of Black women's bodily and sexual aberrance, which have shaped the notion that Black girls and women are always already sexually deviant (Knupfer 2000; McClintock 1995). Amber Jamilla Musser (2018, 16) uses the term "sensual excess" to describe the fleshiness and opacity of women and queer people of color's uncontainable "brown jouissance." Though Musser also analyzes the work of contemporary artists of color that are considered here, such as Kara Walker, her emphasis on sensuality differs from my focus on class relations and the traffic of Black and Latina bodies between vernacular, popular, and elite art cultures.

6. My notion of the complex subjectivities of women and girls of color is informed by Ruth Nicole Brown's (2013) book *Hear Our Truths: The Creative Potential of Black Girlhood*.

7. Brown has discussed how visibility for women and girls of color regularly leads to "increased surveillance, and, at other times, death. . . . Many times, youth of color are punished because of what someone, typically with more power, has seen and surmised as truth" (2013, 105).

8. Clyde Woods urges a consideration of the "racial workings of neoliberalism" in the United States through accounting for how "the Southern pillars of racial supremacy and an anti-union-low-wage economy effectively eviscerated the welfare state" (2007, 48, 47).

9. I have altered the names of collaborating institutions in order to protect my participants' confidentiality. My references to the girls and young women I worked with via WOTR move variously from "WOTR artist" to "participant" and "girl," a term of affection used by WOTR instructors to reference participants of a wide range of ages. For us, saying "girl" did not constitute an infantilizing gesture, but rather named a recognition of youthful spirit and creative energy. It is important to note that girlhood is often denied to Black girls and working-class Latina girls, who are viewed through tropes of deviance. "Girl" is a word that the instructors often used to address each other as well. By employing these different terms, I acknowledge participants as creative authors, members of the collective space of WOTR, interlocutors of my research, and as people whom the WOTR instructors held dear. My use of "girls" in the plural is meant to evoke a radical and often raucous collectivity. The distinction "WOTR artist" is used to help clarify for readers when I refer to a young artist in WOTR or one of the institutionally supported artists I write about such as Nikki S. Lee.

10. Abarca mobilizes the charla in her study of working-class Latinas about food and cooking as a way to subvert the established hierarchies of scholarly production, as the "researcher and the women in the field are intellectually on the same plane" (2006, 9).

11. I am grateful to Juana María Rodríguez for suggesting this framing of body narratives.

12. Parents and guardians granted permission for the girls under eighteen years of age to participate and for me to record our conversations. As the WOTR program

served girls who moved in and out of various education, social welfare, and juvenile justice institutions and processes, I would sometimes meet a girl only once, while I have consistently worked with others for over seven years as of this writing.

13. None of the participants I worked with identified as trans.

CHAPTER ONE. *Reading Black and Latina Embodiment in Miami*

1. The exhibition was titled *Modify, as Needed*, curated by Ruba Katrib.

2. I am grateful to Hoang Nguyen for suggesting this framing.

3. I use the term "Miami-Dade County" to reference the greater Miami area. The city of Miami is a specific municipality within Miami-Dade County, and WOTR praxis took place within and beyond this particular area. We conducted our work as far south as Homestead and close to the northern Miami-Dade County limit in North Miami. When I use the term "Miami," I am referencing this expansive Miami-Dade County area.

4. For more on artwashing, see Vorick (2018); Pritchard (2018); "Artwashing and Soho," *Art and Labor* [podcast], n.d., http://www.artandlaborpodcast.com/podcast /episode-4-artwashing-and-soho/; and Mel Evans's (2015) book *Artwash*.

5. Monika Gosin (2009) offers an extensive analysis of Afro-Cubanxs experiences of racialization in the U.S. among Cuban enclaves in Miami and Los Angeles.

6. This overwhelm and fear led me to agree to the removal of Molinary's image in the promotional materials for the lecture series, in concert with the overall position of the upper administration at MOCA. However, the image was nevertheless discussed in depth by Molinary at our panel.

7. The girdle is typically understood to be a tool of patriarchal control of women's bodies, but the work of feminist scholars, such as Dorothy Ko's (2005) examination of Chinese women's foot binding, and the modest body presentations of pious Islamic women donning headscarves examined by Saba Mahmood (2005), suggests that such body technologies are also utilized by women to exercise their agency in transforming and crafting their bodies.

8. I am grateful to Juana María Rodríguez for pushing my analysis in this direction.

9. For an extended discussion on race, gender, and the beauty and labor politics of beauty service and body aesthetics, see Miliann Kang's (2010) study *The Managed Hand*.

10. Here I use the term "practice of freedom" in the spirit of India Pierce (2017), who mobilizes it as a framework for conjuring Black queer futurity through cultural production.

11. Bedazzling Scars is a WOTR project that instructor Anya Wallace developed. It invites participants to create a representation of a physical or emotional scar and to embellish it with rhinestones, glitter, and other materials to enact a form of healing, rather than covering over. In the dissertation chapter "Spacetime and the Margins: Black Girlhood In and Out of the Black Hole," Wallace (2019) analyzes how the emotional vulnerabilities opened up by this project in the context of the Miami-Dade Regional Juvenile Detention Center's girls' cell block unwittingly resulted in a collective explosion of anger by the girls that was directed at each other, at us as instructors,

and at the correction officers who symbolized the prison-industrial complex that was responsible for incarcerating them. Wallace's essay engages the bedazzling of scars as a metaphor for exploring how the incident revealed WOTR's failures and, at times, complicity with the very systems of domination we critique through our presence in spaces like the detention center.

12. My emphasis on Black and Latinx relations in this study draws from the particular racial and ethnic locations of my research participants and does not mean to erase the presence of Asian American, South Asian, Middle Eastern, and African populations in Miami-Dade County. I address the erasure of Asian Americans in Miami in an essay, "Performing Identity in Miami: A Case Study of Women Artists" (Hernandez 2008).

13. Statements about Cardi B were made after a highly publicized feud that unfolded between the rappers Nicki Minaj and Cardi B at a New York Fashion Week 2018 event (Bailey 2018).

14. In this interview, Beyoncé and her sister Solange discuss their Selena fandom (Beyoncé 2017).

CHAPTER TWO. *Sexual-Aesthetic Excess*

Parts of chapter 2 originally appeared in "'Miss, You Look Like a Bratz Doll': On Chonga Girls and Sexual-Aesthetic Excess," *National Women's Studies Association Journal* 21, no. 3 (2009): 63–91, and "'Chongas' in the Media: The Ethno-Sexual Politics of Latina Girls' Hypervisibility," in *Girls' Sexuality in the Media*, edited by Kate Harper, Yasmina Katsulis, Vera Lopez, and Georganne Scheiner Gillis (New York: Peter Lang, 2013).

1. Ochoa draws on Briggs and Mantini-Briggs's (2003) concept of sanitary citizenship as a discursive apparatus that allocates resources to those who appear to fit modern notions of health and hygiene. Ochoa (2014, 40) expands this notion in her study of the performance of femininity in Venezuela to consider how body aesthetics and body modification play a significant in role in marking particular bodies as "modern," and therefore valuable, as they eschew markers of Blackness and underclass difference.

2. The *Miami New Times* reported that Davila is of Cuban-Bulgarian heritage and Laura Di Lorenzo of Venezuelan-Italian descent (Lush 2007).

3. "Besos" is Spanish for "kisses."

4. See Hernandez (2009) for a more detailed discussion of my methods and the findings of this study.

5. My use of "characterization" here is informed by Monica L. Miller's (2014, 34–35) *Slaves to Fashion: Black Dandyism and the Styling of Black Diasporic Identity*, in particular her discussion of the eighteenth-century European proclivity for reading the surfaces or styles of individuals to assess their character. This process often led to the production of caricatures that sought to contain the forms of difference signaled by racialized subjects, like chongas, whose styles made them both fascinating and

troubling. Miller notes that "being the subject of a caricature was both an honor and an insult" (70).

6. Tomás Ybarra-Frausto has defined rasquachismo as a Chicana/o "sensibility that is not elevated and serious, but playful and elemental. It finds delight and refinement in what many consider banal and projects an alternative-aesthetic-art sort of good taste of bad taste" (Barnet-Sanchez 2007, 58).

7. The Uno Entertainment website is no longer active, but I accessed the page on April 12, 2010, at http://www.unoentertainment.com/portal/hgxpp001.aspx?75,12,26 ,O,E,0,MNU;E;6;4;MNU.

8. For example, several months after the chonga makeover video was posted, Di Lorenzo (who now goes by Lorenzo), who was contracted by Buzzfeed to generate content for Pero Like, was fired from the company after appearing in "Gente-Fied," a web series produced by the major Latinx actress America Ferrara, due to a conflict with their noncompete agreement (Sutton 2016). Such policies make working in the culture industry even more difficult for emerging Latinx talent like Lorenzo, for whom a project such as a web series would constitute a major career boost.

9. It appears that Pero Like content is filmed in Los Angeles; thus this scene was not shot in Miami.

10. The term "dope" is slang for "cool."

11. The life stories and quotes cited here are extracted from video documentation of an interview of the artist with scholar Anna Indych-López at the 2018 College Art Association Conference (CAA 2018).

12. I did not find mention of Elizabeth in press coverage on "Chongalicious."

13. Photos for the *Miami New Times* article "Chongas!" (Lush 2007) were taken by Ivylise Simone.

14. The commodification of chonga style reminds me of the exploitative relationship between contemporary artists such as Keith Haring and poor and working-class people of color, and their aesthetics, which is explored in Arnaldo Cruz-Malavé's (2007) book *Queer Latino Testimonio, Keith Haring, and Juanito Xtravaganza, Hard Tails*. The text includes a testimonio by Haring's longtime partner Juanito Xtravaganza, a queer Puerto Rican man from a poor background who was left with no money from Haring's estate following his passing. Xtravaganza was further vilified as an opportunist in a biography on Haring written by John Gruen. Through "talking back" to the art world by discussing his exclusion from Haring's will with a reporter for the *New York Post*'s Page Six column, Xtravaganza led the Keith Haring Foundation to provide him with a modest stipend, which they eventually discontinued. Despite the fact that Xtravaganza's domestic care work for and professional assistance to Haring made it possible for the artist to realize his lucrative career for the years they were together, he ended up "penniless, without a job, with full-blown AIDS, and *depressed*" (Cruz-Malavé 2007, 53, emphasis in original).

15. The *Projects* series also reflects what Lisa Nakamura describes as "identity tourism," the utilization of racial and gendered identities "as amusing prostheses to be donned and shed without 'real life' consequences" (2002, 14).

16. I discuss this in my essays "Performing Identity in Miami: A Case Study of Women Artists" (Hernandez 2008) and "'Miss, You Look Like a Bratz Doll': On Chonga Girls and Sexual-Aesthetic Excess" (Hernandez 2009). Jessica Gispert is Luis Gispert's sister.

17. Quoted text appeared in Crystal Pearl Molinary, "Works," Crystal Pearl, accessed September 11, 2015, http://www.crystalpearl.info/cubanlinks/2015/2/3/off-the-chain.

18. The azabache is a black stone that is typically worn by Cubans to ward off the evil eye. It is traditionally presented as a gift for newborn children.

19. As Anne Anlin Cheng observes, "Directional ornaments not only follow and enhance bodily movements but also dynamically represent what today we would call prosthetic possibilities by expanding bodily periphery through the extension of inanimate objects" (2011b, 1035).

20. In her study *Shine: The Visual Economy of Light in African Diasporic Aesthetic Practice*, Krista Thompson notes that for Black diasporic subjects, and I would add working-class Black and Latina women more broadly, "the ostentatious display of things might be interpreted as a protective means. We might understand the use of material goods and the production of blinding light as a shield or apotropaic, simultaneously reflecting and deflecting the deidealized gaze on black [and Latina] subjects" (2015, 33).

CHAPTER THREE. *"Fine as Hell"*

1. For more on Sakia Gunn, consult the chapter "Sakia Gunn Is a Girl: Queer African American Girlhood in Local and Alternative Media" in Sarah Projansky's (2014) book, *Spectacular Girls: Media Fascination and Celebrity Culture*.

2. For more on the New Jersey 4, see "The Politics of Representation for Black Women and the Impossibility of Queering the New Jersey 4/7" by Christina Carney (2012), and the documentary film *Out in the Night* (Doroshwalther 2014).

3. I am altering the names of these organizations to further protect the identity of my participants.

4. It appears that part of what compels my masculine-gender-performing participants to use terms like "hoe" and disparage femme women is their resistance to the roles that have traditionally corresponded with femininity. Scholar Kai M. Green, a Black transman, describes how as a teenager who was then perceived as a "sporty femme," his experience of dating a stud entailed that the stud employed a chivalrous yet controlling gender performance: "She opened my door and closed it. She paid for dinner. Something about this interaction made me feel trapped. I decided that I would [be] nobody's femme and therefore I must be like her, a masculine woman, a stud" (2013). Green points out that such dynamics reinforce a gender order that constricts both feminine and masculine-body-presenting women into either submitting to control or being the protector and provider, with little room to maneuver in between. To address, heal from, and transform such dynamics, the New York–based bklyn boihood project organizes workshops that provide critical forums on trans-

forming the dominant meanings of masculinity for queer folks of color who embody gender on the masculine spectrum. bklyn boihood provides spaces for socializing and community building and publishes an annual calendar featuring masculine-presenting women and transmen. It also published a groundbreaking anthology titled *Outside the xy: Queer, Black and Brown Masculinity* in 2017.

5. For more on gender performance and ego formation, see Judith Butler (1993), *Bodies That Matter: On the Discursive Limits of "Sex,"* and Gayle Salamon (2010), *Assuming a Body: Transgender and Rhetorics of Materiality.* Although my analysis of these ego narratives is informed in part by queer and feminist engagements with psychoanalytic theories, I am not attempting to conduct a psychoanalytic study of my participants' body practices here.

6. "Doing you" and "doing me" are terms my participants used to describe the act of being yourself and doing what you desire.

7. "Johannesburg, 15 September–14 October 2016, Zanele Muholi, Faces and Phases 10," Stevenson, accessed November 6, 2012, http://www.stevenson.info /exhibition/1312.

8. The image is not reproduced here because Nkosi has passed and therefore could not consent to including their image in the book. (Since I do not know Nkosi's preferred pronoun, I am using the nonbinary term.)

CHAPTER FOUR. *Rococo Pink*

1. Melissa Hyde (2014, 339) has written about eighteenth-century French literature that framed rococo interiors as having seductive influences upon inhabitants. Her writing sparked my girlhood recollections.

2. In "Traveling Barbie: Indian Transnationality and New Consumer Subjects," Inderpal Grewal (1999) discusses the marketing of a white, "traditionally" dressed Barbie donning a sari in India: "The doll suggests that difference, as homogenized national stereotype, could be recovered by multinational corporations, that the national could exist in this global economy." The ultimately unraced, malleable, neoliberal Barbie body facilitates Minaj's incorporation into mass culture, as evidenced through her regular appearances on major network TV morning shows and daytime programs such as *Ellen.*

3. Cash Money is the parent company of the Young Money label that represents Minaj.

4. Nicki Minaj, "Stripping in the Club," in *It's Barbie Bitch* (Boogie Up Productions, September 30, 2010); Kanye West, featuring Nicki Minaj, "Monster," in *My Beautiful Dark Twisted Fantasy*, October 23, 2010.

5. Illustrated by Francesco Vezzoli and styled by Edward Enninful.

6. The anthology *Black Venus 2010: They Called Her "Hottentot"* (Willis 2010) provides a comprehensive study of Saartjie Baartman and explores how the legacy of her visual representation informs contemporary art and culture.

Parts of chapter 5 appeared in "The Ambivalent Grotesque: Reading Black Women's Erotic Corporeality in Wangechi Mutu's Work," *Signs: Journal of Women in Culture and Society* 42, no. 2 (2017): 427–457.

1. I am indebted to Celine Parreñas Shimizu's notion of race-positive sexuality, a concept she applies to the work of Asian/American cultural producers who "present pleasure, pain, and trauma simultaneously in ways that embrace the liberating possibilities of sexuality while also acknowledging the risks of reifying the perversity and pathology traditionally ascribed to women of color in popular culture" (2007, 25).

2. Weinberger makes this statement in an unreleased short film created by Molinary based on the artist's work.

3. In noting how much documentation of intramural Black life has been redacted by white supremacist visual schemas, Sharpe (2016, 117) offers Black annotation and redaction to describe processes by which Black artists and cultural workers conjure ways of "seeing and reading otherwise," beyond these frameworks.

4. This view is expressed in an article in which a Black male admonishes visitors to the exhibition to recognize that the sphinx symbolizes the rape of Black women (Powers 2014), which contrasts sharply with Walker's own view of the sphinx as a figuration of Black women's sexual power.

Epilogue

1. See the INCITE! (2017) anthology, *The Revolution Will Not Be Funded: Beyond the Non-profit Industrial Complex*, for more on these institutional politics.

2. A small sample of Women on the Rise! workshop content pedagogies is available for download via the Feminist Art Project's Feminist Art Resources in Education website: https://feministartproject.rutgers.edu/fare/fare-curricula/fare-women-on-the-rise/. Following the publication of these projects, WOTR praxis underwent several evolutions, but they provide a sense of where we started.

3. For media stories on the turmoil at MOCA, see Lavelle (2014), Sampson (2013), and Sampson and Buteau (2014).

4. See Aruna D'Souza's (2018) book *Whitewalling* for an excellent analysis of the controversy surrounding *Open Casket*.

5. A link to a PDF of the open letter is available via Claire Voon's *Hyperallergic* article about the controversy.

Abarca, Meredith E. 2006. *Voices in the Kitchen: Views of Food and the World from Working-Class Mexican and Mexican American Women*. College Station: Texas A&M University Press.

Allin, Olivia. 2011. "OTRC: Selena Gomez Dons Chola Look in MTV European Music Awards Promo." *Eyewitness News*, ABC 7, October 19. Accessed January 22, 2020. https://web.archive.org/web/20120125072050/http://www.ontheredcarpet .com/Selena-Gomez-dons-chola-look-in-MTV-European-Music-Awards-promo /8398364.

Alvarado, Leticia. 2015. ". . . Towards a Personal Will to Continue Being 'Other': Ana Mendieta's Abject Performances." *Journal of Latin American Cultural Studies* 24 (1): 65–85.

Alvarez, Luis. 2008. *The Power of the Zoot: Youth Culture and Resistance during World War II*. Berkeley: University of California Press, 2008.

Andrews, Jjenna Hupp. 2015. "Engaging Grotesque Figurations in the College Classroom." *American Society for Aesthetics*. http://aesthetics-online.org/page /AndrewsGrotesque.

Anzaldúa, Gloria. 1987. *Borderlands/La Frontera: The New Mestiza*. San Francisco: Aunt Lute.

Anzaldúa, Gloria. 1990. *Making Face, Making Soul/Haciendo Caras: Creative and Critical Perspectives by Feminists of Color*. San Francisco: Aunt Lute.

Arthurs, Jane. 2003. "Sex and the City and Consumer Culture: Remediating Postfeminist Drama." *Feminist Media Studies* 3 (1): 83–98.

Austin, Tom. 2007. "Homecoming: Luis Gispert Returns to His Miami Roots as a Major Art World Player." *Miami Herald*, October 14.

Báez, Firelei. 2015. "Art Talk: Firelei Báez in Conversation with María Elena Ortiz."

Pérez Art Museum Miami. YouTube, November [Video]. https://www.youtube
.com/watch?v=-k0o04S8Kv8.

Bailey, Alyssa. 2018. "Everything Nicki Minaj Said about Cardi B and Their Fight on
Queen Radio." *Elle*, September 10. https://www.elle.com/culture/celebrities
/a23069346/nicki-minaj-cardi-b-queen-radio-comments-transcript/.

Bailey, Marlon M. 2013. *Butch Queens Up in Pumps: Gender, Performance, and Ball-
room Culture in Detroit*. Ann Arbor: University of Michigan Press.

Bakhtin, Mikhail. 1984. *Rabelais and His World*. Translated by Helene Iswolsky.
Bloomington: Indiana University Press.

Banet-Weiser, Sarah. 2011. "Branding the Post-feminist Self: Girls' Video Production
and YouTube." In *Mediated Girlhoods: New Explorations of Girls' Media Culture*.
New York: Peter Lang.

Barnet-Sanchez, Holly. 2007. "Chicano/a Critical Practices: Reflections on Tomás
Ybarra-Frausto's Concept of *Rasquachismo*. In *Pop Art and Vernacular Cultures*, ed-
ited by Kobena Mercer. Cambridge, MA: MIT Press.

Bettie, Julie. 2003. *Women without Class: Girls, Race, and Identity*. Berkeley: Univer-
sity of California Press.

Beyoncé. 2017. "Solange Brings It All Full Circle with Her Sister Beyoncé." *Interview*,
January 10. https://www.interviewmagazine.com/music/solange#_.

Biesenbach, Klaus. 2011. "Agents Provocateurs: Nicki Minaj Transformed by Fran-
cesco Vezzoli." *W*, November.

bklyn boihood. 2017. *Outside the XY: Queer, Black and Brown Masculinity*. Edited by
Morgan Mann Willis. Riverdale, NY: Riverdale Avenue.

Bourdieu, Pierre. 1984. *Distinction: A Social Critique of the Judgement of Taste*. Cam-
bridge, MA: Harvard University Press.

Briggs, Charles, and Clara Mantini-Briggs. 2003. *Stories in the Time of Cholera: Racial
Profiling during a Medical Nightmare*. Berkeley: University of California Press.

Brody, Jennifer DeVere. 1998. *Impossible Purities: Blackness, Femininity, and Victorian
Culture*. Durham, NC: Duke University Press.

Brown, Jayna. 2008. *Babylon Girls: Black Women Performers and the Shaping of the
Modern*. Durham, NC: Duke University Press.

Brown, Ruth Nicole. 2013. *Hear Our Truths: The Creative Potential of Black Girlhood*.
Urbana: University of Illinois Press.

Brown, Ruth Nicole. 2014. "'She Came at Me Wreckless!': Wreckless Theatrics as
Disruptive Methodology." In *Disrupting Qualitative Inquiry: Possibilities and Ten-
sions in Educational Research*, edited by Ruth Nicole Brown, Rozana Carducci, and
Candace R. Kuby. New York: Peter Lang.

Burgess, Rachel. 2005. "Feminine Stubble." *Hypatia* 20 (3): 231–237.

Butler, Judith. 1990. *Gender Trouble: Feminism and the Subversion of Identity*. New
York: Routledge.

Butler, Judith. 1993. *Bodies That Matter: On the Discursive Limits of "Sex."* New York:
Routledge.

CAA. 2018. "2018 CAA Annual Conference Distinguished Artist Interviews." You-
Tube, March 1 [Video]. https://www.youtube.com/watch?v=_bCrsnqdfs0.

Cacho, Lisa Marie. 2007. "'You Just Don't Know How Much He Meant': Deviancy, Death, and Devaluation." *Latino Studies* 5: 182–208.

Cacho, Lisa Marie. 2012. *Social Death: Racialized Rightlessness and the Criminalization of the Unprotected*. New York: New York University Press.

Cahan, Susan E. 2016. *Mounting Frustration: The Art Museum in the Age of Black Power*. Durham, NC: Duke University Press.

Capó, Julio, Jr. 2010. "Queering Mariel: Mediating Cold War Foreign Policy and U.S. Citizenship among Cuba's Homosexual Exile Community, 1978–1994." *Journal of American Ethnic History* 29 (4): 78–106.

Carby, Hazel V. 1992. "Policing the Black Woman's Body in an Urban Context." *Critical Inquiry* 18 (4): 738–55.

Carney, Christina. 2012. "The Politics of Representation for Black Women and the Impossibility of Queering the New Jersey 4/7." In *Wish to Live: The Hip-Hop Feminism Pedagogy Reader*, edited by Ruth Nicole Brown and Chamara Jewel Kwakye. New York: Peter Lang.

Carney, Christina, Jillian Hernandez, and Anya M. Wallace. 2016. "Sexual Knowledge and Practiced Feminisms: On Moral Panic, Black Girlhoods, and Hip Hop." In "Girls and Popular Music," special issue, *Journal of Popular Music Studies* 28 (4): 412–426.

Case, Ethan. 2012. "Nicki Minaj's Song 'Beez in the Trap' Teaches American Values and Hard Work and Dedication." *Mic*, August 20. https://www.mic.com/articles/13166/nicki-minaj-s-song-beez-in-the-trap-teaches-american-values-of-hard-work-and-dedication.

Charles, Kerwin Kofi, Erik Hurst, and Nikolai Roussanov. 2009. "Conspicuous Consumption and Race." NBER Working Paper No. 13392. Cambridge, MA: National Bureau of Economic Research, 2007. https://www.nber.org/papers/w13392.

Chase, Alisia G. 2007. "Girl with Many Selves." *Afterimage* 34 (6): 31.

Chave, Anna C. 1990. "Minimalism and the Rhetoric of Power." *Arts Magazine*, January, 44–63.

Chen, Kuan-Hsing, and David Morley, eds. *Stuart Hall: Critical Dialogues in Cultural Studies*. London: Routledge, 2006.

Cheng, Anne Alin. 2011a. *Second Skin: Josephine Baker and the Modern Surface*. Oxford: Oxford University Press.

Cheng, Anne Alin. 2011b. "Shine: On Race, Glamour, and the Modern." *PMLA* 126 (4): 1022–1041.

Chin, Elizabeth. 2001. *Purchasing Power: Black Kids and American Consumer Culture*. Minneapolis: University of Minnesota Press.

Chonga Girls. 2007. "Chongalicious." YouTube, April [Video]. https://www.youtube.com/watch?v=uVHdqmN7-XE.

Cohen, Cathy J. 2004. "Deviance as Resistance: A New Research Agenda for the Study of Black Politics." *Du Bois Review* 1 (1): 27–45.

Cohen, Cathy J. 2013. "Punks, Bulldaggers, and Welfare Queens: The Radical Potential of Queer Politics?" (1997). In *The Routledge Queer Studies Reader*, edited by

Donald E. Hall and Annamarie Jagose, with Andrea Bebell and Susan Potter. London: Routledge.

Connell, R. W. 2005. *Masculinities*. Berkeley: University of California Press.

Connelly, Frances S., ed. 2003. *Modern Art and the Grotesque*. Cambridge: Cambridge University Press.

Cox, Aimee Meredith. 2015. *Shapeshifters: Black Girls and the Choreography of Citizenship*. Durham, NC: Duke University Press.

Cruz-Malavé, Arnaldo. 2007. *Queer Latino Testimonio, Keith Haring, and Juanito Xtravaganza: Hard Tails*. New York: Palgrave Macmillan.

Currid-Halkett, Elizabeth. 2017. *The Sum of Small Things: A Theory of the Aspirational Class*. Princeton, NJ: Princeton University Press.

Daniels, Lee, dir. 2009. *Precious*. Los Angeles: Lionsgate.

Dávila, Arlene. 2008. *Latino Spin: Public Image and the Whitewashing of Race*. New York: New York University Press.

Dávila, Arlene. 2012. *Culture Works: Space, Value, and Mobility across the Neoliberal Americas*. New York: New York University Press.

Davis, Angela Y. 1998. *Blues Legacies and Black Feminism: "Ma" Rainey, Bessie Smith, and Billie Holiday*. New York: Vintage.

Davis, Ben. 2016. "How the Rich Are Hurting the Museums They Fund." *New York Times*, July 22. http://www.nytimes.com/2016/07/24/opinion/sunday/how-the-rich-are-hurting-the-museums-they-fund.html.

Dawson, Jessica. 2015. "What to Make of Kehinde Wiley's Pervy Brooklyn Museum Retrospective?" *Village Voice*, March 11. http://www.villagevoice.com/arts/what-to-make-of-kehinde-wileys-pervy-brooklyn-museum-retrospective-7194480.

Decena, Carlos Ulises. 2011. *Tacit Subjects: Belonging and Same-Sex Desire among Dominican Immigrant Men*. Durham, NC: Duke University Press.

De Genova, Nicholas, and Ana Y. Ramos-Zayas. 2003. *Latino Crossings: Mexicans, Puerto Ricans, and the Politics of Race and Citizenship*. New York: Routledge.

Doroshwalther, Blair, dir. 2014. *Out in the Night*. New Day Films, 75 minutes.

Doyle, Jennifer. 2006. *Sex Objects: Art and the Dialectics of Desire*. Minneapolis: University of Minnesota Press.

D'Souza, Aruna. 2018. *Whitewalling: Art, Race, and Protest in 3 Acts*. New York: Badlands Unlimited.

Duggan, Lisa. 2003. *The Twilight of Equality? Neoliberalism, Cultural Politics, and the Attack on Democracy*. Boston: Beacon.

Dunn, Marvin. 1997. *Black Miami in the Twentieth Century*. Gainesville: University Press of Florida.

El-Tayeb, Fatima. 2012. "'Gays Who Cannot Properly Be Gay': Queer Muslims in the Neoliberal European City." *European Journal of Women's Studies* 19 (1): 79–95.

Evans, Mel. 2015. *Artwash: Big Oil and the Arts*. London: Pluto.

Ferguson, James. 2010. "The Uses of Neoliberalism." *Antipode* 41 (1): 166–184.

Ferguson, Roderick A. 2004. *Aberrations in Black: Toward a Queer of Color Critique*. Minneapolis: University of Minnesota Press.

Fleetwood, Nicole R. 2011. *Troubling Vision: Performance, Visuality, and Blackness.* Chicago: University of Chicago Press.

Forster, Ian, prod. 2014. "Kara Walker: A Subtlety, or the Marvelous Sugar Baby." YouTube, May 23 [Video]. New York: Exclusive. https://www.youtube.com /watch?v=sRkP5rcXtys.

Foster, Hal. 1985. "The 'Primitive' Unconscious of Modern Art." *October* 34: 45–70.

Foucault, Michel. 1977. *Discipline and Punish: The Birth of the Prison.* New York: Vintage.

Foucault, Michel. 1978. *The History of Sexuality: An Introduction.* Vol. 1. New York: Vintage.

Fraunhar, Alison. 2008. "*Marquillas Cigarreras Cubanas*: Nation and Desire in the Nineteenth Century." *Hispanic Research Journal* 9 (5): 458–478.

Fraunhar, Alison. 2018. *Mulata Nation: Visualizing Race and Gender in Cuba.* Jackson: University Press of Mississippi.

Fregoso, Rosa Linda. 1999. "Re-imagining Chicana Urban Identities in the Public Sphere, *Cool Chuca Style.*" In *Between Woman and Nation: Nationalisms, Transnational Feminisms, and the State,* edited by Caren Kaplan, Norma Alarcón, and Minoo Moallem. Durham, NC: Duke University Press.

Galt, Rosalind. 2011. *Pretty: Film and the Decorative Image.* New York: Columbia University Press.

Gamson, Joshua. 1998. *Freaks Talk Back: Tabloid Talk Shows and Sexual Nonconformity.* Chicago: University of Chicago Press.

Ganz, Caryn. 2010. "The Curious Case of Nicki Minaj." *Out,* September 12. http:// www.out.com/entertainment/music/2010/09/12/curious-case-nicki-minaj.

Garcia Hernandez, Yessica. 2017. "'Que Alboroto Traen Conmigo': Theorizing Agitated Responses to Understand the Phenomenon of Jenni Rivera's Haters." PhD specialty paper, University of California, San Diego.

Gordon, Avery F. 2008. *Ghostly Matters: Haunting and the Sociological Imagination.* Minneapolis: University of Minnesota Press.

Gosin, Monika. 2009. "(Re)Framing the Nation: The Afro-Cuban Challenge to Black and Latino Struggles for American Identity." PhD diss., University of California, San Diego.

Green, Kai [Kiana]. 2009. "Nobody Knows Her Name: Making Sakia Legible." UCLA Center for the Study of Women: Thinking Gender Papers. http://repositories .cdlib.org/csw/thinkinggender/TG09_Green.

Green, Kai M. 2013. "Navigating Masculinity as a Black Transman: 'I Will Never Straighten Out My Wrist.'" *Everyday Feminism,* April 15. http://everydayfeminism .com/2013/04/i-will-never-straighten-out-my-wrist/.

Grewal, Inderpal. 1999. "Traveling Barbie: Indian Transnationality and New Consumer Subjects." *Positions* 7 (3): 799–826.

Grosz, Elizabeth. 1994. *Volatile Bodies: Towards a Corporeal Feminism.* Bloomington: Indiana University Press.

Guerrero, Aurora, dir. 2012. *Mosquita y Mari.* Indion Entertainment Group and Maya Entertainment.

Halberstam, Jack. 1998. *Female Masculinity*. Durham, NC: Duke University Press.

Halberstam, Jack. 2005. *In a Queer Time and Place: Transgender Bodies, Subcultural Lives*. New York: New York University Press.

Hall, Stuart. 1996. "What Is This 'Black' in Black Popular Culture?" In *Stuart Hall: Critical Dialogues in Cultural Studies*, edited by David Morley and Kwan-Hsing Chen. London: Routledge.

Harney, Stefano, and Fred Moten. 2013. *The Undercommons: Fugitive Planning and Black Study*. New York: Autonomedia.

Hartman, Saidiya. 2008. "Venus in Two Acts." *Small Axe* 26: 1–14.

Hartman, Saidiya. 2019. *Wayward Lives, Beautiful Experiments: Intimate Histories of Social Upheaval*. New York: Norton.

Harvey, David. 2005. *A Brief History of Neoliberalism*. New York: Oxford University Press.

Hattenstone, Simon. 2012. "Nicki Minaj: 'I Have Bigger Balls Than the Boys.'" *Guardian*, April 27. http://www.guardian.co.uk/music/2012/apr/27/nicki-minaj-bigger-balls-than-the-boys.

Hebdige, Dick. 1979. *Subculture: The Meaning of Style*. New York: Routledge.

Hernandez, Jillian. 2008. "Performing Identity in Miami: A Case Study of Women Artists." In *Florida without Borders: Women at the Intersections of the Local and Global*, edited by Sharon Kay Masters, Judy A. Hayden, and Kim Vaz. Newcastle upon Tyne, UK: Cambridge Scholars.

Hernandez, Jillian. 2009. "'Miss, You Look Like a Bratz Doll': On Chonga Girls and Sexual-Aesthetic Excess." *National Women's Studies Association Journal* 21 (3): 63–91.

Hernandez, Jillian. 2014. "Carnal Teachings: Raunch Aesthetics as Queer Feminist Pedagogies in Yo! Majesty's Hip Hop Practice." *Women and Performance: A Journal of Feminist Theory* 24 (1): 88–106.

Hernandez, Jillian. 2017. "The Ambivalent Grotesque: Reading Black Women's Erotic Corporeality in Wangechi Mutu's Work." *Signs* 42 (2): 427–457.

Higginbotham, Evelyn Brooks. 1992. "African-American Women's History and the Metalanguage of Race." *Signs* 17 (2): 251–274.

HipHopStan. 2009. "Nicki Minaj Explains 'Harajuku Barbie.'" YouTube, August 9 [Video]. http://www.youtube.com/watch?v=xkL2r2x6EFg.

Hong, Grace Kyungwon, and Roderick A. Ferguson, eds. 2011. *Strange Affinities: The Gender and Sexual Politics of Comparative Racialization*. Durham, NC: Duke University Press.

Hurston, Zora Neale. 1938. *Tell My Horse: Voodoo and Life in Haiti and Jamaica*. Philadelphia: J. B. Lippincott.

Hyde, Melissa. 2006. *Making Up the Rococo: François Boucher and His Critics*. Los Angeles: Getty Research Institute.

Hyde, Melissa. 2014. "Afterword: The Rococo Dream of Happiness as a 'Delicate Kind of Revolt.'" In *Rococo Echo: Art, History, and Historiography from Cochin to Coppola*, edited by Melissa Lee Hyde and Katie Scott. New York: Oxford University Press.

INCITE!, ed. 2017. *The Revolution Will Not Be Funded: Beyond the Non-profit Industrial Complex*. Durham, NC: Duke University Press.

Johnson, E. Patrick. 2003. *Appropriating Blackness: Performance and the Politics of Authenticity*. Durham, NC: Duke University Press.

Johnson, E. Patrick, and Ramón H. Rivera-Servera, ed. 2016. *Blacktino Queer Performance*. Durham, NC: Duke University Press.

Johnson, Gaye Theresa. 2013. *Spaces of Conflict, Sounds of Solidarity: Music, Race, and Spatial Entitlement in Los Angeles*. Berkeley: University of California Press.

Johnson, Sara E. 2012. *The Fear of French Negroes: Transcolonial Collaboration in the Revolutionary Americas*. Berkeley: University of California Press.

Johnson, Steven. 2016. "The Day Miami Was Rocked by Riot after Cops Cleared in McDuffie Beating." *Miami Herald*, May 15. http://www.miamiherald.com/news/local/community/miami-dade/article77769522.html.

Kang, Miliann. 2010. *The Managed Hand: Race, Gender, and the Body in Beauty Service Work*. Berkeley: University of California Press.

Kaplan, Louis. 2005. *American Exposures: Photography and Community in the Twentieth Century*. Minneapolis: University of Minnesota Press.

Keeling, Kara. 2009. "Looking for M—: Queer Temporality, Black Political Possibility, and Poetry from the Future." GLQ: *A Journal of Lesbian and Gay Studies* 15 (4): 565–582.

Kelly, Zahira. 2016. *Baina Colonial*. Accessed March 5, 2020. http://www.bainacolonial.com.

Kennedy, Elizabeth Lapovsky, and Madeline D. Davis. 1993. *Boots of Leather, Slippers of Gold: The History of a Lesbian Community*. New York: Routledge.

Knupfer, Anne Meis. 2000. "'To Become Good, Self-Supporting Women': The State Industrial School for Delinquent Girls at Geneva, Illinois, 1900–1935." *Journal of the History of Sexuality* 9 (4): 420–446.

Ko, Dorothy. 2005. *Cinderella's Sisters: A Revisionist History of Footbinding*. Berkeley: University of California Press.

Lansky, Sam. 2012. "Nicki Minaj, Can We Talk about Your 'Stupid Hoe' Video for a Minute?" *MTV News*, January 23. http://www.mtv.com/news/2300053/nicki-minaj-stupid-hoe-video/.

Lavelle, Ciara. 2014. "MOCA Board Reportedly Leaving North Miami to Form New Art Museum in Design District." *Miami New Times*, August 6. http://www.miaminewtimes.com/arts/moca-board-reportedly-leaving-north-miami-to-form-new-art-museum-in-design-district-6511557.

Lee, Nikki S. 2001. *Nikki S. Lee: Projects*. New York: Hatje Cantz.

Lee, Phil. 2008. "Indefinite 'Nikkis' in a World of Hyperreality: An Interview with Nikki S. Lee." *Chicago Art Journal* 18: 76–92.

Lichtenstein, Jacqueline. 1987. "Making Up Representation: The Risks of Femininity." *Representations* 20: 77–87.

Loos, Adolf. 1985. *The Architecture of Adolf Loos: An Arts Council Exhibition*. London: Arts Council.

Lorde, Audre. (1984) 2007. *Sister Outsider: Essays and Speeches.* Berkeley, CA: Crossing Press.

Lush, Tamara. 2007. "Chongas! Two Aventura Girls' YouTube Sensation Is Only the Beginning." Photos by Ivylise Simone. *Miami New Times*, June 14–20, 18–30.

Madriz, Esther. 2003. "Focus Groups in Feminist Research." In *Collecting and Interpreting Qualitative Materials*, edited by Norman K. Denzin and Yvonna S. Lincoln. Thousand Oaks, CA: Sage.

Mahmood, Saba. 2005. *Politics of Piety: The Islamic Revival and the Feminist Subject.* Princeton, NJ: Princeton University Press.

Martinez, O. Rubén, and Raymond Rocco. 2016. "Neoliberalism and Latinos." *Latino Studies* 14 (1): 2–10.

M'Bow, Babacar. 2014. "The Politics of Culture: Spaces in Times of Mutations." In *MOCA: Re/claiming Art, Power, Ideas, and Vision in an Ethnically Plural Community*, edited by Babacar M'Bow, Carole Boyce Davies, and Adrienne von Lates. Miami: Museum of Contemporary Art North Miami.

M'Bow, Babacar, Carole Boyce Davies, and Adrienne von Lates, eds. 2014. *MOCA: Re/claiming Art, Power, Ideas, and Vision in an Ethnically Plural Community.* Miami: Museum of Contemporary Art North Miami.

McClintock, Anne. 1995. *Imperial Leather: Race, Gender, and Sexuality in the Colonial Contest.* New York: Routledge.

McDowell, Linda. 1999. *Gender, Identity, and Place: Understanding Feminist Geographies.* Minneapolis: University of Minnesota Press.

McMillan, Uri. 2015. *Embodied Avatars: Genealogies of Black Feminist Art and Performance.* New York: New York University Press.

Mendible, Myra, ed. 2007. *From Bananas to Buttocks: The Latina Body in Popular Film and Culture.* Austin: University of Texas Press.

Mercer, Kobena. 1987. "Black Hair/Style Politics." *New Formations* 3: 33–54.

Mercer, Kobena. 1994. "Monster Metaphors: Notes on Michael Jackson's *Thriller*." In *Welcome to the Jungle: New Positions in Black Cultural Studies*. New York: Routledge.

Michaels, Sean. 2012. "Nicki Minaj Accuses Steven Tyler of Racism in Row over American Idol." *Guardian*, November 28. http://www.guardian.co.uk/music/2012/nov/28/nicki-minaj-steven-tyler-american-idol.

Milian, Claudia. 2013. *Latining America: Black-Brown Passages and the Coloring of Latino/a Studies.* Athens: University of Georgia Press.

Miller, Michael E. 2014. "Miami Artist Destroyed $1M Ai Weiwei Vase Because PAMM 'Only Displays International Artists.'" *Miami New Times*, February 17. https://www.miaminewtimes.com/news/miami-artist-destroyed-1m-ai-weiwei-vase-because-pamm-only-displays-international-artists-6524159.

Miller, Monica L. 2009. *Slaves to Fashion: Black Dandyism and the Styling of Black Diasporic Identity.* Durham, NC: Duke University Press.

Miller-Young, Mireille. 2008. "Hip-Hop Honeys and Da Hustlaz: Black Sexualities in the New Hip-Hop Pornography." *Meridians* 8 (1): 261–292.

Miller-Young, Mireille. 2014. *A Taste for Brown Sugar: Black Women in Pornography.* Durham, NC: Duke University Press.

Molina Guzmán, Isabel. 2007. "Disorderly Bodies and Discourses of Latinidad in the Elián González Story." In *From Bananas to Buttocks: The Latina Body in Popular Film and Culture,* edited by Myra Mendible. Austin: University of Texas Press.

Molinary, Crystal Pearl. 2010. "Off the Chain." YouTube, September [Video]. https://www.youtube.com/watch?v=O7JgytS1LIg.

Moten, Fred. 2003. *In the Break: The Aesthetics of the Black Radical Tradition.* Minneapolis: University of Minnesota Press.

Muholi, Zanele. 2014. *Faces and Phases 2006–2014.* Steidl, Germany: Walther Collection.

Mukherjee, Roopali, and Sarah Banet-Weiser, eds. 2012. *Commodity Activism: Cultural Resistance in Neoliberal Times.* New York: New York University Press.

Muñoz, José Esteban. 1999. *Disidentifications: Queers of Color and the Performance of Politics.* Minneapolis: University of Minnesota Press.

Murray, Derek Conrad. 2015. *Queering Post-Black Art: Artists Transforming African-American Identity after Civil Rights.* New York: I. B. Tauris.

Musser, Amber Jamilla. 2018. *Sensual Excess: Queer Femininity and Brown Jouissance.* New York: New York University Press.

Nakamura, Lisa. 2002. *Cybertypes: Race, Ethnicity, and Identity on the Internet.* London: Routledge.

Nash, Jennifer C. 2008. "Strange Bedfellows: Black Feminism and Antipornography Feminism." *Social Text* 26 (4): 51–76.

Nestle, Joan, ed. 1992. *The Persistent Desire: A Femme-Butch Reader.* Boston: Alyson.

Ngô, Fiona I. B. 2011. "Sense and Subjectivity." *Camera Obscura* 26 (1, 76): 95–129.

Nguyen, Mimi Thi. 2011. "The Biopower of Beauty: Humanitarian Imperialisms and Global Feminisms in an Age of Terror." *Signs* 36 (2): 359–383.

Ochoa, Marcia. 2014. *Queen for a Day: Transformistas, Beauty Queens, and the Performance of Femininity in Venezuela.* Durham, NC: Duke University Press.

O'Grady, Lorraine. 2002. "Olympia's Maid: Reclaiming Black Female Subjectivity." In *The Feminism and Visual Culture Reader,* edited by Amelia Jones. London: Routledge.

Paredez, Deborah. 2009. *Selenidad: Selena, Latinos, and the Performance of Memory.* Durham, NC: Duke University Press.

Pero Like. 2016. "Women Transform into Chongas." YouTube, April [Video]. https://www.youtube.com/watch?v=6Ps13XeDdcg.

Pierce, India. 2017. "Freedom and Futurity: Ethnic Studies Theoretical Paper." Unpublished manuscript, University of California, San Diego.

Poole, Deborah. 1997. *Vision, Race, and Modernity: A Visual Economy of the Andean Image World.* Princeton, NJ: Princeton University Press.

Portes, Alejandro, and Alex Stepick. 1993. *City on the Edge: The Transformation of Miami.* Berkeley: University of California Press.

Powers, Nicholas. 2014. "Why I Yelled at the Kara Walker Exhibit." *IndyPendent,* June 30. https://indypendent.org/2014/06/30/why-i-yelled-kara-walker-exhibit.

Pritchard, Stephen. 2018. "Artwashing Social Space." *Colouring in Culture*, June 22. http://colouringinculture.org/blog/2018/6/22/artwashingsocialspace.

Projansky, Sarah. 2014. *Spectacular Girls: Media Fascination and Celebrity Culture*. New York: New York University Press.

Rameau, Max. 2012. *Take Back the Land: Land, Gentrification, and the Umoja Village Shantytown*. Oakland, CA: AK Press.

Ramírez, Catherine S. 2009. *The Woman in the Zoot Suit: Gender, Nationalism, and the Cultural Politics of Memory*. Durham, NC: Duke University Press.

Ramos-Zayas, Ana Y. 2007. "Becoming American, Becoming Black? Urban Competency, Racialized Spaces, and the Politics of Citizenship among Brazilian and Puerto Rican Youth in Newark." *Identities* 14 (1): 85–109.

Ramos-Zayas, Ana Y. 2012. *Street Therapists: Race, Affect, and Neoliberal Personhood in Latino Newark*. Chicago: University of Chicago Press.

Rand, Erica. 1995. *Barbie's Queer Accessories*. Durham, NC: Duke University Press.

Rees, Dee, dir. 2011. *Pariah*. Chicken and Egg Pictures, MBK Entertainment, Northstar Pictures.

Richardson, Jared. 2012. "Attack of the Boogeywoman: Visualizing Black Women's Grotesquerie in Afrofuturism." *Art Papers* 36 (6): 18–22.

Rivera, Fredo. 2019. "Precarity + Excess in the *Latinopolis*: Miami as Erzulie." *Cultural Dynamics* 31 (1–2): 62–80.

Rivera-Servera, Ramón H. 2012. *Performing Queer Latinidad: Dance, Sexuality, Politics*. Ann Arbor: University of Michigan Press.

Robinson, Hilary. 2006. *Reading Art, Reading Irigaray: The Politics of Art by Women*. New York: I. B. Tauris, 2006.

Rodríguez, Juana María. 2014. *Sexual Futures, Queer Gestures, and Other Latina Longings*. New York: New York University Press.

Rodriguez, Nicole. 2015. "Rethinking Power and Pleasure in the Shame of Abjection." Unpublished manuscript. Critical Gender Studies, University of California, San Diego.

Rosler, Martha. 2013. *Culture Class*. Berlin: Sternberg Press.

Salamon, Gayle. 2010. *Assuming a Body: Transgender and Rhetorics of Materiality*. New York: Columbia University Press.

Sampson, Hannah. 2013. "MOCA Chief Bonnie Clearwater Leaving for Fort Lauderdale Museum." *Miami Herald*, July 17. http://www.miamiherald.com/news/local/community/miami-dade/article1953322.html.

Sampson, Hannah, and Philippe Buteau. 2014. "In Spat with North Miami MOCA Files Suit." *Miami Herald*, April 8. http://www.miamiherald.com/news/local/community/miami-dade/north-miami/article1962527.html.

Sapphire. 1996. *Push: A Novel*. New York: Alfred A. Knopf.

Schein, Louisa. 1999. "Of Cargo and Satellites: Imagined Cosmopolitanism." *Postcolonial Studies* 2 (3): 345–375.

Schiebinger, Londa. 1999. "Theories of Gender and Race." In *Feminist Theory and the Body: A Reader*, edited by Janet Price and Margrit Shildrick. New York: Routledge.

Selena Gomez. 2011. "MTV EMA 2011 Promo." YouTube, October [Video]. https://www.youtube.com/watch?v=cDlHJdyHQes.

Seminole Tribe of Florida. n.d. "History: Where We Came From." Accessed March 27, 2020. https://www.semtribe.com/STOF/history/introduction.

Sharpe, Christina. 2016. *In the Wake: On Blackness and Being*. Durham, NC: Duke University Press.

Shimizu, Celine Parreñas. 2007. *The Hypersexuality of Race: Performing Asian/American Women on Screen and Scene*. Durham, NC: Duke University Press.

Smith, Cherise. 2011. *Enacting Others: Politics of Identity in Eleanor Antin, Nikki S. Lee, Adrian Piper, and Anna Deavere Smith*. Durham, NC: Duke University Press.

Snorton, C. Riley. 2014. *Nobody Is Supposed to Know: Black Sexuality on the Down Low*. Minneapolis: University of Minnesota Press.

Snorton, C. Riley. 2017. *Black on Both Sides: A Racial History of Trans Identity*. Minneapolis: University of Minnesota Press.

Sokol, Brett. 2014. "Those Artsy Early Birds Flew Away." *New York Times*, November 28. https://www.nytimes.com/2014/11/30/arts/design/art-basel-miami-beachs-unfulfilled-promise.html.

Spade, Dean. 2015. *Normal Life: Administrative Violence, Critical Trans Politics, and the Limits of the Law*. Durham, NC: Duke University Press.

Spillers, Hortense J. 1987. "Mama's Baby, Papa's Maybe: An American Grammar Book." *Diacritics* 17 (2): 64–81.

Stallings, L. H. 2015. *Funk the Erotic: Transaesthetics and Black Sexual Cultures*. Urbana: University of Illinois Press.

Stein, Arlene. 1992. "'All Dressed Up but No Place to Go?': Style Wars and the New Lesbianism." In *The Persistent Desire: A Butch-Femme Reader*, edited by Joan Nestle. New York: Alyson.

Stephens, Dionne P., Paula B. Fernández, and Erin L. Richman. 2012. "Ni Pardo, Ni Prieto: The Influence of Parental Skin Color Messaging on Heterosexual Emerging Adult White-Hispanic Women's Dating Beliefs." *Women and Therapy* 35 (1–2): 4–18. doi:10.1080/02703149.2012.634714.

Stewart, Dodai. 2012. "Nicki Minaj's 'Stupid Hoe' Video Features Writhing, Disappointment." *Jezebel*, January 24. https://jezebel.com/nicki-minajs-stupid-hoe-video-features-writhing-disapp-5878769.

Sutton, Kelsey. 2016. "BuzzFeed Fires Two amid Video Push." *Politico*, June 15. https://www.politico.com/media/story/2016/06/non-compete-agreement-buzzfeed-firings-004600.

Taylor-García, Daphne V. 2018. *The Existence of the Mixed Race Damnés: Decolonialism, Class, Gender, Race*. London: Rowman and Littlefield International.

Thompson, Krista A. 2009. "The Sound of Light: Reflections on Art History in the Visual Culture of Hip-Hop." *Art Bulletin* 91 (4): 481–505.

Thompson, Krista A. 2015. *Shine: The Visual Economy of Light in African Diasporic Aesthetic Practice*. Durham, NC: Duke University Press.

Tinsley, Omise'eke Natasha. 2010. *Thiefing Sugar: Eroticism between Women in Caribbean Literature*. Durham, NC: Duke University Press.

Urla, Jacqueline, and Alan Swedlund. 1995. "The Anthropometry of Barbie: Unsettling Ideals of the Feminine Body in Popular Culture." In *Deviant Bodies: Critical Perspectives on Difference in Science and Popular Culture*, edited by Jennifer Terry and Jacqueline Urla. Bloomington: Indiana University Press.

Valdivia, Angharad N. 2011. "This Tween Bridge over My Latina Back: The U.S. Mainstream Negotiaties Ethnicity." In *Mediated Girlhoods: Explorations of Girls' Media Culture*, edited by Mary Celeste Kearney. New York: Peter Lang.

Vargas, Deborah R. 2010. "Rita's Pants: The *Charro Traje* and Trans-sensuality." *Women and Performance: A Journal of Feminist Theory* 20 (1): 3–14.

Vargas, Deborah R. 2014. "Ruminations on Lo Sucio as a Latino Queer Analytic." *American Quarterly* 66 (3): 715–726.

Vargas, Nicholas. 2015. "Latina/o Whitening? Which Latina/os Self-Classify as White and Report Being Perceived as White by Other Americans?" *Du Bois Review* 12 (1): 119–136.

Veblen, Thorstein. (1899) 2007. *The Theory of the Leisure Class*. Edited by Martha Banta. New York: Oxford University Press.

Voon, Claire. 2016. "Appropriated Images of Black People Spark Boycott of St. Louis Museum [UPDATED]." *Hyperallergic*, September 22. http://hyperallergic .com/324466/appropriated-images-of-black-people-spark-boycott-of-st-louis -museum.

Vorick, Rebecca. 2018. "UCLA: Defend Boyle Heights on Artwashing and Gentrification." *FEM*, March 11. https://femmagazine.com/ucla-defend-boyle -heights-on-artwashing-and-gentrification/.

Walker, Sidney, and Sydney Walker. 2004. "Artmaking in an Age of Visual Culture: Vision and Visuality." *Visual Arts Research* 30 (2): 23–37.

Wallace, Anya. 2019. "Spacetime and the Margins: Black Girlhood In and Out of the Black Hole." Unpublished manuscript, Pennsylvania State University.

Waltener, Shane. 2004. "The Real Nikki." *Modern Painters* 17 (1): 67–69.

Weheliye, Alexander G. 2014. *Habeas Viscus: Racializing Assemblages, Biopolitics, and Black Feminist Theories of the Human*. Durham, NC: Duke University Press.

White, Miles. 2011. *From Jim Crow to Jay-Z: Race, Rap, and the Performance of Masculinity*. Urbana: University of Illinois Press.

Whitney Museum of American Art. 2015. "Looking Back at Black Male: Thelma Golden, Hilton Als, and Huey Copeland, Live from the Whitney." YouTube, March 6 [Video]. https://www.youtube.com/watch?v=q9gQdRlKuhw.

Willis, Deborah, ed. 2010. *Black Venus 2010: They Called Her "Hottentot."* Philadelphia: Temple University Press.

Willis, Deborah, and Carla Williams. 2002. *The Black Female Body: A Photographic History*. Philadelphia: Temple University Press.

Woods, Clyde. 2007. "'Sittin' on Top of the World': The Challenges of Blues and Hip-Hop Geography." In *Black Geographies and the Politics of Place*, edited by Katherine McKittrick and Clyde Woods. Toronto: Between the Lines.

Yarbro-Bejarano, Yvonne. 1997. "Crossing the Border with Chavela Vargas: A Chi-

cana Femme's Tribute." In *Sex and Sexuality in Latin America*, edited by Daniel
Balderston and Donna J. Guy. New York: New York University Press.

Ybarra-Frausto, Tomás. 1989. "Rasquachismo: A Chicano Sensibility." In *Chicano
Aesthetics: Rasquachismo* [exhibit catalog]. Phoenix, AZ: MARS.

YLGA22. 2009. "Chongalicious in Cristina Part 1." YouTube, January [Video]. https://
www.youtube.com/watch?v=YO9JyzwK9lQ.

Yúdice, George. 2003. *The Expediency of Culture: Uses of Culture in the Global Era.*
Durham, NC: Duke University Press.

Zendaya. 2018. "Cardi B Opens Up to Zendaya in the New Issue of CR *Fashion Book.*"
CR, December 21. https://www.crfashionbook.com/celebrity/a15956294/card-b
-zendaya-cr-fashion-book-interview/.

Note: Page numbers in *italics* refer to figures.

Dávila, Arlene, 65
Davila, Mimi, 65–67, 73–76, 83, 274n2
Davis, Angela Y., 105–106
Davis, Ben, 258
Davis, Madeline D., 127–128
Davis, Vaginal, 61
Dawson, Jessica, 13, 15
deportation, 6, 11, 20, 54
detention centers, 3, 11, 54, 251–252, 273n11
Detroit, Michigan, 16
deviance, 21–22, 44; and aesthetics of excess,
 3, 9, 11–12, 164–181; and chonga girls, 27,
 65, 73; difference as, 46; and gender, 81,
 104, 130; and perception of working class,
 107; sexual, 6, 80, 213–215, 226, 256,
 272n5
diaspora, 7, 10–11, 48, 72–73, 276n20; African,
 43, 57–58
Di Lorenzo, Laura, 65–67, 73–76, 83, 274n2,
 275n8
Dimple (interviewee), 100–103, 106, 112,
 130–131, 253
Disney, 73, 79, 149
displacement, 42, 45, 162
Dominican identity, 57–58, 115, 261
Domino Sugar Factory, Brooklyn, 223, 225,
 231
D'Souza, Aruna, 262
Du Bois, W. E. B., 16
Duchamp, Marcel: *Fountain*, 86
Dunn, Marvin, 42–45
Dylan, Bob, 158

East Indies, 57
education, 22, 69, 116, 201–202, 229, 251,
 259–260, 265–266; opportunities for, 1–4,
 19, 54, 222–223, 272n12; sex, 230. *See also*
 pedagogy
educators, 3, 6, 96, 155, 222, 229
elitism, 18–20, 85, 165; and contemporary
 art, 27–28, 54, 257–258, 261, 272n5; and
 Cubans, 44
Emin, Tracey, 7
Enlightenment discourse, 146–147, 165
erasure, 44, 56, 61, 121–122, 264; of Black
 queerness, 15; cultural, 11, 55, 253
Essence (magazine), 205
ethnic studies, 26, 255

ethnography, 10, 72, 76, 176, 203; autoethnog-
 raphy, 17, 23
Europe, 9, 57–58, 224; and art, 168, 171,
 176–177, 210, 214; representing high cul-
 ture, 149; and style, 58, 146, 274n5
exile, 8, 44, 48, 55
exploitation, 161, 203; of Black women, 27,
 178–179, 207, 210, 225–226; of chonga em-
 bodiment, 93, 275n14

Facebook, 49, 110–111, 193, 255
facial hair, 105, 121–131
faja, 50, 183
fakery, 6–7, 27, 145–147, 152–158, 270; politics
 of, 164–168, 176, 180, 185
feminist artists, 2, 7–8, 28, 202, 209
feminist politics, 49, 127, 161
femme identity, 39, 110, 116, 127–128, 184,
 210, 212, 276n4. *See also* butch-femme
 aesthetics
Ferguson (Missouri) protests, 263
Ferguson, Roderick, 60, 107
fetishism, 15, 19–21, 104, 160, 183
Figueras, Guadalupe, 2
Figueroa, Rodner, 82
financial power, 103, 128, 160–161
finas, 82, 84
Flagler, Henry, 43
Fleetwood, Nicole, 177, 272n5
Florida, 1, 41–42, 57; Sanford, 6; South Flor-
 ida, 43, 46, 67, 73, 229, 254; Tampa, 44. *See
 also* Miami; Miami-Dade County
Florida International University, 48–49,
 109
Flynn, Karen, 182
France, 146, 165, 167; Paris, 10. *See also* ro-
 coco style
Francophone Caribbean people, 26
Fraunhar, Alison, 68
freedom, 17, 21, 58, 61, 120, 160, 231–232; Black
 feminist, 183; and chonga girls, 84; practice
 of, 54, 273n10
Fregoso, Rosa Linda, 64
Friends with You (artist), 41

Galt, Rosalind, 9
Garcia-Ferraz, Nereida, 2
gay people, 12, 15, 39, 82, 115–116, 121; and body

practices, 9; versus queer, 106; violence against, 104; women, 27, 101, 107–108, 111, 131. *See also* butch-femme aesthetics; lesbians; studs

gender nonconformity, 64, 104–107, 114–131, 179. *See also* butch-femme aesthetics; studs

gender policing, 17, 64, 83, 116–118, 123, 147, 165. *See also* sexual policing

genderqueer identity, 104, 121, 123, 150

gentrification, 6, 20, 38, 45, 70, 72; and art, 41, 261

"ghetto girl," figure of, 16, 67, 70, 88

Gil, Sonia Perla, 48, 52, 53, 54

girdle. See *faja*

girlhood, 144, 151, 184, 222, 253; of author, 6, 23, 148–149, 181, 256, 277n1; Black, 107, 209, 254, 266; consumption, 9; queer, 116; working-class, 96

Girls Summit program, 229

GisMo collaborative, 92

Gispert, Jessica, 3, 92

Gispert, Luis, 93, 96, 257; *Cheerleaders* (photograph series), 85–89; *Untitled (Chain Mouth, a.k.a. Muse Ho)*, 86

GLBTQ youth-serving organizations, 106. *See also* Coalition for GLBTQ Youth (pseudonym); Lifelines (pseudonym)

Golden Age Mexican *cabareta* films, 52

Gomez, Selena, 75, 78–81, *80*

González, Elián, 15

González, Marisleysis, 15

good Latina girl subjectivity, 79

Gosse, Edmund, 168

Grand Theft Auto: Vice City, 88

Great Migration, 21

grotesque aesthetics, 178, 202–210, 213–215, 218, 229–230

Guggenheim Museum Bilbao, 88

Gunn, Sakia, 104

Guzmán, Isabel Molina, 15

Habana Riviera Hotel, 47, 49

Haiti, 26, 45

Haitian Americans, 120, 122, 154

Haitian immigrants, 43–44, 54

Haitian people, 37, 43, 58, 60–61, 70

Haitian Revolution, 44

Halberstam, Jack, 108

Hall, Stuart, 7, 85

Haring, Keith, 10, 275n14

Hartman, Saidiya, 23; "Venus in Two Acts," 218; *Wayward Lives, Beautiful Experiments*, 16

heteropatriarchy, 22, 108

heterosexism, 104, 116, 118, 155

heterosexuality, 9, 12, 22, 108, 124, 214

high culture, 8, 84–85, 149, 165, 258. *See also* low culture

Hill, Renata. *See* New Jersey 4

hip-hop, 145, 150, 153, 160, 165, 174, 176–178, 266; culture, 72, 110, 130, 183; style, 101–102, 168, 230

Hip Hop and Punk Feminisms conference, 182, 255

hipsters, 37, 109, 152, 264

Hispanic Project, The, 89–92, *90*, *91*

Hispanophone Caribbean people, 60

Hitchiti tribe, 42

Holiday, Billie, 209

Home Shopping Network, 183

homonormativity, 82, 106

homophobia, 102, 116, 120

Hong, Grace, 60

"Hoochielicious" (YouTube video), 67

"Hottentots." *See* Khoisan women

Hottentot Venus. *See* Baartman, Saartjie

Hurston, Zora Neale, 10

Hyde, Melissa, 147, 149, 165, 167, 172

hyperfemininity, 13, 37, 79, 92, 96, 107–108. *See also* Minaj, Nicki: and hyperfemininity

hypermasculinity, 13, 15, 179

hypervisibility, 11, 39, 68, 84, 87, 96

Ibsen, Henrik, 168

"I'm in Love with a Chonga" (YouTube video), 67

imperialism, 10, 42, 224. *See also* colonialism; transcolonial formations

incarceration, 1, 11, 20, 42, 104–105, 108, 223, 262, 274n11. *See also* detention centers; juvenile justice system

inclusion, 19, 21, 56, 85, 101

Indigeneity, 16, 42, 135. *See also* Native Americans

Instagram, *166*, 264

social media, 16, 55, 58, 146, 184. *See also* Facebook; Instagram; YouTube
social welfare, 20, 43, 107, 272n12
sociology, 16, 103, 127
South Africa, 27, 121; Eastern Cape, 176
South Americans, 60, 65
South Korea, 89
Space Mountain (venue), 50, 148, 182–183
Spain, 42, 55
Spanish colonialism, 42, 55–58. *See also* Baina Colonial
Spanish-language media, 6, 63, 67, 82, 84
spectacularization, 55, 88, 176–177, 256, 264
Sports Illustrated, 166
Stallings, L. H., 10, 228, 231
Stanley (interviewee), 122
Stark, Jen, 41
Stephens, Dionne, 48–49
Stepick, Alex, 44
Stewart, Dodai, 179
St. Louis, Missouri, 263
studs, 107, 110–111, 116, 122–130
"style blues," 105–108, 120, 129–131
subjectivity, 17, 20, 54, 58, 79, 228, 253; and chonga girls, 70; and gender nonconforming, 112, 117, 124, 129–131, 150
sub-working class, 12, 19, 21, 37, 39, 41
surveillance, 11, 17, 21, 201–202, 213, 222, 272n7
Suzie (interviewee), 124, 126

Tamyra (interviewee), 124–126
Tashell (interviewee), 160, 268
tattoos, 34, 87, 100–103, 110, 119, 270
Taylor-García, Daphne V., 55, 57
Tequesta tribe, 42
Terezi (interviewee), 152–153
Third Space: Inventing the Possible (MOCA exhibition), 259
Thomas, Mickalene, 2, 38
Thompson, Krista, 87, 271n3, 275n20
tignon law, 58
Till, Emmett, 263
Tinsley, Omise'eke Natasha, 57, 105–106
tragic mulata, trope of, 52
transaesthetics, 10, 18
transcolonial formations, 57–58, 61, 148
trans people, 18, 27, 43, 105, 176, 231, 276–277n4; and aesthetics of excess, 121–130
transphobia, 124, 126
Trinidadians, 57, 145, 148
Turner, Tina, 213
Tyler, Steven, 158

Ugly Betty, 75
University of California, San Diego, 182
University of Illinois at Urbana-Champaign, 182, 255
Univision, 67–68, 82
Uno Entertainment, 74–75
upper-class populations, 19, 41, 79, 102–103, 130, 155; and chonga girls, 74–75
U.S. Census, 39, 42, 65, 103
Uslip, Jeffrey, 263–264

Valdivia, Angharad, 78
Vargas, Nicholas, 103
Veblen, Thorstein, 18
vedette performers, 47, 52
Venezuela, 176, 274n1
Venus, figure of, 171, 218, 222. *See also* Baartman, Saartjie
Vergara, Sofía, 63
Vezzoli, Francesco, 148, 164–173, 181; *Rococo Portrait of Nicki Minaj as Françoise Athénaïs de Rochechourat de Mortemart Marquise de Montespan*, 168–169; *Rococo Portrait of Nicki Minaj as Jeanne Bécu, Comtesse du Barry*, 168, 170, 171
Victimas del Pecado (film), 52
Victoria, Monica Lopez de, 2
Village Voice, 27
violence, 51, 67, 160, 163, 179; against Black women/girls, 55, 61, 218; colonial, 23; gender-based, 17, 104–107, 118, 203, 217; race-based, 6, 45–46, 72, 223, 264. *See also* police brutality; racism; sexual violence; slavery; white supremacy

W (magazine), 164–165, 168, 172, 173
Walker, Kara, 6, 9, 27, 178, 205–209, 272n5; *A Subtlety, or the Marvelous Sugar Baby*, 223–229, 225, 231, 253, 269
Walker, Kelley, 264; *Black Star Press (rotated*